D0780993

Color and Design

Color and Design

Edited by
Marilyn DeLong and Barbara Martinson

London · New York

English edition
First published in 2012 by
Berg
Editorial offices:
50 Bedford Square, London WC1B 3DP, UK
175 Fifth Avenue, New York, NY 10010, USA

© Marilyn DeLong and Barbara Martinson 2012

All rights reserved.
No part of this publication may be reproduced in any form
or by any means without the written permission of
Berg.

Berg is an imprint of Bloomsbury Publishing Plc.

Library of Congress Cataloging-in-Publication Data

Color and design / edited by Marilyn DeLong and Barbara Martinson.
p. cm.
Includes bibliographical references and index.
ISBN 978-1-84788-951-5 (pbk.) — ISBN 978-1-84788-952-2 () —
ISBN 978-1-84788-953-9 () 1. Color in design. I. DeLong, Marilyn
Revell, 1939– II. Martinson, Barbara.
NK1548.C64 2013
701'.85—dc23 2012027465

British Library Cataloguing-in-Publication Data

A catalogue record for this book is available from the British Library.

ISBN 978 1 84788 952 2 (Cloth)
 978 1 84788 951 5 (Paper)
e-ISBN 978 1 84788 953 9 (epub)

Typeset by Apex Publishing, LLC, Madison, WI, USA.
Printed in the UK by the MPG Books Group

www.bergpublishers.com

Contents

List of illustrations

PLATES

FIGURES

Notes on Contributors

CO-EDITORS

MARILYN DELONG, PhD, is Professor of Apparel Studies in the College of Design at the University of Minnesota. Her scholarly research is focused upon perception and aesthetics, design education, history, and material culture. Current topics of research include touch preference, design education across cultures, sustainable attitudes, and practices of consumers. Published works include *The Way We Look*, in its second edition and translated into Korean; she has edited eight books and several exhibition catalogs. She is the author of numerous journal articles in such venues as *Fashion Theory*, *Clothing and Textiles Research Journal*, *Senses and Society*, *Textile*, *Qualitative Market Research*, and the *Journal of Fashion Marketing and Management*. DeLong has been co-editor of *Fashion Practice: The Journal of Design, Creative Process and the Fashion Industry* from its inception in 2009. She is on the board of the Costume Society of America and serves on the boards of other foundations and museums.

BARBARA MARTINSON, PhD, is Professor of Design Communication (Graphic Design) at the University of Minnesota. Her scholarly focus is on design education and color. Specific topics include color and surface design studies, design variables and human factors, effects of color and fonts on legibility, and design considerations for diverse users. Published works include numerous book chapters on topics of human factors, learning style, and game-based learning. Martinson's design work has been exhibited in national and international exhibitions, and she recently curated the exhibition, *Seeing Color*, in the Goldstein Museum of Design. She serves on the board of directors for the Inter-Society Color Council and on the editorial board of *Colour: Design and Creativity*.

CONTRIBUTORS

KARIN FRIDELL ANTER is an architect SAR/MSA and PhD in architecture, specialized on color. She is Associate Professor at the Royal Institute of Technology and a researcher at University College of Arts, Crafts and Design, both in Stockholm. Her dissertation from 2000 is titled *What Colour Is the Red House? Perceived Colour of Painted Façades*. She has written several books in Swedish and numerous articles in Swedish and international journals. She is an active member of the International Colour Association

(AIC) and led the scientific committee for its conference in Stockholm in 2008. She is internationally engaged as an academic examiner and guest lecturer, including invited speeches at several color conferences. During 2010–2011 she led the Nordic research project "SYN-TES. Colour and Light Synthesis: Towards a Coherent Field of Knowledge." As a color consultant she works mainly with exterior color design and color selections for exterior use.

SUSAN P. ASHDOWN is Helen G. Canoyer Professor in the Department of Fiber Science and Apparel Design at Cornell University. She holds a bachelor's degree from Grinnell College, an MA from Cornell University, and a PhD from the University of Minnesota. Her research is on technology-driven changes in the design process in the apparel industry. Her research group uses a three-dimensional body scanner to address issues in the design, sizing, fit, and function of apparel, automated custom fit of apparel, apparel fit assessment in research and industry settings, virtual fit, and interactions of materials and design in both fashion and functional design.

JESSICA F. BARKER is Assistant Professor in the Department of Apparel, Educational Studies, and Hospitality Management at Iowa State University. She obtained her bachelor's of science degree from Louisiana State University and her MS and PhD from Florida State University. Her research focuses on the function and comfort of apparel, particularly the implications clothing has on wearer performance and satisfaction. Her research encompasses protective clothing garment design, fabrication, and comfort.

ALEX BITTERMAN, MArch, PhD, is Associate Professor of Design and Architecture at the Rochester Institute of Technology in Rochester, New York. He is an internationally recognized expert in branding, organizational identity, and identity systems. After many years of research he has developed a taxonomy of place brands that provides a basis for testing the efficacy of place brands. Over the past ten years, Dr. Bitterman has made more than thirty conference presentations and various media appearances including radio and television. Dr. Bitterman is the founding editor and current editor-in-chief of three scholarly journals. Commentary and interviews with Dr. Bitterman have appeared in a number of domestic and international publications.

CRISTINA BOERI is an architect. She graduated in 1996 from the Politecnico di Milano, Italy, and she deals in particular with the aspects related to color perception and design. She is the technical manager of the Colour Laboratory of the INDACO Department of Politecnico di Milano, where she carries out teaching and research activities. As practitioner she participates in interdisciplinary teamwork especially on the themes of children's design, and she has developed furniture and other products for several companies in this sector. She gives courses and seminars at various schools, universities, and companies in Italy and abroad. She was the editor of the scientific magazine *Colore: Quaderni di Cultura e Progetto del Colore*, and she recently edited, among others, *Colore:*

Notes on Colour Culture and Design (2010). As a freelance journalist since 1998 she writes for several design and architecture magazines.

LYNN M. BOORADY is Associate Professor at Buffalo State College in the Fashion and Textile Technology Program. Prior to that, she was on faculty at the University of Missouri where she earned her PhD in 2005. Boorady was also the Chair of the Fashion Department at Stephens College and Department Chair of Fashion Design and Merchandising at the American Intercontinental University in Dubai. She is a Fulbright Scholar and invited speaker in her areas of expertise, which include personal protective equipment, issues in sizing and fit, and three-dimensional body scanning.

TRACY DIANE CASSIDY is a trained knitwear designer with experience of knitwear and bespoke bridal-wear design, manufacture, and retail. She obtained her PhD through the investigation of color forecasting and is the first author of the book *Colour Forecasting* published by Blackwell, under the alias Tracy Diane, with her co-author and husband, Tom Cassidy. Trends and color have remained particular areas of research interest in both design and marketing applications in relation to the fashion and textiles industries and disciplines. However, more recently research interests include home furnishings and interiors encompassing fashion in a much broader context. She is an established author with international presence, a reviewer for many reputable journals, and editorial board member. Tracy is currently a lecturer in fashion marketing in the School of Design at the University of Leeds.

TOM CASSIDY studied for and achieved an ATI (Associateship of the Textile Industry) at the Scottish College of Textiles as a sandwich student. In 1978 he returned to the Scottish College of Textiles as a lecturer. He successfully completed an MSc (Textile Evaluation) at Strathclyde University in 1982 and studied at SCOT for a PhD, which he achieved in 1989. He then moved to De Montfort University in Leicester in 1990 as a Principal Lecturer in the School of Design and Manufacture. In 1996 he became Director of Graduate Studies and shortly after was awarded the Chair in Design Technology. In 2002 Tom moved to the Chair in Design at the School of Design, the University of Leeds. In 2005 the book he co-authored, with his wife Tracy, *Colour Forecasting*, was published.

KATHLEEN CONNELLAN is a Senior Lecturer in Design History and Theory and portfolio leader of research in the School of Art, Architecture and Design at the University of South Australia. Her PhD dissertation, "The Meaning of Home and the Experience of Modernity in Apartheid South Africa," was the culmination of an undergraduate degree in fine art and separate postgraduate degrees in art history and theory and design history and theory. Her research interests stem from modernist design and the use of "white goods" in a society of white racial domination. She publishes on connections between the color white in designed spaces and surfaces and operations of power. Most recently she is leading a team research project called "Stressed Spaces" looking at the effects

of design on clients, clinicians, and carers in purpose-built mental health units. Kathleen teaches courses in Representation and Research Methodologies.

HALIME DEMIRKAN is Professor of Architecture at the Faculty of Art, Design and Architecture, Bilkent University, Ankara, Turkey. She received her BS and MS in industrial engineering and PhD in architecture. Her professional experience has included appointments as research assistant and instructor in the Department of Industrial Design, Middle East Technical University; and as a researcher at the Building Research Institute, Scientific and Technical Research Council of Turkey. Her current research and teaching include creativity in architectural design process, design education, and human factors in design. She has published articles in various journals such as *Creativity Research Journal*, *Journal of Creative Behavior*, *Design Studies*, *Applied Ergonomics*, *Learning and Instruction*, and the *Journal of Engineering Design, Optics and Laser Technology*.

GEORGI V. GEORGIEV received an MS in Engineering from the Technical University of Sofia, Bulgaria. He received a PhD in Knowledge Science from the Japan Advanced Institute of Science and Technology in 2009. Currently, he is a postdoctoral researcher in the Innovation Program at the Career Services Office, JAIST, and at the School of Knowledge Science, JAIST. He received a Good Presentation Award at the Fifty-Fifth Annual Conference of Japan Society for the Science of Design in 2008. He is a member and secretariat of the Design Society and its Special Interest Group Design Creativity. He is a program committee member of Creativity and Cognition Conference 2011. His interests lie in design cognition, conceptual structures in thinking processes, human impressions and emotions, and visual communication design.

KEY-SOOK GEUM, PhD, is Professor in the Department of Textile Art and Fashion Design, College of Fine Arts, Hongik University, Korea. She is a designer of wearable art sculptural forms and has exhibited worldwide. She has been a visiting scholar at the University of Minnesota and at the Central Academy of Fine Art in Beijing, China, and also a visiting professor of the China Academy of Fine Art in Hangzhou, China, since 2008. She is the author of *The Beauty of Korean Dress*. She has completed many design projects and teaches in South Korea, China, and the United States. Her research focus includes traditional color and contemporary color for the marketplace.

GOZDE GONCU-BERK, MA, is currently a PhD candidate in the Design Program at the University of Minnesota. Her research interests are driven by a desire to explore the role of design in improving well-being on earth. She specifically focuses on product design processes, social and cultural aspects of design, and sustainable design practices. In her dissertation research she is developing a framework using grounded theory methodology for a culture-centered design process that addresses the cross-cultural interaction between designer and user. She holds an MA (2005) degree in Clothing Design and a BS (2002) degree in Industrial Design. Her teaching experience ranges from new product

development to clothing design. She is the recipient of Fulbright and Turkish Higher Education Council Scholarships.

TOM JEFFERIES is Professor and Head of Manchester School of Architecture, a joint School of the Manchester Metropolitan University and the University of Manchester. He is a qualified architect and consultant urban designer. He is a panel member of PlacesMatter! North West England's design review panel, and his design work has been recognized through international prizewinning competitions. His research critically investigates the relationship between culture, space, landscape process, heritage, and sustainability to propose new forms of contemporary urbanism. He has expertise in architecture, urban design, landscape, master planning and design codes, architectural history, theory, and context, sustainability, and conservation. This develops symbiotic relationships between research and interdisciplinary practice. Built-environment projects have been supported by grants pioneering approaches in problem-based cross-disciplinary work, developing architecture as a critical practice. This has involved placing professional activity within a wider cultural framework recognizing the overlap between theoretical, academic concerns, and production.

HYUN JUNG, PhD, is Instructor in the Department of Fashion Design, College of Arts and Design, Daegu University, Korea. From 1999 to 2002, she was Korean representative of Intercolor, International Commission for Colour, to forecast color trends twenty-four months ahead of the season. Since 2003 she has conducted color research that has focused on the Chinese market. She completed her PhD at Hongik University, Korea, in 2008 and was a research scholar in the Department of Design at Texas Tech University from 2009 to 2010.

JEANNE KISACKY's early training was in architectural design (March, Princeton, 1990), and she spent a few years working in architectural offices. In 1993 she turned to the history of architecture and received her PhD in 2000 from Cornell University. Her work in the history of hospital design overlaps with the history of science and medicine, and from 1999–2001 she was the managing editor of the journal, *Isis*. She has published articles in the *Bulletin of the History of Medicine* and the *Journal of the Society of Architectural Historians*. For the last decade she has been teaching part-time at Syracuse University, Cornell University, and Binghamton University. In 2008 she received a grant from the National Library of Medicine to facilitate completion of a book manuscript on the history of American hospital design.

ULF KLARÉN is Associate Professor in Visual Form and Color Theory at Konstfack, University College of Arts, Crafts and Design, Stockholm, Sweden; he is Head of the Perception Studio—Competence Centre for Perception Studies. He does research on color, light, and space and has published the book *Vad färg är* [What color is] (Stockholm: HLS Förlag, 1996), a large number of articles, reports, and several anthology contributions

on color and light perception and art education. He has been a guest teacher at the University of Art and Design in Helsinki, Finland, and invited lecturer at several universities in Scandinavia. He is a member of the board of the Swedish Color Foundation and Chairman of SE-RUM, the Society for Increased Knowledge about Color and Light. He was a member of the scientific committee for the AIC Conference in Stockholm in 2008. Klarén also works as an illustrator.

KLAUS MADSEN is an architect teaching at the University of Aalborg with experience in sustainable design focusing on themes such as aesthetics, structure, materials, form, and functionality. His work also includes teaching in visual communication in regard to graphic detailing. His current work revolves on the research project "Incentives to Form," which is a decoding of the methodical grip of Danish artist and architect Erik Lynge.

LAUREN MICHEL, MS, completed her education in Textiles, at the University of California, Davis, and she has research interests that include the use and signification of color in dress, both across cultures and in self-expression, and dress history, costuming, and living history, especially the Elizabethan and Victorian eras. Michel has taught numerous college courses on dress, with emphasis on history, culture, and consumers. She writes for the blog, WornThrough.com, founded by Monica Sklar in 2007, highlighting apparel from an academic perspective.

JUDITH MOTTRAM is Professor of Visual Arts at Coventry University. She is a member of the Arts and Humanities Research Council Peer Review College and a Fellow of the Design Research Society. She has spent much of the last decade managing the development of research across Art and Design and in the related fields of Architecture and the Built Environment, working with design and art academics and practitioners as well as with architects, surveyors, civil engineers, and construction and property management experts. Her current interests include visual phenomena and two-dimensional images, particularly in relation to understanding color, drawing, and pattern; and the interrelationships between subject knowledge, creativity, research, and practice. She is on the editorial boards of the following journals: *Association Internationale de la Couleur* (*JAIC*), *Duck Journal of Research in Textiles and Textile Design*, and the *Journal of Visual Arts Practice*.

YUKARI NAGAI is currently Associate Professor at the Graduate School of Knowledge Science, Japan Advanced Institute of Science and Technology. She graduated from Musashino Art University and majored in Visual Communication Design (MA). She conducted research at Creativity and Cognition Research Studios, Loughborough University, UK (2002). She received PhDs from Chiba University, Japan (2002) and the University of Technology, Sydney (2009). She received a prize at DESIGN 2002 (the Design Society conference) and DCC 2006 (Second International Conference on Design Computing

and Cognition). She is the Co-Chair and Secretariat of the Special Interest Group Design Creativity at the Design Society. She was program committee member of the Creativity and Cognition Conference 2009 and steering committee member of the International Conference of Design Creativity 2010. Her current research interests are design creativity, design knowledge, and creative cognition.

NILGÜN OLGUNTÜRK is Assistant Professor of Interior Architecture at the Faculty of Art, Design and Architecture, Bilkent University, Ankara, Turkey. She received her BArch and MA in Architecture and PhD in Interior Architecture. Her professional experience has included appointments as research fellow at the London South Bank University and as instructor at the Middle East Technical University. She has worked on research projects in the United Kingdom for NHS Estates (Department of Health) on color design in hospitals and EPSRC/DTLR LINK (Department of Transport, Local Government and the Regions) on color, visual impairment, and transport environments. She has over ten years of research and experience on color perception, color preference, and color design in interiors. Her current research and teaching include interior design studio, basic design, color, and lighting. Her work has appeared in various journals such as *Color Research and Application*, *Optics and Laser Technology*, *Building and Environment*, and *Architectural Science Review*.

DENNIS M. PUHALLA is Professor of Design at the University of Cincinnati, College of Design, Architecture, Art, and Planning. He teaches undergraduate and graduate courses in visual language design, motion design, color theory, and principles of two- and three-dimensional design. Students and colleagues recognize him for his outstanding teaching. Professor Puhalla served as Director of the School of Design for ten years, initiating innovative and visionary programs. He earned a doctorate in design from North Carolina State University, College of Design. He holds a master of fine arts and a bachelor of science in design from the University of Cincinnati, College of Design, Architecture, Art, and Planning. Puhalla's professional work has been exhibited nationally and is included in public and private collections. Puhalla is committed to the design discipline as a practitioner, author, and researcher.

LUCA SIMEONE teaches design anthropology and interaction design at La Sapienza University and Ateneo Impresa Graduate Business School in Rome. He has published books, reviews, and articles on design anthropology and ethnographic methods applied to design practices. He is also the Founder and User Experience Director of Vianet, a digital design agency based in Rome, Toronto, and Doha and works as independent expert for the European Commission and for the German Aerospace Center. He recently co-edited the books *Beyond Ethnographic Writing* (Armando, 2010) and *REFF: The Reinvention of the Real through Critical Practices of Remix, Mash-Up, Re-Contextualization, Reenactment* (DeriveApprodi, 2010).

MONICA SKLAR, PhD (Design-Apparel Studies, University of Minnesota), has participated in punk and related subcultures since her teens, which influences her research in aesthetics, visual culture, and design. She has a book on punk style in progress, and has focused on the importance of color in team research regarding black leather jackets and in independent research on hair, street gangs, the workplace, and contemporary design. Sklar has taught numerous college courses on dress, with emphasis on history, culture, and consumers. Sklar founded the blog WornThrough.com, in 2007, highlighting apparel from an academic perspective.

BENTE DAHL THOMSEN is Associate Professor of Industrial Design at the University of Aalborg where she teaches courses in aesthetics, sculpturing, design research, ergonomics, and graphic communication. Thomsen's research includes studies of aesthetics, sculpturing, and artistic working methods. Her most recent research examines the role of aesthetic, structural, and functional transparency terms in clarification of design solutions. Her ongoing research is a decoding of the methodical grip of artist Erik Lynges preliminary works or incentives.

JULIA R. VALLERA is a part-time faculty member at Newschool University in New York City. Her interest in public art began as a graduate student in Design and Technology at Parsons School of Design. As a designer/technical artist for Snoozer Loser Art Collective and *New Acquisition*, she frequently works on creating engaging and playful environments using thought-provoking design. Her illustrations have been shown at Glasslands Gallery, Supreme Trading, and Chashama Theater. Her animations have been featured in the International Children's Festival and Krok Film Festival. Most recently, her work was presented in Conflux Festival, *Chronicle of Higher Education*, *Epoca Design*, and at EDULearn2010.

RENE VAN MEEUWEN, faculty member at the University of Western Australia, has been teaching and practicing architecture for eighteen years. After completing his BArch degree at the Royal Melbourne Institute of Technology (RMIT) he collaborated on the urban design of Melbourne Docklands, and speculative urban projects in Beirut, Kuala Lumpur, and China. Rene is a nationally recognized expert on computational technology, and is currently working on a book documenting the effect that software has had on recent architectural design. He was shortlisted in the 2010 Australian Venice Biennale team and won First Prize for the 2010 Cut Hill Residential Design Competition.

NIGEL WESTBROOK is Associate Professor and Discipline Chair of Architecture at the University of Western Australia. His education background includes a BArch (Hons), AA Dip, and MArch from RMIT. He lectures in design, urban studies, and architectural history, and is a partner of De Villiers Westbrook Architects. His research interests include the history of architectural modernism, Byzantine architecture, and historical graphical representations of cities.

HELENA WULFF, PhD, is Professor of Social Anthropology at Stockholm University. Her current research engages with expressive cultural forms in a transnational perspective. Studies of the transnational world of dance and social memory through dance have generated questions in relation to place, mobility, the emotions, to visual culture, and most recently to writing and Irish contemporary literature as process and form. Among Wulff's publications are the monographs *Ballet across Borders* (Berg, 1998) and *Dancing at the Crossroads* (Berghahn, 2007). She was editor of the volume *The Emotions* (Berg, 2007), and co-editor with Vered Amit-Talai of *Youth Cultures* (Routledge, 1995), *New Technologies at Work* with Christina Garsten (Berg, 2003), and *Ethnographic Practice in the Present* with Marit Melhuus and Jon P. Mitchell (Berghahn, 2009). Wulff was editor (with Dorle Dracklé) of *Social Anthropology/Anthropologie Sociale*, the journal of the European Association of Social Anthropologists (EASA). She was vice president of EASA.

Introduction

From products we use, clothes we wear, and spaces we inhabit, we rely on color to provide visual appeal, data codes, and meaning. This book addresses first how we experience color and then, through specific examples, how color is used in a spectrum of design-based disciplines: apparel design, graphic design, interior design, and product design. These topics explore color as an individual and cultural phenomenon, as a pragmatic device for communication, and as a valuable marketing tool. The use of engaging examples increases our awareness and understanding of the potential uses of color within the design disciplines.

This book can be a valuable resource for both design practitioners and scholars. Contributions are based upon well-defined research with a number of different means specified to reach results. Color is the focus in the three sections of the book that delve deeply into the nuance of study, use, and experience of color as it informs and communicates. How we experience color and the visual cognition process are explored through specific applications. These applications are meant to provide an enticing sample of their potential in the study of color.

This book provides insight in the quest for understanding color and design and our human response and the consequences. Semantics influence our perception of color and function in designed objects; color meanings and use evolve out of significant events and mass media coverage; colors influence marketing and our selections of products and services; branding with color promotes marketing efforts.

Color is a feature of products we use and plays a large part in what each of us experiences in our everyday surroundings. We name colors based upon natural phenomenon: sky blue, grass green, or dove gray. We make color associations in understanding ourselves, our culture, and the way we create and communicate through color. Cultures often describe colors based upon their locale, for example, Eskimos have many ways to describe white. We approach the changing seasons with different colors in mind, such as autumn colors are often warm and subdued. Finally trends influence color: black in the clothing we wear was ubiquitous from the 1980s to 2010.

Color preferences may be individual and based upon physical body coloring, memorable experiences, family traditions, or fashion. A motivation for individualizing color that is gaining inroads is the "Do It Yourself" "Design It Yourself" response to mass-produced sameness—be it in the home, on the Internet, or in getting dressed. This means taking an active part in and making color decisions ourselves that will influence the outcomes. Changing color changes appearance of products and brings up the issue of shifting from

what the machine can do to what the individual can do. Then, too, uses of color in one culture may affect other cultures as products are introduced and sold in other cultural settings than the one in which they were produced. For example, the standard uses of neutrals such as white, black, and gray on appliances, computers, and cars in the West have been considered boring in some adopting cultures, as such products have permeated the globe. The creative response that arises is to individualize such products with color, to make the product more palatable in the adopting culture.

Interpretation of color involves understanding color, its combinations, and recognition of its associated forms. For example, red is a central color that our minds access as a response to a limited range of wavelengths. But red can be understood by itself as the color of blood or arousing excitement, or in terms of how it is combined with other colors, such as red, white, and blue. Such combinations may call to mind a country's flag and patriotism, and used prominently in national events when just red might not be interpreted in the same way. But designers such as Ralph Lauren also use such combinations specifically because of prior associations that rely on symbolism and tradition. Color has a propensity to trigger memory and can aid in recognition. Remembering surgical tools in various colors helps to account for what tools must leave the room outside the patient. The natural order of the rainbow has been used to order products in visual display.

Meanings associated with colors can develop in unique ways and change based upon context. For example, colors can be used for sociological or political reasons as in tribal identification, gang colors, or soldiers' uniforms. In the United States, an example of effective public recognition through color is use of a specific hue of a certain pink—a light and intense value red tinged with blue—that is used in the context of building awareness of breast cancer. The pink ribbon looped over and worn on the jacket lapel is recognized by most and associated with support of breast cancer research. Other manufactured products range from pink T-shirts to pink vacuum cleaners, or a Tory Burch pink puffer vest to New Balance running shoes—all in the same recognizable pink. Similarly, the color green has become a symbol of the environmental movement and both the hue itself and its name have come to represent our concern for the earth. But the color green in Ireland or in a hospital surgical setting has entirely different connotations. Such differences reflect upon the use of color in different situations, be they professional or cultural contexts.

Marketing through the use of color is a vital collaboration of color and design. Colors may be identified as "mood colors," such as bright colors tend to cheer us, or neutral colors to calm us. The mood and the attitudes of those who see us may be affected by the color of clothing we wear, the color of the cell phone we carry, or the colors used in our surroundings, that is, colors to prevent depression or to promote healing. Color is used for brand recognition. Some well-known designers are associated with certain colors. For example, what would Donna Karan do without black, Vivienne Westwood without red, or Georgio Armani without the subdued neutral grays?

In this book color is explored through examples of brands and the role that color plays in the making of a brand. How do color trends originate and then filter through the various design applications of products and communications? Research studies have shown that people may immediately recognize product and corporations via color alone without the associated shapes or words often contained in a brand image, for example, Coca-Cola's red. Conversely, colors typical of a geographic locale may become a form of local branding.

Trends and forecasting play an influential role in the way we see and identify color. Fashion decades are often identified through colors and movements popular at the time. For example, the 1960s are remembered along with the florescent, acid, and psychedelic colors associated with the youth movement and drug experiences. Consider colors and specific values and intensities that not only become a signature of a specific time period but the wearer. For example, color was introduced into menswear in the 1970s when somber blacks, browns, and navy blues were replaced by brilliant lime greens and reds, as well as colorful patterned fabrics seen in men's semiformal dinner jackets.

This book will be valued as a college-level textbook in courses related to color: design and human perception, aesthetics, history, and material culture. But the contents of this book are also broadly applicable to professional designers to differentiate and sharply focus the messages of design and marketing, and the general public will come to understand how and why color is so extensively varied and offers such potential to communicate.

Marilyn DeLong and Barbara Martinson

PART I

EXPERIENCING AND RESPONDING TO COLOR

In part I we explore the ways we as humans experience color and how we may respond to color as individuals. This includes human sensation and cognition, preferences, and individual evaluation. Chapters in this part address two primary questions regarding how people experience color and how color relationships affect our perception of the world. What is the role of color and design in shaping how we see the world? How do people see and understand color?

LEVELS OF COLOR EXPERIENCE

Our understanding and appreciation of design can be understood and analyzed as related to varying levels of experience. Klarén and Fridell Anter propose a model that explains the complexity of color perception. At the core level, categorical perception is based on preconditions shared by all humans and includes perception of space, light, and shadow. On a second level is our direct experience of the surrounding world, things that we learn through living, such as our experience of nature. A third level is our indirect experience that includes culture, which varies with time and place. At this level we have agreed upon symbols such as internationally accepted traffic lights. These perceptions will be altered by temporal trends that mirror their time and will be judged differently when that time has passed.

The human brain determines the way visual information is processed and our proclivity to organize information in terms of categories, prototypes, and schemata and in both language and visual images. We often use colors to signify our feeling and emotions, such as feeling blue or seeing red. How do these concepts of color and mood fit into our perception of objects and spaces? From household products to automobiles, color sends a distinct message that is related to both function (a juicer made of orange plastic) and also to our ideas about status (a black limousine or a black tie). Color uses can be perceived as standard or communicate ideological stance. Just as our personal perceptions of color vary, the way in which designers use color in our physical environment influences our daily behavior. In "Color in the Designed Environment" Mottram and Jefferies explore the role of color in the urban environment and its effect on perception.

They assert that color must move beyond personal meaning to a global understanding of how color functions in the built environment and in branding. Insisting that color education must be an essential part of design pedagogy, they envision a world where designers use materials to enhance global commerce and communication.

COLOR INTERACTIONS

Colors are rarely seen in isolation. Boeri's thorough discussion of how color theorists have explored combinations of colors in terms of color harmony, contrast, and proportion is an exploration of how humans have sought to create order out of the color vision experience. In her chapter, "Color Relationships," she elaborates on the color structure developed by Albert Munsell and how this approach leans toward a rational scientific taming of a phenomenon most frequently attributed to subjective experience.

Dennis Puhalla's quantitative study, "Color: Organizational Strategies," also seeks to provide a rational approach to color ordering via codes based in Munsell's vocabulary. This study uses quantitative measures to provide evidence that color-coding, color categorization, and color selection can be objectively derived. He demonstrates the link between human perception of color and the abstract form of color order systems. His goal is to enhance the communication of messages through appropriate color combinations. Used effectively, these colors will allow people to navigate through the world of media and information systems.

Seeing Color

Ulf Klarén and Karin Fridell Anter

Chapter Summary. The goal of the chapter is to present a model for describing and analyzing color design, and to show its potential by discussing concrete examples from the field of design and architecture. The model has been developed by Ulf Klarén as a pedogogical tool based on experience and on literature from the fields of perception psychology, cognitive science, philosophy, ethnology, and so forth. Color constructs our inner image of space. The world of colors is complex and dynamic and colors have many sensitive qualities, but nevertheless the experience of color has a nature of coherence. Just like the rest of our sensual experiences, color is perceived and understood on different levels, from the basics that are common to all humans to the most rapidly changing cultural trends.

Do we all perceive color the same way—or is color only a matter of taste? In this chapter we analyze the different levels of color perception, from the categorical common to us all to the culturally transferred indirect experiences. For each level we give examples of how it is dealt with in art and architecture, and we also analyze how designed objects can be perceived on different levels.

When discussing and using color in art, design, and communication we often focus separately on formal color structures, on conventional color meanings, or on color expressions. Formal and conventional aspects of color can easily be described and understood. Contrary to this, color expressions arousing emotions and feelings are often looked upon as something that can be used but can neither be described nor understood.

Professional design is the art of using knowledge—implicit or explicit—about how humans perceive, experience, and relate to the world around them and things in this world. In this all senses are involved, but when talking about color we can restrict ourselves to vision. A designer must understand the conditions of visual perception.

It is one thing to experience or intuitively imagine the "tone" of an object or a "mood" of a space. Another thing is to be able to consciously reflect on the sources of such experiences. Professionals in the field of design must in one way or another find distinct concepts and concise approaches in order to understand coherence and causes of aesthetic expression. Such concepts and approaches are not easily found. The essence of our experiences and emotions might even be beyond the limits of (verbal) language. But,

as Ludwig Wittgenstein (Austrian-British philosopher 1889–1951) has pointed out, even if we cannot explain them verbally they manifest themselves to the senses. They can be demonstrated and their cognitive and perceptual basis can be described.[1]

TO SEE IS TO SEE COLOR

Human perception is not a process where one thing automatically follows another from A to Z. Understanding of the world is an *activity*.[2] It is a searching with varying perceptive and cognitive strategies and approaches. It is an interaction with the world, sometimes spontaneous or conventional, sometimes temporary or target-oriented. By "using the world as a tool"[3] visual structures become meaningful—or change meaning. This dynamic and changing worldview continuously influences our perception of the world around us; how we feel, what we recognize and attend.

We live in a spatial and continuously changing world. Our cognitive and perceptual systems derive their distinctive characters from this fact. Even if our perceptions are subjective, our basic spatial experiences are natural perceptual facts and functionally similar. All senses add to the experience of a spatial and changing world around us, but the principal *spatial* sense is sight. Vision provides a coherent and continuous understanding of space. We always experience the surrounding world as three-dimensional: visual patterns that *can* be understood as spatial are given such an interpretation in perception.[4]

Perception of color is a prerequisite of seeing and essential for survival: color is what we see; to see color *is* to see. What things of a given color have in common is the way they look. If everything in the surrounding world—even the shadows—had the same hue and nuance, we would not be able to discriminate one thing from another. There would be no visual relations, no significant visual form. And without any color at all—not even the imagined monochrome color—a visual world would not be conceivable. Visually we perceive form by color. Color contrasts help us to distinguish borders and edges. Not only object colors, however, form our impression of the surrounding world. Also cast shadows, object shadows, reflected light colors, and back light contrasts form color areas in our visual field. An experience of living space is given by continuously changing light conditions and by perception of color contrast, logic distribution of shading, and the color of reflected light.

Hence color is essential to cohesive experience of a spatial world. Mentally, color light and space are inseparable. Human experience of the world is coherent, dynamic, and simultaneous.

PERCEPTIVE ATTENTION

Our appreciation of what we see around us is only superficially a question of what is usually called taste; taste is part of our cultural adaptation. Ultimately our intuitive

preferences are about understanding the world. They are means for adaptation to the world as a whole.

The perceived surface of the world is very complex. Thus to a large extent it has to be taken in intuitively. Perceived color and form in space is a logical structure recognized intuitively. At the same time experiencing always means to find ways of choosing what in a given context has to be attended, to develop an *attention structure*.[5] Finding new approaches and new ways of thinking demands abilities to make this kind of "perceptive judgment." Seeing something *as* something or seeing something *in* something is fundamental to art and science, to human life.

Perceiving is also a continuous interplay between conscious experience of *one thing after the other* and intuitive experience of *all in one*. In all creative processes it is essential to take up different modes of attention. Experiencing color, form, and space is a mode of exploring how things appear, a process of meeting the world.[6] Maurice Merleau-Ponty (French philosopher 1908–1961) discusses how we experience the surrounding world in different ways depending on situation. He makes a distinction between two modes of attention: *the reflective attitude* and *living perception*.[7] The perceived color of a shaded white wall may be greyish, but at the same time we can experience what color the wall would have without the shading. This distinction is significant to our perception of color in spatial context.

Through times ideas about color and light have been related to different worlds of inner images: from animistic ideas about color and light as spiritual values, to Platonic and Christian ideas about color and light as reflections from ideal worlds. Today we still can appreciate the shining light in the Gothic cathedrals and the colors in old frescoes, but from a perspective of our time and thus with other expectations. Even if we may have different experiences and ways of explaining causal relations in different historic or ideological contexts, our color and light experiences are still and always attempts to explore, understand, and embrace the world. See Figure 1.1.

Our understanding of the world is intuitively holistic and we do not spontaneously ask ourselves why we perceive it in this or that way, why we like or dislike an object or a place or what feelings or experiences are the cause of our judgment. This is also true for the color aspect of visual experience.

The world of colors is complex and dynamic and colors have many sensitive qualities, but nevertheless the experience of color has a nature of coherence. Just like all sense experiences, color is perceived and understood on different levels, from the basics that are common to all humans to the most rapidly changing cultural trends.

The *categorical perception* of color gives basic spatial and temporal structure to the surrounding reality; perceived color structures create tactile and spatial inner images. Basic expressions as *stability*, *coherence*, and so on are dependent on the categorical perception.

Direct experiences—the spontaneous visual experiences of the surrounding world—give emotional "color" to logical color combinations in the real world around us: they can be used as symbols for "felt life" and can, removed from their normal context, be used

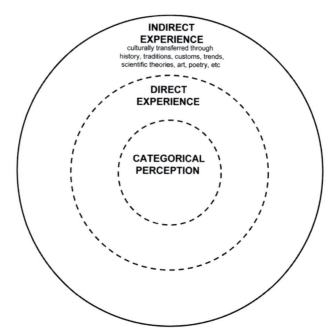

Figure 1.1 Levels of experience. The graphic model shows levels of experience—from experiences based on categorical perception through direct experience of the world around us to the indirect experience embedded in cultural expressions. The three experience levels are mutually dependent and they are all implicitly present in all perceptions. Colors can be understood in many ways and on all levels. They can never be separated from the coherent experience of the world. Model by Ulf Klarén 2010.

freely as *expressive symbols* in art and design; expressive symbols exemplify *aspects* of something experienced. When we meet such color structures abstracted in pieces of art, in design, or architecture, our perceptual answer is first of all intuitive *recognition*, not *interpretation* of meaning.

Indirect—"cultural"—*experiences* associate colors conventionally with current tradition of knowledge, meanings, and values.

CATEGORICAL PERCEPTION

The spontaneous experience of color and space, perception of contours and contrasts, balance, verticality and horizontality, and so on is based on the so-called *categorical perception*, the aim of which is to structure our perceptions. *A reality without well-defined borders is divided up into distinct units by our perceptual mechanism.*[8] The categorical principles of perception are the most basic and normal in our everyday experience of the world. They are so obvious that we often don't recognize them; we only intuitively feel

their presence and the content they get by their function in life. The categorical percep-
tion is in some respects determined genetically, but for the most part acquired. By natu-
ral selection man has been endowed certain perceptive and cognitive tools for survival
and this is basically common for us all.

We are genetically predetermined to perceive color, but what we perceive is not spe-
cial colors but the relations between them.[9] The estimated number of hues and nuances
that we are able to discriminate is nearly ten million—however, observed together. To
see *is* to perceive visual distinctions and similarities. The aim of color perception is per-
ceiving color distinctions and color similarities. Without this kind of differentiation the
concept of color would not have any content.

Ewald Hering (German physiologist 1834–1918) has discussed the perceptual cat-
egorization of colors. His *opponent color theory* is based on basic distinctions and
similarities to six elementary colors: yellow, red, blue, green, black, and white.[10] Based
on Hering's color theory the Swedish Natural Color System (NCS) starts from these
six elementaries. NCS describes color perceptions in terms of *hue* (a relationship be-
tween two chromatic elementary colors) and *nuance* (a relationship between black,
white, and the most chromatic of each hue [C]). The hues are systemized in a color
circle and the nuances are systemized in color triangles, the corners of which symbol-
ize elementary white (W), elementary black (S), and the most chromatic hue in ques-
tion (C). See Figure 1.2.

By dynamic adaptation the categorical perception adds to perceptual stability and
order in a continuously changing world. We have a tendency to regard experienced

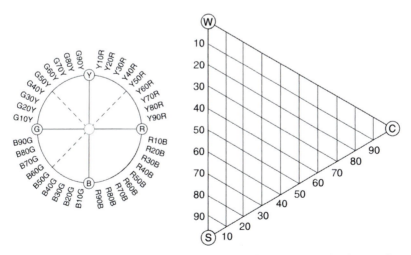

Figure 1.2 The Swedish Natural Color System (NCS) starts from six elementaries
(yellow/Y, red/R, blue/B, green/G, white/W, and black/S). NCS describes color percep-
tions in terms of hue (a relationship between two chromatic elementary colors) and
nuance (a relationship between black, white, and the most chromatic of each hue [C]).
The hues are systemized in a color circle and the nuances within each hue are system-
ized in color triangles. (SS 01 91 02)

structures in the outer world as "harmonious," "balanced," "coherent" when they agree with basic regulating principles of the categorical perception.

If colors in a combination have the same whiteness, blackness, chromaticness, hue,[11] or lightness we feel that the colors have something in common. We used to say that such color combinations *fit together* or *harmonize* and that the colors of a painting or a room *hold together*. The experience of unity of colors follows from the structure of the visual system. The ability of recognizing color distinctions and color similarities is part of the categorical perception and predetermined—"natural"—in the same sense as recognition of characteristic color scales in the NCS system.

Lightness is an important aspect of categorical perception. Contrast and similarities of lightness have a great importance to our understanding of space. Lightness contrasts emphasize borders and similarity of lightness makes it difficult to distinguish them.

The phenomenon called *simultaneous contrast* is part of categorical perception that adds to increasing contrast and to distinction of borders between color areas in the field of vision.

In color design a great deal of attention is paid to contrasts between so-called *complementary colors*, that is, colors with hues that differ very much. When placed directly adjoining, complementary colors get mutually increased perceived chromaticness, especially when they have the same lightness. Hence a surface pattern can appear distinctly even if the pattern as a whole has the same lightness.

Simultaneous contrast phenomena can be regarded as isolated *examples* of the function of normal vision in spatial situations. Our visual system is developed for a continuous spectrum of light and gradual changes between different light situations. Under these circumstances we perceive colors as more or less constant. In spatial context color contrast phenomena are intrinsic and complex functions of color and light adaptation.

Also part of categorical perception is the so-called *spreading effect*. In an evenly distributed pattern with contrasting color the contrast may decrease (an effect contrary to that of simultaneous contrast). This adds to coherence of the surface.

The most fundamental aspect of the categorical perception is that perceptual patterns that can be perceived as spatial are to be perceived that way; pictures and other visual patterns on plane surfaces are always perceived as *pictorial space.*

In surface patterns—for example, textile patterns or wallpapers—our tendency to perceive pictorial space can cause problems; lightness contrasts interpreted as pictorial depth tend to break the visual continuity of the surface. In both traditional decorative art and in modern design complementary colors are frequently used. A combination of adjoining complementary colors increases perceived chromaticness, but it also helps to solve the problem with pictorial space in surface patterns: complementary colors, distinctly contrasting in hue and with the same lightness add to an impression of surface flatness and accentuate visual borders. Hence the use of complementary colors can give great color variety and at the same time coherence and spatial unity.[12]

Like medieval architecture, Modernism and Functionalism have a direction toward formal purity, harmony, and monumentality. In mid-twentieth century design and architecture

there is a preference for monochrome unpatterned or evenly patterned plane surfaces corresponding with basic principles of categorical perception. In Art Noveau and in modernistic posters and advertising bills a feeling of plane surface is achieved by assimilation and low color contrasts. They are to be recognized as pictures or painted decorations and, simultaneously, to function as integral parts of the architectonic space.

When working with aesthetic expressions you can never ignore the basic principles of categorical perception, whether about striving toward "harmony" and stability or about creating dynamic design. Even an expression of *chaos* needs great skill and consciousness about basic perceptual rules—otherwise it will end up in trivial muddle. A conscious or unconscious infraction of given perceptual rules will always be related to them and be regarded as a deviation from normality. In other words it is quite possible to deviate from them, but not to question or avoid them. In artistic tradition there is great consciousness of such perceptual prerequisites.

DIRECT EXPERIENCE AND EXPRESSIVE SYMBOLS

The second circle in Figure 1.1 represents our direct experience of the surrounding world, things that we gradually learn through living. Here we have such things as the colors of nature. All of us learn that fresh leaves are green, but there are also important differences in our experiences, depending on the time and place where we live. Color and form, texture and gloss, everyday sounds and music, movements and dance, stench and perfume can *look as*, *sound as*, *feel as*, *smell or taste as* we imagine feelings or emotional reactions. That is why we are able to bring about "feelings" in design.

Susanne Langer (American philosopher 1895–1985) claims that the emotional content we experience in objects or spaces is symbolic in a special way. In the surrounding world we perceive visual qualities that are spatially logical patterns of color, light, form, and movements. Patterns of such qualities always belong to functional situations in life, each one with its own characteristic emotional content. Hence color and form structures can give visual experience of the world. Abstracted from their normal context—for example, in designed objects and designed spaces—color and form patterns, according to Susanne Langer, can be experienced or used as symbols for *felt life*.[13] Susanne Langer calls them *logically expressive*—or articulated—*symbols*. They are what we may call the artistic or aesthetic dimension in pictures, in utility goods, in architecture—in the surrounding world.[14]

Ludwig Wittgenstein says that feelings follow experience of a piece of music, just as they follow courses in life;[15] a piece of music consists of a sequence of tones. It has a structural resemblance to courses in life—a rhythm, pauses and breaks, pitches, and so on—and thus it can be used as examples. The auditive structure in music is not a course of life, but *felt life* abstracted in a logically expressive symbol. The same is true for all sense experiences.

From light to shade in normal light situations—say, in even daylight—the perceived colors of an object have the same proportions between whiteness and chromaticness.[16]

Our ability to recognize gradients of this kind helps us to perceive volume and space in the surrounding world. It also helps to make perceptual distinctions between what is shaded and what is a dark object color. See Figure 1.3.

Such an experience of space, light, and color together is expressed in the *chiaroscuro* in classic painting tradition. A scale with lighter and darker surface colors having this relationship is chromatically analogous with our visual experience of shade and light in spatial context. It is similar to—reminds of—our experience of light and shade; it is a felt light and shade relationship abstracted in an expressive symbol for a certain light/ shade relationship. These types of color scales are perceptually well established as logically expressive symbols for light and shade. Even if they do not appear in a light/ shade situation we can feel that they have something in common—and even if they are used, say, in a simple checked tablecloth without any intention to be seen as a symbol for light and shade.

Here we see two kinds of color relationships. One is the formal unity of colors based on color similarities and color distinctions as such. The other is the sense of coherence based on appearance of color and light in space. When we meet such patterns of experience in pictorial art, in pattern design, object design, in interior design or architecture, we answer with intuitive recognition. Thus a certain color combination, a light arrangement or an articulated space, can act as a logically expressive symbol, a symbol for felt life. Expressive symbols are *not* about abstract signs with associated or conventional meanings. They are *objectified feelings* based on visual experience that can only be

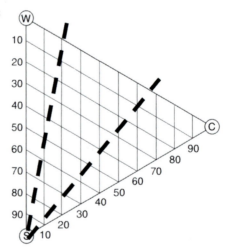

Figure 1.3 From light to shade in normal light situations—say, in even daylight—the perceived colors of an object have the same proportions between whiteness and chromaticness. All nuances on a straight line from black (S) in the NCS triangle have the same such proportions.

communicated by significant patterns of perceived qualities. They are colors in connection with life.

So, to be able to make conscious color choices, the designer has to find or create expressive symbols, patterns of perceived qualities, that are likely to cause special emotional reactions and feelings in the person perceiving the object, the principles of which can be learned and analyzed. Based on everyday experience of life, and contrary to what is often stated, "taste" plays only a minor part in the judgment of what we see—and not even personal taste is so unique as we might want to believe.

INDIRECT EXPERIENCE AND MEANING

The cultural and social contents of the human world can be reinterpreted, but can never totally be taken in or controlled by individuals. Social contents and meanings are based on indirect experience transferred through cultural expressions: history, scientific theories, poetry and art, traditions, customs, and trends. They formulate or express ideas and imaginations *about* the world.[17] They give meaning and context to the direct experience.

A color or a color combination may be *symbolic*, dependent on a convention or an agreement (e.g., traffic signals, liturgical color codes, social color codes, fashion colors, temporary color trends, etc.). In nineteenth-century Swedish class society it was rather common that lower-class people were not allowed to wear strongly chromatic clothing; it was an upper-class privilege. However, in certain social or religious situations chromatic clothes have been regarded as vulgar or indiscrete and low chromaticness is often looked upon as discrete and sophisticated. One example of this is the strong convention for men to wear black in socially important situations. Identity color codes are legion— and often very subtle—in modern society.

The use and interpretation of colors can also be based on analogy (e.g., love or revolution associated with redness of blood and of fire). Underlying historic, economic, or social circumstances may lay the basis for a tradition of high social value in certain colors or color combinations. The high value of purple and—in China—of the yellow color springs from the fact that these once were extremely expensive to produce. In ancient Greece purple was regarded as the color of the gods and according to the Bible heaven is decorated in purple and gold. Purple became the color of the officials in ancient Rome, and the cardinals of the Roman Catholic Church are dressed in purple. The color of Emperor of China was the saffron yellow.

Today we artificially can make dye and paint that give purple color and "Imperial yellow" to relatively low costs. In ancient times, however, 1,200 purple shells were needed to produce 1.4 grams of real purple and 15,000 stigmas from saffron crocus were needed to produce 0.5 kilogram of saffron yellow.[18] We may—by tradition—regard purple as valuable even if we do not know the "expensive" background. Hence what once was based on knowledge about a real *economic* value has turned into a symbolic content of

social value. Which one of many possible meanings a color may be connected with is—also like words—dependent on context.

Colors may have *contents* in the same way as abstract figures or words can represent certain meanings. A color combination, a light character, or a spatial arrangement (or whatever) can conventionally refer to different contents that, in turn, arouse thoughts and feelings. But this is not the whole truth. Even if conventional concepts may help to specify meanings they are neither representative nor fundamental to our spontaneous perceptual experiences. The cultural meaning of colors is arbitrary and they can be given new meanings if we agree about it. These meanings are not, as the direct experiences, determined by certain perceived qualities. The content of direct human impressions is an intrinsic part of living experience. Theoretical systems and models, art, poetry, and social conventions are attempts to *describe* the world by transferring indirect experiences. The indirect experience—always fragmentary and incomplete—is a context and a reference to the basic categorical perception and our direct experiences.

A COHERENT WHOLE

The three experience levels are mutually dependent and they are all implicitly present in all perceptions. A distinction between a red color and other colors is a basic—categorical—perception, the experience of red walls is a direct experience, and the knowledge that red houses may be of high social importance is based on indirect experience. Our experience of the world is a coherent whole.

To be able to understand and describe color phenomena it is necessary to regard them as integrated and functional parts of the comprehensive and dynamic processes that influence our understanding of the world as a whole. When working with color in design the designer must remember that we experience on many levels. We can never confine ourselves to using formal solutions, to following temporary cultural preferences, or to generalizing our own visual experiences. Human experience of color is universal, dependent on cultural context, and individual—simultaneously! As colors in real life, colors in design must be looked upon as multidimensional and living qualities.

WAYS OF APPROACHING COLOR AND DESIGN: THREE EXAMPLES

To show how the model in Figure 1.1 can be applied in design we here present the results of three specific design tasks. All examples are Swedish, covering different fields of design and ranging from the mid-1970s until very recently.

In the striped garments in Plate 1, the contrasts between the colors are perceived categorically. One of the garments has stripes with low chromaticness and closely related hues. In that case the contrast is that of lightness, whereas the other color qualities create a unity. The second garment has stripes with less lightness contrast. The

hues are still related, but one of the colors has much higher chromaticness than the other one. The stripes on the third garment are similar in lightness and chromaticness, but strongly contrasting in hue. Here the contrast enhancement creates a vibrant pattern, sometimes even difficult to focus due to the constant flickering in the borderlines between colors. As already said, all this is perceived categorically, more or less the same by everybody. There is no need to tell which description fits which garment—the reader would understand that anyhow.

The stripes are also perceived categorically. They connect to the understanding of horizontal and vertical that is necessary for spatial awareness and a prerequisite for all our movements. Even the slightest divergence from the absolutely horizontal is perceived and apprehended as such. Thus a pattern with horizontal stripes can reveal very much of the shape it is placed—or draped—upon. This we gradually learn in our direct experience of the world.

Those who have dealt with or produced textiles also have other direct experiences of stripes. We know that striped textiles can be produced through rather simple weaving methods, and we recognize the production procedure when seeing the result.

But, of course garments like these are also perceived and assessed on the third level, dealing with tradition and trends. Here we can see much less agreement between different persons, and between the same person during different times. A certain color combination or pattern can be understood as referring to freedom, joy, or solemnity, to be feminine or masculine, to be sophisticated or banal—and these notions vary between times and places. They are also highly contextual—in the Western culture of 2010 the highly contrasting pattern to the right might well be appreciated on a woman's garment or a candy bag but hardly on a house façade or funeral clothing.

The categorical perception of Plate 2 is common for us all. We perceive distinct lightness contrast between white details and darker surfaces. We can see a regularity in the detailing, that either conforms to the categorical directions of horizontal and vertical or deviates from them in a symmetrical and repeated manner. We can also see that the strong colors all have some degree of yellowness and lack blueness.

From our direct experience we can understand that the shapes in the picture are houses surrounded by vegetation. The color palette of the façade colors is very similar to the color scale of natural vegetation. In nature, most colors are somewhat yellowish. Also, in nature, yellow colors are most often lighter and less blackish than red and green colors. This we learn to recognize as "natural" simply by living, and the colors of the houses make us recognize this natural pattern.

Those of us who work with pigments know that mineral pigments when burned change their hue toward red and at the same time become darker. The relationship between the red and yellow façade color thus confirms our direct experience of pigment relationships, even if they in fact are made with other pigments than the mineral pigments we base our experience on.

Those of us who do not work with pigments might still have experience of color scales that derive from the material preconditions of cheap and stable pigments. In Sweden

the foremost example of this is Falun red, known and recognized by everybody. Traditionally, Falun red is most often combined with white on windows and other details. This is a direct experience for everybody who has grown up in Sweden. Even if the façades in Flogsta are not painted with the traditional red wash, their red color still refers to this deeply rooted and commonly shared experience.

Those who have no direct experience of Swedish color tradition do not perceive the red in the same way. But they might still be able to understand the geographical placement of these buildings, based on knowledge obtained from books, mass media, or other people. From a culturally acquired understanding of color trends in the past we might also be able to understand that these houses were built during the colorful 1970s, and not during the more modest 1960s or the 1980s dominated by pastels.

The unity in detail and the relative similarity between façade colors create an immediate and intuitive understanding of coherence and make us understand that this is a color planned area. This understanding is based on experiences on all levels of perception, partly shared by all and partly diverse because of our different direct and indirect experiences.

Another thing is if we like the houses or not. This is very personal and depends on the feelings, emotions, and associations connected with our past experiences of similar type. Even if we agree that the houses have a traditionally based color scale with parallels to the colors of nature, both tradition and nature might arouse different feelings in each one of us and thus make us like or not like the houses.

The two artifacts on Plates 3 and 4 have distinctly different colors and forms. On the levels of categorical perception and direct experience the differences are obvious, but tell us nothing about their functions—if any. And on the level of indirect experience our first understanding will prove to be false.

Starting with the categorical perception, we can establish that one artifact is light and the other one is dark. The light color of the first one is supplemented by one accent color that is clear and virtually lacks blackness. The dark color of the other one is distinctly contrasted by an orange red accent and something shining.

Using our direct experiences of the world we can easily comprehend the shape of the light artifact through the distribution of shaded and lit parts. The shape of the dark one is more difficult to grasp, as its two colors could be interpreted as one dark color partly shaded. The red detail attracts our immediate attention in the same way as a fruit, a flower, or maybe fire would be immediately seen through its contrast against a darker and less chromatic background.

People of today can also, by direct experience, get the impression that the bottom part of the dark artifact is made of metal and that both of them are some sort of machines. Some hundred or thousand years ago people did not have such experiences and artifacts like these would have been mysterious.

From our experience of nature, where dark colors normally occur close to the ground whereas light and bluish colors belong to the sky, we get the impression that one artifact is heavier than the other. The light-colored machine reminds us of water and air, and its

form and name refer to our direct or indirect experience of a dolphin. We would expect it to be rather light to lift and hold, as if filled with air. The dark colors, strong contrasts, and shining steel of the other one signal strength and make us believe that the machine is meant for heavy tasks that require solid materials. We would expect it to be rather heavy, as if made from stone or solid metal.

The most interesting aspect of these two artifacts is connected to our indirect experience.

We can understand that both of them are electrical machines, but for what purpose? In judging this we have to rely on the design traditions that have manifested themselves in other machines we have seen.

The left one, with its smooth form and light colors, refers to a design tradition used in products meant to be bought and used by women. The design signals joy and friendliness ("swimming with dolphins") and the technical functioning and performance of the machine are not stressed but rather hidden in an uncomplicated design that makes it easy to use. Many readers would probably understand it as a hairdryer. But it is, in fact, a drilling machine.

The other machine is designed in a tradition used in products meant to be bought and used by men. The red trigger is similar to that of a weapon and indicates that you need special skill to use it, and also the machine as a totality refers to weapons. This type of design, including this very color combination, is often used in products like drilling machines and motor saws. But this one is a hand blender for kitchen use.

NOTES

1. Ludwig Wittgenstein, *Tractatus logico-philosophicus* (Stockholm: Thales, 1992), 64, 122.
2. Alva Noë, *Action in Perception* (Cambridge, MA: The MIT Press, 2004), 3; Karl R. Popper, *Popper i urval av David Miller. Kunskapsteori-Vetenskapsteori-Metafysik Samhällsfilosofi* [A pocket Popper] (Stockholm: Thales, 1997), 113.
3. Heidegger claims that meaning originates in human interaction with the world around us, when *using the world as a tool.* Quoted in Martin Heidegger, *Sein und Zeit* (Tübingen: Niemeyer [1927] 1986), 69.
4. Tor Nørretranders, *Merk verden—En beretning om bevissthet* (Oslo: Cappelans Forlag A/S, 1992), 199.
5. An "attention structure"—conscious or unconscious—directs attention to certain aspects of a phenomenon. In science such a "perceptual principle" is usually called a "theoretical perspective." Bo Eneroth, *Hur mäter man "vackert"? Grundbok i kvalitativ metod* (Stockholm: Akademilitteratur, 1984), 24. Acquiring knowledge is to develop special attention structures. H. Gardner, *De sju intelligenserna* [Frames of mind—the theory of multiple intelligences] (Jönköping: Brain Books AB, 1994), 24.
6. Noë, *Action in Perception,* 163ff.
7. Maurice Merleau-Ponty, *The Phenomenology of Perception* (London: Routledge, [1962] 1989), 305.

8. Peter Gärdenfors, *Hur homo blev sapiens* (Nora: Nya Doxa, 2000), 40.

9. A. Valberg, *Light Vision Color* (New York: John Wiley & Sons, 2005), 266.

10. Ewald Hering, *Outlines of a Theory of the Light Sense* (Cambridge, MA: Harvard University Press, 1920).

11. Color concepts in this text—*elementary color,hue,nuance, chromaticness,* and so on—are used according to NCS (Natural Color System), the Swedish standard for color notation. A. Hård, L. Sivik, and G. Tonnquist, "NCS Natural Color System—from Concepts to Research and Applications," *Color Research and Applications* 21 (1996): 180–205.

12. Ulf Klarén, "Vara verkan eller verka vara—Om färg, ljus, rum och estetisk uppmärksamhet," in *Forskare och praktiker om Färg-Ljus-Rum,* ed. Karin Fridell Anter (Stockholm: Formas, 2006), 54–56.

13. Susanne K. Langer, *Problems of Art—Ten Philosophical Lectures* (New York: Charles Scribner's Sons, 1957), 60ff.

14. Susanne K. Langer, *Feeling and Form—A Theory of Art Developed from Philosophy in a New Key* (London: Routledge & Keagan Paul, 1953), 31ff.

15. Ludwig Wittgenstein, *Särskilda anmärkningar* [Vermischte Bemerkungen/Culture and value] (Stockholm: Thales, 1993), 19.

16. Klarén, "Vara verkan eller verka vara," 50.

17. Popper describes the social world—*World 3*—as a totality of thoughts, theories, and formulations in the culture—scientific theories, poetry, art, and so on. According to Popper World 3 has an "independent existence" of intellectual material that cannot be influenced by individuals (Popper, *Popper i urval av David Miller*, 61ff). Merleau-Ponty describes a social world, which forms a significant connected whole of cultural, social, and political contents and expressions, which can change and be reinterpreted, but can never totally be taken in or controlled by individuals. Maurice Merleau-Ponty, *Kroppens fenomenologi* [Phénoménologie de la perception: le Corps] (Oslo: Pax Forlag, 1994), 23.

18. Ulf Klarén, *Vad färg är* (Stockholm: HLS Förlag, 1996), 78.

REFERENCES

Ehrnberger, Karin (2006), *Design och genus—hur vi formger produkter och hur de formar oss,* http://www.arkitekturmuseet.se/utstallningar/abnorm/design%20och%20genus,%20slutrapport.pdf.

Eneroth, Bo (1984), *Hur mäter man "vackert"? Grundbok i kvalitativ metod,* Stockholm: Akademilitteratur.

Gärdenfors, Peter (2000), *Hur homo blev sapiens,* Nora: Nya Doxa.

Gardner, H. (1994), *De sju intelligenserna* [Frames of mind—the theory of multiple intelligences], Jönköping: Brain Books AB.

Hård, A., Sivik, L., and Tonnquist, G. (1996), "NCS Natural Color System—from Concepts to Research and Applications," *Color Research and Application* 21: 180–205.

Heidegger, Martin ([1927]1986), *Sein und Zeit,* Tübingen: Niemeyer.

Hering, Ewald (1920), *Outlines of a Theory of the Light Sense,* Cambridge, MA: Harvard University Press.

Klarén, Ulf (1996), *Vad färg är*, Stockholm: HLS Förlag.

Klarén, Ulf (2006), "Vara verkan eller verka vara—Om färg, ljus, rum och estetisk uppmärksamhet," in Karin Fridell Anter (ed.), *Forskare och praktiker om Färg-Ljus-Rum*, Stockholm: Formas.

Langer, Susanne K. (1953), *Feeling and Form—A Theory of Art Developed from Philosophy in a New Key*, London: Routledge & Keagan Paul.

Langer, Susanne K. (1957), *Problems of Art—Ten Philosophical Lectures*, New York: Charles Scribner's Sons.

Merleau-Ponty, Maurice ([1962] 1989), *The Phenomenology of Perception*, London: Routledge.

Merleau-Ponty, Maurice (1994), *Kroppens fenomenologi* [Phénoménologie de la perception: le Corps], Oslo: Pax Forlag.

Noë, Alva (2004), *Action in Perception*, Cambridge, MA: The MIT Press.

Nørretranders, Tor (1992), *Merk verden—En beretning om bevissthet*, Oslo: Cappelans Forlag A/S.

Popper, Karl R. (1997), *Popper i urval av David Miller. Kunskapsteori-Vetenskapsteori-Metafysik Samhällsfilosofi* [A pocket Popper], Stockholm: Thales.

Valberg, A. (2005), *Light Vision Color*, New York: John Wiley & Sons.

Wittgenstein, Ludwig (1992), *Tractatus logico-philosophicus*, Stockholm: Thales.

Wittgenstein, Ludwig (1993), *Särskilda anmärkningar* [Vermischte Bemerkungen/Culture and value], Stockholm: Thales.

Color in the Designed Environment

Judith Mottram and Tom Jefferies

Chapter Summary. Architectural and product design in the twentieth and early twenty-first centuries has been marked by clear periods where color has had variable roles within the designers' toolkit. We suggest that both cultural understanding and physiological determinants motivate the use of particular colored or tonal schemata. The context for our exploration of color knowledge and attitudes to signification in the fields of architecture and urbanism is recent work looking specifically at urban design and place-making. To develop the discussion on color in urban space, we focus on the work of Maccreanor Lavington Architects (Rotterdam), who use road paint as a transformative medium, and Dashing Tweeds, who sample urban color as the development palette for traditional tweed fabrics. We ask at what level might conscious engagement with color knowledge and theory be present in contemporary design, in virtual environments, and in design education, and what barriers might there be to using color to add to the legibility and live-ability of the urban environment.

This chapter explores the tension between what we may know about color and how color is used by designers. Color can be an effective differentiating medium for aiding discrimination between products and places, but the history of product design and architecture in the twentieth and early twenty-first centuries has been marked by clear periods where color has not been particularly evident as a part of the designer's toolkit, despite increasing understanding of its perceptual impact on users. We discuss two contemporary designers that illustrate specific strategies for engaging with color. Some interesting strands emerge from the consideration of these exemplars against a broad understanding of color knowledge across relevant disciplines: color and color stories as part of branding and positioning; the tension between materiality and seeing in the digital domain; and the role of color decisions in procurement. Against this background we look at design codes and education benchmarks and see that if design is to operate fully within a global context, greater understanding of how color works beyond the realms of personal experience might be an important part of future practice.

KNOWING ABOUT COLOR

Color as a topic of interest for artists and designers in the Western world has moved on and off the radar over the past 500 years. Knowledge about its physical, optical, and emotional properties has been needed at different levels at different times for practical purposes. Following a brief overview of the ebbs and flows of color knowledge in this field, we consider how designers could use intelligence in this topic as a design tool.

During the Renaissance period in the visual arts (throughout the fifteenth century), the move to using oil paints on lightweight canvas supports, in combination with perspective systems of pictorial organization, enabled both a new luminosity to be created through glazes and body color, and a new verisimilitude in representation. At this time, painters either ground their own pigments into the oil medium, or instructed others to do so for them. They knew what amounts of oil were needed for different pigments and which had the required transparency for effective use as glazes. Within the decoration of the internal and external spaces of the wealthy, color and pattern was liberally applied, with trade routes to the Far East feeding an appetite for novelty and sumptuousness in fabrics and other materials. By the eighteenth and nineteenth centuries, artists had less need for detailed knowledge about pigments, as new industrial "colormen" began to supply paint in tubes. By the early years of the twentieth century, color comes back into the frame. The color theory of Johannes Itten was a distinctive aspect of the contribution of the Bauhaus to instruction for artists and designers. Looking at *The Art of Color* (Itten 1974) now, it is striking how clearly he was drawing upon psychoanalysis in his identification of the students who made particular set of studies. The way he writes about what happens when one looks at blocks of different colors adjacent to each other also suggests a familiarity with optics and visual perception.

In the last fifty years, there has been less emphasis placed upon color within the professional sphere of art and design, apart from the flurry of post–World War II design innovation and then the brief flirtation with applied color by Memphis and postmodernist architecture in the mid-1970s and 1980s (Branzi 1992). However, during this same period, knowledge about color in the fields of psychology, anthropology, and optics has increased.

Within the broad field of the human sciences, the understanding of the perception of color and the way the eye and brain work in concert has advanced. We have come to understand that trichromacy, the ability to distinguish the three primary colors or the ability of mixing the three additive or subtractive primaries to enable matching of all colors, is not a physical property of light but a physiological limitation of the eye. We have three types of retinal photoreceptors: the short-wave sensitive cones, the mid-wave sensitive cones, and the long-wave sensitive cones. The rods are understood to not contribute to color vision except in low-light levels. The cones support three sorts of discrimination, of light from dark, of yellow from blue, and of red from green. This is achieved by summing rates of quantum catch for distinguishing luminance (drawing on M- and L-cones);

comparing relative rate of quantum catch of S- to M- and L-cones (for yellow/blue discrimination); and comparison of relative quantum catch rates in M- and L-cones, for red/green contrast (Sharpe et al. 1999).

As Clyde Hardin noted, red/green incompatibility did not have anything to do with language or with colors, but "it had to do rather with how we are made." In his discussion of *Color for Philosophers*, Hardin comments that this undermined much previous thinking about color within the field of philosophy. He suggested that clinical and behavioral studies and practical "wetware" brain investigations "have begun to bear fruit of the greatest potential importance for our understanding of language, self-identity, and mental functioning" (Hardin 1988: xi). He reflected that the theoretical revolution in vision science in the 1950s that established this opponent process theory was little known outside its own field.

While it may not be immediately apparent what an understanding of opponent process theory might have for the artist or designer, an understanding of how we see and discriminate between objects is likely to be of some utility within the design process and for the visual arts. While the work of James J. Gibson (1979) and David Marr (1982) helped determine the importance of edges and shapes to image recognition, discrimination of color areas provides another powerful tool for the designer. We are now in a better position to work with the psychologists, neurologists, and others to determine just what is happening when we are looking at Itten's color contrasts, or Yves Klein's blue color field paintings, on a physiological level. Determining why task efficiency is enhanced in offices of certain colors (Kwallek, Soon, and Lewis 2007) may have a basis in how we are made as well as in what we are acculturated to.

The linkage between opponent process theories of color vision and how cultures talk about color was seen by Berlin and Kay (1969), who had shown how basic color terms could be mapped across languages. They saw a correlation between the elementary red or green that is neither bluish nor yellowish and the sequencing with which color terms appear in language development. Hardin and Maafi (1997) describe how this work on color terms linked to the work of Ewald Hering in the late nineteenth century and the work by Hurvich and Jameson in the mid-twentieth century. While the consensus appears now to suggest some connection between physiological determinants and culturally specific languages, there have been challenges to both the work of Berlin and Kay and to the opponent process theory model (Saunders and Brakel 1997). Saunders (2005) criticized the research methods of Berlin and Kay and suggested that the widespread acceptance of their model indicated a "suspension of critical faculties" that drew on a "sychophantic adulation of scientistic methodology" among other factors. Her challenges generated much discussion in related scientific communities, but work on the mapping of numbers of basic color categories has continued and is now published as part of *The World Atlas of Language Structures Online* (Kay and Maafi 2011).

As well as recognizing that even in the fields of science the thinking about topics like color vision moves on at some pace, we also need to recognize that what we know about

color and its perception has an interpretive or meaning framework that might be subject to a similar process of changing ideas. In relation to color meaning and interpretation there are additional social and cultural factors to take into account, reflecting deeply embedded historical differentiators as well as global influences in the contemporary period. The very different subjective readings given to different colors by different cultures are explored elsewhere in this book, but need to be kept in mind throughout this discussion. David Batchelor's identification of "chromophobia" (2000) came at a moment just before digital color became the ubiquitous medium of advertising and global communication. Advertising used to be in print, and apart from billboards and glossy magazines, color was expensive. Now we use the web and electronic displays, which use an entirely different means of color rendering that is as cheap as black and white and relies upon a very different color system. Colored light is not quite the same as colored stuff, but there are still levels of perceptual work that give differentiation and gratification. And in the context of global trade, the ubiquity of the palette for technological goods has not yet been broken. Knowing that *brain gray* is the term used to denote the absence of stimulus into the visual cortex from the retina suggests we might want to be careful about the use of medium gray.

COLOR, SPACE, AND PLACE

When thinking specifically about color in relation to the designed environment, there is a balance to be made between local color use related to indigenous materials and accessible color codes that might be meaningful beyond the local. In the fields of architecture and urbanism, the tendency is to presume operation as part of an international community. While locally sourced building materials were used in the past to produce the color and identity of place, this model is being undermined in the globally scaled culture of contemporary practice. To counter this tendency, the following studies are notable for reminding us of how color meaning adds to the perceptual experience of space and place.

In the 1960s, Kevin Lynch (1960) established the basis on which we describe cities and ascertain their legibility. Of his five main elements, nodes, paths, and edges all draw upon the edge detection or two-dimensional sketching associated with Gibson's and Marr's models of visual perception, but landmarks and districts both have scope to be differentiated by color as much as by the other key determinants of visual perceptual processing. Lynch developed an index of "imageability" from his study of the experience and visual memories of residents and visitors and suggested that while it is the "traversability of the city," the paths, which underscore its success or failure, landmarks and districts provide the key features for the visual memories for imagining the place.

In counterpoint to this proposition of traversability as a key determinant of place legibility is the notion that some places have a particular color. This is clearly evident where

local building materials give a clear steer to the perceptual system, but historic changes can subvert our understanding. Bente Lange made an analysis of the colors of buildings in Rome in the eighteenth century (1993), and found that they were not the golden hue they are now, but were a polychromatic mix of blues, greens, and greys as well as the color of the untreated stone. What this suggests is that we must be particularly careful to ground subjective analysis of color meaning or interpretation on the basis of some certainty.

If the changes wrought by history can be put to one side, the work undertaken by Lenclos and Lenclos (2004) on the geography of color might add to useful knowledge about the "chromatic personalities" of regions and cities across the world. They mapped the combinations of light, geology, climate, local traditions, and vernacular techniques that give expressive color distinction to different places, and which "contribute to the affirmation of national, regional or local identity." A related piece of work by Swirnoff has analyzed the light quality of cities to produce a typology that distinguished bright cities like Santa Fe from shadow cities, such as Stockholm. In combination with building materials and other external visual clues, the light quality and atmospheric conditions are one of the key determinants on how things are actually perceived in specific environments.

Hemelryk, Gammack, and Gammack (2005) conducted an online survey with worldwide respondents between November 2004 and January 2005 that asked "If Sydney [or one of Hong Kong or Shanghai] was a color, what would it be?" Respondents were asked to select from a reference palette of twenty colored swatches covering a full range of hues, including white, black, and gray. Follow-up questions asked for why the choice had been made. The answers from the Sydney-based respondents, commenting on Sydney and Hong Kong, indicate that the predominance of blue choices for Sydney were based on reasoning that the city was clear, clean, vibrant, and beautiful. Comments were made on environmental features such as the harbor, sky, natural environment, with many referring to the quality of light.

In contrast, the colors of contemporary commerce within the city draw more mixed responses. Kobayashi (1990) has looked at the associations between color combinations and key image words used in branding, particularly in relation to the advertising hoardings of Tokyo. He reports both a fascination for and a mistrust of how color and image are used. He sees scope to use conventions drawn from this work as a part of the branding of the city itself, and thus contribute to the underlying identity of the place and its social-symbolic value. Symbolic meanings increasingly form a basis for brands and for a city; its brand serves as a persona—it can engage "affective perceptions" such as friendliness, attractiveness, trust, and integrity. There is, however, the underpinning dilemma related to the difference between the colors of light and the colors of stuff. The award-winning work by Laura Bayliss of Building Design Partnership in the United Kingdom (2008) exemplifies the impact of colored light in the city at dark, but also reminds us that the range of colors achievable through the use of light is at a distance to the range of colors seen when we see material in daylight.

COLOR SYSTEMS

The difference between colored stuff and colored light presents what might be seen as a problem for design. The specification of materials, particularly in a global manufacturing or construction environment, requires specificity and exactitude. Over the past century, a range of methods has been developed for managing specification of color, and several of the systems have come to incorporate different finishes. The Munsell system developed through his 1929 *Book of Color* (Munsell 1929) has contributed several standards to U.S. industry. The RAL system, originated in 1927 (RAL 1927), became the standard system for central Europe, while the Natural Color System (NCS) (1979), developed in 1946, was adopted as the Swedish standard in 1979. The Pantone system, first published in 1963, has gained dominance in the graphic arts industry (Pantone 1963). The Commission Internationale de l'Eclairage (CIE) (2000) developed the first mathematically derived color space, which has come to provide the most constant referent point for other color systems. Along with the International Color Consortium (ICC) (2005), British Standards Institute (BSI) (2010), and the International Standards Organisation (ISO), it provides widely accessible standards for the use of color in a wide range of industrial and manufacturing contexts.

Urban space presents the viewer with a complex visual landscape comprising elements that can be defined by a number of color systems that draw upon these international and national standards. Specific standards apply to many aspects of the built environment such as the colors used on road signs, industrial finishes, and other materials. There are now ubiquitous colors such as the yellows or reds of post boxes, the orange of shipping buoys, or the brown of historic or tourist attraction signage. The majority of the colors selected for such signs draw upon the base group of distinguishable colors: the red that has no green, or the blue that has no yellow, with a second set of colors drawn from the secondary mixes of brown, orange, purple. What these colors do have in common is a generally high level of saturation that places them in specific regions of CIE or other color spaces (CIE 2000).

The color systems used in this environment include the statutory color systems defined by government and institutional agencies. They are often instructional and provide visual notation to the environment in the form of road markings, traffic signs, and place names, often conforming to internationally recognized norms. Statutory color draws upon the internationally recognized color systems including BSI, RAL, DIN (1953), ISO, CIE, and Pantone to ensure consistency in use and legibility. For example, the standard colors of UK road signs are set out in *Traffic Signs* (H.M. Stationery Office 1963: 139), and refer to the specific red, blue, yellow, and gray BS colors, and two BS greens.

As distinct from statutory systems, material color systems in the built environment are defined by what has been built. A material system derives from and reflects the ethos and objectives underpinning the design of buildings and the infrastructure in which they are located and is influenced by town planning, design codes, and the means

of construction available. Material color reflects the local or global nature of a place, and can exist either as post-hoc rationalizations of what is, or can be embedded in theoretical propositions or "design codes," to determine what might be built.

The third system of color in the built environment is cultural. This might refer to color as applied in the form of signage or through the choice of visual embellishment of buildings and surfaces, normally through the use of paint or graphics. Cultural color can reflect deep-rooted traditions or ephemeral events, sometimes simultaneously.

The predominance of one system over another depends on the nature of the space in question and it is rare for one system to exist in isolation from others. This produces a situation where there are interrelationships set up by the viewer between systems and where particular systems predominate or recede depending on the nature of interrelationship between the user or viewer and the environment. This complex triangulation of meaning and values provides the designer with an operational field within which new forms of engagement with color may occur and through its complexity provides opportunities for identifying design questions and resolutions.

DESIGN CODES

While color systems provide a conceptual framework within which color can be described or prescribed, design codes give guidance on how color and other visual attributes should be used in specific contexts, thus providing another set of directional frameworks for the designer in the urban context. The use of design codes as a means of improving quality of the urban environment is widespread as is the body of theory supporting it (Commission for Architecture and the Built Environment 2005), and they are recognized by the UK government as a means of improving urban quality. Design codes are typically either statutory or guidance-based.

Statutory design codes are identified in documents such as Building Regulations and provide a framework within which construction takes place. Certain constructional elements may fall within statutory color systems, for example, warning signs, but others are the result of aesthetic and technical choices that are not color-critical, therefore they may vary within a given context. The purpose of a statutory instrument is to ensure that design decisions meet certain minimum levels of conformity or performance. This results in readily identifiable visual elements recurring within the environment, typically in the form of information or instructional media. Statutory code can also be applied to the design of instruments of the state, for example, the emergency services and armed forces to produce a level of consistent aesthetic.

A supplementary layer of information in addition to statutory instruments is provided by Guidance notes. These may be used to control the visual appearance of the built environment, by specifying the color of the building and the specific materials that are to be used for construction. Guidance directives were originally designed to ensure that visual conformity was maintained in prestigious developments. A notable example is the

guidance for the stucco façades of the Nash Terraces in Regent's Park, London, which have to be painted either white or cream. This specification is covered by a covenant drawn up following completion in 1825. Since the introduction of Conservation Areas to the United Kingdom in 1967, local controls can now be enforced to preserve the aesthetic quality of an area, including many elements that compose architectural character. In the United Kingdom, the use of design guidance has gained prominence since the 1970s as a means of ensuring consistency in the visual environment. This is often done through the control of acceptable building materials that deliver a predictable tonal palette as well as in the formal characteristics of the built environment. The most recent high-profile examples of design codes are those prescribed for Seaside in Florida and Poundbury in Dorset. In Poundbury all aspects of the external appearance of the built environment, from "traditional" architectural styles, relationship between buildings, materials used, and colors chosen for front doors are controlled by the Poundbury Building Code, drawn up and enforced by the Duchy of Cornwall. In the Crewkerne Easthams Development Design Code (Prince's Foundation 2006) there are minimal references to color, with specification of "natural," or buff-colored stone, and of doors being painted in 'sympathetic' colors. Such codes control all aspects of the built envelope, from the distance between buildings to their form and the materials used and their disposition.

The use of design codes has been extensively promoted by theorists, has been used in various forms since the Renaissance, most recently by the American New Urbanist movement, and has also been both promoted and tested by organizations including the UK's Commission for Architecture and the Built Environment (CABE). CABE (2005: 15) defines design codes as "a document that sets rules for the design of a new development." These codes initially emerged from technical requirements derived from pragmatic issues such as fire resistance. Wren's building codes for London, developed after the Great Fire of 1666, defined extensive elements of the urban environment, including building height, facing materials, and window size and proximity. Through technical means this defined the aesthetic of the new city that emerged.

Latterly design codes have increasingly become aesthetic documents, a means to impose some form of visual order on development. The result has been a delamination between technical and aesthetic concerns. The aesthetic objectives of design codes are intended to produce control and consistency within developments. This can take many forms, however, typically it will define building mass and building interrelationship, acceptable roof and façade forms including fenestration types, along with approved material palettes. The level of control is dependent on the objectives of the designer, but can extend to defining the colors of any external finishes and whether illuminated elements such as signage are acceptable.

Design codes can be read as a means of bureaucratizing design, replacing individual creative freedom with a set of rules that produce collective coherence. Design codes tend to normalize design, removing extremes, and emphasizing shared (or imposed) value systems. Unless design guides are applied intelligently, conformity can result in banality, where design innovation is replaced with compliance.

SPECIFICATION AND PROCUREMENT

As well as the influence of design codes and guidance on the choices that may lead to the selection of color within the built environment, color in urban space and architecture is typically also a byproduct of the building processes, where the palette develops from the natural condition of materials, as well as being a clearly applied medium with a designed objective.

The construction process is governed by design instructions placing available technology within a timetabled program. Decisions are made in advance of the build and involve specification from known materials or components. The choice of materials is governed by budget and the decisions of the design team. This tends toward a convergence within any era, reflecting dominant taste. Taste affects the detail of design; however, technology informs fundamental shifts in the material nature of the environment.

We have already referred to the impact on London of the transformations that took place as a result of the design codes implemented after the Great Fire of 1666, where the city was transformed from a black-and-white timber city, to a brick-and-stone city, an aesthetic transformation driven by the technological requirement for fireproof buildings. More widespread transformation due to procurement influences took place in Britain in the mid-nineteenth century when locally sourced building materials were replaced by mass-produced industrialized materials, local stone was replaced by brick, local roofing materials replaced by mass-produced Welsh slate. This removed the direct connection between building construction and place. Buildings were no longer made of the place they were sited in but became specified and global objects. Increasingly, this distancing from site and building process has become the norm.

Components are now globally sourced, and it is common for all the key elements of a building to be produced in widely dispersed places, brought together through a coordinated building process. A result of this is an increasingly homogenous urban environment.

The route to building procurement is highly structured, and design decisions are distanced from delivery. In the United Kingdom, the Royal Institute of British Architects (RIBA) Plan of Work for Architect's design services summarizes the process into twelve primary stages including the initial commissioning of a project, which provides a structure for the delivery of a building process but does not engage with aesthetic issues. The selection of materials and color is developed and resolved early in the process, with specification of materials and components usually happening well before the scheme emerges out of the ground. Judgments relating to color and tonality, particularly with self-colored materials, are very difficult to change as the construction process progresses beyond the production of tender documents (the seventh of the twelve stages). Decisions relating to building materials are informed by numerous pressures on the design team. Choice may be affected by availability, cost, timescale, performance, as well as aesthetic, and the design process is often under significant time pressures where known solutions are favored.

Beyond buildings, significant areas of the urban environment are the result of default decisions with little or no aesthetic consideration. Road surfaces are governed by

standardized signage and notation criteria, which may extend to coloring the road surface itself, and the road pavement is defined by technical criteria associated with wear resistance, adhesion, and cost. Street lighting is defined by the minimum cost of delivering defined illumination levels onto the pavement surface. Color-rendering quality is of secondary importance to running cost. The (orange) high-pressure sodium lamps that characterize much British urban space are a direct result of this, having replaced (blue/green) mercury lamps, a change driven by the running costs. In situations where color rendering is judged important, changes to the choice of lamp result, justified by the cost/benefit decisions. So while significant changes can take place around us in the built environment merely by changing the light we use to render our cities, how are contemporary designers responding to the challenge of bringing color to bear upon our lived experience?

CASE STUDIES IN COLOR

To enable us to develop our thinking about color in urban space, we explored how two design teams have realized and theorized color within the urban context. Maccreanor Lavington Architects (Rotterdam) uses road paint as a cheap transformative medium for urban intervention, and Dashing Tweeds samples urban color as the development palette for traditional tweed fabrics. Semi-structured interviews were conducted with both design teams as the basis of accounts of their approach to color.

Traditional means of engaging with the design of urban space have typically concentrated on the form or the function of the building or space under scrutiny, rather than considerations of color and its role in determining the quality or utility of the environment. This is reinforced by the training given in schools of architecture and town planning, where chromatic design does not form part of the curriculum. The development of urban design as a discipline aligned with architecture and town planning has opened opportunities for exploration of new areas of design practice, along with the willingness of professional practitioners to engage with unconventional media and transdisciplinary modes of design.

A questioning of the appropriate and possible means of engaging with the representational possibilities of the city underpin the case studies described here. Importantly, elements that were previously considered either banal or outside the remit of designers have entered the designers' consideration. The language of signage and urban materiality reappears in unexpected form as a re-representation of the city. Both of the case studies discussed here use different media to engage with the city and take the urban color palette and develop it in different ways.

MACCREANOR LAVINGTON ARCHITECTS: DUBLIN'S PARLOUR

The architectural practice Maccreanor Lavington is based in Rotterdam and London. It has successfully developed award-winning architectural schemes in parallel with innovative urban design work, winning the Stirling Prize for Architecture in 2008 and the Masterplanning Architects of the Year in 2009, among many other accolades.

Dublin's Parlour was an architectural competition proposal for a temporary and flexible urban public space designed to accommodate up to 6,000 people exiting an adjacent concert venue. The project location was complex and indeterminate, incorporating a surface that covered the hole left by six-story-deep foundations for an unfinished office tower, unified by a thin layer of asphalt, the most neutral of all urban materials, defining the site as a dark gray surface. The drivers of low cost and speedy delivery led the design team to explore alternative solutions toward defining the space. The architects realized that schemes relying on traditional forms of space and place definition, including building of enclosures or conventional structures, would be too expensive, insufficiently flexible, and take too long to realize. The requirement was for a scheme with maximum impact that could be delivered quickly, and on a low budget, driving an innovative solution.

Analysis of possible quick and cheap means for redefining space informed the choice of color as the primary medium for the scheme. This built on research work into visual impact undertaken by members of the design team. They reasoned that while color can be extremely visually dominant, it can at the same time be formally and spatially neutral. A painted surface can define movement, patterns, and activities, or simply exist as a surface. The design team explored marking patterns on highways and airport runway taxiways, while referencing artists including Barnett Newman and Robert Morris. Cost analysis confirmed that road paint can be applied for approximately $1.20/square foot, offering an ideal means of transforming the urban surface at minimal cost. As architect Kevin Logan said, "It's cheaper than pizza!" Color is used to produce a proposal that is striking yet functionally ambiguous, subverting the statutory coding implied by the use of road paint, encouraging spontaneous use and redefinition of the space. The visual dominance of the resulting colorful street surface is counteracted by its neutrality of form.

The use of color as a primary architectural element is made explicit by the architect's design concept statement, referring to "bold" pattern and color as "a dynamic mechanism to organise and articulate the space, offering structure to events and activities, enabling orientation and adjusting the scale of the space." The layering of patterns and colors was designed to form a composition that works at different scales, with areas of detailed "patternation" encouraging intimate engagement balanced by extensive color fields (Plate 5). The shifts in the scale of pattern elements enable the user to develop an understanding of how to use the space, through embedded visual clues, referring to pattern and color as "subconscious markers" that set out "how the space and adaptive elements . . . maybe [sic] used."

The assertion is made that the strong and bold colors used were selected to "complement local light levels." They drew their influences from the historical northern European architectural traditions of the painted façades to articulate and add depth to the surfaces. The color was realized through the use of road paints and the materials and technologies used for sports surfaces. The architects suggest that this will enable the surface patterns to be reworked in the future, perhaps as an arts commission, although this might undo their careful articulation of the pattern elements.

The designers' statement of concept for the scheme reinforces what might be seen as an overlap between disciplinary practices. While operating initially from the perspective of the architect, the practice demonstrates that an ability to absorb and reconfigure numerous references and visual forms underpins this scheme. Essentially what we see here is a design solution that is focused on presenting an opportunity for a cultural visual system, based on the articulation of color and pattern, to act as the unifying aesthetic driver of the scheme. While its conceptual framework of subconscious markers could provide a powerful tool for ensuring the space is memorable and distinctive, drawing upon elements of Lynch's theory of place (1960), the prospect of a reworking of these distinguishing features by later arts commissions might render the intervention of Maccreanor Lavington less long-lived than it deserves.

DASHING TWEEDS

A fascination with the use of the color of the city also informs the work of Dashing Tweeds, who is reframing the traditional look and use of tweed to meet the demands of twenty-first-century urban life. Dashing Tweeds is designed by photographer Guy Hills and weaver Kirsty McDougall. They have taken a palette and transformed its representation through changing its medium. Dashing Tweeds uses urban color to inform its range of innovative clothing and cloth and claims that it is "inspired by the colors of London, from the wet pavements of Piccadilly to the green parks of St. James."

The traditional form of tweed is recast through the introduction of contemporary elements including yarns in colors not normally used in the production of this fabric, with colors derived from road paint and signage, as well as the dominant background tones of asphalt and construction materials, and the inclusion of reflective material within the yarns. The designers' intention is to establish a contemporary urbanity, a collective identity derived from context. They note that "for color fidelity samples of double yellow-lines and red routes were chiselled up and replicated to produce the yarn shades of the city." They have developed a unique weave that uses a wool worsted and reflective yarn that they call Lumatwills™. By day these tweeds appear as a combination of different colored yarns. By night, however, hidden reflective fibers are revealed under illumination (Plates 6 and 7), "offering an inventive and stylish solution to attire for the pedestrian, cyclist or scooter rider." They describe this as "Capturing the urban zeitgeist in a fabric."

The design result of Dashing Tweeds differs from the Dublin Parlour scheme in that the color is used as a palette, introduced into an unexpected medium, rather than as a medium that is reframed in its normal context. The juxtaposition of traditional design elements and production methods with advanced, overtly contemporary materials, and modern tailoring, restate the condition of contemporary urban space. Dashing Tweeds is driven by the context of early twenty-first-century urban life, where elements are continuously recontextualized. The color and form of road markings reappear as design

elements of the woven fabric, the tonality of building materials forming the background weave.

By reframing the city into a new medium, the wearer can become part of the city, simultaneously expressing belonging to a collective place and social group, while also expressing individuality through the particular choice of garment and the contemporary ways in which this is used. Garments are designed for specific urban uses, for example, cycling, business accessories, and so on, reinforcing the identity of the clothing as urban while reframing the reference point of the wearer and viewer. The Lumatwill™ Cape is highly reflective and Teflon-treated to allow water to roll off if caught in the rain. The call to cultural systems again is expressly made in its statement that it was "Initially available in the yellow raver design as a play on the high visibility vest worn by emergency workers."

REFLECTIONS ON CASE STUDIES

While ambiguity is a defining characteristic of contemporary design practice, reflecting the move away from the certainties of Modernism, the givens of the human form and human physiology and psychology do also have a bearing on the success of these projects. The story of the intentions of the artist or designer starts to have a powerful role in the branding of exclusivity or reusability. The nature of this practice is that all elements and media can be used as critical forms for expression. We suggest that the Dublin Parlour scheme and Dashing Tweeds designs engage with contemporary qualities of urban life, reframing traditional or everyday color through design processes that reengage the viewer with color in new ways. They demonstrate how the use of color as a primary design element is again emerging as a theme, one that is highly malleable and that operates at a fundamental level in the design process.

In contrast to this reengagement with color through these two cases, there appear to be tensions between the notion of cultural color systems, place-making, and global procurement, exacerbated by the way lived experience is mixed with the images relayed by communications devices and global electronic media. Simultaneous global and local experiences are becoming normal, creating new forms of visual experience, where the real is mixed with or mediated by the virtual, with each condition having its own color system.

The recent phenomena of Second Life proposed a parallel virtual world as a mirror to real space. As any visitor to Second Life will notice, however, a purely virtual world lacks the visual richness of reality. Colors are brighter and more defined, but the lack of dirt, shadow variation, weather, and diurnal change produces a visually static and sterile environment. The lack of restriction in choice of architectural materials leads to a consistent and banal urban simulation. This directly contrasts with reality where material choices are directly informed by performance and cost constraints that drive architectural and design innovation. Gravity and weathering are crucial architectural drivers that virtual worlds lack.

BENCHMARKS AND DIRECTIONS

Much of the work on color described above is currently at the margins of curricula, outside the mainstream of design education. Despite the core aspect of color as a defining characteristic enabling visual distinction between objects, and its increasingly important role in branding and place-making, color as a topic of study does not feature clearly within the benchmarks for professional education in the fields of architecture or art and design in the United Kingdom.

British and European architectural education is governed by a European Union (EU) directive (2005). At no point is color mentioned directly as a design consideration, rather it appears only as an implied component within aesthetic requirements and knowledge of fine arts. The directive on architectural education is intended as a framework within which local interpretation and practice can operate, consequently there are wide variations in how architectural education is delivered throughout Europe. All providers do address the criteria of ensuring the ability to create designs that satisfy the aesthetic and technical requirements of construction and use, and embed an understanding of how the fine arts influence architectural design. The third key criteria is the understanding of the relationship between people and buildings.

Similarly in the field of art and design, the UK Quality Assurance Agency (QAA 2008) Subject Benchmark for bachelor's degrees with honors in Art and Design indicates the focus of study in the field as upon "the conception, production, promotion and dissemination of the outcomes that constitute our visual culture." Design is referred to as covering "all aspects of decision-making in relation to the aesthetic, operational, user, market, production and/or manufacturing characteristics of artefacts and systems." While drawing ability is highly regarded as a prerequisite skill, and the acquisition of technical skills in discipline-specific materials and processes is cited, there is no explicit reference to color. While subject-specific knowledge and understanding are considered to be fundamental, the focus of the benchmark is more directed to the graduate's ability to act rather than to know.

COLOR IN A GLOBAL CONTEXT

Given the investment from other fields into understanding color and its role in everyday vision, in cultural activity, and its supposed role as a key component of visual creativity, the absence of focus on it within the education sphere is interesting. Whether this reflects the assertion that colorists are born, not made, as claimed in Itten's *Art of Color*, or the disinclination to explore the base components of creativity—too much analysis leads to paralysis—a key question remains. For designers, and those that educate them, the challenge must be to consider what level of conscious engagement with color knowledge and theory are sufficient for professional operation in a global context.

We see color and color stories becoming integral to product branding and location positioning. We know that there are arguments for cultural color systems that relate to local differentiation in relation to preference or perception. Material systems can be manipulated to both reinforce and break cultural location specificity, and statutory systems can themselves become part of the cultural frame. Beyond the management of color within the design sphere, the industrial context of global commerce requires designers to have some fluency with specification models such as the international color space nomenclatures. And understanding how the eye works, even if as background understanding, can help to reinforce design decisions. While the late twentieth and early twenty-first centuries saw a massive rise in "gray goods," the carriers of electronic color data that subvert the experience of "stuff," the role of gray within the built environment has become all-pervasive. Gray is the color of concrete, of steel, and of neutrality. Gray is both the color of the dead brain, and the color against which we can see color.

Color, existing as a medium that lies outside the definition of standard academic curriculum, has the advantage of freedom of interpretation. This is potentially a liberating condition. In very tightly prescribed areas such as architecture, the ability to engage with areas of knowledge that are not defined is welcome. However, the converse side of this situation is that no space is set aside in the curriculum to study the subject.

It seems evident that knowledge of color theory and practice is a potential benefit to design practitioners, but this needs to be as an area that creates potential synergies with other areas of practice, not as a normative means of creating conformity. The case studies explored above illustrate how understanding some of the contextual conditions of color can inform design decisions, even when the operational color palette is extremely limited. The cross-disciplinary benefits of understanding a fundamental issue such as color are exciting, and could be seen as an area of shared knowledge that could facilitate interaction between different areas of practice, a goal that has eluded design practice with increasing professional specialization.

If design is to operate fully within a global context, greater understanding of how color works beyond the realms of personal experience might be an important part of future practice.

REFERENCES

Batchelor, David (2000), *Chromophobia*, London: Reaktion Books.

Bayliss, L. (2008), "Lighting for Liverpool One," http://www.bdp.com/Projects/By-Name/F-L/Liverpool-ONE.

Berlin, Brent, and Kay, Paul (1969), *Basic Color Terms: Their Universality and Evolution*, Berkeley: University of California Press.

Branzi, A. (1992), *Primary Design* in *The Complete Works*, New York: Rizzoli.

British Standards Institute (2010), "British Standards," http://bs_color_guides.e-paint.co.uk/ and http://www.bsigroup.com/en/Standards-and-Publications/About-BSI-British-Standards/History.

Commission for Architecture and the Built Environment (2005), *Design Coding: Testing Its Use in England*, London: Commission for Architecture and the Built Environment/Office of the Deputy Prime Minister.

Commission Internationale de l'Eclairage (2000), "Commission Internationale de l'Eclairage," http://www.cie.co.at/index.php/LEFTMENUE/About+us.

DIN (1953), "DIN Color System," http://www.colorsystem.com/projekte/engl/47dine.htm.

European Union (2005), "Article 46 of the European Union Directive 2005/36/EC on the Recognition of Professional Qualifications," Luxembourg: European Union.

Gibson, J. J. (1979), *The Ecological Approach to Visual Perception*, Boston: Houghton Mifflin.

H.M. Stationery Office (1963), *Traffic Signs*, London: H.M. Stationery Office, 139.

Hardin, C. L. (1988), *Color for Philosophers: Unweaving the Rainbow*, Indianapolis: Hackett.

Hardin, C. L., and Maafi, L. (eds.) (1997), *Colour Categories in Thought and Language*, Cambridge, UK: Cambridge University Press.

Hemelryk, Stephanie, Gammack, Donald, and Gammack, John (2005), "Drawing Sydney: Flatlands and the Chromatic Contours of a Global City," *SCAN: Journal of Media Arts Culture*, 2/1 (April). http://scan.net.au/scan/journal/display.php?journal_id=49.

International Colour Consortium (2005), "International Colour Consortium," http://www.color.org/index.xalter.

Itten, Johannes (1974), *The Art of Color: The Subjective Experience and Objective Rationale of Color*, 2nd ed., New York: John Wiley & Sons.

Kay, P., and Maafi, L. (2011), "Number of Non Derived Basic Color Categories," in *The World Atlas of Language Structures Online*, Munich: Max Planck Digital Library, Chapter 132. http://wals.info/chapter/132.

Kobayashi, S. (1990), *Color Image Scale*, Tokyo: Nippon Color and Design Research Institute.

Kwallek, N., Soon, K., and Lewis, C. M. (2007), "Work Week Productivity, Visual Complexity, and Individual Environmental Sensitivity in Three Offices of Different Color Interiors," *Color Research and Application*, 32/2: 130–43.

Lange, Bente (1993), *The Colors of Rome: Urban Spaces and Façades from the Renaissance to Our Days*, Rome: Edizioni d'Europa.

Lenclos, J. P., and Lenclos, D. (2004), *Colors of the World: A Geography of Color*, New York: W. W. Norton.

Lynch, Kevin (1960), *The Image of the City*, Cambridge, MA: MIT Press.

Marr, David (1982), *Vision: A Computational Investigation into the Human Representation and Processing of Visual Information*, New York: Freeman.

Munsell, A.E.O. (1929), *Book of Color: Defining, Explaining, and Illustrating the Fundamental Characteristics of Color*, Baltimore: Munsell Color Co.

Natural Color System (1979), "Natural Color System," http://www.ncscolor.co.uk.

Pantone (1963), "Pantone," http://www.pantone.com/pages/pantone/pantone.aspx?pg=19295&ca=10.

Princes Foundation (2006), "Crewkerne Design Code," http://www.princes-foundation.org/index.php?id=169.

Quality Assurance Agency (QAA), (2008), *Subject Benchmark Statement: Art and Design.* http://www.qaa.ac.uk/academicinfrastructure/benchmark/statements/ADHA08.pdf.

RAL (1927), "RAL Colors," https://www.ral-farben.de/ral-farben.html?&L=1.

Royal Institute of British Architects (1999), *Standard Form of Agreement for the Appointment of an Architect* (SFA/99), London: Royal Institute of British Architects.

Saunders, B.A.C., and Brakel, J. van (1997), "Are There Nontrivial Constraints on Color Categorization?," *Behavioral and Brain Sciences*, 20/2: 167–79. Available on Cambridge Journals Online, http://journals.cambridge.org/action/displayAbstract?fromPage=online&aid=29229&fulltextType=RA&fileId=S0140525X97001428.

Saunders, Barbara (2005), "Revisiting Basic Color Terms," in Robert M. Young (ed.), *Science as Culture*, http://human-nature.com/science-as-culture/contents.html.

Sharpe, Lindsay T., Stockman, Andrew, Jägle, Herbert, and Nathous, Jeremy (1999), "Opsin Genes, Come Photopigments, Color Vision and Color Blindness," in Karl R. Gegenfurtner and Lindsay T. Sharpe (eds.), *Color Vision: From Genes to Perception*, Cambridge, UK: Cambridge University Press.

Color Relationships

Cristina Boeri

Chapter Summary. Relationships between colors are of primary importance to both the color theorist and the designer. Historical perspectives on color relations include a number of different points of view, both theoretical and personal. This analysis of the leading authors who investigate color relationships provides a comparative discussion of the literature and probes the usefulness of these treatises in developing a critical color sense that is the basis of any design process. The study of color relationships is not intended to achieve rules within which to operate, but to provide a theoretical and practical structure to support the compositional and perceptual possibilities of color.

A much-studied aspect of color theory is the relations among colors, sometimes described as "harmonies," "chords," "interactions," or "contrasts." The fact that colors, in their practical applications, are almost never seen as an isolated phenomenon, but are always related with other colors, is probably the main reason this topic is particularly interesting. As observed by Josef Albers "we are able to hear a single tone. But we almost never (that is, without special devices) see a single color unconnected and unrelated to other colors. Colors present themselves in continuous flux, constantly related to changing neighbours and changing conditions."[1] Much attention has been placed on the aspects connected to color combinations, both in terms of mutual relationships and chromatic interactions—how colors interact via perceptive change. Is it possible to trace the reasons why some color arrangements seem more effective than others? Numerous authors have tried to answer this question, starting from the consideration that some color combinations will be seen as more balanced, efficient, and pleasant than others. Although the concept of "harmony" itself is subjected to different interpretations, we can ascribe its sense to the etymology of the Greek word *armonía*, namely link, disposition, proportion, that derives from the verb *armózein*, namely to connect, to link, to agree. In other words a correspondence among the parts creates a tie that sustains color relationships.

SCIENCE OR INSTINCT?

In treating the theme of color relationships, two diverse approaches to color harmony are delineated. For some color theorists, color harmony can be ascribed to a "scientific nature" and therefore to principles, rules, laws, objectives, on the basis of how the eye and the mind conceive relations among what is different. For others, the selection of colors is an innate ability, an instinct which no rule can accomplish. John Ruskin warned: "if you need examples of utterly harsh and horrible colour, you may find plenty given in treatises upon colouring, to illustrate the laws of harmony. . . . If ever any scientific person tells you that two colours are 'discordant', make a note of the two colours, and put them together whenever you can."[2] In more recent times, Albers expresses the necessity to develop an eye for color "instead of mechanically applying or merely implying laws and rules of color harmony."[3]

Even if it is clear that employing any of the theories on color harmony doesn't automatically produce effective chromatic results, we can still conclude that the purpose of studying relations among colors is not to achieve strict rules within which to operate but to offer a structure of support. As Itten already noted in the introduction to his book *The Art of Color*,[4] the purpose of studying relationships is to provide a theoretical and practical structure to support all the possible chromatic compositions; in this case, even today, the importance of these theories and this particular study field is still tangible. The true risk in dealing with the issue of relations among colors starting from any of the available treatises is to be persuaded to have unambiguous and shared "recipes" that can be employed when making chromatic choices. So, in analyzing the treatises of the leading authors who investigated the relations among colors, the emphasis is not on the value of the single contribution. But, through a comparative view of the whole area of study, emphasis is on the real current usefulness these treatises can still offer in developing that necessary critical sense that is the basis of any design process.

MUTUAL INFLUENCES AMONG COLORS

In 1824, the chemist Michel Eugène Chevreul (1786–1889) was appointed director of the dyes department of the Paris Gobelins' royal tapestry factories with the intention of remedying the apparent "gloominess" of the pigments employed in the factory. He discovered that the problem didn't concern the coloring agents, but the way the yarns were woven or the way the colors were matched. Goethe had earlier noticed how the observation of colors led to the emergence of changes in their qualities, attributed to the fact that contrasting colors intensify themselves.[5] Leonardo da Vinci observed how each color is seen more distinctively when it is opposed to its contrary than when matched with any other similar color.

From his studies on the mutual influences among colors, Chevreul came to demonstrate, through a series of experiments, that by simultaneously observing two

juxtaposed colored surfaces, two types of alterations are produced in the color appearance: one concerns the color intensity or lightness (*contrast of tone*) and the other applies to the color itself (*contrast of color*); these alterations happen because each color "yields" to the one close to its complementary, the so-called law of simultaneous contrast and it is for this reason that complementary colors, when matched, seem brighter. See Figure 3.1.

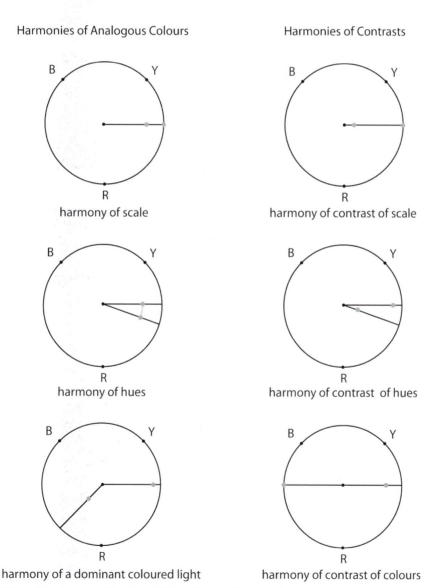

Figure 3.1 An exemplification of Michel Eugène Chevreul's harmonies of analogous colors and harmonies of contrasts. Image by Cristina Boeri.

In 1839, Chevreul published his observations on chromatic combinations in a book, entitled *The Principles of Harmony and Contrast of Colors and Their Application to the Arts*,[6] which later would strongly influence the Impressionism and Neo-Impressionism art movements. As Ball observes, his work spread rapidly among painters not because his discoveries were something new—painters had known for a long time that color perception was influenced by what surrounded it—but it was rather due to the scientific aura of his systematic treatise.[7] Chevreul also describes a particular aspect of the relations among colors starting from the notion that if "the eye undoubtedly takes pleasure in seeing Colours, independent of design and every other quality in the object which exhibits them"[8] the sight of some color combinations produces a pleasant experience.

He categorizes the chromatic harmonies in two substantial typologies, which he called harmonies of analogous colors and harmonies of contrasts. The harmonies by analogy are produced by the simultaneous viewing of colors sharing similarities: colors of different tones belonging to the same scale and adjacent, that is, colors of the same hue with different lightness; colors with the same, or similar, tones belonging to adjacent scales, that is, colors with the same lightness that are adjacent on the color circle; and, finally, colors even very distant, different, one from the other, provided that one prevails on the others, as it happens when colors are observed through a slightly colored glass or when the same hue, although left transparent, is laid on different colors.

The harmonies by contrast are produced by the simultaneous sight of very different colors: colors of different tones belonging to the same scale yet distant one from the other, colors with different tones belonging to adjacent scales, that is, adjacent colors on the color circle having different lightness; or colors belonging to very distant scales, for example, complementary colors, selected in accordance with the law of contrast.[9] Chevreul then focuses upon some combinations of primary colors with white, black, and gray, observing how they appear particularly beautiful; nonetheless to conclude that in treating this particular field of relations among colors, he only aimed at stating general propositions expressing his own personal idea and not at establishing rules based on scientific principles.[10]

Another author who has dedicated particular attention to the action of color and to the reciprocal relation among colors is Josef Albers (1888–1976). Trained in the Bauhaus School in Weimar, where he taught until the school was shut down in 1933, Albers developed an experimental way of studying and teaching color based on the observation and experience of color interaction. The effects of simultaneous contrast are highlighted through a series of practical exercises that show us how the same color applied on different backgrounds appears different, but also, vice versa, how two different colors can look alike or nearly alike in function of the backgrounds with which they interact.

The interdependence of color is not limited to the interactions between color and color, but also between form, placement, quantity, quality of light, and the existence of separating or connecting boundaries that all can modify color appearance. It is just this interdependence of color with the context, its relativity, that in Albers's opinion ratifies the necessity of an approach to color which, beyond any color arrangement theory, sees in discovery and experimentation the only means to utilize color effectively. See Figure 3.2.

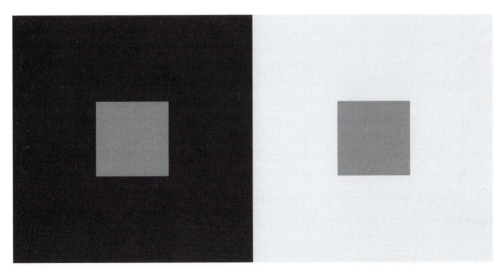

Figure 3.2 Examples of color interactions: the smaller gray squares contained in the bigger squares are identical, but they appear different in lightness (Plate 8) and also in hue and saturation. Image by Cristina Boeri.

COLOR ORDER SYSTEMS AS COLOR RELATIONSHIP SYSTEMS

Color organizational systems represent the human being's innate desire to create an order able to subject colors. Starting from Aristotle's and Leonardo da Vinci's linear color sequences, followed by two-dimensional representations of color circles, and eventually three-dimensional models that structure color according to its characteristics of hue, lightness, and saturation, the goal of these models is, as Philipp Otto Runge said referring to his sphere,[11] to provide universal charts that allow one to find an orientation within a color context. These systems are also attempts to structure and highlight the relations among colors. As Rudolf Arnheim notes, the purpose of these systems is clearly to allow an objective identification of any color, but also to "show which colors reciprocally match."[12] This is the principle of common elements, which comes from the prerequisite that, as Wilhelm Ostwald (1853–1932) once said, colors, in order to harmonize, must be equal in their essential elements.[13] Ostwald based his harmony principles on hue identity and on the content of white, black, and saturation. Therefore, according to Ostwald, a pleasant effect results from chromatic juxtapositions arranged in a precise and well-regulated mutual relation, stating the fundamental principle that harmony is equal to order. See Figure 3.3.

Ostwald, who had a chance to meet Albert Munsell in 1905 during a trip to the United States, developed his harmony principles from a color order system, which, similar to Munsell, is based on the perceptual comparison of the respective similarities and differences among colors. He organized the *full colors*, to their maximum saturation, in a twenty-four-hue color circle, which, drawing from Ewald Hering's[14] system, is organized starting from four primary colors: *yellow*, *red*, *blue*, and *seagreen*. Among these colors,

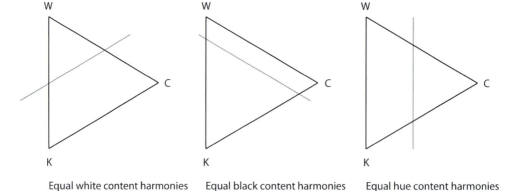

| Equal white content harmonies | Equal black content harmonies | Equal hue content harmonies |

Figure 3.3 An exemplification of Wilhelm Ostwald's monochromatic harmonies of equal white, black, and hue content. Image by Cristina Boeri.

he then places four more principal colors (*orange*, *purple*, *turquoise*, *leafgreen*) so that the complementary colors—according to Ostwald's definition these are the most different hues that once combined in an optical mix produce a neutral gray—lie directly opposite each other on the color circle. He then assembles a series of perceptually equally spaced colors that, starting from the full color, progressively lighten toward white and darken toward black. These series are represented in an equilateral triangle on whose vertexes are placed the white, the black, and the full color. Inside the triangle, we also find all the possible series, which are formed by mixing the full color and the gray scale. Observing these triangles all together, for each of the hues forming the chromatic circle, the shape of a double cone appears, a color solid in which the entire world of colors is included.[15] It is within this color organizational system that Ostwald thinks we can find all the possible harmonies, by studying all the possible arrangements allowed by its solid, in accordance with the geometric rules. The simpler the relation among colors is, the more effective the harmony will be.[16]

Among the various attempts to achieve a logical color order system, the effort of the American painter Albert Henry Munsell (1858–1918), at the beginning of the twentieth century, is generally acknowledged as one of the most successful. In accordance with the three dimensions employed by Munsell to describe and identify each possible color—that is, hue, value (lightness), and chroma (saturation)—the samples of the system are placed in a solid, the so-called Munsell's tree, based on the principle of "perceived equidistance," so that the variations between each color and its adjacent one are perceived as identical.

In Munsell's solid, the vertical lightness scale is divided into nine steps of gray with white at the top and black at the bottom; hues are organized in a circle made up of five basic hues: red, yellow, green, blue, and purple—selected by his skilled eye on the basis of their apparent equidistance and with a gray of the same lightness—and of five intermediate hues, formed by their mixtures. The chroma parameter is assigned to the

principal hues and to their mixtures, following an open horizontal scale that depends on the intensity that each hue can reach.[17]

While the Munsell color system was such a success, which today is still one of the most widespread methods of color identification and notation, Munsell's theories and principles on harmony are less known. Munsell dealt with the issue of color harmonies starting from a simple and easily verifiable principle: in order to be harmonic all color combinations must be well balanced. This means that the addition of the employed colors has to produce a middle-value gray (N5 according to Munsell's scale). He detected several harmonic and well-balanced color sequences, which he called "color paths," moving along or through his color solid. The paths, identified by Munsell, could move horizontally from one side of the solid to the other, thus detecting color sequences of the same lightness, or on an inclined level, thus detecting colors compensating in lightness; these paths could move from one color to its complementary one, passing through the achromatic lightness axis or not passing through the neutral scale. Among the series of harmonic colors detected by Munsell, besides those based on colors of opposite hue, there are those within the same hue and those among adjacent hues, in which harmony, as Chevreul had already enounced, is produced by proximity and not by contrast. At the root of his "color paths," there is the concept that every color combination can be harmonic and well-balanced if traced back to a color sequence intended as a gradation scale between one color and the other, in which some steps are cut off. The color harmony is therefore achieved through order that is implicit in the relations among colors.[18]

The attraction exercised by this systematic kind of approach is widely counterbalanced by the numerous criticisms regarding the excessive simplification of the problem. Arnheim, in underlining how Ostwald, as much as Munsell, recognized the influence played by the dimension in altering the relations among colors, raises doubt that the simple intervention of this single additional factor would make the above-mentioned harmony rules so complicated, they would become almost useless (and size is only one of the many factors that cannot be as easily controlled through quantitative measurement).[19] Sivik and Hård presenting their studies on a color combination model based on the NCS system for color description outline still more clearly the heart of the matter: "geometrical relations in a graphic model have, of course, no value per se. Of value, on the other hand, are those color-phenomena that the model and its geometry may possibly stand for—and this must also be critically tested."[20] Finally, if it is true, as Narciso Silvestrini underlines, that we cannot "force" the color into strict geometrical models, then we have to consider the color order models as an attempt to dominate more complex concepts through visual representation. In this sense they can inevitably offer and represent only a partial vision of reality and nonetheless provide a useful support to its comprehension.

> In the discussion of color harmony in the past there has been too much of a tendency to lay rules which must be followed. There are no rules; there are only possibilities.[21]
>
> —Arthur Pope

COLOR CONTRAST

Among the different authors who have investigated and systematized the relations among colors, the work of Johannes Itten (1888–1967) is well known. His work is founded on the concept of harmony as balance—symmetry of forces—and on the opposition or antagonism of the colors fading away in the gray, which he synthesized in the seven chromatic contrasts of his color theory (see Plate 9).[22]

In comparison to the idea that only those color combinations that share the same character and therefore can be juxtaposed without strong contrasts can be described as harmonic, Itten defines as harmonic those colors whose combination produces a neutral gray. He traces the "fundamental principle of harmony" back to the rule of complementary colors, referring to the simultaneous and successive contrasts investigated by Chevreul. Itten, who was both painter and teacher at the Bauhaus School in Weimar, strongly objected to Ostwald's theories, as well as his chromatic circle that placed green on the same level as red, yellow, and blue, among the primary colors, thus breaking the rules of pigment mixture.

Starting from his chromatic twelve-hue color circle where the complementary colors are placed on the opposite sides, Itten identifies the harmonic combinations in all the pairs of complementary colors and in those colors that can be combined by an equilateral or isosceles triangle, by a square, or by a rectangle; these schemes, once applied to Runge's sphere, allowed him to obtain endless combinations. At the root of Itten's theory is an explicit intent to move the concept of color harmony from the emotional level, subjectively influenced, to a level of strict objectivity.[23] Therefore, we see that if the gray combines with the balanced state demanded by our optical system—as it is demonstrated by the simultaneous and successive contrast phenomena in which the eye produces the complementary color to automatically restore the balance—Itten establishes that harmony happens every time the need of the eye's physiological balance is satisfied.

Wassily Kandinsky (1866–1944) sums up the chromatic action in four major inner contrasts or pairs of opposites. For Itten "we speak of contrast when distinct differences can be perceived between two compared effects"[24]—highlighting how our senses value always and only through comparisons. Kandinsky's contrasts are the contradictions of his time "antitheses and contradictions, these make up harmony."[25] Kandinsky introduces the concept that over time the considerations about color combinations regarded as harmonic and disharmonic can change and yesterday's dissonances might become today's consonances.

As fundamental as are the "spatial" specificities, for instance, both the dimension, in which a chromatic composition is concretized, and also the cultural and temporal "context," changing our evaluations on color combination, play a role in questioning the necessity of reasoning by rules that lead to *the good color combinations*. Indeed if we accept, as Michel Pastoureau underlines, that color is in the first place defined as a social phenomena and that it is the society that assigns to color its meanings and values,[26]

then also the color relationships and hence the related theories on harmonies feel the effect of the social and cultural conventions peculiar to each time.

THE DESIGN CONTEXT

The interest in studying color relationships relates to the practical implications involved. Color, in fact, is a fundamental design component not just in the fine arts, but also in several application sectors such as textiles, fashion, packaging, and interior design. As Gaetano Kanizsa observes, we never perceive pure chromatic qualities, since we always feel colors in relation to a particular perceptive structure; these are colors belonging to something, they appear to us as integrated with other phenomenal aspects of our visual world.[27] In other words, when a color combination is applied, it is necessarily subjected to the sense that the colors concur in expressing and it is only in coherence with the context that we can value its effectiveness. And it is just starting from these semantic implications, sensorial and emotional, implied in color relationships, that the more recent studies on color combinations move from. The work of Shigenobu Kobayashi, who organizes color combinations into categories motivated by the different moods to which they refer, can be mentioned as an example.[28] If, on one hand, these studies represent the umpteenth attempt of the impossibility to ascribe the relations among colors to a univocal theory, on the other hand, they attest the vitality that still characterizes this research field on color. As cultural contexts change, so do notions of order and harmony. Contemporary color literature continues to explore color relationships and the coexistence of a scientific approach along with intuitive ability that is still an integral part of both color theory and practice.

NOTES

1. Josef Albers, *Interaction of Color*, paperback ed. (New Haven, CT: Yale University Press, 1971), 5.
2. John Ruskin, *The Elements of Drawing* (London: Smith, Elder, and Co., 1857), 233–34.
3. Albers, *Interaction of Color*, 1.
4. Johannes Itten, *The Art of Color* (New York: Reinhold, 1961); original ed., *Kunst der Farbe* (Ravensburg: Otto Maier Verlag).
5. Johann Wolfgang von Goethe, *Goethe's Theory of Colors* (London: Murray, 1840); original ed., *Zur Farbenlehre* (Tübingen: J. G. Cotta, 1810).
6. Michel Eugène Chevreul, *The Principles of Harmony and Contrast of Colors and Their Application to the Arts* (London: Longman, Brown, Green, and Longmans, 1854); original ed., *De la loi du contraste simultané des couleurs et de l'assortiment des objets colorés* (Paris: Pitois-Levrault, 1839).
7. Philip Ball, *Bright Earth: Art and the Invention of Color* (Chicago: University of Chicago Press, 2001).

8. Michel Eugène Chevreul, *The Principles of Harmony and Contrast of Colors and Their Application to the Arts*, new ed. with an introduction and commentary by Faber Birren (West Chester, PA: Schiffer, 1987), 75.

9. Chevreul uses the word *tones* to designate the modifications of color, taken at its maximum intensity, due to the addition of white and black. With the word *scale*, he designates a collection of tones of the same color thus modified. Finally the word *hues* denotes the modifications that color assumes by the addition of a small quantity of another color. *Principles of Harmony*, 1987, 70.

10. *Principles of Harmony*, 1987, 81.

11. Philipp Otto Runge, *Die Farben-Kugel, oder Konstruktion des Verhältnisses aller Mischungen der Farben zu einander, und ihrer vollständigen Affinität, mit angehängtem Versuch einer Ableitung der Harmonie in den Zusammenstellungen der Farben* (Hamburg: Friedrich Perthes, 1810).

12. Rudolf Arnheim, *Art and Visual Perception* (Berkeley: University of California Press, 1954).

13. Wilhelm Ostwald, *The Color Primer*, ed. Faber Birren (New York: Van Nostrand Reinhold, 1969); original ed., *Die Farbenfibel* (Leipzig: Unesma, 1916).

14. Ewald Hering (1834–1918), physiologist, highlighting the difference among physical, chemical, and psychological colors, concludes that the fundamental colors are four, that is, yellow, red, blue, and green, since, along with white and black, these colors take part in the elementary visual experiences, not ascribable to any kind of mixture.

15. Ostwald, *The Color Primer*, 58.

16. Ostwald, *The Color Primer*, 65.

17. Albert Henry Munsell, *A Color Notation* (Boston: Ellis, 1905).

18. Albert Henry Munsell, *A Grammar of Color* (Mittineague: Strathmore Paper Co., 1921); new ed. edited by Faber Birren (New York: Van Nostrand Reinhold, 1969).

19. Arnheim, *Art and Visual Perception.*

20. Sivik, Lars, and Hård, Anders, *On Studying Color Combinations: Some Reflexions and Preliminary Experiments* (Färgrapport 22, Stockholm: Scandinavian Color Institute, 1989).

21. Arthur Pope, "Notes on the Problem of Color Harmony and the Geometry of Color Space. With Reference to Articles by Moon and Spencer," *Journal of the Optical Society of America*, 34/12 (December 1944): 759–65. See also P. Moon and D. E. Spencer, "Geometric Formulation of Classical Color Harmony," *Journal of the Optical Society of America*, 34/1 (1944): 46–59.

22. Itten, *The Art of Color.*

23. Johannes Itten, *The Elements of Color: A Treatise on the Color System of Johannes Itten Based on His Book* The Art of Color, ed. Faber Birren (New York: Van Nostrand Reinhold, 1970), 19.

24. Itten, *The Elements of Color*, 32.

25. Wassily Kandinsky, *The Art of Spiritual Harmony* (London: Constable, 1914), 86; original ed., *Über das Geistige in der Kunst* (Munich: R. Piper, 1912).

26. Michel Pastoureau, *Blue: The History of a Color* (Princeton, NJ: Princeton University Press, 2001); original ed., *Bleu. Histoire d'une couleur* (Paris: Editions du Seuil, 2000).

27. Gaetano Kanizsa, *Organization in Vision: Essays on Gestalt Perception* (New York: Praeger, 1979); original ed., *Grammatica del vedere* (Bologna: il Mulino, 1980), 211.

28. Shigenobu Kobayashi, *A Book of Colors* (Tokyo: Kodansha International, 1987); original ed., *Haishoku Imeiji Bukku* (Tokyo: Kodansha Ltd, 1984).

REFERENCES

Albers, J. (1963), *Interaction of Color*, New Haven, CT: Yale University Press.

Chevreul, M.E. (1987), *The Principles of Harmony and Contrast of Colors and Their Application to the Arts*, West Chester, PA: Schiffer; original ed. (1839), *De la loi du contraste simultané des couleurs et de l'assortiment des objets colorés*, Paris: Pitois-Levrault.

Itten, J. (1961), *The Art of Color*, New York: Reinhold; original ed., *Kunst der Farbe*, Ravensburg: Otto Maier Verlag.

Kandinsky, W. (1914), *The Art of Spiritual Harmony*, London: Constable; original ed. (1912), *Über das Geistige in der Kunst*, Munich: R. Piper.

Kobayashi, S. (1987), *A Book of Colors*, Tokyo: Kodansha International; original ed. (1984), *Haishoku Imeiji Bukku*, Tokyo: Kodansha Ltd.

Moon, P., and Spencer, D.E. (1944), "Geometric Formulation of Classical Color Harmony," *Journal of the Optical Society of America*, 34/1: 46–59.

Munsell, A.H. (1921), *A Grammar of Color*, Mittineague: Strathmore Paper Co.; new ed. edited by Faber Birren (1969), New York: Van Nostrand Reinhold.

Ostwald, W. (1969), *The Color Primer*, ed. Faber Birren, New York: Van Nostrand Reinhold; original ed. (1916), *Die Farbenfibel*, Leipzig: Unesma.

Pope, A. (1944), "Notes on the Problem of Color Harmony and the Geometry of Color Space. With Reference to Articles by Moon and Spencer," *Journal of the Optical Society of America*, 34/12: 759–65.

Sivik, L., and Hård, A. (1989), *On Studying Color Combinations: Some Reflexions and Preliminary Experiments*, Färgrapport 22, Stockholm: Scandinavian Color Institute.

Color: Organizational Strategies

Dennis M. Puhalla

Chapter Summary. The form and function of color are structural systems, providing a meaning associated with the order in which visual phenomena are seen and interpreted. Intrinsic color structures and color harmonies serve as a means to communicate visual order and information hierarchy. The intrinsic structure of color is hue, value, and chroma. Color function can be understood only within the context of overall structures. Controlling the visual relationships of hue, value, and chroma contrast can significantly assist a person's cognitive ability to assign importance and dominance to a controlled color structure.

A quantitative research study provides significant findings supporting the hypothesis that intrinsic color structures can be formulated objectively; represent a visual hierarchy; and be perceived in comprehensible order. The natural inferences of the study support the proposition that there is a natural relationship between objective color ordering principles and human comprehension. Color can be assembled according to objective rules or "codes."

Color has a logic as severe as form.

—Pierre Bonnard

Color is an intrinsic visual attribute of form. It serves as an activating stimulus that intensifies visual consciousness and responsiveness. "Since perception of color is the single most strongly emotional part of the visual process, it has great force and can be utilized to express and reinforce visual information to a great advantage" (Dondis 1973: 55).

Persons with a normally functioning visual system obtain a rather large amount of information about their surroundings from the visual sense and color plays a most important part in this sensory interpretation (Kuehni 1983). Structuring color for functional communication has been addressed in the literature related to information design, color theory, and color application. Authors Favre and November contend color substantially improves efficacy of the message transmission (Favre and November 1979). Opinionated judgments are made about the appropriateness of color contrast and perceived order within an image application, which makes concepts understandable. However,

little credible empirical evidence to support these assertions is cited. Tufte (2001: 154) affirms, "Color often generates graphical puzzles. Despite our experiences with the spectrum in science textbooks and rainbows, the mind's eye does not readily give a visual ordering to colors, except possibly for red to reflect higher levels than other colors." The literature is not scientifically based and is not intended to advocate a scientific argument. Hence, a need exists to present credible empirical evidence that the mind's eye does "readily give a visual ordering of color."

Certain social scientists believe that perceived color order and harmony may be related to a common, residual evolutionary human trait. In ancient times, people needed to receive clear and certain messages in order to survive (Byrne 1997). Uncertainty and ambiguity of received messages might result in instability, discomfort, even death. The ordering of information is as critical to understanding as the mere presence of information. Thus, uncertain or random color ordering communicates ambiguous messages evoking inaction, wrong action, or tardy action. Lakoff and Johnson (1999) contend that "Our preponderance of commonplace basic experiences—that include basic-level objects, basic spatial relations, basic colors, and basic actions—lead to a commonsense theory of meaning and truth, that the world really, objectively is as we experience it and conceptualize it to be" (509).

Defining an objective rationale for color ordering and establishing its hierarchical structuring of parts follows particular conventions found within color's attributes. Finding color combinations that communicate visual order accommodates meaningful information transmission. The application of objective color ordering is critical to making information understandable. The findings of this research could impact color selection options based on objective criteria rather than by "opinion" alone.

HYPOTHESES AND COLOR VARIABLES

If color is organized to function as a visual language the message will be clear. Color combinations can be formulated objectively leading to visual order of importance (hierarchy) and sequence. This is dependent upon controlling the visual relationships of the three attributes of color—hue, value, and chroma contrast. Controlling these three attributes can significantly assist our perception of importance and dominance within a prescribed color combination. While the viewer cognitively constructs perceived color dominance, the integral attributes of color are the contributing factors.

These three attributes of color are controllable variables that form a color language. By visually comparing the similarities and differences of these attributes, structured patterns of color organization can emerge. Of course the fundamental variables of size, shape, space, and position are additional factors that influence perception. In order to focus on color interaction alone, these additional variables need to be constrained.

It was hypothesized that the intrinsic attributes of color form specific categories that generate visual hierarchical structures. These hierarchical color structures within a category comprise inherent contrasting relationships. Therefore intrinsic color structures can establish a visual hierarchy. The primary focus of this research was to find empirical evidence that color combinations can be categorized according to variables defined by three attributes—hue, value, and chroma. Furthermore, the study sought to establish whether color categories could be manipulated in an order of importance that assists the cognitive ability to understand and comprehend specific systems of color contrast.

LIMITATIONS OF THE STUDY

It has been theorized by some design practitioners that people make judgments of importance primarily on the basis of relative value contrast and that chroma and hue are defined by the specific nature of those value relationships. This research study hypothesized that each color attribute intrinsically constituted a system of color contrast within itself, thereby producing a hierarchical order of color dominance. It was assumed that viewers would be able to discern hierarchical color structures. The focus here is on two main aspects: the differing emphases in the structure of the color combinations and the manner in which people perceive color order and hierarchy. The tacit implication of the experiment advances a proposition that color structure is a visual language mediating the interplay among the form, the message, and interpretation. In this study, message and interpretation are directly related to an organizational color structure that is concerned with the perceived and assigned importance of color within that system.

The intent was to investigate which derivative color combinations in hue, value, or chroma communicate visual order for the purpose of meaningful information transmission. The principles of color selection and organization are founded upon objective criteria originating from colors derived from conventional color harmonies. Derivatives were obtained from the context within each of the three attributes of color. The derivative color combinations can establish visual order of importance and contribute to the human ability to understand a message. Color can be assembled according to certain rules or "codes." Color communication elicits the intentions and purposes of the initiator. If users do not have a clear understanding of color codes, translation is more than likely invalid. Without intelligible visual recognition of color pattern in design application, interpretation and purpose are lost.

IMPORTANCE OF THE STUDY IN DESIGN RESEARCH

Generally, designers intuitively agree on the most pleasing color combinations, though established theories about the specific nature of color composition have no basis in

empirical research. In short, there are no rules. The importance of this study was to find guiding principles of fact. It was, therefore, necessary to statistically determine the predominant trend or tendency in viewers' perception of color organization. The documented findings of this study presented explicit evidence that addresses specific mechanisms for objective color ordering.

It is an observable fact that color plays an influential role in the interpretation of a message. One scientific study conducted by the Xerox Corporation and International Communications shows 90 percent (within a margin of error $\pm3.1\%$) of the people responding confirmed color increases memory retention (Xerox Corp. Research and the International Commission 2003). A second laboratory experiment studied the effects of color on a person's ability to extract information from different graphical tables (Hoadley 1990). Results from this study indicate color improves a person's time and accuracy in performance. This study also acknowledged that preliminary guidelines for the use of color have been established based on limited research. "These guidelines should be qualified since the empirical literature on the effects of color is troubled by poor research designs and is lacking in consistent and conclusive findings" (Hoadley 1990: 135). Neither of these studies makes a case for color selection methodology based on hierarchical color relationships. Both studies offer an argument for continued research on objective color ordering.

Effective color assembly strategies produce strong visual impact, improve legibility, and define product identity. Meaningful color communication should improve the efficiency and efficacy of the message. Simultaneously, color must function successfully on several levels. Color must serve as a primary structural element in print, digital, and product design. In this capacity, color must create appropriate spatial and navigational effects that are specific to operational tasks. The designer must identify ideal and normal sequences—what the user should see first; where the eye should move next; and how much time the viewer's attention should be held within each area.

It is a commonly accepted notion that it is best to keep color combinations to a minimum number of components. When a minimum of colors and shapes exists within the visual field, the brain is able to understand and to organize information. Multiple colors of too many unrestrained contrast constructions create *visual noise* making it impossible to focus and find anything. "The unconscious mind is astonishingly good at filtering out superfluous data and seizing on essential truth, but too much time or information can confuse and blind it" (Grossman 2005: 57).

In this study, the strategy for color selection, categorization is based upon the contrasting relationships of hue, value, and chroma exemplified in the Munsell Notation System (1979) of color organization. The color selection strategy employs a method that transcends the selection of conventional color categories. Conventional color categories (harmonies) are known to be primary, secondary, and tertiary triad schemes; as well as complementary, analogous, and monochromatic schemes. However, within these schemes or categories hierarchical structuring is not perfunctory. Therefore, hierarchical structuring within these schemes must be constructed. By evaluating and addressing

the ordinary relationships found within these color schemes in relationship to Munsell's hue, value, and chroma organizational structure, hierarchical color categorization may be realized.

Visual designers and researchers agree that color is a powerful nonverbal communication means of conveying messages with clarity. However, it appears that little is currently known regarding a formal and structured application of color ordering, sequence, and hierarchy. Objective color selection based upon derivatives of the conventional harmonies is not a strategy found in the literature related to color theory and application.

The inferences, implications, and analysis of this study, entitled "Intrinsic Color Structures," offers probable and credible empirical findings that need to be moved forward, exploring this fertile ground of color application and interpretation. Therefore, the mechanism for studying color hierarchy supports findings that can influence design research, design practice, and design education. "Colors trigger very specific responses in the central nervous system and the cerebral cortex. Once they affect the cerebral cortex, colors can activate thoughts, memories, and particular modes of perception" (Gobé 2001: 77).

THEORETICAL ORIENTATION OF THE INTRINSIC
COLOR STRUCTURES RESEARCH STUDY

Perception is the process by which we acquire information about the world around us using our five senses. Sight, sound, touch, smell, and taste are ways of representing and thinking about the world. Experiencing the world is dependent on a conceptual structure providing representational properties of experience. Reasoning connects the world we experience through structure. The rational structure of the mind reflects the rational structure of the world and of things-in-themselves. The human mind is an active originator of experience, rather than just a passive recipient of perception.

Color is a system of representation that relates to our cultural and psychological experiences. Hence, color has emotional and symbolic meanings. Color also functions as a visual communication system that strengthens conceptual awareness. Herein, reside two propositions: (1) color is subjective as it is associated with our psychological state-of-mind; and (2) color is objective as it has inherent hue, value, and chroma characteristics.

The objective of the research was to determine if patterned color categories derived from inherent color attributes could cause a consistent human reaction to perceived color dominance. An orderly visual hierarchy determined by hue, value, and chroma coding authenticates an objective color language independent of color naming, which may be anchored in subjective persuasion or cultural practices. Therefore, the meaning of color is represented through perceived dominance within one of the structured categories— hue, value, and chroma.

RESEARCH METHODOLOGY: INTRINSIC COLOR STRUCTURES EXPERIMENT RESEARCH STIMULI—COLOR SELECTION LOGIC

Color is the phenomenon that results from the interaction among a light source, an object, and an observer. It is generally agreed that the three attributes of color are defined conventionally. *Hue* is the family or generic name of color. It is a term used for colors contained within the visible spectrum (Plate 10).

Value is the relative lightness and darkness represented in a white to black scale. Colors modified by white or black are referred to as *tints* and *shades* derived from one full chroma hue. Additionally, the hues of the color wheel consist of a value structure from light to dark. The light to dark order follows the sequenced position of the hue in direct relationship to the color wheel. Yellow is the lightest in value followed by orange, red, green, blue, and violet the darkest value (Plate 10).

The *chroma* attribute is defined by a color's saturation point. Contrasting relationships in chroma are compared in terms of color fullness and color reduction, which correlates with the dimension of saturation. Specifically, the chroma of a color indicates the degree of departure from a fully saturated hue to gray or brown (Plate 10). Fully saturated colors, which have been modified by gray, are referred to as *tones*. Additionally, complementary colors generate desaturated colors. When mixed, complements yield chromatic grays or browns. Complements are colors opposite each other on a color wheel.

STIMULI—VALUE/CHROMA/HUE CATEGORIZATION

The principles of the Munsell Color Notation System provided the framework from which derivative color combinations were formulated and clearly defined. Color sensation unites three distinct qualities of the color attributes. One quality may be varied without disturbing the other. Munsell's Color Notation System established numerical nomenclature scales with visually uniform steps for each of the three color attributes.

The variables of color are its three attributes. Each of the attributes forms categories initiating a structure, which facilitates a control mechanism. Within the value contrast structure, hue and chroma were restrained. Similarly, within the chroma contrast structure, value and hue were restrained. Both structures displayed a visual color hierarchy. Contrast in hue alone was not enough to generate a visual hierarchy. Variable contrasting configurations within the hue structure achieved detectable color hierarchies. Since dominant colors were consistently perceived, this study produced credible empirical evidence to support the hypothesis.

The findings in this research rendered a rationale for the basis of understanding color selection processes. The conventional color harmonies form the foundation of color organization methodology. However, this methodology is insufficient unless the contrasting relationships of the color's attributes are taken into consideration. Specifically, a primary color harmony comprising red, yellow, and blue does not in itself establish a

visual hierarchy. By analyzing the hue, value, and chroma scheme of a primary harmony or any other fundamental harmony, color-coding and categorization are possible.

A discrete property and distinguishing characteristic of an informational organism is a hierarchical color system. Factually, we do not have definitive taxonomies for the attributes of informational color organisms or for the uses to which they may be put. Controlling the contrasting relationships among the attributes of color is a methodology that helps to define new taxonomies. The new taxonomies may in themselves define the ways in which they are used. By focusing attention on the intrinsic properties of the color attributes, objective criteria for color selection are imminent.

EXPERIMENTAL RESEARCH DESIGN: INTRINSIC COLOR STRUCTURES

To determine if color combinations could be identified and objectively qualified and quantified, an experimental research design strategy offered the strongest possibility for internal validity. The experimental design was organized to determine whether an objective selection of organized color would cause a consistent human response to visual importance. The experimental research implemented a precisely defined method that was central to cause–effect inferences. Within the Intrinsic Color Structures experimental research framework, the three independent variables (hue, value, and chroma) were tested. The study was designed to determine if specific color combinations structured within each of the three categories communicate a color hierarchy.

RESEARCH DESIGN INSTRUMENT OVERVIEW

The Intrinsic Color Structures experiment was divided into two sections. Section one consisted of the test for color deficiency and section two provided the means by which the color stimuli were presented. Participants were tested one person at a time.

Participants

Students at North Carolina State University were recruited to participate in a research study. Participants were a representative sample type that came from various majors within the Department of Communication and the Department of Sociology and Anthropology. Participating students had no formal course work in color theory or visual communication design. The age and gender participants varied.

Sample Size

The Intrinsic Color Structures experiment consisted of enough units in the population to achieve the desired probability to assess whether or not the specific color categories

caused a significant response to color dominance. Two potential participants were found to be color deficient in various portions of the visible spectrum and were excused from the experiment. The actual number of student participants totaled ninety-nine.

Setting and Equipment

The experiment was conducted at North Carolina State University, Usability Research Lab. The lab is specifically designed to conduct controlled experiments following the principles of user-centered design. The setting and equipment for the experimental research process provided a mechanism that focused on the user (participant) and task. Additionally, behavioral measurements of task effectiveness and task efficiency were actualized.

All participants in the Intrinsic Color Structures experiment were recorded on video-tape during the experiment. With equipment in the observation room, a video captured the participant's audio response, visual reaction to the stimuli, and time stamp. Simultaneously, the video capture records the screen of the color stimuli with a smaller split screen of the user's image.

Stimuli—Color Selection Logic

The stimuli for this study were based on the selection of color harmonies (color structures) that were intrinsically derived from objective logic based upon similarity and contrast of hue, value, and chroma. Therefore, the method of color selection was based on objective criteria rather than subjective appeal. The constructed relationships were derived from principles of the Munsell Color Notation System. The value contrast category comprised color variables that were constrained (no contrast) in chroma and hue. The chroma category comprised color variables that were constrained in value and hue. The hue category consisted of four contrasting relationships.

Stimuli—Value/Chroma/Hue Categorization

The Intrinsic Color Structures experiment included eighteen color combinations. The value color structures consisted of six hues that were derived from the primary (red, yellow, blue) and secondary (orange, green, violet) colors. Similarly, the chroma color structures consisted of six hues that were derived from the primary and secondary colors (Plate 11). The rationale for selecting the primary and secondary colors was based on their light to dark value dimension within the visible spectrum. The hue structure was formulated on variable value and chroma configurations of contrast (Plate 12). Following variable contrast configurations for each attribute, the number of possibilities for color organization was substantial. Consequently, it was necessary to limit the number of hue families to three (orange, green, blue). The eighteen color structures were derived from

objective criteria established by color positions that were intrinsic to the Munsell System. By restraining the hue, value, and chroma variables in this manner, the method of color selection placed significant limitations on the final color structure.

Stimuli Sequence Order

The sequence was arranged in value, followed by of hue and chroma. To constrain human preference for order and visual sequencing, two progressions of the stimuli were presented. Considering that human response to the stimuli might differ from starting point to ending point, the eighteen combinations were presented in a forward order for one group and in reverse order for the other group.

Variables Constrained

- A gray screen separated each of the eighteen sequenced color stimuli. The gray screen function allowed the eye to refresh before moving to the next color image.
- A white background was used to ensure that the foreground text colors and the background color provided sufficient contrast. Color contrast and the screen display luminance contrast affect readability. In addition, white would not influence the appearance of the text color, thereby minimizing the effect of simultaneous contrast.
- To avoid confusing meaningful text of various hierarchical levels of importance, the two lines of (dummy copy) are a Latin phrase in Frutiger—a sans serif typeface.
- The text was composed of two single-spaced lines that were approximately the same length. The two lines of text, identified as text blocks, remained constant throughout the eighteen color structures. Each screen contained three text blocks arranged in a staggered position on a white screen background. The staggered arrangement was utilized to minimize the effect of sequential order by position or placement.

Method of Data Collection and Instrumentation

Two types of data were collected in the experiment. Data generated by a participant's response to the stimuli were identified as task effectiveness. Data generated by a participant's time to complete the task were identified as task efficiency.

Data Analysis

The data analysis was computed for task effectiveness as ordinal scale measurements for task effectiveness. For task efficiency, minimum, maximum, mean, and median scores were computed. Additionally, for each of the eighteen color structures, chi-square

analysis was calculated for the ninety-nine participants. To analyze task effectiveness, three ANOVA calculations were made for value, hue, and chroma.

Ordinal Scale Tabulation Results Task Effectiveness

Data summaries were tabulated for task effectiveness. The task effectiveness (frequency) illustrates the number of respondents selecting a particular color in a grouping of three. Participants had the option of selecting "none," thereby acknowledging that no one color was more dominant than the others. In seventeen of the eighteen color structures, the recorded response for task effectiveness confirmed that a significantly high number of the ninety-nine participants agreed upon one color being more dominant than the remaining two in a frequency of choice.

A fairly high percentage of the respondents (forty of ninety-nine) concurred that no one color was dominant for the color structure in the hue "J" category. Frequency for this particular color structure represented an anomaly in relation to the other seventeen color structures. As the variables of value and chroma were equal and the hue contrasting, it was hypothesized that the participant response to this hue structure would be indiscriminate. Contrast of hue alone was not enough to determine a clearly dominant color. Respondents determined that no one color was dominate in this structure. No other color structure received this type of frequency distribution.

Task Efficiency Response

Task efficiency, time to complete the task, supports the predicted indecisive frequency response factor found for hue "J" structure. The time responses reinforce the frequency results in a sensible way. The maximum time to complete the task was 16 seconds with a mean score of 3.4. The task efficiency represented a slower response time and indecisiveness from participants.

Chi-Square Analysis for Task Effectiveness—Frequency

The chi-square analysis was used to measure the agreement between categorical data and the frequency of response. Chi-square analysis predicted the relative frequency of outcomes in each color category. The data analysis found that the probability calculated for the null hypothesis is less probable, thereby rejecting the null hypothesis and accepting the research hypothesis. The probability factor for each of the eighteen color structures was found to be less than 0.001 ($p < 0.001$). Since the p value is less than 0.001, the distribution of the data was found to be significant.

Analysis of the frequency data presents evidence that within controlled color structures, value and chroma contrasts play a prominent role in the participants' response to

selecting a dominant color. Within the hue category, the 8.515 chi-square value for the "J" color structure is represented by a *p* value less than 0.001.

ANOVA Analysis for Task Efficiency

Analysis of Variance (ANOVA) is a way to test the equality of three or more means at one time by using variances. To determine if the responses within each of the three groups were different, three ANOVAs were calculated: one for value; one for hue; one for chroma.

Inspection of the data from the ANOVA summary calculations for the value color structures demonstrates consistent variances for values C, D, and E. The time variances for values B, A, and F increase significantly. Given that the value structures were presented in the first linear sequence for one-half of the participants and last in the linear sequence for the remaining half of the participants, human fatigue would not appear to be a factor.

FINDINGS

Hue, value, and chroma categories generated significant probability results. Contrast within the value structure and within the chroma structure was dependent upon constraining the two remaining variable attributes. Within the hue contrast categorization, at least one additional contrast variable was required.

The data summaries specified a strong acknowledgment for chroma (saturation) contrast. Participants selected the most saturated color within each of the six structures. Four of the six chroma structures received a 98 percent of the population agreement to the dominant color. However, the ANOVA time variance analysis within the chroma category shows significant differences in response time. It is not certain what contributed to the time variance within the chroma category. One might speculate the time variances within the chroma category are related to particular hues. As described earlier, the chroma combinations comprised six different hue families. In these combinations hue and value remained constant while chroma (saturation) was contrasted. This appears to suggest that some hue families are not as convincing and decisive as others.

The value structures charted a fluctuating frequency response rate from the population. Among the value structures, participants selected the darkest contrasting color. In one of the value structures, 100 percent of the population agreed upon a dominant color. At the other end of the scale, one value structure demonstrated a frequency response at 87 percent. This same structure revealed a task efficiency level at a greater number of seconds to respond to the stimulus. Within the value category, ANOVA time variances specify a relatively similar response time to determine the dominant color stimulus.

The contrast of hue category consisted of four contrasting variable structures. Given the composition of the four contrasting categories, participant response to stimuli

demonstrated a pattern that recognized contrast in all three variables (hue, value, and chroma). One of the six hue structures followed the methodology of color composition as defined for value and chroma. Specifically, this structure was composed of contrast in hue with no contrast in value and saturation. It was hypothesized that the frequency response to this structure would be erratic and inconsistent. Chi-square analysis confirmed this finding to be significant. Contrast of hue alone was not enough to discern a clearly dominant color. Demonstrating indecisiveness among the population, the timed reaction to this color stimulus reinforced the frequency response factors. While this color structure does not demonstrate a hierarchical order, it does advance the proposition that the colors are perceived to be similar in importance.

The remaining five hue summaries were similar in percentage range to value. One hue structure received 98 percent of the population in agreement on the dominant color. The composition of the hue structure consisted of contrast with all three variables. In addition to contrast in hue, the three colors contrasted in light/dark value and in low to high saturation. When two colors were similar in value and chroma contrast and the third darker and more saturated, a significant percentage agreed upon the dominant color.

INFERENCES

The natural inferences of the study support the proposition that there is a natural relationship between objective color ordering principles and human perception. The consequences of the study could have an extraordinary effect on color selection, application, interpretation, and teaching.

Understanding color recognition, related to perceived order and importance, could have useful applications to a naturalistic, real-world display of visual information systems based upon objective color selection strategy. Color adds significance to visual communication as it accentuates and makes perceptible the identification of that which is perceived first, as the main idea, before decoding additional elements in the message. Perceived hierarchy represents a sequence of visual commands in the language of color. Therefore, color adds functionality and definitive relationships to many informational entities. Effective color communication permits users to view, retrieve, access, decipher, interpret, understand, and experience a variety of information systems in a meaningful, valid, and authentic manner.

This research provided a rationale for the basis of understanding color selection processes. Color structures contain patterns of visual harmony. Color harmonies are traditionally defined as having an internal orderly structure composed of a dynamic equilibrium between homogeneous and heterogeneous parts. Since the value and chroma structures stay within the same hue family, they may be classified as a monochromatic harmony. In the value structure, the homogenous part is the hue family and the heterogeneous parts are the contrasting value and/or chroma. Innumerable color configurations can be formulated by nine conventional color harmonies.

A matrix of nine conventional harmonies is represented in Plate 13. The monochromatic harmonies of value and chroma yield two levels of contrast hierarchy. Since the remaining conventional harmonies consist of hue contrast, three levels of hierarchical contrast are constituted. Under certain conditions, colors may appear to reside in the same visual space.

Three color organization patterns form hierarchical contrast patterns. Value and chroma structures generate two contrast levels. At the first derivative level, value is the contrasting attribute; hue and chroma can remain equal. At the second derivative level, value and chroma are the contrasting attributes and hue must remain the same. The value and chroma structures imply that the following visual characteristics occur: *level 1*—two colors reside in the same hierarchical visual space, and *level 2*—three colors reside in three different levels of visual hierarchical space.

The hue structure yields four levels of contrast. Within the hue structure, visual differentiation shifts. As the research study demonstrates, contrast in hue alone does not create a visual hierarchy. At least two attributes must be contrasting to establish a hierarchy in the hue structure.

FURTHER STUDIES

As this study yielded favorable findings, further research is necessary. Additional factors need to be identified for further testing. For design in particular, the gaps in color research are apparent. Among the scientific community of scholars, an enormous amount of empirical evidence in color research can be found in the social and cognitive sciences. Research in human factors, ergonomics, sustainability, and marketing has provided design-worthy findings. However, research in visual communication design has rarely followed a scientific methodology.

CONCLUSION

Relating color principles to communication and language links theory to practice. The natural/intrinsic ordering of color within the categories of hue, value, and chroma provides a guiding principle of fact for the purpose of useful color selection methodology. These principles of fact are rooted in common relationships of color's intrinsic structure.

REFERENCES

Byrne, A., and Hilbert, D. R. (1997), *Readings on Color*, Cambridge, MA: MIT Press.
Dondis, D. A. (1973), *A Primer of Visual Literacy*, Cambridge, MA: MIT Press.
Favre, J. P., and November, A. (1979), *Color and Communication*, Zurich: ABC Zurich.

Gobé, M. (2001), *Emotional Branding: The New Paradigm for Connecting Brands to People*, New York: Allworth Press.

Grossman, L. (2005), "Jumping to Conclusions," *Time*, 165: 57.

Hoadley, E. D. (1990), "Investing the Effects of Color," *Communications of the ACM*, 33/2: 120–39.

Kuehni, R. G. (1983), *Color, Essence and Logic*, New York: Van Nostrand Reinhold.

Lakoff, G., and Johnson, M. (1999), *Philosophy in the Flesh: The Embodied Mind and Its Challenge to Western Thought*, New York: Basic Books.

Munsell, A. H., and Munsell, A.E.O. (1979), *A Color Notation*, Baltimore: Munsell Color Co.

Tufte, E. R. (2001), *The Visual Display of Quantitative Information*, Cheshire, CT: Graphics Press.

Xerox Corp. Research and the International Commission (2003), "Small Businesses Work Better with Color."

Credits

Puhalla, D. (2005), "Color as Cognitive Artifact: A Means of Communication. Language and Message," PhD diss., North Carolina State University.

Puhalla, D. (2008), "Perceiving Hierarchy through Intrinsic Color Structure," *Visual Communication Journal*, 7/2: 199–228, London: Sage.

PART II

COLOR IN CONTEXT, CULTURE, AND TRADITIONS

This part contains chapters that examine the design element of color with interactions of ideas, dreams, place, and culture. Some questions addressed include: How do colors promote professional objectives, signify social status, and lifestyle choices based upon context? How is color used in different situations to appeal to and communicate with people? How are cultural issues made visible through the symbolic use of color?

SPECIFIC COLORS AND MEANING

Specific colors may have a variety of meanings and the study of color may be approached by focusing on the color itself. Historical examples of space and contemporary case studies are used to explore the sustainability of the color white in Connellan's chapter "The Social Politics of White in Design." The modernist project is presented as using white to entrench an order in architecture and design. White is shown to have varying types of silence, which can be both uplifting and oppressive within the modernist framework. These ambiguities of white are then discussed under the theme of language and the attempts of stabilizing white meanings through cultural coding. White is then discussed in conjunction with light: white light from a Newtonian viewpoint; lighting and how it operates as an agent of power; the dominance of light over dark; shadows; cleanliness; and normative patterning. Finally the materiality of white is emphasized through a discussion of its substance, the dangers of white lead, and the durability of white as a color of choice.

Green is another color that may be understood by focusing on the color itself, but with entirely different connotations based upon context: to signal sustainability, or be used for cultural recognition. In the context of sustainability and going green, the shift from "Consumer to Citizen" moves the consumer from conspicuous consumption to consuming with resource awareness and responsibility. This movement involves the designer as well and students in design explore how colors are associated with sustainability in "What Color Is Sustainability" by DeLong and Goncu-Berk. This complex concept is illuminated in a redesign activity involving brainstorming that expanded the potential of color to be used for branding the concept of sustainability. Green is then discussed

broadly in terms of Irish tradition and cultural recognition. In the chapter, "Color and Cultural Identity in Ireland," Wulff explores the meaning of the color green in Irish culture, what it symbolizes for the Irish and for foreign tourists. Wulff uses methods of participant observation, interview, and archival work to explore the politics of the color green in Ireland as cultural identity constructed in relation to firstly, folklore and dress, and secondly, tourist design. Identity has several sides: an inner side cultivated among people who share an identity; an outer side, which is how a group presents itself to outsiders; and a third side constructed by outsiders to promote a certain Irish charm, such as in the example of "Lucky Charms," a U.S. brand of cereal. Even though there are overlaps in the uses of color, these sides of cultural identity are somewhat different.

COLOR FOR INFORMATION, RECOGNITION, AND FUNCTION

Color coding is used in a variety of contexts. Color may be recognized as an aspect of locale in country towns or governmental offices. We find our way in complex buildings such as hospitals or parking ramps via information systems that include color cues, but what about being rescued from a fire?

Barker, Boorady, and Ashdown, in "Signaling Protection: The Use and Function of Color in Firefighter Clothing," explore how color can be a signal for protection or something to fear in firefighter gear. In focus groups of firefighters in fourteen fire departments, these researchers explored the colors used in current turnout gear and the relation of the popularity of tan and black to the profile and traditional image of the men and women who become firefighters. We learn that traditionally and functionally the surface color used for the uniform has been middle-value beige or tan to help counteract heat absorption and reflect light. Criteria for color selection of their gear includes consideration of the firefighters wishes, as well as reactions of those who are rescued.

Kisacky examines color choices for hospital operating rooms in "Blood Red, Soothing Green, and Pure White." She explores the historical background of colors of white and green used for surgery spaces and garb worn by surgical staff. Highlighted is the use of color as both a cultural element and an aid to efficient functioning within the hospital.

COLOR AND CULTURAL MEANING

Colors have different meanings and aesthetic appeal and should be considered for their associations within a culture or subculture. A color may be used differently in one culture than in another. In South Korea the traditional colors favored throughout their history, used on clothing and the ceilings of architecture, are evolving into new uses; for example, for cultural identity to the rest of the world. In Geum and Jung's "Color Continuity and Change in Korean Culture," traditional and contemporary color applications are explored in terms of cultural contexts of architecture, costumes, crafts, and painting, as

a medium to express visual beauty, political principle, and marketing strategies. Characteristics and symbolism of color in traditional and modern Korean society are compared and interpreted. For example, red has evolved from use in the stripes on the sleeves of traditional dress, to a signifier of communism in the early twentieth century, to being used recently for a red T-shirt worn ubiquitously throughout Korea to cheer on the Korean team for the World Cup.

Color may communicate symbolic meaning at many levels: social, cultural, and national. In "Exploring the Colors of Turkish Culture," Goncu-Berk describes how color is used for national branding. Color origins arise from the blending of diverse elements within the culture, and turquoise, red, and white are colors significant within the contexts of history, culture, and the geography of Turkey.

Finally, the communication of color within a subcultural group of punks living in large cities in the United States is noted by Sklar and Michel in "The Punk Palette: Subversion through Color." Professional men and women who self-identify as punk are interviewed about their dress and how color plays a prominent role in their selections: the use of contrasts of black, silver, and neon are described and explained in terms of their iconic meanings.

The Social Politics of White in Design

Kathleen Connellan

Chapter Summary. This chapter focuses on white in designed environments; the order of neo-modern flatness and the freedom of light-filled white spaces. Power, color, and race are intertwined into a theoretical reading of historical and contemporary examples. While the examples are located in particular places, the intention is to question global understandings of white, design, and social boundaries. Richard Dyer and Mark Wigley's writing on white as code for privilege and purity is combined with Michel Foucault's work on normativity and power relations. Central to this chapter is the notion of white dominance in design and the built environment.

I examine the color white within social and cultural domains. In saying this I try to avoid the polemical approach and the creation of an adversarial situation that might set white up as "the root of error."[1] Therefore, following Foucault: rather than taking politics to the issue, I will take the issue (white) to politics. In doing this white needs to be posed in as many of its forms as possible. "It is problematization that responds to these difficulties . . . it develops the conditions in which possible responses can be given; it defines the elements that will constitute what the different solutions attempt to respond to" (Foucault 2000: 118).

Consequently this chapter is as much about color as it is about the powers of representation. In presenting the varying forms and guises of white, this chapter will ask what it does, what it says, and how this comes to be. There are three main sections: the modernist project; light; and materials.

THE MODERNIST PROJECT

Modernism is known in the history and theory of design as a grand narrative. Its grandness was powered by whiteness. That whiteness remained unsaid at the time and, this is still the case in contemporary postmodern societies.

Modern architecture was never simply white. The image of the white walls is a very particular fantasy. It is the mark of a certain desire, the seemingly innocuous calling card of an unspoken obsession. Although the image [of white] is extremely powerful, it is also extremely

fragile. It is vulnerable and yet is carefully protected by multiple institutional practices. (Wigley 2001: xv)

There are two related issues here: firstly there is the problem of the white wall as indicative of *Western* modernism, particularly the International Style of architecture. Secondly there is the problem of whiteness as an image of institutionalized *power relations*. The issue of the West is not going away, not yet anyway, and it brings whiteness with it. It's a "Western problem" David Batchelor points out when writing about white minimalism (2007: 13). And Wigley argues that one of the many deceits of modernist whiteness is that the walls and surfaces of Western modernism were painted to seem as if they were intrinsically white. In this instance, white as a color becomes a code for power but, most important, this code is made to seem so ubiquitous that it is no longer visible in and of itself. Consequently the carefully constructed "invisibility" of white becomes enmeshed in the institutionalization of the Western modernist project. To put it another way: because white could operate incognito, it became particularly useful in the building and branding of Western modernism into a veritable power base.

The classical roots of modernism are well documented as are the misconceptions that Ancient Greek temples were white. The modernist utopian ideal of order was the realization of a long-term project which, while rooted in Classicism, was reiterated in the Renaissance and again reinforced in Neo-Classicism with its far-reaching Enlightenment theories (Zaknic 1990).[2] Whiteness can be added to what Foucault calls the "scientific order" of the Western "*episteme*" (1994: 54). This epistemology of order and control is closely connected with hierarchies of race, a subject that is not often addressed in design theory or practice (Lokko 2000: 15).[3]

If the color white is so prevalent in design that it is no longer noticed then it becomes philosophically invisible and it is through this invisibility that it gains its strength to spread.[4] Invisibility's twin mechanism of power in this scenario of white surfaces is silence. It is easier and swifter for something (e.g., whiteness) to proliferate if it is done quietly and without consultation. In referring to modernism and Le Corbusier's writing, Wigley notes that architecture gained "a rhetorical seal of legitimation that insulated certain practices from further scrutiny. Of those practices it was the white wall that was able to proceed with the least questioning" (Wigley 2001: 302). The hushing up of the white wall among architects in modernism created a climate for more covering up. But there is a difference between the silence *about* white and the nuanced silences *of* white and whiteness.

Silence

Silence is not only silencing. It can be charged with poetic understatement; several tonalities of white can emit whispers and aestheticize harshness (Connellan 2012). Anne Varichon notes the manner in which Wassily Kandinsky relates to the positive silence of

white as a color filled with possibilities. She says, that for Kandinsky, "white silence is not dead . . . white is the oblivion before the beginning, before birth" (Varichon 2006: 15). In *Concerning the Spiritual in Art* Kandinsky writes about the problems of breaking through silence and how white can assist in the process: "A great silence, like an impenetrable wall, shrouds its life from our understanding. White therefore has this harmony of silence which works upon us" (Kandinsky 1977: 46). Expanses of whitened surfaces can cast a veil of silence upon a space and aestheticize harshness. This is still common curatorial and design practice in galleries and museums; white is a color that can blur into other whites allowing the, at times, disturbing exhibits to hover in a mist of whiteness (O'Doherty 1999).

Susan Sontag notes that "silence is the furthest extension of that reluctance to communicate" (2002: 6). While Sontag is referring to modernist art, silence in all communication *contains* meaning in its very attempt to withhold it. Michalinos Zembylas describes the religious, philosophical, and pedagogical praxes of silence. He notes the ostensible (Western) binaries between silence and speech and emphasizes the Buddhist understanding that "speaking is silence and silence is speaking" (Zembylas and Michaelides 2004: 199).[5] In this way there can be an ontology of silence "the silence of being or life itself" (Zembylas and Michaelides 2004: 199). Whiteness has the ability to offer up a space for peaceful meditative silence. However an expanse of pure, dense white on flat surfaces across large spaces with little interruption can also instill anxiety. In this way the silence of opaque white provides an emptiness for sounds to be detected as opposed to a void within which sounds are received. See Figures 5.1 and 5.2.

Batchelor describes his experience of the vast white interior of an art collector's house, on the occasion of his invitation to a dinner party. He recounted his passage through the kitchen, living room, and all entertainment areas that were seamlessly connected and almost indistinguishable from each other. Most objects of utility were hidden in cabinets that were so smoothly aligned with other surfaces, that they too were hidden.

> This was assertive silence, emphatic blankness, the kind of ostentatious emptiness that only the very wealthy or the utterly sophisticated can afford. It was a strategic emptiness, but it was also *accusatory*. (Batchelor 2007: 10)

In this instance the white spaces provide a silence that amplifies the sounds that interrupt it. The sound of one's steps on the white marble floor, the echo of speech that, upon hitting the surface, sounds brittle. The sense that what one has said is not sufficiently scripted to stand up to the silence. Therefore there are designs that because of their pervasive and engulfing white flatness, prescribe silence. The body is reduced to silence. This silencing quality is what Batchelor calls the "tyranny" of white (2007: 10).

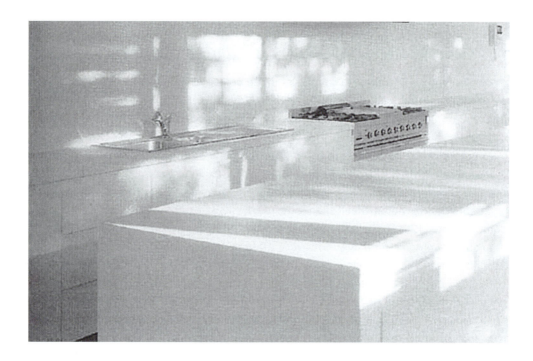

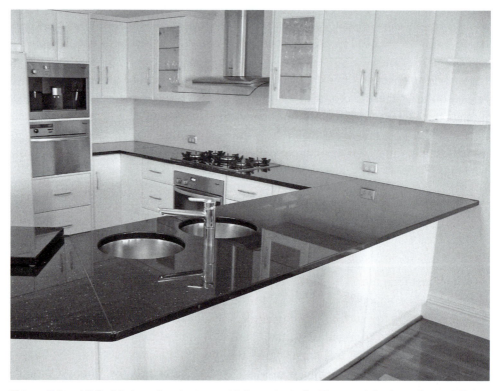

Figures 5.1 and 5.2 Interiors of contemporary kitchens, Australia. Photograph by the author and Sharee Kuchel, 2010.

Language

How whiteness is spoken or unspoken is part of the power of language, but language (and visual language with it) is one of the most dominant of all mechanisms of power. Foucault calls for a revival of "noise" in language: "of rendering once more noisy and audible the element of silence that all discourse carries with it as it is spoken" (Foucault 1994: 298). The silence and silencing qualities of white are framed in language but the visuality of white is fraught with contradictions and ambiguities. Because of white's simultaneous being and not being, it can only ever be truly stable in a language that controls its meaning. Richard Dyer writes that white as a symbol only "remains firmly in place at the level of language" (2001: 60). Dyer is referring to a metalanguage, that is, the language of defining *and* describing. White cannot be stable in visual language alone because it escapes from the confines of its denotations into the freedom of the connotative visual space. This connotative space opens up endless visual metaphors and signs. Therefore it is the careful combination of linguistic and visual signifiers that help to situate the meaning of white in society and design.

White color performs its meaning through visual language and more specifically through the visual language of design. White performs its identity through the context and brief of the design. For example: The white of the British Museum creates an aura

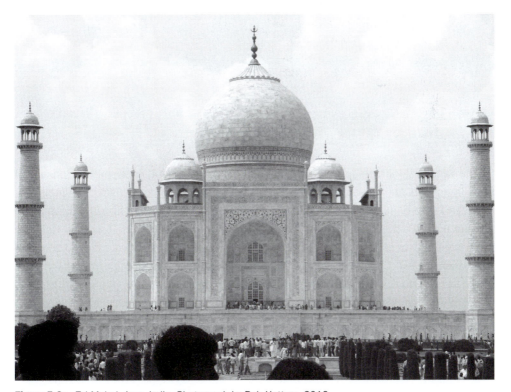

Figure 5.3: Taj Mahal, Agra, India. Photograph by Rob Hattam, 2010.

of space, a contrast for exhibits (when are not themselves white), and a gallery for surveying and surveillance. And white in the Taj Mahal rises as a singular, unchanging entity above the Indian city brimming with color and movement. See Figure 5.3.

Language in all of its forms is a codified means of social communication and therefore colors are coded culturally at an ordinary "everyday" level, which is where most of the transference of meaning takes place, even unconsciously (De Certeau 1984: 136–37 and Connellan 2010). According to Foucault this is how power operates, the relations of power have "polymorphous techniques of subjugation," which work on the outer limits like a "capillary" (2004: 27). As such, culturally coded colors become so common in a given context that they are taken for granted and not contested. (This point is enlarged upon later under the theme of normalization.) Therefore on this level white is a code for different things in different cultures with some commonalities such as the white flag of surrender. It is useful to list a few of these ways in which white is culturally and symbolically coded as a means of illustrating how signs are coopted by various agencies and instill themselves over time into cultural fabrics. See Figure 5.4.

White = Creation
 = Divinity/Celestial Power
 = Purity/Clean
 = Virginal
 = Sterility
 = Unity (Islam)
 = Birth and Rebirth (Milk and Sperm)
 = Wisdom (age)
 = Lies/Cover-up
 = Sickness
 = Death and Mourning
 = Peace/Surrender (Feisner 2006: 120–21)

The various books on color techniques, color meanings, and anecdotal histories that have been published over time as manuals and references for artists and designers have tended to endorse the symbolic codes of the color white listed above without much critique (Birren 1963). John Gage notes that "color, in spite of a widespread belief in the universality of certain color ideas, is like all formal characteristics, ideologically neutral" (Gage 1990: 518). But white is not just a formal characteristic, white cannot be divorced from its context because it so often is its own context. In this sense white is charged with ideology and meaning and cannot be neutral. Gage is using the language of art theory but what still needs to be done more effectively is for philosophy, aesthetics, color theory, and design to share each other's languages.

For example Foucault noted the long separation of language from its objects of representation, which eventually attempted a reunification "into the field of thought" in the late nineteenth century (1994: 286).[6] But this "returned" language became a differently

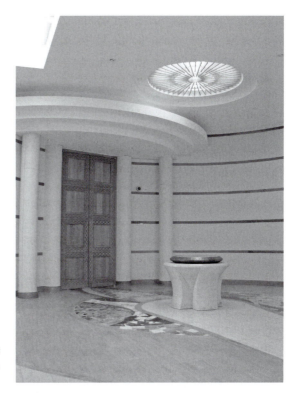

Figure 5.4 Interior of St John's Catholic
Church, with baptismal font, Cavehill Belfast.
Photograph by the author, 2007.

empowered entity in Western twentieth-century discourse. According to Foucault, language in the twentieth century used its renewed criticality to celebrate autonomy of form *and* discursiveness in meaning. Following Foucault's position on language and representation, therefore, white is both the object and the representation of the object. White is both form and meaning; it is within these *still* unresolved divisions between modernism and postmodernism that the potency of white is felt most keenly; white is both inside and outside of language. White can therefore be used both for and against itself by the agents of power in design, architecture, and visual communication.

LIGHT

White Light

The active or dynamic quality of white is light; and light as *lux* was regarded as divine in medieval times. When *lux* is combined with *lumen* (perceived light) it links divinity with science (Lokko 2000: 29).[7] The Newtonian interpretation of color is that it is all light. When white light passes through the prism, it is refracted into the seven spectral or radial colors: red, orange, yellow, green, blue, indigo, violet. Newton demonstrated that these

hues then come together again into white light. In this way Newtonian color theory gives precedence to white light (Gage 1993: 153–76). And places it in opposition to black:

> white = white light
> black = the absence of light

This privileging of white as a white light from which all other hues emanate lasted in various uptakes of color theory throughout the nineteenth and twentieth centuries. Richard Dyer notes how Newtonian understandings of white as containing all other hues became entrenched into school syllabi thus teaching generations of Western children that white was supreme (2001: 47). However, Dyer notes the important contradiction of white as both a color and a noncolor, because if it is a hue and therefore constituent of light, it is not a color at all (2001: 47). The pedagogically entrenched supremacy firstly of white as white light, and secondly that light is superior to pigment/material constitutes the "Cartesian moment"[8] of color theory (Foucault 2005: 14). René Descartes, the sixteenth-century French philosopher, is responsible for the mind-body split that continues to haunt critical theory.[9] In problematizing white light and white, the Cartesian division can be described as follows:

> white light = science/mathematics/intellect/thought
> white pigment = art/materials/body/emotions

Descartes's Renaissance *cogito ergo sum* (I think therefore I am) is reenacted in the Enlightenment, the period of Newton's experiments. The preeminence of intellectual thought aligned well with Newton's theory of light, which in turn fitted neatly into the logic of the Enlightenment, an age that celebrated reason, naming, and structured separation.

Within this climate of categorization, white slipped across the boundaries of art and science with its ambivalent nature. White is both light and color, air and substance. Therefore once again, the inability of white to be pinned down to a category does not rest as an instability but on the contrary this freedom of ostensible identity grants it a specific potency.

Lighting and Its Agents

It is instinctual to look toward a light in darkness; the eye is naturally drawn to light. This is a psychophysiological fact, which fascinated Johannes Itten in his color classes at the Bauhaus, where he dealt with some of the formal characteristics of color and the light/dark experience (Itten 1973: 153). But as mentioned earlier, the formal attributes of light and white only tell part of the story. The control of light affects not only the visibility but also the racial identification of people in lit spaces. Dyer explains the role of light in the reception and delivery of racial signifiers:

People who are not white can and are lit to be individualised, arranged hierarchically and kept separate from their environment. But this is only to indicate the triumph of white culture and its readiness to allow some people in, some non-white people to be in this sense white. Yet not only is there still a high degree of control over who gets let in, . . . the technology and culture of light is so constructed as to be both fundamental to the construction of the human image and yet felt to be uniquely appropriate to those who are white. (Dyer 2001: 200)

Dyer develops a strong argument for "a culture of light" that controls those within its lenses. Dyer's examples are drawn from photography and cinematography and as such he writes of this power of light as being external. The Foucauldian position is that power, and consequently light, is not external but internal. In adopting this position, the same can be applied to light as an agent of power. Dyer's crucial positioning of white as an unacknowledged racial signifier and one that is consequently rendered invisible can therefore be extended with the addition of a Foucauldian angle. For example, Foucault notes that "visibility is a trap" (1995: 200). In this sense *designed* visibility captures that which would not otherwise be obvious. Lighting, therefore, is not just to make the space easier and safer to navigate because it is not dark, it also ensures that nothing is missed by an omniscient and panoptic gaze. This gaze is not merely surveillance cameras but also, our own internal anxieties that click into place in a brightly lit space.

And in order to be exercised, this power had to be given the instrument of permanent, exhaustive, omnipresent surveillance, capable of making all visible, as long as it could itself remain invisible. (Foucault 1995: 214)

The subject becomes a spectacle in the whiteness of harsh electric light that provides false realities in the name of modernity. Electricity and its concomitant associations with power/energy (Connellan and Moss 2004) control the visibility of those within its ambit. The self-styled critic of technology and modernity, Paul Virillio said in an interview that "electricity . . . kills the night" emphasizing the way in which vision is modified by artificiality (1995: 81–82).

The image of the typical international airport shows how it is brightly lit to allow for maximum surveillance. In addition to the overall brightness, closed circuit cameras capture all movement below them. In this sense the bright white airport is a contemporary panopticon. Pervasive neon lighting replaces the need for structural walls and divisions previously used to control, channel, and observe people. In this way the invisible wall is the light itself, thus exchanging form for space. This lit space gives the artificial impression of openness and freedom but it is, in the example of the airport, quite the opposite. The artifice is so carefully designed to coincide with neo-modernist interiors that the brightness is an accustomed space and people may not necessarily find it strange. Consequently there is more likelihood for people to behave as if in a shopping center, an apartment block foyer, or a corporate office space.

The extensive use of glass alongside white surfaces, such as floors, ceilings, and furnishings, creates reflections upon reflections that literally add to the ambiguity of

the white spaces. Glass is ostensibly used to let in natural light but it is also an ally of whiteness. Jonathan Westphal attempts to explain the tension between light, reflections, transparency, and surface white. He explains that "it is visible whiteness which is necessarily untransparent" but in a world of sensation (in referring to film) "there is no whiteness, only achromatic brilliance" (Westphal 1987: 34). And it is this glossiness of combined glass and white that brings the interiors of office foyers and apartments into a spotlight akin to shiny televisual images.

Dominance

In the early 1970s Jacques Derrida wrote an essay entitled "White Mythology," which according to Charles Riley is adopted from a dialogue by the nineteenth-century writer Anatole France. France lamented the departure "of metaphysics into abstraction . . . and the loss of color to the dimness of white" (Riley 1995: 64). Riley comments that the essay deals with the danger of rhetoric and "established the role of white in Derrida's writing as a metaphorical reference point against which other colors play" (1995: 64). Derrida says that the dimness of color produces a "white mythology" which "assembles and reflects Western culture" and is "inscribed in white ink" (1974: 11).

In his *The Truth of Painting* Derrida attacks the inherent orders of color. Here Derrida is particularly ruthless with the hegemony of design and ultimately the dominant role of line in the organization of color. He criticizes the frames of paintings and calls for a retreat from color in the framed border of art (Derrida 1987: 64). Derrida's assault upon color does not appear to indict white with the same judgment; rather his views in *The Truth of Painting* unseat the primacy of color above noncolor. As a result, noncolor (which could be white) does not succeed in providing the Derridean space of "between" but rather it (white) becomes a determinant of the other, which is color.

Despite Derrida's attempt to dismantle binaries in theory, in practice they are still ubiquitous. Stuart Hall summarizes and emphasizes this difficulty by his distinction of bold/unbold, dominant/less dominant binaries:

> One pole of the binary [Derrida] argues, is usually the dominant one, the one which includes the other within the field of operations. . . . We should really write **white**/black, **men**/women, **masculine**/feminine, **upper class**/lower class, **British**/alien to capture this power dimension in discourse. (Hall 1997: 235)

Another way of writing the **white**/black binary is dark/**light** because in the case of lighting, light is used to overcome the strength of the dark. Goethe picked up on this when contesting Newtonian theory, "The history of authority fascinated Goethe. He saw the history of science in general and of color theory in particular, as the establishment of authority" (Jackson 1994: 682).[10] He concentrated upon the activity of light upon a dark surface and noted the way in which the light had to be immensely strong to counteract the enveloping force of darkness.[11] Goethe strove to remove color from the confines

of Newtonian physics or "optiks," seeking to arrive at an understanding of the physicality of color. As such there is a phenomenological core to Goethe's theory of colors, which addresses more intuitive analyses of color and therefore reflects the other side of the Cartesian divide discussed earlier (Riley 1995: 22).

To illustrate this from Goethe's point of view, the diagrams (Figure 5.5) show how a white shape surrounded by a black boundary throws the light into sharp contrast and, conversely the black shape against a white boundary shows the strength of the black shape (Feisner 2006: 43–45).[12] Using these and other similar diagrams of black and white, it is the white or the light that struggles to maintain its presence.[13] See Figures 5.6, 5.7, and 5.8.

> [L]ight—the famous dazzling effect of power—is not something that petrifies, solidifies, and immobilizes the entire social body, and thus keeps it in order; it is in fact a divisive light that illuminates one side of the social body but leaves the other side in shadow or casts it into darkness. (Foucault 2004: 70)

Shadows

Goethe believed that light was not only outside of oneself but also within: "a dominant light resides in the eye." Goethe gave precedence to colors that emerged from shadow

Figure 5.5 Black rectangle and white rectangle. Diagrams drawn up by the author.

Figure 5.6 Corporate office space (foyer and exterior), Melbourne. Photograph by the author, 2009.

Figure 5.7 Entrance to an apartment block in Adelaide. Photograph by the author, 2009.

Figure 5.8 Adelaide International Airport. Photograph by the author, 2008.

rather than from light, referring to the darkness of the imagination, which can "call up the brightest images" (Goethe 1971: 214).

In the white modernism of the trans-Atlantic West, darkness was cast as the enemy in a dichotomy of good versus evil. The Japanese author Jun'ichirō Tanizaki praises shadows, drawing distinctions between Western approaches to domestic design and traditional Japanese design. "I marvel at our [Japanese] comprehension of the secrets of shadows, our sensitive use of shadow and light" (Tanizaki 1977: 50). Tanizaki explains the simplicity of allowing shadows to play in a dark alcove or corner and notes how it is not necessary to use a "clever device" as Westerners tend to, to bring about the magic of darkness. He notes that "were the shadows to be banished from its corners, the alcove would in that instant revert to a mere void" (Tanazaki 1977: 20). He also explains how white is cruel to beautifully designed objects because of its harshness. He explains why Japanese design incorporates so much shining black lacquer, saying that the reflective surfaces of the dark surfaces are polished to bring them to life in a dim and gloaming light. He notes especially that Japanese meals are predicated upon darkness. The "glistening black lacquer rice cask," which when filled with steaming white rice gives off a glow against the equally deep black of the table, which Tanizaki says is a wonderful appetite stimulant. "Our cooking depends on shadows and is inseparable from darkness" (Tanizaki 1977: 16–17).

Western eating is more closely associated with the white tablecloth and whiteness is a ubiquitous color in restaurant interior decorating and design. But there is solace and poetry to be found in such whiteness too, this type of whiteness is fluid and atmospheric. Gaston Bachelard draws our attention to the spreading of the white tablecloth as a central sign of the home; even a home that is open to the sea winds and has a wildness of spirit. With reference to René Cazelles, Bachelard writes: "This bit of whiteness, this tablecloth suffices to anchor the house to its center" (Bachelard 1994: 52). It is as if, without the spreading of the white cloth, these houses of openness would not have a place for people to gather. Drawing upon the poetry of Cazelles and Georges Spyridaki, Bachelard writes about houses that one could dream of spending healing time in. These are "immense dwellings the walls of which are on vacation," they are houses where "winds radiate from [a] center and gulls fly from windows" (Bachelard 1994: 52). So while there is a freedom here quite unlike the softness of the shadowed Japanese house or the tightness of the art collector's white house, there is an absence of defined spatiality for human locatedness and this is brought into being by the substance of the white tablecloth and the action of its spreading. Here white is a signifier of unity in a vast spatiality, but it is a space of wild freedom, not a space of confinement. White (as in the tablecloth) takes on a necessary materiality in the "image of these houses that integrate the wind, aspire to the lightness of air, and bear on the tree of their impossible growth a nest all ready to fly away" (Bachelard 1994: 52).

Clean and White

White is also most commonly associated with cleanliness. In modernism, the Villa Savoye was regarded by architects of the time as the culmination of Le Corbusier's domestic architecture. It provided Le Corbusier an opportunity to realize some of his ideas on white cleanness and the "Law of Ripolin." He was influenced by the annual ritual of white washing and spring cleaning along the Mediterranean coast (Wigley 2001: 30). This process of whitening and cleansing fed his utopian beliefs of an ordered society. "People who wash their shirts, paint their houses, clean the glass of their windows, have an ethic different from those who cultivate dust and filth," writes Le Corbusier (Wigley 2001: 284).[14] For society to live orderly lives, Le Corbusier believed that clear white surfaces were essential. However, as Wigley emphasizes, keeping white surfaces clean requires constant touching up and the white wall is only as permanent as its thin surface layer. "The delicate layer of paint holds together a vulnerable conceptual structure that starts to be exposed when the layer cracks or flakes" (Wigley 2001: xviii). It is the whiteness that is the mechanism of control and if the white paint is allowed to become dirty, it fails in its utopian mission to purify social habits. "What has to be concealed is the fact that white is a layer" (Wigley 2001: xviii).

The association between white and clean design reached its zenith with the modernist "domestic appliance revolution" and the design and manufacture of white goods.

Postwar fears of disease and contagion as well as racial and gendered propaganda were used in marketing campaigns to sell cleaning appliances (white goods) and kitchen designs (Connellan 2005, 2007, 2009). Such campaigns were used to reinforce messages that the reconstruction of the family unit as the basic building block of society was an important national duty (Wilson 1977 and Winship 1984).[15]

Washing and whitening is a form of erasure. Therefore as much as painting white is an application upon a surface, cleaning is a removal of a surface layer. The fragments of "dirt" or marks upon that surface that are removed by the process of cleaning are often regarded as impurities. Purity has long been associated with white in Western mythologies. Mary Douglas's work *Purity and Danger: An Analysis of Concepts of Pollution and Taboo* has had several reprints since its initial publication in 1966 because a great deal of what Douglas explained remains relevant amid current fears of contagion (Coetzee 1996: 179–82).[16] The "white" civilizing project of colonialism had much to do with "cleansing," and the colonizing process is ongoing. This makes the problematization of white and cleaning in terms of social design timely.

Cleaning is also a clearing out of previous marks of use. Real estate agents require professional cleaning certificates and receipts as proof that all reminders of previous tenancy in a dwelling are removed. D.J.B. Young notes that real estate agents he researched in London required that walls were painted white, "anything that is not neutral, i.e. colored, is by implication, a personal idiosyncrasy" and personal marks interfere with the idea of a clean start, a clean slate (Young 2004: 9).

Mary Douglas asserts that preoccupations with dirt and cleaning are a result of classification systems. Douglas argues that "rational behaviour involves classification" and therefore much of nineteenth- and twentieth-century Western approaches to cleaning were as a result of the perpetuation of Enlightenment theories of reason and structuralist anthropology. "They should remember that there is no such thing as dirt: no single item is dirty apart from a particular system of classification into which it does not fit" (Douglas 2002: xvii). And that which is not white upon a white surface, "does not fit." To be white and fitted is something that I have explored in more detail in relation to kitchen design and the choice of white fittings (Connellan 2010). However, it is more than just choosing kitchen whites and standardized fittings, it is, as Douglas has noted about disorder, spoiling the pattern (Douglas 2002: 117).

Pattern and Normalization

Pattern here is not used in the decorative design sense but as a system of repetition. The repeated order of whiteness and white surfaces do not invite interference and distraction. They are, as Batchelor had said, "uninterruptable," which is very different from "uninterrupted," the former can*not* be interfered with and the latter can (2007: 43). The more the pattern of whiteness is repeated in both public and domestic design, the more it *becomes* the pattern.

When the pattern becomes widely accepted so as to become invisible, it has in fact been normalized. Foucault calls this process of normalization a "different type of power," one that "has established itself without ever resting on a single institution but by establishing interactions between different institutions" (2003: 26). In this sense an uninterruptable white(ness) slides easily across many institutions because (a) as a color it has a representational task, the color white can represent any one or more of those symbolic attributes (listed previously), and (b) as a noncolor it is exempt from representation but nonetheless carries the subliminal attributes of those same symbolisms that can then be assigned signification to many different institutions without ever having to be obvious about it. White in this instance is, "Cleansed of its representational masks, it is simply present in its pure state, transparent to the viewer" (Wigley 2001: 3). The irony here is that the apparent transparency is in itself a mask that contributes to the generalization of a plain, as opposed to a patterned, surface.

When white is used as a norm, it eludes intelligibility, and that is how the process of normativity works. If it was to be clearly understood, it would then be easily identifiable and defeat the processes of normalizing power. "The norm is not simply and not even a principle of intelligibility; it is an element on the basis of which a certain exercise of power is founded and legitimized" (Foucault 2003: 50).

MATERIALS AND THE SOCIAL

The Substance of White

White as solid matter (as opposed to air, light, and space) includes substances such as pearl, ivory, salt, lead, chalk, marble, alabaster, quartz, granite, and limestone; added to this are the alloys such as white gold that combine nickel or palladium. Many of these substances are regarded as "precious" in Western symbology and they carry literal, mythological, and quasireligious connotations similar to those of light.

To make white paint or white dye as white as possible, combinations of lead, calcium, chlorine, carbon, and oxygen have been used depending on the recipient surface (McLaren 1986). White lead, as an ingredient of white paint, provides a bright luminosity that was regarded as superior to other whites. However, it is now known that lead is fatally poisonous. Victoria Finlay explains the Ancient Roman method of making lead paint from thin slivers of lead and acid (usually vinegar), which, once the acid had worked its way through the metal, changed it into white lead carbonate, which was the basic ingredient for lead white. This chemical action was intensified in later centuries by what was called the "stack method" in Holland where pottery containers were divided, one half for the acid and one for the lead shavings, around which a stack of fresh manure was stacked. A shed full of such stacked and arranged pots was then sealed off for ninety

days to allow for the evaporative heat and carbon dioxide to intensify the transformation from metal and acid to white lead carbonate (Finlay 2002: 122). This process and indeed most of the lead white processing was left to the lot of peasants, Finlay notes, "The greatest of whites and certainly the cruelest is made of lead. . . . It was made by the poor and it poisoned the poor" (2002: 123).

White lead (lead carbonate) was also used for skin whitening in notorious products such as "Laird's Bloom of Youth" used by Victorian women to keep their skin white (Finlay 2002: 123). Finlay notes that "Lead exposure made women seem like ethereal spirits, almost like angels—which was part of its fraud" (2002: 123–24). White as a pigment in skin color is another myth of whiteness, there is no such thing as a white skin. There are only degrees of paleness. Therefore the skin whiteners used in various cultures throughout history for all manner of reasons (including the signification of gentility from nonexposure to the sun and outside work) are just paint-jobs (Connellan 2009; Glenn 2008; McClintock 1995).

Durability

The degrees of white opacity and luminosity varied depending on the method and ingredients in production. For example, as stated above lead white was regarded as superior but this was not necessarily lasting. Cennino Cennini warned the Renaissance artists to be aware of the changeable qualities of lead white:

> A color made alchemically from lead is white, and it is call white lead. This white lead is very brilliant; and it comes in little cakes like goblets or drinking glasses. If you wish to recognize the choicest sort, always take some of that on the top of the lump, which is shaped like a cup. The more you grind this color, the more perfect it will be. And it is good on panel. It is even used on walls, but avoid it as much as you can, for in the course of time it turns black. (Cennini 1960: 45)

The fact that lead white turns black or dark brown when it is oxidized as a result of exposure to hydrogen sulphide, which results from altered light conditions, was not fully understood until recently. The irony is not lost when one considers the risks taken to make light what is dark, only for it once again to revert to darkness. Finlay remarks on the strange twist of art following life as whitened pink flesh turns to "blackened bone" over years of exposure (2002: 120, 135).

White as an applied layer of color has been shown to be impermanent, a quality that is at odds with its initial brightness. The struggle to maintain the dominant visibility of white is a struggle for endurance. Consequently those materials that are white or as near as possible to general acceptances of white, like marble and alabaster, are coveted for their substance and materiality of whiteness. Of all materials, white marble is the most lasting and the most revered in the Western world.

CONCLUSION

In this chapter I problematized the role of white in the philosophy and politics of design. I began by looking at the visual language of modernism and specifically at the Western project of modernism. In the framework of Western modernism, white in architectural design is shown to be both powerful and fragile. The whiteness of modernist walls and surfaces became a silent branding of modernism as an institution of power. The white walls were painted as if they were intrinsically white. I linked this essentialism and order to Foucault's writing on power relations. What is clear is that white in design thrives on being unclear. This theme of contradiction arises repeatedly in different ways throughout the chapter and a Foucauldian position shows how contradictions and ambiguities of white feed the capillaried relationships of normalizing power. White in this way is about rendering sameness, it is the visual voice of a neutrality that makes anything that is colored or varied seem out of place or distinctly different. The "backdrop" quality of the white space is not so much a backdrop as a foreground, middle ground, and background merged into one.

The silence mentioned above is not only the lack of writing about or lack of admission that the walls of modernism were predominantly white; the silence of white spaces is also an aesthetic. This aesthetic goes both ways, it can offer a profound void for meditation to take place in, and it can do just the opposite. The former is "interruptible" and the latter is "uninterruptable," which as Batchelor pointed out, is a tyrannical whiteness, a "strategic emptiness" (2007: 10).

White cannot be neutral despite the efforts of corporate design and culture to equate white with neutrality. Neutrality is its chief disguise, and it is under this cloak that white can be used to increase the normalization of spaces. The visual language of white communicates power in a "polymorphous" manner (Foucault 2004: 27). White holds the formal aspects that its status as a color grants it but, conversely it also holds a discursiveness of meaning that its nonstatus as a color delivers to it. It is the Judas of colors as it lies both inside and outside of the canon, it is and is not.

Most of the ambiguous nature of white is as a result of its twin identity with light. Newtonian theories are presented as privileging white light as the totality of all color. This understanding of white was compatible with the Enlightenment divisions of science/art and intellect/body, and an endorsement of Cartesian philosophies. Richard Dyer's work on white and light shows how light lights up racial difference. Although Dyer's examples draw from film there is much in his work that can be applied to a political reading of white interior design. Therefore by adding Foucault's ideas on the panopticon to Dyer's thoughts on the control of light in race and exclusion, I arrive at a space that uses light as its walls. Light in this sense takes the place of the structural divide and together with the reflective and repetitive white surfaces, the space becomes an open panopticon. A typical example is the contemporary airport check-in space. Brightly lit, white painted interiors like contemporary apartment and corporate office blocks are designed to be socially exclusive. No words or signs are needed, just white and plenty of

light. And the Foucauldian twist to this is that even the watchers watch themselves, this is the ultimate panopticon; we watch ourselves more closely, are more cautious toward others in an overall environment of visible caution.

It is a case of dominance; Jacques Derrida devoted his life to dismantling binaries, and he voiced his fears that order had brought about a mythology of whiteness that reflected Western hierarchies. These hierarchies include the pervasive strength of Newtonian physics and Enlightenment theories of light. Goethe tried to dislodge Newton's bias on white light by concentrating upon the physicality of color and focusing more upon darkness than light. What this did was to shift the pole from the one to the other rather than deal with the full spectrum and simultaneously address the place of pigment. Darkness also has mystery and density, and a chapter on black could address the place of black in design but this chapter has concerned itself only with white.

What is perhaps the most obvious and simple revelation of white in design is its association with hygiene. White is heralded as a surface that reveals dirt immediately. Modernism was also largely responsible for the cleaning campaigns of the mid-twentieth century but, as Wigley stressed, the white surface is only a surface. This surface has to be constantly touched up or wiped down. The modernist obsession with cleanliness that was supported by architects like Le Corbusier put forward utopian ideals of purity. Fears of contagion and the white "civilizing" mission of colonialism continue into the late twentieth century in various guises. Whitening and washing are a form of erasure and this can be a wiping out of past occupancy in a rental or "for sale" apartment by cleaning it and repainting it white. However, the deeper issue here is that of removing signs of life and living, creating an order that drives away the fear of disorder associated with the unknown. The struggle for clean, ordered (and white) surfaces is a struggle for sameness. If most designs and designed spaces convey a lack of detail, then this continuance perpetuates normativity.

Foucault makes it clear that there is another kind of power at work, and that is the power of normativity (2003: 26). This is what ubiquitous white walls, spaces, and surfaces achieve. Mary Douglas says that anything that interrupts the pattern is disorder, and unplanned color or spotting in an expanse of designed whiteness intervenes in the code of normalcy. However, for the Foucauldian power of normativity to be understood within this chapter of whiteness, whiteness needs to be seen as synonymous with the multiple operations of power, the constant availability of the agents of power to move and change without seeming to do so. Foucault notes that normalization is not easily intelligible, that would undermine its strength. The power of white and the normalization of this power are shown to be supported immensely by light. However, the substance of white pigment also contributes to the dominating hold that white has over other colors. Lead white is the most lethal of all pigments, it makes the most brilliant white, but it is also not lasting when it has long exposure to strong light.

The sustainability of white in design needs to be questioned at the end of this chapter. White is not durable in any form, be it light, whitewash, lead paint, acrylic, or even

marble. The surface requires cleaning or repainting to remain pristine. Neither is white stable as a symbol of purity, nothing is guaranteed and yet white remains in constant use. The human effort to maintain purity and whiteness, illusions of space and expanses of visibility, is immense. Large expanses of white do not represent the natural world unless we are looking at snow-covered landscapes, which constitute the exception for the majority of the planet. White is not socially affirming because it does not induce comfort; instead it is a color on show, and by extension it positions those within it on display as well. This is made manifest when combined with large sheets of reflective glass, where the boundaries of space and form are indeterminate. White in design offers a freedom, but "Freedom," writes Foucault, "is not a white surface" (Foucault 2008: 63).

NOTES

1. Foucault, in an interview with Paul Rabinow just before his death, looked back on his life's work and considered his methodology. M. Foucault, "Polemics, Politics, and Problematizations," in *Ethics: Subjectivity and Truth*, ed. P. Rabinow, trans. Robert Hurley (Harmondsworth: Penguin, 2000), 112.
2. I. Zaknic, "Le Corbusier's Epiphany on Mount Athos," *Journal of Architectural Education*, 43/4 (1990): 27–36. Here Le Corbusier is cited as being humbled and in ecstasy by the discoveries of Classical architecture and the ruined monasteries. See also I. Zaknic, *Le Corbusier: Journey to the East* (Cambridge, MA: MIT Press, 1987), 208.
3. Lesley Naa Norle Lokko emphasizes the slowness of architecture to respond to race. L.N.N. Lokko, *White Papers, Black Masks: Architecture, Race, Culture* (Minneapolis: University of Minnesota Press, 2000), 15.
4. This is a theme that is dealt with in more detail under the subsections of "Light" in this chapter.
5. For more on silence in philosophy see E. Levinas, "Philosophy and the Idea of the Infinite," in *To the Other: An Introduction to the Philosophy of Emmanuel Levinas*, ed. A. Peperzak (West Lafayette, IN: Purdue University Press, 1993), and N. Rose, *Inventing Ourselves: Psychology, Power and Personhood* (Cambridge: Cambridge University Press, 1998).
6. Foucault's genealogy traces the slow but determined separation of language and representation. He notes the distance that came between the sign and the object of representation through the abstraction of words and writing, pointing out that language became "dried up and frozen into immobility by writing." Foucault marks the return of language in the late nineteenth century; he attributes this renewed criticality of language primarily to Nietzsche and literature. Thus it could be said that the visual language of color, which also suffered the stigmas of formalism on a par with the stigmas of structuralism in literature, is regaining a currency and legitimacy through poststructural thought and late postmodern criticality. In other words: color (and white with it) can now be spoken of beyond its formal attributes or its symbolic connotations by bringing all aspects together in discourse. M. Foucault, *The Order of Things: An Archaeology of the Human Sciences* (New York: Vintage, 1994), 305.

7. Lokko says that the medieval fascination with "the metaphysical implications of light (light as divine *lux*; rather than perceived *lumen*) gave rise to the linear perspective, symbolizing total harmony between mathematics and God's will." Lokko, *White Papers*, 29.

8. Foucault discusses the fifth-century Greek notion of *epimeleia heautou*, the attitude toward "self and others," which is divided into know yourself (*gnothi seauton*) and care of the self (*epimeleia heautou*), but Foucault notes the need for knowledge and care, intellect and body to combine more holistically.

9. Rob Hattam notes that "the problem of the Cartesian subject is not a minor philosophical fetish, but one of the major contemporary problems facing human life and hence a problem of ethics, politics and responsibility." R. Hattam, "Pursuing Deconstructive Subjectivity: Intellectualising Isn't Enough," in *Spirituality, Mythopoesis and Learning Contexts*, ed. P. Willis, T. Leonard, S. Hodge, and A. Morrison (Mt. Gravatt, Queensland: Post Pressed, 2009), 119.

10. See also N. Ribe and F. Steinle, "Exploratory Experimentation: Goethe, Land, and Color Theory," *Physics Today*, 55/7 (2002): 43–49, for an account of the spectral versus the primaries. Goethe's trials used white rectangles on black rectangles, thus with the distance through the (larger) prism and the sharper resulting contrast, it became clear that green was merely a result of yellow and blue mixing. In these experiments of Goethe's, colors did not emanate solely from white light but were dependent on the boundaries of black.

11. Hegel followed on from Goethe and attached a strong symbolism to color, and it was not until Wittgenstein that Goethe's theory of colors was challenged. Wittengenstein questioned what he felt to be inconsistencies in Goethe's theory because of too much emphasis upon intuition and feeling. Wittgenstein believed in close analysis of every minute tone and hue of color in order to arrive at an understanding of its constituents. As a result of Wittgenstein's analytical and textual approach, his successors tended to separate colors more and more, attaching different meanings to each. C.A. Riley, *Colour Codes: Modern Theories of Colour in Philosophy, Painting and Architecture, Literature, Music, and Psychology* (Hanover, NH: University of New England, 1995).

12. Feisner illustrates contrast and toning in architectural and typographical orders of black against white and vice versa.

13. Rider Haggard's tale of the white (male) colonial explorer "penetrating" the vast black interior darkness of Africa is a classic account of white racial fear of black dominance. See H. R. Haggard, *King Solomon's Mines* (London: Octopus, 1979). And Ann McClintock's summary of this tale in A. McClintock, *Imperial Leather: Race, Gender and Sexuality in the Colonial Contest* (London: Routledge, 1995), 240–48.

14. Le Corbusier, *Quand les catedrals etaient blanches: Voyage au pays de timtides*, translated by Francis E. Hyslop as *When the Cathedrals Were White* (New York: Reynal and Hitchcock, 1947), 29 in M. Wigley, *White Walls, Designer Dresses: The Fashioning of Modern Architecture* (Cambridge, MA: MIT Press, 2001), 284.

15. The responsibility of ensuring personal and domestic hygiene was firmly and conveniently placed with women. See E. Wilson, *Women and the Welfare State* (London: Tavistock, 1977) and J. Winship, *Nation before Family: Formations of Nations and People* (London: Routledge, 1984), for information on the responsibility that was propagandistically placed upon women as nation builders particularly after World War II; however, women were also seen as agents of postwar reconstruction in the interwar period. Domestic Science manuals of

housekeeping written in England also found their way to South Africa during the 1920s and 1930s. Noted among these is a book written by "Mrs. Peel," *The Labour Saving House* (London: Bodley Head, 1918).

16. Apart from recent concerns about new flu viruses such as bird and swine flu, see J. Coetzee, "Apartheid Thinking," in *Giving Offense: Essays on Censorship* (Chicago: University of Chicago Press, 1996), 179–82.

REFERENCES

Bachelard, G. (1994), *The Poetics of Space: The Classic Look at How We Experience Intimate Places*, Boston: Beacon, 1994.

Batchelor, D. (2007), *Chromophobia*, London: Reaktion.

Birren, F. (1963), *Color: A Survey in Words and Pictures, from Ancient Mysticism to Modern Science*, New York: University Books.

Cennini, C. (1960), *The Craftsman's Handbook: Il Libro dell'Arte*, translated by David V. Thompson Jr., New York: Dover.

Coetzee, J. (1996), *Giving Offense: Essays on Censorship*, Chicago: University of Chicago Press.

Connellan, K. (2005), "The Meaning of Home and the Experience of Modernity in Pre-Apartheid South Africa," PhD diss., Louis Laybourne Smith School of Architecture and Design, University of South Australia, Adelaide.

Connellan, K. (2007), "White Skins, White Surfaces: The Politics of Domesticity in South African Domestic Interiors 1920–1950," in D. Riggs (ed.), *Taking Up the Challenge: Critical Race and Whiteness Studies in a Postcolonising Nation*, Adelaide: Crawford House.

Connellan, K. (2009), "Washing White," in B. Baird and D. Riggs (eds.), *The Racial Politics of Bodies, Nations and Knowledges*, Newcastle upon Tyne: Cambridge Scholars Press.

Connellan, K. (2010), "White and Fitted: Perpetuating Modernisms," *Design Issues*, 26/3: 51–61.

Connellan, K. (2012), "White Whispers: Concealing and Revealing Cloth," *Textile: The Journal of Cloth and Culture*, 10/1: 6–27.

Connellan, K., and Moss, J. (2004), "Power to the People: Electricity and Domestic Design," in *Futureground*, Proceedings of the Design Research Society Conference, Melbourne, Australia.

De Certeau, M. (1984), *The Practice of Everyday Life*, Berkeley: University of California Press.

Derrida, J. (1974), "White Mythology: Metaphor in the Text of Philosophy," *New Literary History*, 6/1: 5–74.

Derrida, J. (1987), *The Truth of Painting*, translated by Geoff Bennington and Ian McLeod, Chicago: University of Chicago Press.

Douglas, M. (2002), *Purity and Danger: An Analysis of Concepts of Pollution and Taboo*, London: Routledge.

Dyer, R. (2001), *White*, London: Routledge.

Feisner, E. A. (2006), *Colour Studies*, New York: Fairchild.

Finlay, V. (2002), *Colour: Travels through the Paintbox*, London: Sceptre.

Foucault, M. (1994), *The Order of Things: An Archaeology of the Human Sciences*, New York: Vintage.

Foucault, M. (1995), *Discipline and Punish: The Birth of the Prison*, translated by Alan Sheridan, New York: Vintage.

Foucault, M. (2000), "Polemics, Politics, and Problematizations," in P. Rabinow (ed.), *Ethics: Subjectivity and Truth*, translated by Robert Hurley, Harmondsworth: Penguin.

Foucault, M. (2003), *Abnormal: Lectures at the Collège de France 1974–1975*, New York: Verso.

Foucault, M. (2004), *Society Must Be Defended: Lectures at the Collège de France 1975–1976*, translated by David Macey, London: Penguin.

Foucault, M. (2005), *The Hermeneutics of the Subject: Lectures at the Collège de France 1981–1982*, translated by Graham Burchell, New York: Picador.

Foucault, M. (2008), *The Birth of Biopolitics: Lectures at the Collège de France 1978–1979*, New York: Palgrave Macmillan.

Gage, J. (1990), "Color in Western Art: An Issue?," *Art Bulletin*, 72/4: 518–41.

Gage, J. (1993), "Colour under Control: The Reign of Newton," in *Colour and Culture: Practice and Meaning, from Antiquity to Abstraction*, Berkeley: University of California Press, 153–76.

Glenn, E.N. (2008), "Yearning for Lightness: Transnational Circuits in the Marketing and Consumption of Skin Lighteners," *Gender and Society*, 22: 281–300.

Goethe, J.W. (1971), *Goethe's Colour Theory*, edited by R. Mattahaeit, London: Studio Vista.

Haggard, H.R. (1979), *King Solomon's Mines*, London: Octopus.

Hall, S. (1997), *Representation: Cultural Representations and Signifying Practices*, London: Sage.

Hattam, R. (2009), "Pursuing Deconstructive Subjectivity: Intellectualising Isn't Enough," in P. Willis, T. Leonard, S. Hodge, and A. Morrison (eds.), *Spirituality, Mythopoesis and Learning Contexts*, Mt. Gravatt, Queensland: Post Pressed.

Itten, J. (1973), *The Art of Colour: The Subjective Experience and Objective Rationale of Colour*, translated by Ernst van Haagen, New York: Van Nostrand Reinhold.

Jackson, M. (1994), "A Spectrum of Belief: Goethe's 'Republic' versus Newtonian 'Despotism'," *Social Studies of Science*, 24/4: 673–701.

Kandinsky, W. (1977), *Concerning the Spiritual in Art*, translated by Michael Sadler, New York: Dover.

Lokko, L.N.N. (2000), *White Papers, Black Masks: Architecture, Race, Culture*, Minneapolis: University of Minnesota Press.

McClintock, A. (1995), *Imperial Leather: Race, Gender and Sexuality in the Colonial Contest*, London: Routledge.

McLaren, K. (1986), *The Colour Science of Dyes and Pigments*, Bristol: Adam Hilger.

O'Doherty, B. (1999), *Inside the White Cube: The Ideology of the Gallery Space*, San Francisco: University of California Press.

Riley, C.A. (1995), *Colour Codes: Modern Theories of Colour in Philosophy, Painting and Architecture, Literature, Music, and Psychology*, Hanover, NH: University of New England.

Sontag, S. (2002), "The Aesthetics of Silence," in *Styles of Radical Will*, New York: Picador.

Tanizaki, J. (1977), *In Praise of Shadows*, translated by Thomas J. Harper and Edward G. Seidensticker, Sedgwick, ME: Leete Island Books.

Varichon, A. (2006), *Colours: What They Mean and How to Make Them*, translated by Toula Ballas, New York: Abrams.

Virillio, P. (1995), "Critical Mass," *World Art: Magazine of Contemporary Visual Arts*, 1: 78–82.

Westphal, J. (1987), *Colour: Some Philosophical Problems from Wittgenstein*, Oxford: Blackwell.

Wigley, M. (2001), *White Walls, Designer Dresses: The Fashioning of Modern Architecture*, Cambridge, MA: MIT Press.

Wilson, E. (1977), *Women and the Welfare State*, London: Tavistock.

Winship, J. (1984), *Nation before Family: Formations of Nations and People*, London: Routledge.

Young, D.J.B. (2004), "The Material Value of Color: The Estate Agents' Tale," *Home Cultures*, 1/1: 5–22.

Zaknic, I. (1990), "Le Corbusier's Epiphany on Mount Athos," *Journal of Architectural Education*, 43/4: 27–36.

Zembylas, M., and Michaelides, P. (2004), "The Sound of Silence in Pedagogy," *Educational Theory*, 34/2: 193–210.

−6−

What Color Is Sustainability?

Marilyn DeLong and Gozde Goncu-Berk

Chapter Summary. The color green has been widely used for messages of sustainability both in visual and verbal formats. As the message becomes more critical, it behooves us to examine the message and its connotations that must remain at the forefront if sustainable practices are to be realized. To this end, design students completed an exercise that examines the use of color and other design elements and principles to promote the message of sustainability. Results confirmed use of the color green to promote sustainability, although students acknowledged that this was associated more with environmental and not social and economic values. Other colors were also considered and the principle of import in carrying the message was repetition. When students redesigned a T-shirt, they focused upon sustainability of the materials of the T-shirt and not the message.

Color can be a powerful tool that helps to communicate complex information by invoking emotional responses. Color has been used as a retrieval tool by designers and marketers to create a sense of personality for brands, products, and in marketing messages and promotion of trends. It is an easily recognized design element when associated with marketable products. Color is second only to shape in cognition and is recognized before content in the cognitive sequence: shape, color, content (Wheeler 2003).

Sustainability will be an increasingly critical issue in the next decade and clear communication using color could help direct attention to a focused message that could transform behaviors within industry and for consumers. The color green is currently associated with a wide variety of products and services that all promote messages of sustainability. Although the color green has been promoted as the color of sustainability, its primary association is to the environment, leaving out two other equally important aspects: the social and economic spheres. Also green has been promoted to cue into sustainability for all products and services. Some messages do not directly reference sustainability but instead imply the association of green = sustainability, for example, "green living expo," or "adopt a greener lifestyle," implying sustainable best practices only indirectly. The apparel industry is no exception in using the color green as a cue to messages broadly crafted to promote fair trade products that are environmentally friendly or economically viable. Currently, however, terms such as *eco-friendly* may conjure up images of products that are drab and lifeless. When the current cues are used

to promote an unfavorable or misconstrued image, how does one decide whether or not to retain such cues and when does one decide it is time to develop a different cue for a more clear and up-to-date message?

The complexity and ambiguity of the concept of sustainability regarding apparel creates an obstacle for the stakeholders of the industry to establish sustainable practices. The first step toward these practices is the awareness about the issue of sustainability by all stakeholders. Because sustainability is a dynamic concept rather than a static one, to move from awareness to actual sustainable practice requires agreed upon communication of the concept, criteria, and policies similar to that of other industries. Yet as the issue of adopting sustainable best practices by all parts of our society and around the globe becomes more critical, designers, manufacturers, marketers, and consumers all need to get on board with a clear and directive message that includes both visual and verbal cues to prompt action.

Aaker (1996) distinguishes between brand image, that is, how a brand is perceived, and brand identity, that is, how the brand would like to be perceived. In creating a brand identity, he urges taking a broad view including emotional and self-expressive benefits, organizational attributes, brand personality, brand symbols, as well as product-related characteristics. To learn about how messages of sustainability are related to color, design students completed a brainstorming activity with two objectives: to understand

1. Which colors they associate with sustainability and why;
2. How they might incorporate sustainability into a basic redesign activity.

This exercise aims to understand cues of sustainability in terms of one specific but complex industry: the apparel industry and its products. The question asked: What color is sustainability for the apparel industry and what could it be? Might sustainability be depicted as transparent since it is a concept associated with systems thinking: like the way we cannot see the linkages of the parts of the system we know exist? *Or*, Might colors of sustainability be interpreted as the primary colors of red, yellow, and blue to associate with minimalism and careful use of resources?

LITERATURE

Sustainability

The topic of sustainability is likely to become increasingly critical in the next decade as evidence mounts concerning the devastation related to the environment, our economy, and social practices resulting from our prevailing attitudes and values. In 1987, the United Nations' Brundtland Report defined sustainable development as meeting the needs of the present generation without compromising the ability of future generations to meet their own needs. Sustainable development is composed

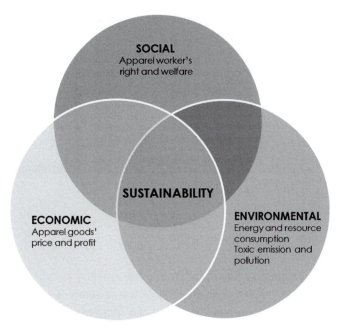

Figure 6.1 Three spheres of sustainability in the apparel industry. Adapted from Vanderbilt University, "Three Spheres of Sustainability," www.vanderbilt.edu/sustainvu/sustainability.php, 2006.

of three spheres: environmental, social, and economic (Figure 6.1). In the middle where these three spheres overlap and are considered simultaneously is the area of sustainability.

Sustainability has been a widely used topic in advertisements of products that are promoted as organic, eco-friendly, or as fair trade. The color green is currently associated with a wide variety of products and services that all promote messages of sustainability such as the logo for USDA "Organic" certification and the logo for "Green-E" certification for verification of renewable energy and greenhouse gas mitigation products.

Another color that is mostly used to communicate issues of sustainability is blue. The ENERGY STAR certification—joint program of the U.S. Environmental Protection Agency and the U.S. Department of Energy helping us all save money and protect the environment through energy-efficient products and practices—is communicated with a blue logo that is placed on energy-efficient homes, products, and buildings. A more specific example from apparel industry is the "bluesign" standards. Bluesign Technologies is an independent Swiss-based company that audits and improves resource consumption and environmental performance of companies operating in apparel and textiles industry from chemical suppliers and textile manufacturers to brands and retailers by means of input-stream management. Three input categories coded with colors are used under the bluesign standard; blue—safe to use, gray—special handling required, and black—forbidden under the standard (bluesign.com n.d.). See Figure 6.2.

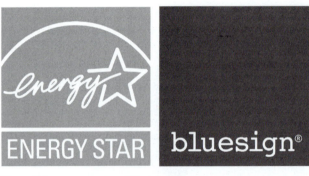

Figure 6.2 ENERGY STAR and bluesign logos.

The Apparel Industry and Sustainability

Sustainability is becoming a concern in the apparel industry because it is a significant area of human behavior that impacts all three of the spheres of sustainability, and production from use through disposal. Trends in the industry especially exacerbate the impact of apparel on social and environmental spheres. Today, apparel businesses are associated with short life cycles of products and rapid consumption. Practices related to short clothing life cycles from production to retailing, use, care, and disposal contradict environmental, social, and economical aspects of sustainability. Major environmental impacts of apparel businesses involve toxic chemicals, energy use, and water consumption. Social impacts are related to working conditions of low-paid workers. The continual decline in apparel pricing and consequent glut of cheap clothing has driven up consumption (Schor 2005); "excess labor supply has allowed firms to depress wages and avoid paying environmental costs" (Schor 2002: 309).

The apparel industry is especially prone to adopt messages that are quickly transformed into seasonal buzzwords and images that promote any new trend that comes along, but then as quickly changes for the next season. As we move into a more pressing and continuous need to adopt sustainable best practices, how can we be sure the message promotes what is the hoped-for outcome? A recent step taken by outdoor products brands and retailers is the Eco Index. The Eco Index is an environmental assessment tool to benchmark and measure sustainable practices throughout the life cycle of products including apparel, shoes, and equipment. The Eco Index Framework lays out the index content. In addition, a glossary of terms related to sustainability was developed. The companies who participated in the development of the Eco Index range from outdoor apparel brands and retailers such as Timberland, Patagonia, and the North Face to Levi Strauss & Co. The aim is to create common language and standards to communicate throughout the supply chain about sustainability at a product level (Eco Index, n.d.).

From the perspective of many businesses and consumers the concept of sustainability in apparel has remained abstract and theoretical. According to Niinimaki (2010) there

has been an attitude-behavior gap in the practices of sustainable fashion that is caused by limited awareness from designers and retailers in terms of consumers' expectation of sustainable fashion. According to Mann (2002) although consumers will often say they want more sustainable products, they are rarely prepared to compromise to obtain them. Given a choice between product parameters such as performance, price, convenience, and sustainability, consumers may place sustainability at the bottom. Consumers will be attracted to sustainability if and when they perceive it is important (Mann 2002), and product characteristics are only one aspect in creating identity. The concept of the whole is that humans do not usually perceive separate attributes, but a meaningful pattern of associations or *gestalt*. In this context, the design and core identity must represent the essence of the message in cohesive and meaningful groupings called mental networks (Aaker 1996: 93).

A number of current writers have addressed issues related to sustainability in the apparel industry and a vision for how a sustainable product might look. Black (2008) examines the relationship of the preconceived idea of eco-fashion as wholesome, undyed, and shapeless—a compromise in quality and style—to a fashion industry just learning to accommodate the environmental concerns of the twenty-first century through a new wave of sustainable and genuinely desirable clothing. Schor (2002) emphasizes that while minimalism is a morally satisfying position, that is, clothing should be functional and comfortable and we should be satisfied to buy as little as possible, most people do not and will not find minimalism appealing. Ehrenfeld (2004) states that aesthetics are important to sustainability because they function as social attractors. By making sustainable fashion more attractive, designers can encourage the user to willingly embrace it. Finally Manzini (1994) suggests that the fundamental elements of design such as form, function, users, technology, and aesthetics need to be revisited in terms of sustainability.

Color

Form, material, and color are powerful factors of natural and built environments influencing decision making, attitudes, and emotions of individuals interacting with those environments. These fundamental design elements can directly and indirectly affect individuals at the physiological and psychological levels. The physiological responses to stimuli are universal such as the way the human eye sees color. On the other hand, the psychological level refers to how we interpret the meaning of that color and what type of emotions the color evokes. These are all subject to variables such as culture, experience, gender, or age.

Color can convey many meanings and messages at a time. According to Kress and Leeuwen (2002) color communicates meanings at three levels; ideational, interpersonal, and textual. At the ideational level color helps to identify "the representations of the world" including specific people, places, or ideas. Association of the color orange with the Netherlands or vibrant pink with breast cancer can be examples of ideational roles of color. Color conveys interpersonal meanings when it is used "to do things." For

example, the use of yellow and orange colors to warn people against danger is regarded as interpersonal meaning. Finally at the textual level color can be used to convey "unity and cohesion." Kress and Leeuwen (2002) use the example of different door colors in a building associated with different departments that create unity within each department but at the same time, distinguish the different departments.

Hutchings (2004) categorized the symbolic uses of color under three driving forces, as economical, historical, and social. As an example to economic forces: achromatic colors of black, gray, and off-white are inexpensive and easily cleaned and thus can provide suitable dress for individuals unable to afford other clothing. Historical driving forces include the use of color in a patriotic sense. Color as a social driving force conveys messages for healing purposes, rites of passage, and supernatural forces.

Color can be used as a metaphor for concepts by establishing continuity and consistency in communication of the concept, such as the way the color green has been used as a metaphor for the concept of sustainability. In this case, color has been used to communicate a complex and abstract concept by associating it with the green from the environment and found in nature. According to Kim (2006) the image of nature can be expressed by four elements: fire, earth, water, and air, and by the colors that represent them: red, yellow, green, and blue. The author suggests that these colors can convey a nature-friendly message. Kim also did a content analysis of fashion magazines within ten years and found that even the colors used in fashion convey a natural theme that would undergo change every season to give rise to new trends. Madden, Hewett, and Roth (2000) analyzed the emotions associated with colors cross-culturally to determine the role of color combinations in brand logos. They found that blue, green, and white colors were associated with peaceful, gentle, and calming effects, both in Western and Eastern cultures.

METHOD

We developed an exercise to understand how design students associate color with sustainability and what design elements they would use to communicate sustainability in the design of a specific apparel item. The exercise was distributed in four undergraduate design classes from freshmen to senior-level students in a college of design in a large midwestern university. Design classes in sizes from 14 to 124 students ranged from small studio classes to large lecture-based design courses, with a total number of 252 students. Due to the diversity in the sizes of classes and the need for a consistent process, students were invited to engage in an individual brainstorming activity that took ten to twenty minutes depending on the size of the class.

The exercise included five open-ended questions for which students could respond by using text and sketches. Students were asked to list the colors they associate with the concept of sustainability and explain why. Students were then asked whether they associate the color green with sustainability and their reasons for the association. They

were asked to brainstorm about design elements and principles that could be used to communicate sustainability and finally, they were asked to redesign a basic T-shirt, incorporating the idea of sustainability.

The results were analyzed by grouping responses under major themes using color coding. Then, the frequencies of themes were counted and the number of mentions was calculated. Multiple themes were often mentioned by a student in one response.

RESULTS AND DISCUSSION

In totaling responses "green" was most frequently associated with sustainability with 233 mentions (Table 6.1). The next most frequently mentioned colors were natural and earth colors, white and brown, blue, tan, yellow, beige, and no color or transparent in order of frequency. When students used the words *natural* and *earth colors*, they did not specifically state what they were; therefore this statement may include green, brown, and blue since they are all colors found in nature.

The direct relationship between the color green and nature was described as the main reason for associating green with sustainability (Table 6.2). The next result with the frequency of 104 mentions was the already existing use of green in campaigns, slogans, advertisements, and marketing. They described this relationship with the following quotes: "Green has become a buzzword in the campaign for sustainability," "Media and retail are constantly hounding the concept of going green into our brains," "Going green is such a worldwide trend right now." From the comments of students it was clear they thought the use of the color green and media use of going green is regarded as a temporary trend and new marketing strategy. Green was also associated with the color of the symbol for recycling. Other colors and associated reasons were described. Brown was related to the concept of sustainability because of its availability in nature. Most of the students used phrases such as "It is the color of the trees or dirt." Blue and yellow were associated with the notion of sustainability for similar reasons: "Blue is the color of ocean," "Yellow is the color of sun." White was associated with sustainability due to the perceptions of purity and cleanliness. Students explained that white is associated with no dye in apparel. Since dying processes may cause environmental concerns, they

Table 6.1 Colors associated with sustainability mentioned by students (#252).

Color	# of Mentions	% of Mentions
Green	233	35
Natural and Earth colors	142	22
Brown	83	12
White	83	12
Blue	66	10
Tan and beige	38	6
Yellow	14	2
No color and transparent	3	1

associated lack of dyes with the color white and therefore sustainability. A number of students described white as the color of organic. Here is a dilemma in the association of the color white with sustainability regarding apparel: the nonuse of dyes does not necessarily mean sustainable, as bleaching and finishes to reach a desirable white are also harmful to the environment. In this context, the answers indicate lack of awareness and knowledge about what could be regarded as sustainable in apparel. Tan and beige were regarded as colors that could be associated with sustainability because they are earthy and similar to white, and they represent no dye. In the context of apparel tan and beige were defined as the color of cotton, bamboo, or hemp and the color of sustainable and organic clothing. The dyeing process to reach high-intensity colors in the development of apparel items is toxic and causes environmental consequences. Thus, apparel items promoted as sustainable have been lacking vivid colors, and sustainable fashion has been associated with dull colors and simplicity and lack of styling. Additionally, these colors were recognized to be used by the media in marketing sustainable clothing. Most of the student responses were focused on the environmental sphere of sustainability and they defined colors of sustainability as they relate to the environment. A small number of students defined sustainability as larger than environmental issues alone: they do not associate sustainability with any one color because it is a concept and therefore should be transparent.

Table 6.2 Reasons mentioned by students (#252) for associating colors with sustainability.

Color and Reason for Association	# of Mentions	% of Mentions
Green	*229*	*58*
Natural, environmental, Earthy	109	28
Going Green campaigns and slogans		26
Media influence and advertisement	104	
Color of recycling symbol	16	4
Brown	*59*	*15*
Natural, environmental, Earthy	54	14
Recycled	5	1
Tan and Beige	*46*	*8*
Natural, environmental, Earthy	16	4
No dye	9	2
Organic	5	1
Marketing	16	1
Blue	*34*	*9*
Water, natural, environmental, Earthy	31	8
Recycling	3	1
White	*33*	*9*
Pure and clean	16	4
No dye	14	4
Organic	3	1
Yellow	*6*	*1*
Sun	6	1

When we asked students how much and how they associate sustainability with green, our aim was to understand the impact of the "going green" slogan on the ideational meaning of the color green. Responses revealed that although students did associate green with sustainability, they are overwhelmed by the use of this color to market the concept of sustainability. Some students explained that green has been exploited by companies to market their products and increase their margins: "Green is being interpreted to create higher profits for retailers by taking advantage of what started out as a positive work," "I very much am tired of the word *green*, to me green has become a front that is put up by many companies to cover up habits. Being green has no definition and really carries no value." Though students associate sustainability with the color green, this association limits the meaning of the concept: "Color green became an eco-cliché, it has been overused and now doesn't express much," "I try to avoid associating green with sustainability because that makes sustainability a fad and the word loses its credibility." A large majority of students thought green and sustainability refer to a temporary lifestyle trend: "The trend of a green lifestyle is mainly for show, most people just like to say it." Results also conveyed resistance to use of green in communicating sustainable fashion: "I don't want to look sustainable, but fashionable. If everything is to be green then we might as well all dress in hemp green body suits."

Smaller numbers of students positively associated green with sustainability. Some stated that use of green in communicating sustainability makes it easier to understand the concept that is otherwise complicated and abstract, "Green and sustainability go hand in hand, green is sustainability's logo in what it tries to convey to people."

Sustainability and Design Elements and Principles

Students were asked to determine design elements and principles that could communicate sustainability as a concept (Table 6.3). In this way we were able to compare the ideational meaning of color used in design to other design elements used in the design process. Organic and curvilinear forms were the first design element students associated with sustainability, with a frequency of 39 mentions. Color was the next most frequently mentioned design element at 30. Soft hues instead of vibrant colors were defined as more sustainable. Texture was the next most important design element with 28 mentions—especially rough textures were identified with the concept of sustainability. Repetition was the design principle mentioned most by design students to communicate sustainability. Repetitive use of symbols and slogans related to sustainability would be effective, they responded, with 27 mentions. The design principle of balance and harmony was mentioned with a frequency of 12. Students defined use of balance and harmony in the context of balancing and finding the harmony between what is fashionable, trendy, and temporary and what is classic and long-lasting. The last design principle with 6 mentions was simplicity, described as a minimalist approach in style.

Table 6.3 Design elements and principles mentioned by students (#124) that they would use to communicate sustainability in design.

Design Elements and Principles	# of Mentions	% of Mentions	Examples
Form	39	27	Organic and curvilinear lines and shapes
Color	30	21	Soft hues
Texture	28	20	Rough textures
Repetition of symbol and slogan	27	20	Recycling symbol
Balance and harmony	12	8	Balance and harmony between fashion and classic
Simplicity	6	4	Minimalist style

Table 6.4 Design aspects mentioned by students (#124) that they would use in redesign of a t-shirt.

Ways to Incorporate Sustainability in T-Shirt Redesign	# of Mentions	% of Mentions	Examples
Material	73	33	Organic and recycled fabric
Fair and local supply chain	30	18	Fair supply chain conditions and local manufacturing
Informative tags and labels	26	10	Manufacturing details, sustainable care options, reminder to recycle
Durability	23	9	Long-lasting, reinforced stitches
Dyes and finishes	21	9	Organic and natural dyes, low-impact finishes
Care options	19	8	Stain resistant, less washing and ironing requirements
Style	13	6	Minimalist, not trendy
Color	8	4	Natural colors, green and white
Packaging	7	3	Eco-friendly packaging

An Exercise in Design Implementation

Students were asked how they would incorporate sustainability into a T-shirt redesign (Table 6.4). Choice of material, more specifically fiber and fabric, was defined as most important for incorporating sustainability in a T-shirt redesign. Local manufacturing and fair trade, informative labeling, and tag design were the next important aspects of sustainability considered in redesign. Durability of the item was the third most important factor. Durability was defined from two perspectives: the physical durability of the apparel item as well as the stylistic durability over time. The use of dyes and finishes and garment care were the next most common sustainability factors mentioned. Design elements that students mentioned they would use in redesign of a sustainable T-shirt were style and color, with 13 and 8 mentions. Finally, packaging was mentioned as a sustainability aspect considered in T-shirt redesign.

Results showed that students view the use of color to communicate sustainability as more of a marketing effort. When it comes to actually designing apparel items with sustainability in mind, they approach design considering social, economic, and environmental aspects all together.

CONCLUSION

Whenever color is used for a promotional message, the following questions must be asked: What are the connotations of the message? What color selection clarifies the message? Does brand image, that is, what is, need to be separated from brand identity, that is, a vision of what it could be? Color selection may be complicated when a specific color is selected that has been adopted for one purpose, for example, save the environment, and then broadened to encompass economic and social concerns. Further when the color is adopted and applied within a specific industry that is not perceived as easily adapting to the criteria for sustainability, the issue is further compromised (Walker 2006). Verifying the message with the user or consumer is a worthwhile exercise in determining how such associations get configured into the message and whether the message is clarified with the selection of the color.

This exercise with design students examined the use of colors and their associations with sustainable best practices, especially within the apparel industry. Students were first asked to describe their concept of sustainability and then, how it translates into design elements and principles. While green was the color of choice for reasons of current use and its association with the environment, other colors such as brown, blue, and tan were considered. Students mentioned the principle of repetition as important to the message of sustainability.

When students were asked to redesign a T-shirt using sustainable best practices, other factors came to the forefront as important to the concept of apparel and sustainability. They were not locked into green as the color message of sustainability. However, most of the suggestions for other colors were associated with the environment and nature, even though they were aware of the broader context within which sustainability was being defined. Color was considered more as a marketing or branding tool than as critical to the T-shirt redesign.

REFERENCES

Aaker, D. A. (1996), *Building Strong Brands*, New York: Free Press.

Black, S. (2008), *Eco-Chic: The Fashion Paradox*, London: Black Dog.

bluesign.com (n.d.), "How Does bluesign® Work?," http://www.bluesign.com/index.php?id=121.

Eco Index (n.d.), "Eco Index," http://www.ecoindexbeta.org/content/about-project.

Ehrenfeld, J. R. (2004), "Searching for Sustainability: No Quick Fix," *Reflections: The SoL Journal*, 5/8: 1–13.

Hutchings, J. (2004), "Color in Folklore and Traditions: The Principles," *Color Research and Application*, 29/1: 57–66.

Kim, Y. I. (2006), "Color and Symbolic Meaning of Elements in Nature," *Color Research and Application*, 31/4: 341–49.

Kress, G., and Leeuwen, T. V. (2002), "Colour as a Semiotic Mode: Notes for a Grammar of Colour," *Visual Communication*, 1/3: 343–68.

Madden, T. J., Hewett, K., and Roth, M. S. (2000), "Managing Images in Different Cultures: A Cross-National Study of Color Meanings and Preferences," *Journal of International Marketing*, 8/4: 90–107.

Mann, D. L. (2002), "Changing the Game: Sustainability without Compromise," Seventh Annual Conference of the Center for Sustainable Design, London, October.

Manzini, E. (1994), "Design, Environment and Social Quality: From Existenzminimum to Quality Maximum," *Design Issues*, 10/1: 37–43.

Niinimaki, K. (2010), "Eco-Clothing, Consumer Identity and Ideology," *Sustainable Development*, 18/3: 150–62.

Schor, J. B. (2005), "Prices and Quantities: Unsustainable Consumption and the Global Economy," *Ecological Economics*, 55: 309–20.

Schor, J. B., and Taylor, B. (eds.) (2002), *Sustainable Planet, Solutions for the Twenty-First Century*, Boston: Beacon Press.

Vanderbilt University (2006), "Three Spheres of Sustainability," www.vanderbilt.edu/sustainvu/sustainability.php.

Walker, G. (2006), "The Ambivalence and Complexity of Sustainability," Workshop on Governance for Sustainable Development: Steering in the Context of Ambivalence, Uncertainty and Distributed Control, Berlin.

Wheeler, A. (2003), *Designing Brand Identity, a Complete Guide to Creating, Building and Maintaining Strong Brands*, Hoboken, NJ: John Wiley & Sons.

Plate 1 Design and photograph by Swedish design house Gudrun Sjödén, 2010.

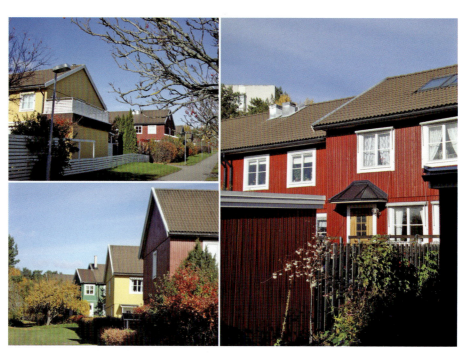

Plate 2 Flogsta housing area, Uppsala, Sweden. Built in 1974, the houses have colors planned by the architect and maintained by house owners. Photograph courtesy of the author.

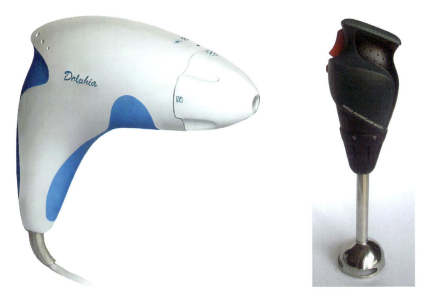

Plates 3 and 4 Two artifacts designed by Karin Ehrnberger (2006) as part of her master's work in Industrial Design, University College of Arts, Craft and Design, Stockholm. Photograph by Karin Ehrnberger.

Plate 5 Maccreanor Lavington, model for Dublin Parlour, 2009, showing the combination of colored surface with bold urban furniture. (© Maccreanor Lavington).

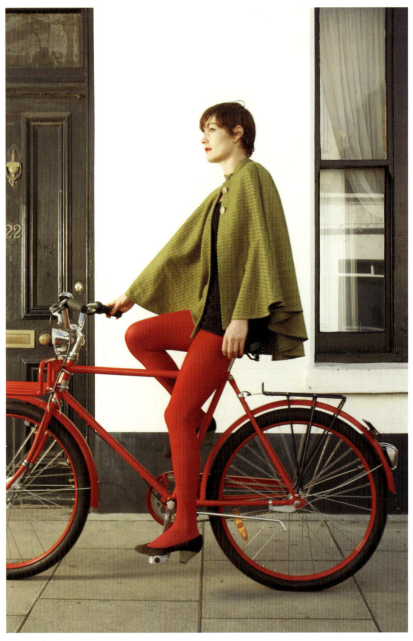

Plate 6 Dashing Tweeds, Lumatwill™ Cape by day, 2010. Courtesy of Guy Hills.

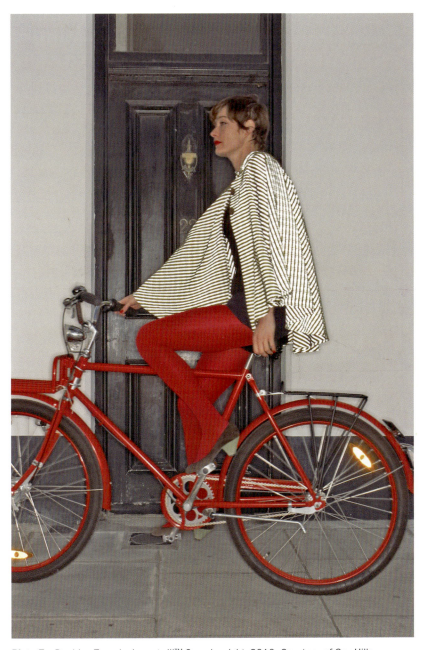

Plate 7 Dashing Tweeds, Lumatwill™ Cape by night, 2010. Courtesy of Guy Hills.

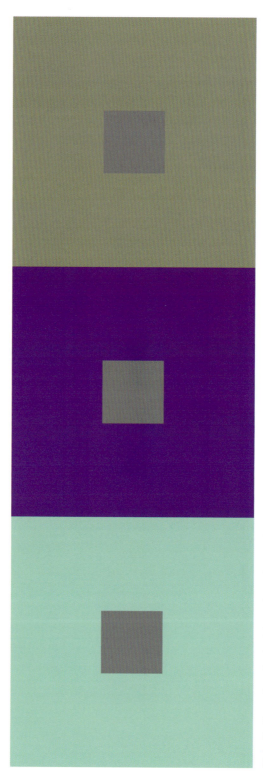

Plate 8 Examples of color interactions: the smaller gray squares contained in the bigger squares are identical, but they appear different in lightness and also in hue and saturation.

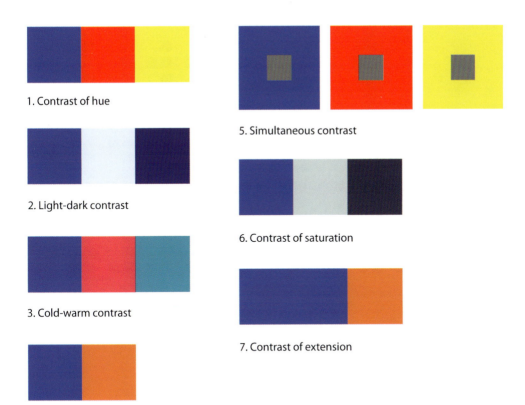

1. Contrast of hue

2. Light-dark contrast

3. Cold-warm contrast

4. Complementary contrast

5. Simultaneous contrast

6. Contrast of saturation

7. Contrast of extension

Plate 9 Itten's seven color contrasts.

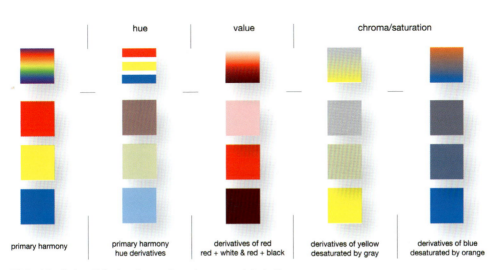

hue

value

chroma/saturation

primary harmony

primary harmony
hue derivatives

derivatives of red
red + white & red + black

derivatives of yellow
desaturated by gray

derivatives of blue
desaturated by orange

Plate 10 Color attributes: hue, value, chroma, and derivatives.

value structure

chroma structure

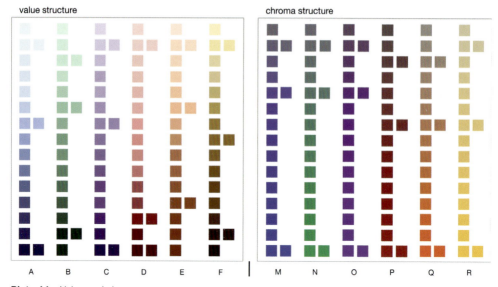

A B C D E F M N O P Q R

Plate 11 Value and chroma structures.

Hue contrast variable 1

Hue contrast variable 2

Hue contrast variable 3

3 contrasting hues
equal value
equal chroma

Hue contrast variable 4

sequential variation contrast

contrast hue | value | chroma

— 2 colors equal value

— 2 colors equal chroma

— 1 color contrast
 chroma | value

— 3 colors equal chroma

— 2 colors equal value

— 1 color contrast value

lighter and less saturated than other two

darker than one | lighter than one
more saturated than one |
less saturated than one

darker than two | more saturated than two

G H I J K L

Plate 12 Hue structure.

conventional color harmonies contrast

	value	chroma	hue	
1 monochromatic – tints / shades				value structure
derivative 1	□	●	□	
derivative 2	●	●	□	
2 chroma / saturation – colorful / neutral gray				chroma structure
derivative 1	□	●	□	
derivative 2	●	●	□	
3 primary – red / yellow / blue				hue structure
derivative 1	□	●	●	
derivative 2	●	□	●	
derivative 3	●	●	●	
4 secondary – orange / green / violet				
derivative 1	□	●	●	
derivative 2	●	□	●	
derivative 3	●	●	●	
5 tertiary – hybrids between primary/secondary				
derivative 1	□	●	●	
derivative 2	●	□	●	
derivative 3	●	●	●	
6 analogous – adjacent on color wheel				
derivative 1	□	●	●	
derivative 2	●	□	●	
derivative 3	●	●	●	
7 complementary – opposites on color wheel				
derivative 1	□	●	●	
derivative 2	●	□	●	
derivative 3	●	●	●	
8 split complementary – 1 hue / 2 opposites				
derivative 1	□	●	●	
derivative 2	●	□	●	
derivative 3	●	●	●	
9 dissonant – harmony = a color deviant				
derivative 1	□	●	●	
derivative 2	●	□	●	
derivative 3	●	●	●	

● contrast
□ no contrast

Plate 13 Conventional color harmonies.

Plate 14 Leprechaun. Drawing by Egil Röckner.

Plate 15 Riverdance photograph by kind permission of Abhann Productions.

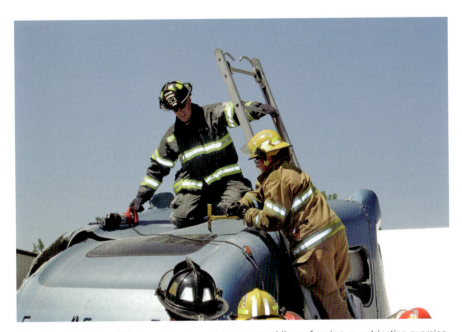

Plate 16 Firefighters' black and tan turnout gear worn while performing an extrication exercise. Photograph courtesy of the author.

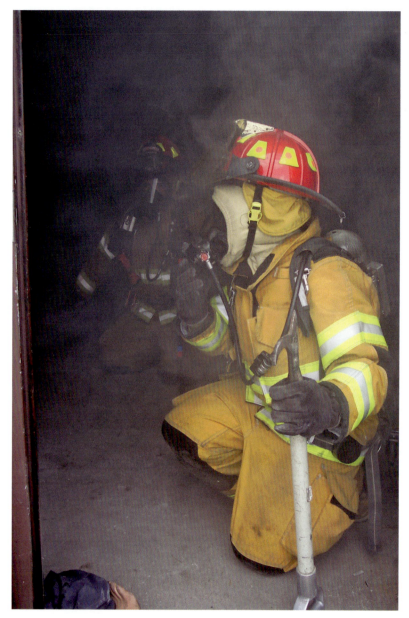

Plate 17 Firefighters' yellow turnout gear worn during a live fire exercise. Photograph courtesy of the author.

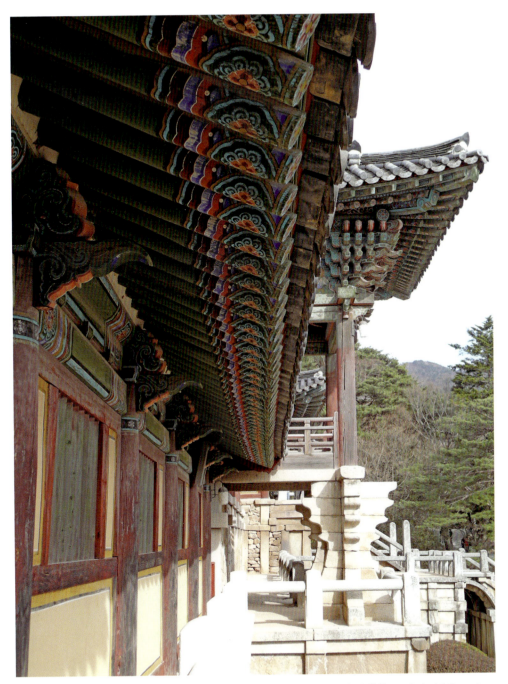

Plate 18 *Dancheong* at *Bulguksa*, temple of Buddhism in Gyeongju, *United Shilla* period, eighth century. *Dancheong* refers to the painting of building constructed of wood. In addition to its decorative function for beauty and majesty, it was applied for practical purpose to prolong the life of the building. Photograph by Hyeon-Joo Kim.

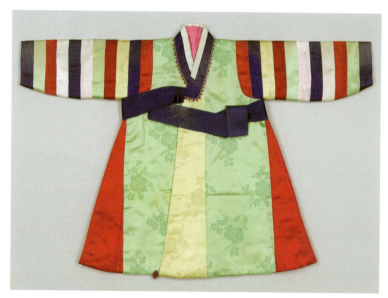

Plate 19 *Kachi Durumagi* was worn by young children on New Year's Day at the end of the *Joseon* period. The name *Kachi* was taken from the word for a bird, magpie, which was supposed to bring good news the day before New Year's Day, and signifies a desire to enjoy the New Year. The color of *Git* (neck band) represents the gender of wearers: blue for a boy and purplish-red for a girl. *Kachi Durumagi* was also used for the clothing worn on the first birthday, using the colors of the Five Elements to keep evil spirits away and to wish for a long life for the child (Kim 1987: 132–35).
Source: The National Folk Museum of Korea.

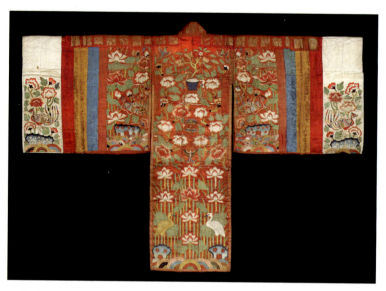

Plate 20 *Hwalot* for wedding ceremony, the *Joseon* Dynasty. *Hwalot* is a type of Korean traditional clothing worn by a bride for the wedding ceremony. It had auspicious designs embroidered on the surface of red color.
Source: The National Folk Museum of Korea.

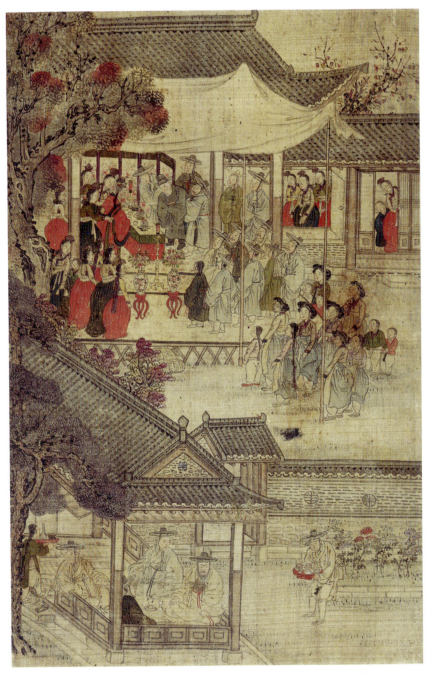

Plate 21 *Pyeongsaengdo*, sixtieth wedding anniversary, painted by Hong-Do Kim, late eighteenth century. *Pyeongsaengdo* is a series of drawings that show important life events such as first birthday, wedding, and other ceremonies. With the husband and wife to celebrate their sixtieth anniversary, this drawing depicts the festivities of their family through distinct colors such as red, yellow, blue, and green apparel. In contrast, this drawing also shows guests in white, to depict Koreans' preference for white.
Source: The National Folk Museum of Korea.

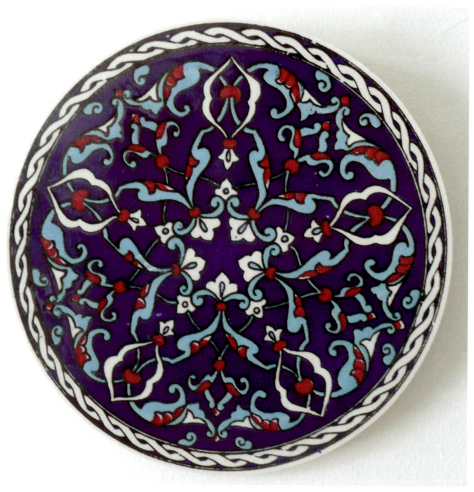

Plate 22 Traditional Iznik tile motifs. Photograph by Gozde Goncu-Berk.

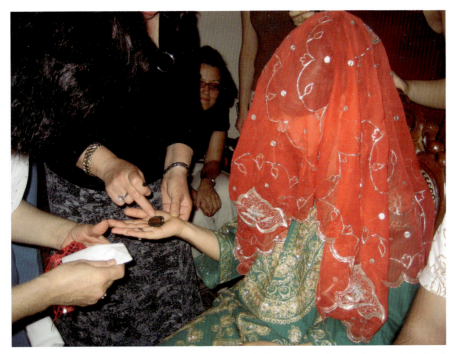

Plate 23 Henna and a gold coin are placed in the bride's palm during the henna night ritual. Photograph by Gozde Goncu-Berk.

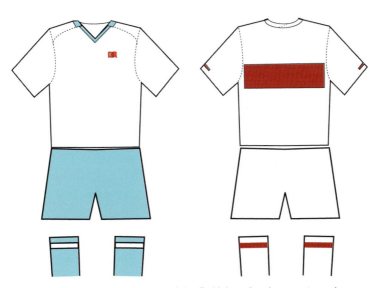

Plate 24 Exemplary illustrations of the Turkish national soccer team jerseys. Drawing by Gozde Goncu-Berk.

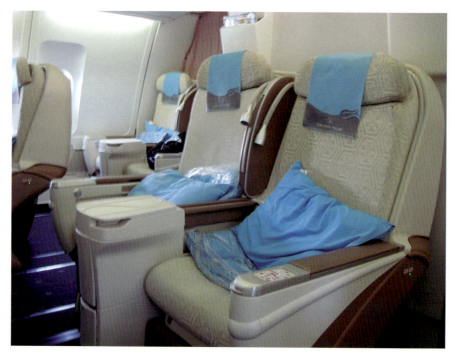

Plate 25 Turkish Airlines' aircraft interior decoration. Photograph by Sebastian White.

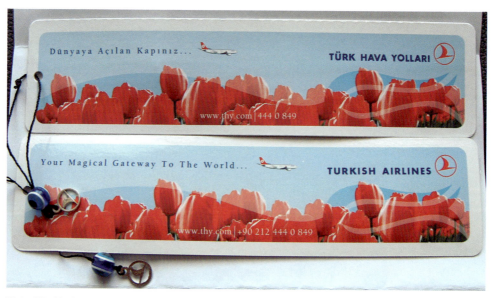

Plate 26 Bookmarks given as complimentary gifts by Turkish Airlines. Photograph by Abdullah Nergiz.

Plate 27 Author Monica Sklar's pink, red, and orange hair.

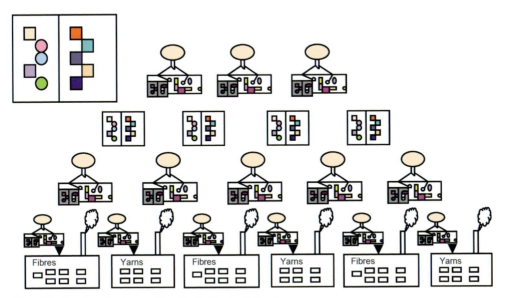

Plate 28 A national color meeting. Illustration by T. Cassidy.

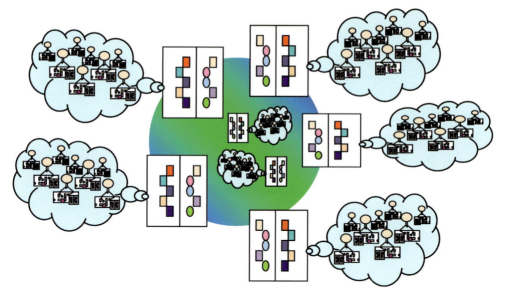

Plate 29 The national color meetings happening simultaneously around the globe. Illustration by T. Cassidy.

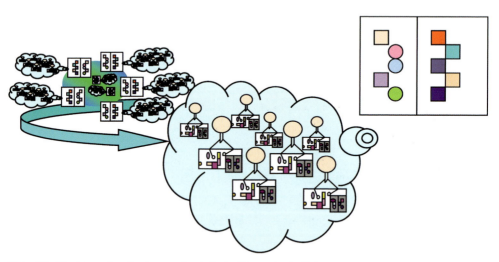

Plate 30 The international color meeting in Paris. Illustration by T. Cassidy.

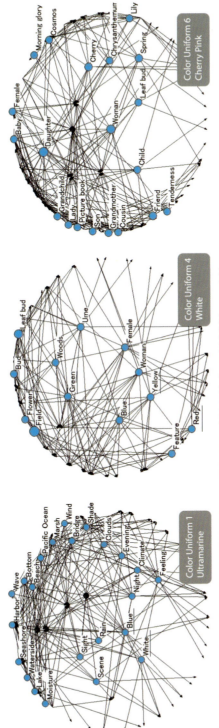

Plate 31 Associations for colors in cases of CU1 (ultramarine), CU4 (white), and CU6 (cherry pink).

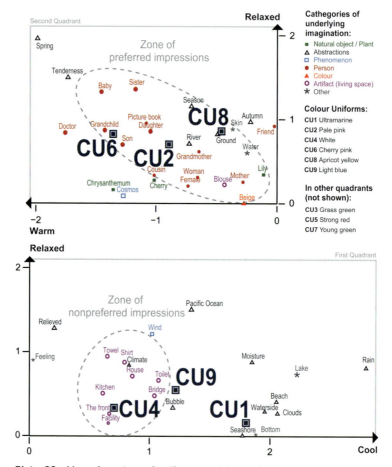

Plate 32 Maps for colors of uniforms and the underlying associative words based on CRA.

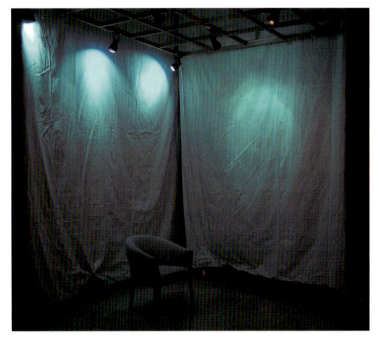

Plate 33 A "calming" ambiance.

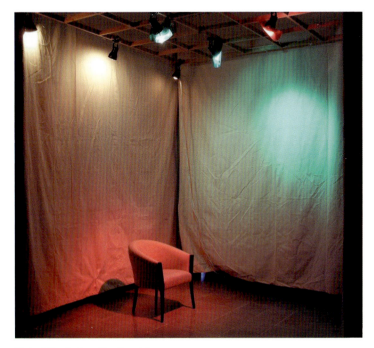

Plate 34 An "exciting" ambiance.

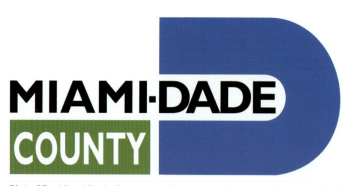

Plate 35 Miami-Dade County identity, showing the major elements of a city brand logo: unique typography, clearly articulated color scheme, and graphic form. Courtesy of Miami-Dade County.

Area Name	Government Logo	Primary	Secondary	Tertiary	Travel Logo	Primary	Secondary	Tertiary
Toronto Ontario	**TORONTO**	Blue	White	None	tourism **toronto** Toronto Convention & Visitors Association	Black	Purple	None
Montréal Quebec	Montréal	Red	White	None	à la **M●ntréal**	Brown	Red	None

Plate 36 Sample of two database entries, Toronto and Montreal. Note the use of two different logos, one by the civic government, one by the travel and tourism NGO. Table by Alex Bitterman.

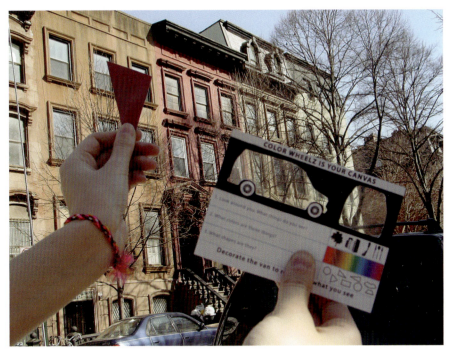

Plate 37 Color Wheelz instructional sheet, NYC, NY. Photo courtesy of the author.

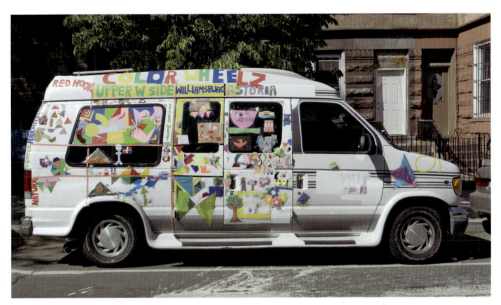

Plate 38 Color Wheelz van, NYC, NY. Photo courtesy of the author.

Plate 39 Thermos with open discharge.

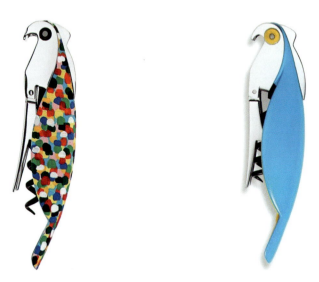

Plate 40 Parrot corkscrew, Alessandro Mendini. Courtesy of/© Alessi (www.alessi.com).

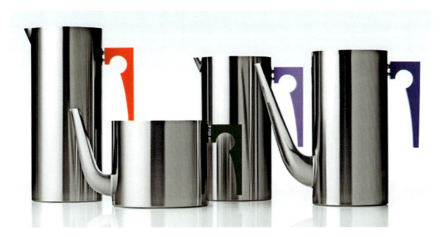

Plate 41 Arne Jacobsen's classics in Paul Smith's colors. © Stelton A/S (www.stelton.dk). Photograph by Tue Schiørring.

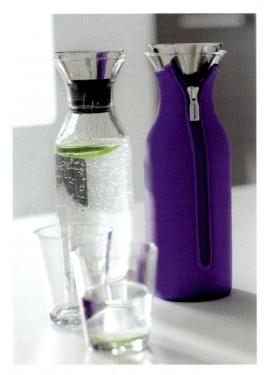

Plate 42 Decanter, Eva Solo. © Eva Solo (www.eva solo.com).

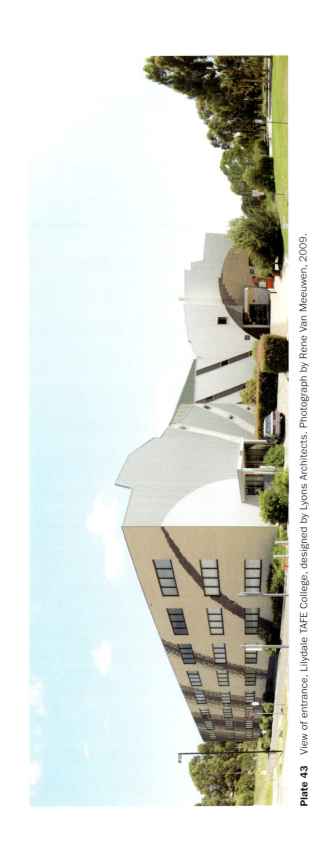

Plate 43 View of entrance, Lilydale TAFE College, designed by Lyons Architects. Photograph by Rene Van Meeuwen, 2009.

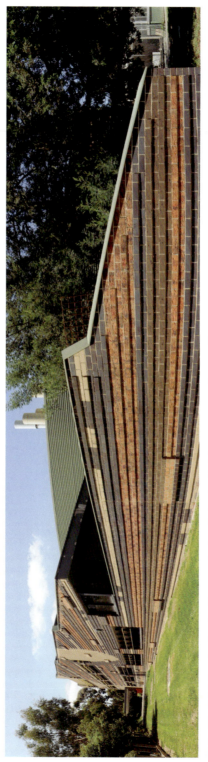

Plate 44 Brick façade showing the use of color of standard bricks to create an image effect. Lilydale TAFE College, designed by Lyons Architects. Photograph by Rene Van Meeuwen, 2009.

Plate 45 View from the internal courtyard of the façade showing the Eternity graffiti and the use of red. National Museum of Australia, Ashton Raggatt McDougall. Photograph by Rene Van Meeuwen, 2009.

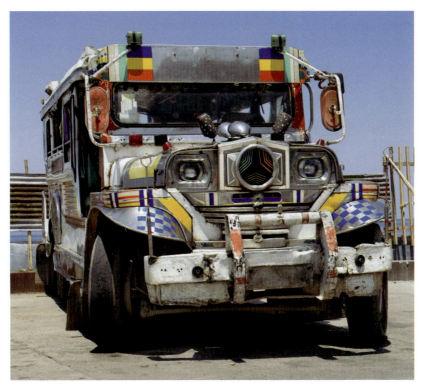

Plate 46 Filipino Jeepneys are recycled and rebuilt American jeeps from World War II used as buses for local public transport. Photograph by FlemishDreams.

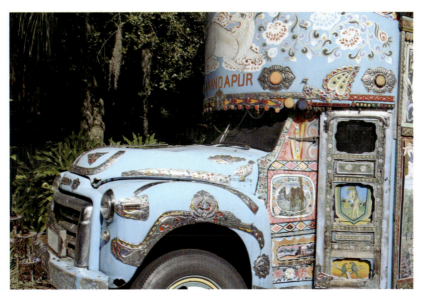

Plate 47 Indian bus encrusted with multicolored decorations. Photograph by Elvis Santana.

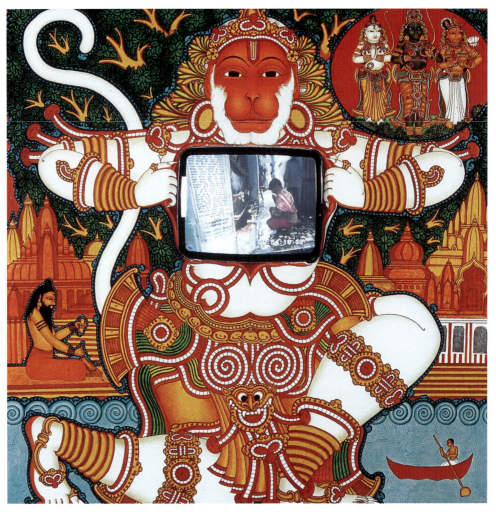

Plate 48 Ranjit Makkuni, Crossing Project: Living, Dying, and Transformation in Banaras, Sacred World Research Laboratory, New Delhi, 2001. Photograph by Sacred World Research Laboratory.

−7−

Color and Cultural Identity in Ireland

Helena Wulff

Chapter Summary. With its green landscape, Ireland has long been identified as the Emerald Isle, or the Green Isle. This chapter explores the politics of the color green in Ireland as cultural identity constructed in relation to firstly, dress, and secondly, tourist design. Starting out as a political statement of insider identity among Irish people, green became an identity marker to outsiders signaling Irishness. The ban on the wearing of the green during colonialism reinforced the significance of green in Irish inside identity. Now green remains an indicator in outsiders' construction of Irishness. The extensive wearing of the green on St. Patrick's Day, the national day, is a continued celebration of national independence, cultural identity, as well as recognition by outsiders. The impact of Ireland's green reaches across the globe such as when Riverdance represents Ireland abroad. The color green is the signature color in the branding of Ireland as a tourist destination.

Ireland is often referred to as the Green Isle, or the Emerald Isle, not because emeralds are to be found there, but because the rain makes its countryside greener than in most places in Europe.[1] But why is green still a prominent color in Ireland? What does green convey about Ireland and the Irish? What does Ireland's green symbolize for the Irish on one hand, and for foreign tourists on the other? This chapter explores the politics of the color green in Ireland as cultural identity constructed in relation to firstly, dress, and secondly, tourist design (Wulff 2007a,b).[2] Identity has mainly two sides: the inner side that is cultivated among people who share an identity, such as a cultural identity, and the outer side, which is how they present themselves to outsiders. Even though there are overlaps, the two sides are somewhat different. A third side of cultural identity is its construction by outsiders.[3]

Importantly, this anthropological research on cultural identity and the color green in Ireland reveals a color to be highly charged politically and culturally. There was a time when there was a ban on "the wearing of the green" in Ireland (Cronin and Adair 2002: xiii). Now green is the signature color in the branding of Ireland as a tourist destination. One of the first instances when a tourist might notice Ireland's green is, of course, around the Irish national airline, Aer Lingus, which has its logo, a green shamrock, painted on its planes. Its crews are dressed in green uniforms.

Green is one of the colors of the tricolor, the national flag of the Republic of Ireland, the other colors being white and orange. Green was identified as the national color long before Ireland became an independent nation, which it did in 1922, after 400 years of British colonialism. Going back in history, it is significant that there was no typical Irish or national dress (Cullinane 1996). Instead, in the nineteenth century, there was an English ambition to have Irish people follow English fashion (Robb 1998). Cronin and Adair (2002: xiii) quote an Irish nineteenth-century ballad entitled "The Wearing of the Green" by Dion Boucicault, which says: "And they're hanging men and women for the wearing of the green," and it continues: "Then since the colour we must wear is England's red, Sure Ireland's sons will ne'er forget the blood that they have shed." The ballad also talks about how wearing a shamrock in one's hat was a way to rebel. Green was the color of the republican revolutionary organization, Society of the United Irishmen. But in the beginning of the twentieth century, the Gaelic League[4] launched a national costume as one way to promote Irish culture: kilts for men while women wore long dresses with shawls. Green dominated and red was avoided because of its association with England. It was this national dress that was turned into Irish dancing costumes that often still are green or have green details. These colorful costumes with Celtic embroidery represent different Irish dancing schools. Dancers who have won medals at competitions might sew the medals on the costumes. Girls' and women's costumes are supposed to be modest with skirts reaching not more than four inches above the knee. Now boys and men tend to wear black trousers and a white shirt rather than a kilt. Irish dancing costumes are worn at championships in Irish dancing in Ireland and further afield, in Britain, the United States, Canada, Australia, and New Zealand (Wulff 2007a), and at other major events abroad when Irish dancers represent Ireland, ranging from Irish cultural festivals to St. Patrick's Day celebrations in Tokyo, Dubai, and Montserrat among many other events worldwide. Since 1994, when Riverdance, the Irish dance show (Plate 15), had a sensational breakthrough as an interval entertainment in the annual Eurovision Song Contest broadcast from Dublin, this show with its long line of glamorous Irish dancers beating the floor, has also represented Ireland on a global scale (Wulff 2007a). Green has often appeared in their costumes, in the women's soft miniskirts with black tights, and the men's open shirts and black leather trousers, as well as in the marketing of the show, in posters and on CDs, DVDs, videos, and souvenirs from the show.

CULTURE AND COLOR

In anthropological texts, color has been inserted here and there as adjectives in order to paint lively ethnographic portraits of people and their lives. There is also a strand that has included attention to colors in symbolic analysis. Victor Turner's ([1969] 2008) research among the Ndembu people is a prominent classic, highlighting multivocal meanings of red, white, and black in local rituals. It is these three colors that Berlin and Kay (1969) identify as the most basic colors in their influential but somewhat

controversial study *Basic Color Terms*. Red, white, and black recur in earlier anthropological studies mostly in relation to relatively small traditional societies (cf. Jacobson-Widding 1979). They are, of course, bodily colors to be found in blood, semen, and breast milk, and pupils, and in that sense universal, but their cultural meanings do vary quite substantially. There may not even be a semantic domain for certain color words, as Wierzbicka (2006) has noted, which has to be taken into special account in research on color. And there are, again, many cultures where other colors are more significant than red, white, and black, such as green in Ireland. Diana Young (2005: 61) writes about the impact of the smell of green-ness among the Pitjantjatjara people in the Western desert in Australia. Young found that they made a connection between color and odor, and that "when the first rain drops hit the ground after a long dry spell, the smell of land is the smell of the new green growth to come."

Berlin and Kay (1969) argued that color naming is related to biology and thus universal rather than only cultural. In their comparison of terms for color in twenty languages, they found that color naming originates in perception. Those languages that separate six colors, according to Berlin and Kay, have terms for black, white, red, green, blue, and yellow. This is where they mention green. In *The Anthropology of Color*, edited by MacLaury, Paramei, and Dedrick (2007), there is a section on green in an article by Irena Vaňková (2007: 448–49). She observes that "both red and green colors are closely connected with elementary human experience with the world," and goes on to say that "green is—contrary to animal red—primarily the color of plants, vegetative life." But when green is linked to a human being, it has a negative meaning: "In relation to the human body, green always means illness even closeness of death and decay." Vaňková also considers that "beings that are non-human—but that resemble human beings and have a face—are often depicted as green, especially water goblins or water nymphs that often have not only green hair, but also a green complexion."[5] This could have been a description of Irish fairies who are visualized as all kinds of elusive creatures in imagery, but characteristically green, at least partly, in appearance or dress.

GREEN IN IRISH TRADITION AND ADVERTISEMENT

Irish fairy legends are still being told in Ireland. There are urban contemporary ones as well as traditional legends. These stories are in many cases living legends that are transferred between generations. A fairy legend is typically a story about a human who meets other beings, so-called good people, little people, or fairies. It opens in the ordinary, in everyday life or on a journey, but then something remarkable, good or bad, suddenly happens. The legend tends to close back in the ordinary. (In folklore, the belief in legends is explained by the storyteller's ability "to reconcile the impossible with the unexceptional." Whether the listeners believe in them, or not, it is the betwixt-and-between nature of fairy legends that make them alluring, according to Bourke 2003: 27–30.)

When some fairies or other figures from Irish mythology make it to tourist design, a part of inside Irish cultural identity has moved to one promoting Irish identity to outsiders. This is especially materialized in dolls of the little leprechaun (Plate 14) in a green suit and a big green hat. Leprechauns are said to be shoemakers and known for saving all their money in a hidden pot of gold at the end of the rainbow. These tricksters are traditionally believed to bring luck, but they can be both good and bad, and do engage in mischief. If a leprechaun is ever captured by a human, he is supposed to have the magical power to grant three wishes in exchange for his release. Stories about leprechauns are told by professional storytellers at festivals, and informally as oral tradition, also to and among children. There are children's books on leprechauns, and many references in literature and poetry, both classic and contemporary, to these little creatures. They appear in popular culture such as film and television cartoons, as well as in advertisements. This is not always appreciated by Irish people, though, who sometimes see popular versions of leprechauns as stereotypes. This is the point of departure for media scholar Diane Negra (2001: 77) in the article "Consuming Ireland: Lucky Charms Cereal, Irish Spring Soap and 1–800-Shamrock," where she critiques the usage of the leprechaun in tourist advertisements of Ireland in the United States. Her purpose is to "challenge the notion of that cruel stereotypes such as the Lucky Charms leprechaun are best shuddered at and dismissed (however tempting)." She goes on to argue for a "linkage between commodification and colonialism."

Studying the consumption of Irishness in the United States, Natasha Casey (2006: 91–109) interviewed Irish Americans and Irish Canadians who she admits had a favorable, even romantic view of Ireland. To her question: "When you hear the word *Ireland* what idea, images, or words does it conjure up?," a woman college teacher replied: "Green hills, ocean, castles, fairies." The reply from a man who worked as a technician also started by emphasizing the green-ness: "Green shamrocks, Book of Kells, Irish traditional music." Also a man working with environmental issues included green in his observations of Ireland: "friendly towards Americans, green, and pubs." As did a woman student who said that the word *Ireland* made her think of "the country of Ireland, green, Irish dance and music, friendly people, rainbows, Irish language, Celtic symbols." Four out of five reported replies included a reference to something green in Ireland. It is likely that these replies partly emanate from direct experience of Ireland, in combination with family stories about the land of their parents and/or grandparents that the interviewees had heard while growing up. There is also a striking resemblance in these replies with how slogans in Irish tourist advertisements tend to be phrased.

In an article on emotions, memory, and nature in images of travel and tourist advertisements of Ireland, I described how:

> Images of Irish journeys stand out for their particular combination of portraying hospitality, traditional culture in music and dance, wit and loquacity. There is an abundance of pastoral landscapes and dramatic cliffs along the coast. On the home page of Tourism Ireland in 2004, an image unfolded of horses galloping on a beach against a background of a blue sea. This was soon followed by the text "Welcome to the island of memories." (Wulff 2007b: 532)

The dominant color on the website was green, and there was a shamrock in a corner. Tourism Ireland still has a green shamrock as logo. In 2011, there was also a green background with a shamrock inserted and a text welcoming visitors to Ireland. Contrary to the 2004 texts and captions, the 2011 invitation combines the romantic rural past with a more contemporary urban scene when it presents Ireland as:

> blessed with a tapestry of magical natural settings that have become the inspiration and stage for many an Irish myth and legend, Ireland is home to vibrant and cosmopolitan cities, picture-card country landscapes and retreats, and a friendly and artistically creative population, always welcoming to visitors with a smile and no doubt a story and a joke or two! (http://www.discoverireland.com.sg/consumer/en/index.html)

Going back to the replies in Casey's (2006) study, in light of the fact that the interviewees were of Irish descent, some personal reminiscences could have been expected. There is nothing about people, or visiting relatives. Incidentally, this parallels interview replies I got in my study on tourist imagery in Ireland (Wulff 2007b). This is very interesting not least as there was a major difference in our studies in the sense that Casey's question about Ireland focused on the "word Ireland" while my study investigated visual imagery of Ireland. This meant that my interviews took the form of photo-elicitation (Harper 2002). I showed (the same) ten tourist images to every interviewee, asking for his or her comments to them. The images were from travel catalogues and tourist sites on the Internet. They represented the Irish rural landscape as well as urban settings, some featured people, Irish as well as tourists. I also encouraged the interviewees to select images advertising Ireland, images they found startling, and tell me about them. And I asked the interviewees to write stories about one or two images and send to me on email. An Irish nurse sent this comment on email where she discussed the idea of reality in relation to tourist imagery:

> The pictures are often of nature or people who eat, drink, play music and dance. The pictures of nature are probably very realistic—you have been here yourself and know how pretty the countryside is. When I see the pictures I think of the greenery. I am reminded of how green it actually is. (Wulff 2007b: 532)

In my pursuit here to trace the color green in Ireland, what stands out in this reply is: "When I see the pictures I think of the greenery. I am reminded of how green it actually is." The nurse had lived in Sweden, and was contemplating moving back there again. This made her write about her longing for Ireland when she was abroad, and that:

> What I will miss if I return to Sweden, is the greenery, the little fields and the beaches by the sea. There is a harmony in all these things that I have never experienced anywhere else. (Wulff 2007b: 536)

Also here, green, in the form of landscape greenery, and presumably green "little fields," is what makes the difference, what the nurse expects is what she would miss if

she were to move back to Sweden. Taken together, all these replies from Casey's study as well as from my study, bring out an emphasis on the color green in Ireland, both in verbal terms and in visual imagery.

GREEN IN MODERN TRADITION AND FASHION

The green element in Irish dancing costumes is used both as a way to foster Irish cultural identity and a sense of belonging among Irish people (including non-Irish who take part in the dancing), and as a way to promote Ireland abroad at major events and celebrations to outsiders, as well as in tourist advertisements where images of Irish dancers appear such as on postcards. There are dolls of Irish dancers in different sizes and materials for sale. And not only are costumes worn at Irish dance performances as a part of national celebrations on St. Patrick's Day, March 17, the national day in Ireland, typically green, but it is also more common than not to dress up in green, on this day both in Ireland and in the diaspora. This can range from just one garment such as a tie or a skirt to wearing a spectacular green attire for the St. Patrick's Day parade in Dublin, as well as in New York, Sydney, or Tokyo.

On St. Patrick's Day in Dublin in 2002, a dance critic who figured in my study on dance and culture in Ireland gave me a real shamrock, which she fastened on my lapel before I went out to watch the parade in the rain. She also invited me to her family's St. Patrick's dinner. As we were getting ready to go, she said that she was looking for a certain scarf as "I'm going to wear something green!" And when I asked a woman choreographer, also a part of this study, the following week if she had celebrated St. Patrick's Day, her reply was "No, I didn't do anything. Just bought a green dress for my granddaughter" (Wulff 2007a: 107).[6] Which, of course, is a significant act after all.

St. Patrick's Day is the day when the river Liffey that runs through Dublin is dyed green. The celebration, in the form of parades and parties, has been criticized by some for being commercial and commodified, but for others this is a lighthearted family feast with Irish tourist paraphernalia from leprechaun green hats in adult sizes and plastic shamrock tiaras to green beer in pubs. The Dublin parade has become a multicultural event in a cosmopolitan context. The mood is inclusive, inviting anyone to Irish cultural identity—at least for this joyous day, just like my dance critic did when she saw to it that I wore a shamrock (Wulff 2007a: 134). In her study of young musicians in Ireland, Virva Basegmez (2005) noted on St. Patrick's Day that "the celebration of Irishness by non-Irish people is, however, more like a masquerade, or perhaps a 'cool thing to do,'" yet she confesses that it did make her feel "a little Irish" temporarily, as did I when I was wearing my shamrock.

When it comes to Irish high fashion, green is included, but not as a distinct color. Recently, green has had an additional meaning in relation to Irish fashion as described in the feature "Irish Fashion Goes Green" by Melanie Hick (2008). It is about Ireland's first festival of sustainable fashion.[7] Hick writes:

Ireland, a country renowned for its lush rolling green hills has never before held a green fashion week. They're making up for that great shame by launching *Fashion Evolution,* Ireland's first ethical fashion week, which will take place in Dublin from 19th–25th April. Over six days the fash fest will cover ethical and environmental issues within the Irish and international fashion industry. A series of public and industry masterclasses and events will culminate in a big green bash on Thursday April 24th. Big names include Katherine Hamnett, Mike Barry, head of Marks and Spencer's corporate social responsibility and Dilys Williams, director of London College of Fashion's new Centre for Sustainable Fashion. Ethical fashion is the future, and the festival should deliver some results the worldwide industry can learn from. (http://www.thevine.com.au/fashion/news/irish-fashion-goes-green20080419. aspx)

GREEN AS CULTURAL IDENTITY AND RECOGNITION

By way of historical data, ethnographic observations, and interview extracts, this chapter has shown that the green landscape of Ireland, the Emerald Isle, or the Green Isle, is indeed the source of the national symbolism attributed to the color green in Ireland. Starting out as a political statement of insider cultural identity among Irish people, the color green soon became an important identity marker in relation to outsiders signaling Irishness. The ban on the wearing of the green during colonialism seems to have reinforced the importance of green in Irish insider identity. Now green remains an indicator in outsiders' construction of Irish identity. It is noteworthy that expressions of green in the three sides of Irish cultural identity are to be found separately, as well as simultaneously. The extensive wearing of the green on St. Patrick's Day continues to be a celebration of national independence, of cultural identity, and recognition by outsiders. Such national pride reaches abroad, in fact across the globe, such as when Irish dancers perform Riverdance, representing Ireland abroad. Irish politicians and ambassadors, as well as writers, and other artists, can also be seen wearing green when they represent Ireland abroad, especially when they give speeches or appear at social functions. The fact that the color green, moreover, is a signature color in the branding of Ireland as a tourist destination both in travel advertisements and material objects is yet another sign of its cultural significance. Irish tourist design is invariably green. This is a color known to be associated with Ireland, and thus continues to be promoted as such by the Irish tourist industry.

Finally, in terms of green as a part of the branding of Ireland as a tourist destination, green is considerably more strongly emphasized in Irish tourist advertising on Internet websites, in television commercials, and in travel brochures than the national (flag) colors of countries such as Britain, France, Germany, Sweden, India, or China. The colors of the flags of these nations also appear, especially in the advertising of Britain, Germany, Sweden, China, and of course, India with its "Incredible India" campaign, but far from as prominent and elaborate as green design, such as Celtic knotwork, the harp, shamrocks, and leprechauns, does in Irish tourist advertisements.

NOTES

1. The association of green with Ireland can be found in early Irish texts. The first reference to the Emerald Isle seems to be in a 1795 poem by the Belfast United Irishman William Drennan, where the green of the country is clearly the basis for the epithet. B. Ó Cuív, in "The Wearing of the Green," *Studia Hibernica*, 17–18 (1977–1978): 107–19, also mentions a statement by John of Salisbury (written in 1159) referring to the Pope's grant of Ireland to Henry II of a token of his investiture of the government of Ireland sent to the king in the form of a gold ring adorned by an emerald. (Personal communication with Diarmuid Ó Giollain January 24, 2011.)
2. This chapter builds on the anthropological research project "Dance in Ireland: Memory and Mobility in a Postcolonial Age," funded by the Bank of Sweden Tercentenary Foundation. Research methods have been participant observation and interviews, as well as archival work.
3. See R. Byron, "Identities," in *Encyclopedia of Social and Cultural Anthropology*, ed. A. Barnard and J. Spencer (London: Routledge, 2002), 441, for an anthropological definition of identity as either "properties of uniqueness and individuality" or "qualities of sameness, in that persons may associate themselves, or be associated by others, with groups or categories on the basis of some salient, common feature, e.g. 'ethnic identity.' " As Byron says "nations are frequently said to have identities."
4. Founded in 1893 in Dublin by politicians and artists aiming to strengthen the position of the Irish language and national culture such as dance, this association still exists although with less political impact. It did contribute to making Ireland an independent nation. D. Ó Giolláin, *Locating Irish Folklore: Tradition, Modernity, Identity* (Cork: Cork University Press, 2000).
5. Vaňková expands her exploration of green to include how we imagine "inhabitants of Mars" as green, and enumerates "green demons, green phantoms." She notes that "green faces often appear in horror films." I. Vaňková, "To Have Color and to Have No Color: The Coloring of the Face in the Czech Linguistic Picture of the World," in *Anthropology of Color*, ed. R. Mac-Laury, G. Paramei, and D. Dedrick (Amsterdam: John Benjamin, 2007), 448.
6. O Suilleabhain writes about the idea in Irish folklore that green in children's clothes and at weddings is regarded as unlucky. S. O Suilleabhain, "Green," in *A Handbook of Irish Folklore* (Detroit: Singing Tree, 1970).
7. "Ethical Fashion is an umbrella term to describe ethical fashion design, production, retail, and purchasing. It covers a range of issues such as working conditions, exploitation, fair trade, sustainable production, the environment, and animal welfare." Victoria and Albert Museum, http://www.vam.ac.uk/collections/fashion/features/ethical_fashion/ethical_fashion/index.html.

REFERENCES

Basegmez, V. (2005), *Irish Scene and Sound: Identity, Authenticity and Transnationalism among Young Musicians*, Stockholm Studies in Social Anthropology, 57, Stockholm: Almqvist & Wiksell International.

Berlin, B., and Kay, P. (1969), *Basic Color Terms: Their Universality and Evolution*, Berkeley: University of California Press.

Bourke, A. (2003), "The Virtual Reality of Irish Fairy Legend," in C. Connolly (ed.), *Theorizing Ireland*, Basingstoke: Palgrave Macmillan.

Byron, R. (2002), "Identities," in A. Barnard and J. Spencer (eds.), *Encyclopedia of Social and Cultural Anthropology*, London: Routledge.

Casey, N. (2006), "The Best Kept Secret in Retail: Selling Irishness in Contemporary America," in D. Negra (ed.), *The Irish in Us*, Durham, NC: Duke University Press.

Cronin, M., and Adair, D. (2002), *The Wearing of the Green: A History of St Patrick's Day*, London: Routledge.

Cullinane, J. (1996), *Irish Dancing Costumes: Their Origins and Evolutions*, Cork City: Cullinane.

Harper, D. (2002), "Talking about Pictures: A Case for Photo Elicitation," *Visual Studies*, 17/1: 13–26.

Hick, M. (2008), "Irish Fashion Goes Green," *The Vine* (April): 19.

Jacobson-Widding, A. (1979), *Red-White-Black as a Mode of Thought: A Study of Triadic Classification by Colors in the Ritual Symbolism and Cognitive Thought of the People of the Lower Congo*, Stockholm: Almqvist & Wiksell International.

MacLaury, R., Paramei, G., and Dedrick, D. (eds.) (2007), *Anthropology of Color: Interdisciplinary Multilevel Modeling*, Amsterdam: John Benjamin.

Negra, D. (2001), "Consuming Ireland: Lucky Charms Cereal, Irish Spring Soap and 1–800-Shamrock," *Cultural Studies*, 15/1: 7–97.

Ó Cuív, B. (1977–1978), "The Wearing of the Green," *Studia Hibernica*, 17–18: 107–19.

Ó Giolláin, D. (2000), *Locating Irish Folklore: Tradition, Modernity, Identity*, Cork: Cork University Press.

O Suilleabhain, S. (1970), "Green," in *A Handbook of Irish Folklore*, Detroit: Singing Tree.

Robb, M. (1998), *Irish Dancing Costume*, Dublin: Country House.

Turner, V. ([1969] 2008), *The Ritual Process: Structure and Anti-Structure*, New Brunswick, NJ: Aldine Transaction.

Vaňková, I. (2007), "To Have Color and to Have No Color: The Coloring of the Face in the Czech Linguistic Picture of the World," in R. MacLaury, G. Paramei, and D. Dedrick (eds.), *Anthropology of Color*, Amsterdam: John Benjamin.

Wierzbicka, A. (2006), "The Semantics of Colour: A New Paradigm," in N. J. Pitchford and C. P. Biggam (eds.), *Progress in Colour Studies*, Philadelphia: John Benjamin.

Wulff, H. (2007a), *Dancing at the Crossroads: Memory and Mobility in Ireland*, Oxford: Berghahn Books.

Wulff, H. (2007b), "Longing for the Land: Emotions, Memory and Nature in Irish Travel Advertisements," *Identities*, 14/4: 527–44.

Young, D. (2005), "The Smell of Green-ness: Cultural Synaesthesia in the Western Desert (Australia)," *Etnofoor*, XVIII/1: 61–77.

Websites

http://www.discoverireland.com.sg/consumer/en/index.html

http://www.thevine.com.au/fashion/news/irish-fashion-goes-green20080419.aspx

http://www.tourismireland.com

http://www.vam.ac.uk/collections/fashion/features/ethical_fashion/ethical_fashion/index.html

Signaling Protection: The Use and Function of Color in Firefighter Clothing

Jessica F. Barker, Lynn M. Boorady, and Susan P. Ashdown

Chapter Summary. Firefighters wear protective clothing in the form of turnout gear in order to effectively perform their required duties. Color variations in turnout gear are used by firefighters to determine new members, rank, and/or a particular fire company; however, there is no uniform understanding of the use of color in turnout gear. In this study, firefighters preferred tan gear over other colors. Certain colors are preferred by individual firefighters based on functionality—ease in identifying soil or damage, perception of reflecting heat, and even the perception of level of experience. However, no studies have been performed that indicate that a particular color functions better than other available colors for turnout gear, and the National Fire Protection Association (NFPA) does not recommend any particular color be used for turnout gear. Further studies are recommended in order to more fully understand the use of color in turnout gear.

Firefighters traditionally used their protective clothing as a last defense from fires, but as the structures and materials of buildings evolve, firefighters are increasingly fighting fires from inside rather than outside of buildings (Whitehead 2000). This shift in firefighting methods now puts firefighter gear as the first line of defense. It is critical that firefighter gear be as functional as possible, for both the firefighters wearing the gear and the public responding to the firefighter wearing the gear. Color is a key element of firefighter clothing for perceptual meaning for both the firefighter and the public and to fill functional needs of visibility and identification while fighting fires. Black and tan, as shown in Plate 16, are two common colors for turnout gear. In this example, two firefighters from different stations are performing an extrication exercise. Plate 17 shows yellow turnout gear, another common color, worn during a live fire exercise.

Each firefighting station, whether a municipal department of professional firefighters, or a volunteer station, chooses its turnout gear colors individually, so there are vast differences in gear colors chosen from department to department. The color of firefighter gear chosen by a department may reflect historical imperatives of the department and the overall firefighting occupation. Fire departments and individual firefighters spend a substantial amount of money procuring turnout gear. Economic considerations often

inform choices, especially for smaller volunteer fire departments. In these circumstances, more emphasis is usually placed on cost when departments select color of firefighter gear, rather than other factors such as department traditions. In situations where economic considerations are not as critical, specific colors may be preferred based on departmental traditions and occupational culture. Yet no studies or recommendations for manufacturers and fire departments were found to aid firefighters in the selection of appropriately colored turnout gear. The aim of this study is to identify how the color of firefighter gear can affect the gear's function, as well as possible impacts of color on the wearer's perceptions of the gear and the viewer's perceptions of the firefighter wearing the gear.

FUNCTIONAL ROLE OF COLOR IN FIREFIGHTING

The functional role of color in firefighting is pervasive. Color serves as a signal for a variety of information, including signage for water pressure levels of fire hydrants, flammable substances that are present at fire scenes, and even fire truck functions (Margrain, Birth, and Owen 1996). Much research has been done on the use of color to create higher visibility for fire trucks, through either base colors or contrasting reflective colored striping on the truck (Solomon and King 1995).

Fire departments use clothing color to differentiate between or create unity among firefighters. For instance, within a department, color variations in coats, pants, helmets, and/or positioning of contrasting reflective tape located on the helmet, coat, and pants can be used to signify the fire chief, firefighter rank, new recruits, or even companies of firefighters assigned to certain trucks. Distinguishing members among and within different firefighter departments can be an issue particularly if the department responds to fires regularly where other fire departments may also be responding. All firefighters within one department may wear identical turnout gear to more readily recognize each other, and may choose color to distinguish themselves from other local fire departments.

The color of firefighter gear can be constrained by material properties that limit the colors that can be achieved in the functional materials used to provide protection. The natural color of Kevlar 149, a para-aramid fiber that is the predominant fiber in many uniforms, is a deep gold color. Yarns and woven fabrics of Kevlar cannot be readily dyed, but different varieties of Kevlar are naturally colored differently (bright yellow, sage green, royal blue, midnight black). However, each Kevlar variety also has different strength and durability properties that may make them less desirable in firefighter turnout gear (Kadolph and Langford 2002; Yang 1993). This limits the range of colors available for firefighter gear and creates cost variations between colors. Similar problems exist with Nomex fabrics. Generally the highly crystalline nature of these materials makes them difficult to dye using conventional dyeing processes (Hodge and Dodgson 1991).

PERCEPTUAL ROLE OF COLOR IN FIREFIGHTING

The relationship between firefighters and the public is important, not only because fire-fighters are supported with public tax revenues, but also as the firefighter needs to have authority and to be able to elicit cooperation from the public in stressful situations. It is not known whether color of uniform can help or hinder this relationship, but the fact that people respond differently to different colors is well documented.

Research shows that colors invoke specific and consistent emotions in people and that these emotions can change as people age. A study of color-emotion linkages in adults found that bright colors (e.g., white, pink, red, yellow, blue, purple, green) produced more positive responses than dark colors (e.g., brown, black, gray) (Hemphill 1996). Clarke and Costall's (2008) investigation of emotional connotations of color also found that black and brown were viewed negatively. Of adult participants, 69 percent associated black with evil, malice, and death, while light, bright colors invoked positive emotions, such as happiness and pleasure. Terwogt and Hoeksma (2001) evaluated color preferences and emotions associated with colors for children aged seven and eleven years and adults. For adults and eleven-year-old children, black was most often associated with fear and was the least preferred color for all ages. In seven-year-old children, black was associated with anger and white was most commonly associated with fear. For all ages, blue was the most preferred color. Adults and eleven-year-olds also indicated a strong preference for red, as well, while seven-year-olds had a stronger preference for yellow. Other studies have documented that younger children are most attracted to yellow (Khambata 1967) and relate light colors with positive emotions and dark colors with negative emotions (Boyatzis and Varghese 1994).

These findings related to studies of color as an abstract concept may not apply specifically in real-world uses of color in clothing. However, others have studied how people respond to color and color perceptions of uniforms in a variety of situations, such as policing and athletics, that show some similar findings. In a study of police uniform color (Johnson 2005), black police uniforms were rated the most negatively when viewers were presented with four variations in uniform color (light blue shirt/navy pants, white shirt/navy pants, black shirt/black pants, and tan shirt/tan pants). A study of athletic uniform colors shows that athletes in black uniforms are perceived by viewers as meaner than those in other colors, while red-uniformed athletes are perceived as stronger (LeMaire et al. 2007). Similarly, Frank and Gilovich (1988) found that professional sports teams in black uniforms were penalized more frequently and harshly by referees than sports teams in white uniforms. Further, athletes wearing black uniforms behaved more aggressively than those in nonblack uniforms.

METHODS

Focus group interviews of firefighters were conducted to determine firefighter gear color selections and how such color selections affect perception and function of the gear.

Participants included eighty-nine career and volunteer firefighters from fourteen different fire departments, both urban and rural. Information was also collected on purchasing decisions. Focus group data were analyzed using content analysis and thematic analysis methods.

RESULTS AND DISCUSSION

Manufacturers commonly provide turnout gear in the following colors: yellow, gold, tan, red, blue, navy, and black (Globe n.d.; Lion n.d.; Veridian Limited n.d.). Among the fourteen fire departments represented, the firefighters reported wearing turnout gear colors of tan, black, and yellow, with tan as the most commonly worn color. Ten departments used tan turnout gear, two wore yellow gear, and one wore black gear. Sales data from manufacturers indicates a recent shift from tan gear to gold gear as the most popular color choice among fire departments, with black being the second most popular color choice (J. Mason, Product Manager of Uniforms, Lion Apparel, personal communication, December 6, 2010; B. Van Lent, President and Owner, Veridian Limited, personal communication, December 2, 2010). Among the departments participating in our study, gear color choices represented past color trends, most likely because the departments had not made recent purchases of new gear.

Color Function in Firefighter Clothing

Although this study reflects a small sample of firefighters, participants perceive functional impacts on turnout gear based on color, citing issues around visibility of dirt allowing for easier and less damaging cleaning of the gear, thermal effect of color, and enhancement of their visibility at night. Other functional purposes of gear color can be to relay information among firefighters, including rank, experience, and/or designation of members of specific truck companies or fire departments.

Of the gear colors represented in our study, the tan color was viewed most positively by the firefighters. Participants wearing tan gear indicated that the color was one of the better features of the gear. One functional property of this color that firefighters commented on was that lighter colors made it easier to see dirt and blood, thus allowing them to spot clean the gear as necessary rather than laundering the entire gear set. Firefighters wearing black gear reported having to wash their gear more frequently to keep it clean, since they couldn't see spots and therefore couldn't remove dirt from specific areas. Cleaning the whole gear more frequently resulted in more rapid deterioration of the gear.

Firefighters viewed the black gear as more problematic than the tan or yellow from a functional perspective. One functional issue cited relates to the thermal properties of color, in this case the fact that darker colors absorb heat, and lighter colors reflect heat. Those firefighters who hadn't worn black gear expressed concern it would be too hot,

and those wearing black gear confirmed that they felt hotter in black gear over lighter colors. Testing of the functional properties of firefighter gear related to color is limited. Given the fact that the uniform has many layers of thermal protection, it is not clear whether the small differences in thermal load due to the use of different colors would be significant. It is possible that the perception of black uniforms as being hotter to wear could be only a perceptual issue. Testing of the thermal properties of sets of gear that differ only in color could resolve whether this is the case.

Firefighters wearing black gear felt there were visibility issues with black gear, particularly at night. Even though all gear must have a certain amount of reflective tape, regulated by the National Fire Protection Association (NFPA),[1] reflective properties are often diminished by repeated washing or residual dirt and soot from fighting fires that builds up on the tape. Participants expressed concern that the darker color in combination with the reduction in reflection of the tape would greatly reduce their visibility as compared to lighter, brighter gear colors.

Wearer Perception of Firefighter Clothing Color

Although two departments currently wore yellow gear, responses of firefighters from other departments indicated that they felt that yellow gear was too bright to be acceptable. They cited a cultural stigma in firefighting against having bright, clean gear, which signals to other firefighters a lack of experience in live fires. Firefighters who received both tan and yellow gear believed that wearing new tan gear was more socially acceptable than wearing new yellow gear because the tan color appeared to be soiled even when new as compared to the yellow gear, which was more apparently clean and unused.

Despite the negative functional issues firefighters experienced with black gear, participants from three departments reported an aesthetic preference for black gear. The reason given for this preference was an aspiration to resemble New York's Fire Department (NYFD). A recent increase in the use of black turnout gear by some volunteer firefighter participants was attributed to a desire to show support for this fire department, in particular to honor the hundreds of NYFD firefighters who lost their lives on 9/11. One career department in our study switched to black gear shortly after 9/11, but stated the change was made due to more economical pricing of the black gear.

Previous research shows that black uniforms are viewed more negatively by people than light-colored uniforms, in a variety of situations, thus implying that the public may respond better to firefighters in lighter turnout gear. Further, our findings show that many firefighters had concerns specific to black gear. Given these factors, the popularity of black turnout gear by some firefighters is somewhat puzzling. The reason may lie in the psychological profile of the men and women who become firefighters. U.S. firefighters tend to be conservative, and reluctant to change traditional gear. For example, recent developments in European firefighter uniforms and helmets that are more form fitted and have functional advantages are generally rejected by U.S. firefighters. This can be due to two different factors: the desire to maintain their traditional image,

and the fact that they feel comfortable in the uniform they currently wear—they know and trust its functions and limitations. Changing to a new uniform, that must protect you from life-threatening conditions, is as not as simple as deciding on a new dress fashion.

Viewer Perception of Firefighter Clothing Color

Although firefighters in this study preferred tan gear, yellow gear may create a more positive public perception of firefighters than either tan or black gear. Adults may respond more positively to firefighters in lighter, brighter gear than those in darker gear. Research indicates that people of all ages associate dark colors with negative emotions (Boyatzis and Varghese 1994). Fear and anger are common emotions connected with the color black (Terwogt and Hoeksma 2001), and shades of brown (such as tan) also create negative responses (Palmer and Schloss 2010). Lighter, brighter colors in clothing invoke more positive emotions (Clarke and Costall 2008; Hemphill 1996) and perceptions of the wearer, particularly in uniforms (Johnson 2005; LeMaire et al. 2007), than dark-colored clothing.

Research also shows that children are highly attracted to yellow and even prefer this color (Boyatzis and Varghese 1994; Khambata 1967). A study of the response of young children to firefighters in yellow gear would be of interest given these results. Children may be more attracted to firefighters in lighter-colored gear than firefighters in darker-colored gear. Children are often frightened of firefighters when they are dressed in turnout gear (Saunders 2004). They may be less likely to hide from firefighters in light gear trying to help them escape a fire than those firefighters wearing dark gear.

CONCLUSIONS

The results of this study indicate that many firefighters prefer the tan-colored gear over the yellow or black gear. The black gear is perceived by these firefighters as hot and difficult to clean, and the yellow gear carries a negative stigma associated with gear that looks too new, indicating an inexperienced firefighter.

The NFPA currently regulates reflective materials on firefighter gear to ensure that a firefighter who is in trouble can be found by other firefighters, and so that firefighters working together in different conditions can be aware of each other's locations. It is possible that color could also play a role in these situations, yet no consideration has been made to the impact of color on firefighter gear performance. Further, there is no common understanding of the use of color of turnout gear or standard use of color to signify rank or experience, which could create confusion and identification challenges when multiple fire departments are brought in to deal with one situation. The development of performance specifications instead of specific regulations in this case may foster more creative and effective solutions to these problems.

Given these factors, the lack of color recommendations, and the desire of different firefighter departments to distinguish themselves from others (or to associate themselves with others, such as is shown by firefighters emulating the NYFD), the color variations exhibited by different firefighting units will probably continue. However, testing of the perception and functional properties of different colors of uniforms would give firefighters useful information for making decisions about the color of their gear. It is especially recommended that children's perceptions of and response to firefighters in different gear color be evaluated, to determine if children are less likely to hide from firefighters wearing certain colors. By determining if one color of firefighter gear will create more positive responses than another, guidelines for future selection of gear color can be developed for fire departments.

NOTE

1. The firefighter gear is required to have fluorescent and retroreflective tape that meets certain visibility requirements. The minimum fluorescent surface allowed is 50 mm^2/linear mm (2 in.2/linear in.) for all required trim. The reflective trim must be a minimum of 2 inches wide and be circumferential around each sleeve within 2 inches of the sleeve hem and another band within 1 inch of the coat hem. A horizontal band must be on the coat front at chest level within 3 inches of the sleeve at the underarm seam. The back of the coat may have either a horizontal band at the upper back or two vertical bands on the right and left sides, perpendicular to the coat hem. The trousers must have circumferential bands on both legs between the hem and knee area. Regulations also state the minimum gap in reflective tape due to elements that interfere with the application of the tape (i.e., zippers). National Fire Protection Association, *Standard on Protective Ensembles for Structural Fire Fighting and Proximity Fire Fighting*, 2007 ed. (Quincy, MA: National Fire Protection Association, 2006), 24–25.

REFERENCES

Boyatzis, C. J., and Varghese, R. (1994), "Children's Emotional Associations with Colors,"*Journal of Genetic Psychology*, 155: 77–85.

Clarke, T. and Costall, A. (2008), "The Emotional Connotations of Color: A Qualitative Investigation," *Color Research and Application*, 33: 406–10.

Frank, M. G., and Gilovich, T. (1988), "The Dark Side of Self- and Social Perception: Black Uniforms and Aggression in Professional Sports," *Journal of Personality and Social Psychology*, 54/1: 74–85.

Globe (n.d.), "Globe Firefighter Suits Gearbuilder," http://globefiresuits.com/globe/gearbuilder/#.

Hemphill, M. (1996), "A Note on Adults' Color-Emotion Associations," *Journal of Genetic Psychology*, 157: 275–80.

Hodge, J. D., and Dodgson, E. A. (1991), "Printing Technology for Aramid Fabrics," in T. L. Vigo and A. F. Turbak (eds.), *High-Tech Fibrous Materials: Composites, Biomedical Materials, Protective Clothing, and Geotextiles*, Washington, DC: American Chemical Society.

Johnson, R. (2005), "Police Uniform Color and Citizen Impression Formation," *Journal of Police and Criminal Psychology*, 20/2: 58–66.

Kadolph, S. J., and Langford, A. L. (2002), *Textiles,* 9th ed. Upper Saddle River, NJ: Prentice Hall.

Khambata, D. (1967), "A Study of Preschool Children's Color Preferences Selected from Three Primary, Three Secondary and Three Neutral Colors," master's thesis, Maharaja Sayajirao University, Baroda, India.

LeMaire, J., Short, S., Ross-Stewart, L., and Short, M. (2007), "The Effect of Uniform Color on Athletes' Readiness for Competition and Perceptions of Opponents' Attributes," *Journal of Sport and Exercise Psychology*, 29: S180–81.

Lion (n.d.), "Janesville Turnouts," http://www.lionprotects.com/lion-janesville-turnouts.

Margrain, T.H., Birth, J., and Owen, C.G. (1996), "Color Vision Requirements of Firefighters," *Occupational Medicine*, 46: 114–24.

National Fire Protection Association (2006), *Standard on Protective Ensembles for Structural Fire Fighting and Proximity Fire Fighting*, 2007 ed., Quincy, MA: National Fire Protection Association.

Palmer, S.E., and Schloss, K.B. (2010), "An Ecological Valence Theory of Human Color Preference," *Proceedings of the National Academy of Sciences of the United States of America*, 107: 8877–82.

Saunders, M. (2004), "Overcoming Children's Fear of Firefighter Gear," *Fire Engineering*, 157: 124–25.

Solomon, S.S., and King, J.G. (1995), "Influence of Color on Fire Vehicle Accidents," *Journal of Safety Research*, 26/1: 41–48.

Terwogt, M.M., and Hoeksma, J.B. (2001), "Colors and Emotions: Preferences and Combinations," *Journal of General Psychology*, 122/1: 5–17.

Veridian Limited (n.d.), "Turnout/Structural Products," http://www.veridian.net/turnoutgear.php.

Whitehead, K. (2000, June), "Can You Feel the Heat?," *Company Clothing Magazine*, http://www.companyclothing.co.uk/library/pdf/Features/ccjune10_fire_heat_634106444336494592.pdf.

Yang, H.H. (1993), *Kevlar Aramid Fiber*, Chichester, UK: John Wiley & Sons.

Blood Red, Soothing Green, and Pure White: What Color Is Your Operating Room?

Jeanne Kisacky

Chapter Summary. Until the early twentieth century, in the interests of cleanliness, operating rooms in American hospitals were all-white affairs. Between the 1910s and 1920s, doctors, hospital architects, and hospital consultants debated different colors for operating rooms as a means of reducing glare and improving the surgeon's vision. While some continued to champion "whiteness," many considered a blue-green color (the complementary color to blood) as a better, more "scientific" color choice. In the end, this debate reveals a shifting cultural configuration of color and sickness—as blue-green became the color of surgery, white shifted from signifying clean to standing for the uncomfortable sterility of the hospital.

"White is the color of cleanliness," wrote Miss M. E. McCalmont, a nurse and hospital superintendent, in 1913.[1] She did not mean it figuratively. In the early twentieth-century hospital, interest in aseptic (germ-free) conditions gave the traditional Western cultural equation of white with purity a new hygienic field of operation. White made dirt visible, this visibility promoted hygienic vigilance. As one practitioner put it, "An all-white operating room will lend itself to habits of cleanliness better than any other color, because dirt of any kind will obtrude to such an extent that the nurses or cleaners will have to remove it."[2] In turn-of-the-century surgical spaces, white paint, white tile, white furniture, white uniforms, and white linens were ubiquitous. The most prestigious hospitals installed expensive white marble everywhere—walls, doors, floors, ceilings, and trim.[3] White was an aseptic billboard; absence (of color, germs, dirt) was the message. See Figure 9.1.

But there was a problem with white surgical spaces; they were literally a pain in the eyes for the doctors. Operating rooms required shadow-free illumination of high intensity. In nineteenth-century hospitals, large windows and skylights provided extensive daylighting. By the early twentieth century, the skylights and windows grew larger while powerful electric lights also ringed the operating table. The glare from the all-white surfaces during surgery caused intense fatigue and eyestrain. That was dangerous. A surgeon who looked up from the wound to the glaring white walls might "find his eyes useless for a moment" when he looked back to "the less well illuminated wound."[4] But if not white, what color was an operating room to be? And why?

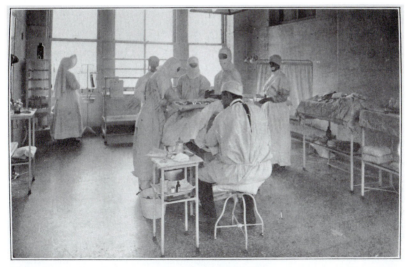

SALLE D'OPÉRATION

Figure 9.1 The all-white operating room of the French Hospital in New York City is relatively dimly lit, lessening the glare. From French Hospital, New York City, *Société Française de Bienfaisance de New York. Rapport Annuel du Président*, 1915, fp. 3.

In the early 1910s, to reduce glare, Dr. Carrell at the Rockefeller Institute in New York City covered his surgical subjects (lab animals) with dark cloths and operated in a dark green room.[5] By July 1914, he was using black garments and linens in his operations on people. At the same time, Dr. H.M. Sherman inaugurated the use of spinach green walls in St. Luke's Hospital, San Francisco. See Figure 9.2. Why dark green? According to Dr. Sherman, an operating room's color scheme "should start from the red of the blood and of the tissues." He chose spinach green, because it was complementary to, and thus would not visually compete with, hemoglobin or blood red. He also experimented with dark green linens, but because the green did not withstand steam disinfection, like Dr. Carrell, he resorted to black gowns, black sheeting, and black towels. The green room was soon the favorite of the hospital's operating rooms; "no one who could get into the green room to do an operation ever went into the white room." Doctor Sherman tried to explain the clear preference by speculating that the green lower walls, with bright (white) upper walls and ceiling, imitated "the optical environment out in the fields or among low bushes, where the ground of the surroundings, to above the level of the eyes is green, and the sky overhead is full of white daylight." This was the "natural" environment for eyes.[6]

The colorful craze spread. The Edward W. Sparrow Hospital of Lansing, Michigan, got Dr. Sherman's scheme upside down—its operating room had "white tiled floors and high, white vitrified tile wainscoting," but above that the "walls and ceilings are painted a soft but decided green."[7] Champions of other colors appeared. In 1915, hospital consultant Oliver Bartine agreed with hospital architect Meyer J. Sturm that

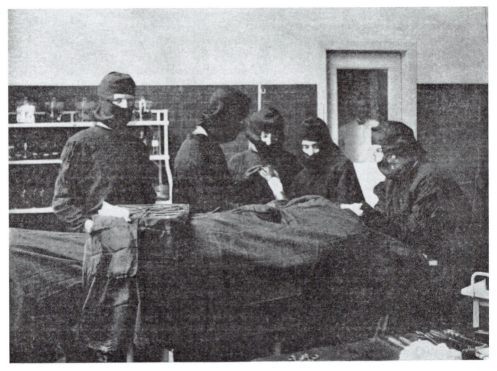

Operating room in St. Luke's Hospital, San Francisco, as arranged by Dr. H. H. Sherman.

Figure 9.2 Dr. H.M. Sherman's spinach green operating room and black linens and surgical garb in St. Luke's Hospital, San Francisco, 1914. From "Green and Black Operating Colors," *Modern Hospital*, 3/1 (July 1914): 67.

colorful operating rooms were useful, but rather than green, they suggested that "the walls should be treated in light tan color, with straw-color ceiling."[8] Another expert recommended a dull gray floor and lower walls with a darker gray above.[9] By 1918, experts confidently stated "a soft gray or light green color" was "more suitable than white for the walls of operating rooms."[10]

Nevertheless, champions of "whiteness" remained. In 1915, St. Mary's Hospital in Green Bay, Wisconsin, proudly announced its use of white glass walls for its new operating room.[11] In 1917, Texas doctor William Lee Secor broadened the argument for white. He noted that the original all-white operating room had been part of a spatial solution to the lighting problems of pre-electricity days—the large windows and the reflective white surfaces maximized daylight. By the 1910s, numerous experiments had also established that exposure to sunlight (and its UV rays in particular) killed microorganisms. White walls, by reflecting daylight, maximized this sterilizing effect. Secor worried that "to tint the walls of an operating room . . . makes it much more difficult to keep the room clean and sterile." Colored walls hid the "macroscopic" dirt and, by darkening the room, interfered with the natural germicidal influence of bright light. Secor's

solution to the problem of all-white rooms was straightforward: "to obviate the effect of the glare we have used beaks on our caps, and on bright days large amber-tinted spectacles are worn."[12]

The difficult interaction between color and lighting in the operating room created yet another problem. Color perception of the bodily tissues during surgery was critical to the surgeon's assessment of the patient's conditions. Daylight, or full spectrum light, provided accurate color perception, and white rooms with lots of windows provided daylight in abundance. Some worried that altering the colors of the operating room would alter the color of the light, and thus distort the surgeon's color perception of the surgical wound.[13] Others worried that colored operating rooms would be too "dark." In late 1915, Oliver Bartine published the light absorption rates of different colors as a warning against redoing operating room color without considering the effects on a room's ambient light.[14] In response, hospitals installed more and stronger supplemental artificial lights. The increased use of non-full-spectrum artificial lights provided yet another source of color distortion and brought back the original problem; when brilliantly enough lit, even green rooms had glare.[15]

Green, however, was increasingly hard to escape even though the exact shade varied. Between 1915 and the early 1920s the Chicago Lying-In Hospital had a delivery room painted in grass green; the hospital of the Iowa State College had a moss green operating room; another hospital reported a two-tone scheme with "dead-faced green" on the lower walls and a lighter green above.[16] Dr. Sherman stuck with his spinach green, noting that not only was it the complement of blood, it was a "mid-spectrum" color (then touted by several color theorists as the most desirable color range).[17] It wasn't until 1924 that Dr. Paluel J. Flagg, a New York doctor, used the new Munsell Color System to determine "scientifically" that the complement of blood-red was a blue-green. Dr. Flagg named it "eyerest" green.[18] (The ubiquitous blue-green scrubs of late twentieth-century hospitals are a clear indicator of the winning green).

The shift from white to green operating rooms was made in the interest of utilitarian scientific practicality. Color, however, is rarely a wholly scientific, practical undertaking. Any extensive use of a specific color (like the hospital's ubiquitous adoption of white or green) inevitably altered its cultural resonance. While green was being popularized "scientifically," white was being reinterpreted culturally. As early as 1914, architect Robert J. Reiley, noted that the standard white enamel hospital interior had become "repellant to patients."[19] By the 1920s, William O. Ludlow, another architect, thought that white suggested sterility and coldness, "and [lacked] all power to create pleasurable and helpful sensation."[20] White was harsh, sterile, inescapable; it created a "hyper-aseptic atmosphere."[21] Hospital expert Wiley E. Woodbury made the cultural shift explicit when he commented that "glaring white walls and white enameled furniture are suggestive of sickness."[22] Excessive whiteness might even be harmful. M. J. Luckiesh stated that white in overabundance had proven psychological ill effects. Ludlow suggested that the "unbroken whitened sterility of walls and ceiling produces sterility of thought in the sick mind."[23] If hospitals had made

green the color of surgery, they had also strengthened white as the color of cleanliness, but of a cleanliness so extreme as to be discomforting, sickening.

NOTES

1. M.E. McCalmont, "Practical Details in Hospital Planning and Equipment," *Brick Builder*, 22/7 (1913): 161.
2. "All-White Operating Rooms," *Modern Hospital*, 2/1 (January 1914): 45.
3. The world-famous Syms Operating Theatre of Roosevelt Hospital, in New York, (1891) was perhaps the most notorious use of extensive white marble.
4. "Green and Black Operating Colors," *Modern Hospital*, 3/1 (July 1914): 67. With the advances of anesthesia, asepsis, and surgical technique, the increasing duration of surgical procedures compounded the problem. While early nineteenth-century surgeries had often been measured in minutes, early twentieth-century surgeries were measured in hours.
5. "All-White Operating Rooms," 45.
6. "Green and Black Operating Colors," 67–68.
7. Maude Landis, "The Edward W. Sparrow Hospital, of Lansing, Michigan," *Modern Hospital*, 5/4 (October 1915): 236.
8. Oliver H. Bartine, "Artificial Illumination in Hospital," *Modern Hospital*, 4/1 (January 1915): 47.
9. "Operating Room Floors," *Modern Hospital*, 8/2: (February 1917): 148.
10. "Redecoration of Operating Room," *Modern Hospital*, 11/2 (August 1918): 150.
11. "Green Bay Has New Hospital," *Modern Hospital*, 4/1 (January 1915): 50.
12. William Lee Secor, "The White Operating Room," *Modern Hospital*, 9/3 (September 1917): 171. The caps were similar to the "Mayo Caps" worn at the Mayo Clinic.
13. M. Luckiesh, "Artificial Daylight in Surgery," *Modern Hospital*, 9/4 (October 1917): 3 11–12.
14. Oliver H. Bartine, "Hospital Construction," *American Architect*, 108/2077 (October 13, 1915): 241.
15. Luckiesh, "Artificial Daylight," 311–12.
16. "Operating Room Floors," 148; "Chicago Lying-In Hospital," *American Architect and Building News*, 108/2079 (October 27, 1915): 283; W.R. Raymond, "The Iowa State College Hospital," *Modern Hospital*, 17/1 (July 1921): 4.
17. Harry M. Sherman, "The Green Operating Room at St. Luke's Hospital, San Francisco," *Modern Hospital*, 11/2 (August 1918): 97–98. Sherman cited works on color theory and the physiology of color perception by Hering, Landon, Heckel, Risley, and Cutting.
18. Paluel J. Flagg, "A Scientific Basis for the Use of Color in the Operating Room," *Modern Hospital*, 22/6 (June 1924): 555–59; "Correct Color for Operating Room," *Modern Hospital*, 28/5 (May 1927): 56.
19. Robert J. Reiley, "The New Hospital of the House of Calvary," *Modern Hospital*, 3/2 (August 1914): 82.
20. William O. Ludlow, "Color in the Modern Hospital," *Modern Hospital*, 16/6 (June 1921): 511.

21. M. Luckiesh and A.J. Pacini, "How the Light and Color Improve the Patient's Room," *Modern Hospital*, 29/6 (December 1927): 116; Frank E. Chapman, "Hospital Planning and Its Trend," *Architectural Forum*, 49/6 (December 1928): 829.

22. Wiley E. Woodbury, "Some of the Special Departments of a General Hospital," *Architectural Forum*, 37 (December 1922): 272.

23. William O. Ludlow, "Some Lessons the War Has Taught," *Modern Hospital*, 12/4 (April 1919): 283.

REFERENCES

"All-White Operating Rooms" (1914, January), *Modern Hospital*, 2/1: 45–46.

Bartine, Oliver H. (1915, January), "Artificial Illumination in Hospital," *Modern Hospital*, 4/1: 46–48.

Bartine, Oliver H. (1915, October 13), "Hospital Construction," *American Architect*, 108/2077: 241–46.

Chapman, Frank E. (1928, December), "Hospital Planning and Its Trend," *Architectural Forum*, 49/6: 827–32.

"Chicago Lying-In Hospital" (1915, October 27), *American Architect and Building News*, 108/2079: 283–84.

"Correct Color for Operating Room" (1927, May), *Modern Hospital*, 28/5: 56.

Flagg, Paluel J. (1924, June), "A Scientific Basis for the Use of Color in the Operating Room," *Modern Hospital*, 22/6: 555–59.

Flagg, Paluel J. (1939), "Color in the Operating Field," *Modern Hospital*, 52/6: 75–80.

"Green Bay Has New Hospital" (1915, January), *Modern Hospital*, 4/1: 50.

"Green and Black Operating Colors" (1914, July), *Modern Hospital*, 3/1: 67–68.

Landis, Maude (1915, October), "The Edward W. Sparrow Hospital, of Lansing, Michigan," *Modern Hospital*, 5/4: 235–38.

Luckiesh, M. (1917, October), "Artificial Daylight in Surgery. Nearest Approach to Daylight Desirable Where Color Discrimination Is Required—a Study in Color Development," *Modern Hospital*, 9/4: 311–12.

Luckiesh, M., and A.J. Pacini (1926), *Light and Health: A Discussion of Light and Other Radiations in Relation to Life and to Health*, Baltimore: Williams and Wilkins.

Luckiesh, M., and A.J. Pacini (1927, December), "How the Light and Color Improve the Patient's Room," *Modern Hospital*, 29/6: 116.

Ludlow, William O. (1919, April), "Some Lessons the War Has Taught. In Time of War Prepare for Peace—War Time Psychology Forced Us to Think of Men in Terms of Groups, but It Is the Individual Soul That Counts in Every Sphere, Including Hospitals," *Modern Hospital*, 12/4: 283–84.

Ludlow, William O. (1921, June), "Color in the Modern Hospital," *Modern Hospital*, 16/6: 511–13.

McCalmont, M.E. (1913), "Practical Details in Hospital Planning and Equipment. Part II—General Continued," *Brick Builder*, 22/7: 158–61.

"Operating Room Floors" (1917, February), *Modern Hospital*, 8/2: 148.

Raymond, W.R. (1921, July), "The Iowa State College Hospital," *Modern Hospital*, 17/1: 1–6.

"Redecoration of Operating Room" (1918, August), *Modern Hospital*, 11/2: 150.

Reiley, Robert J. (1914, August), "The New Hospital of the House of Calvary. An Institution for the Treatment of Sufferers from Cancer, Where, Although in Every Respect a Modern Hospital, It Has Been Sought to Create the Atmosphere of a Home," *Modern Hospital*, 3/2: 79–82.

Secor, William Lee (1917, September), "The White Operating Room. Suggestion of Remedy for Its Defects—Beaked Caps and Amber-Tinted Glasses Used to Obviate Effect of Glare from White Walls," *Modern Hospital*, 9/3: 170–71.

Sherman, Harry M. (1918, August), "The Green Operating Room at St. Luke's Hospital, San Francisco," *Modern Hospital*, 11/2: 97–98.

Woodbury, Wiley Egan (1922, December), "Some of the Special Departments of a General Hospital," *Architectural Forum*, 37: 271–76.

Color Continuity and Change in Korean Culture

Key-Sook Geum and Hyun Jung

Chapter Summary. Color usage characterizes a specific society or group and plays an important role in enabling us to understand how people who belong to that group experience and use colors. Accordingly, just as the meaning of a word is understood through cultural context rather than only through a dictionary definition, the meaning or value of color used by a specific group also needs to be understood in a cultural context of continuity and change. For example, wearing white in the rites of both birth and death is a very specific characteristic of Korean traditional culture but has distinct symbolic meaning in each rite. Knowing the uses and meanings of colors within a specific culture provides an opportunity to understand the culture and helps ease mutual communication by enabling an understanding of the way of thinking of that people.

Color is affected by philosophy, religion, custom, and the natural environment within a society and is used as a sign that signifies concrete or abstract objects or ideas. To analyze and interpret the characteristics of colors being used in a culture and effectively apply those to actual designs, it is necessary to simultaneously consider specific characteristics related to ethnic sentiment and historical background and its modern interpretation, as well as the common universality of being human. For this, an objective knowledge of the relevant culture, as well as both a general and a specialized understanding of the culture, is required (Zollinger 1999: 197).

However, according to McCool (2008: 206), in the past, studies of color in culture often emphasized the negative implications of color within highly contextualized cultural events. For example, when red symbolizes communism and white means death, using these colors within a certain culture attracts attention and entails risk. Such implications may present limitations in the understanding of universal color prototypes that are used in modern society. As common associations derived from the affective meaning of colors in nature come into play as a basis for color symbolism formed by the influence of systems of thought such as philosophy and religion in a certain group, responses to colors may be universal and transcend cultural borders and cultural differences (Mahnke 1996: 17). In addition, changes in the sociocultural environment, such as the inflow of foreign cultures, influence of color trends and preferences, political

revolution, and technology innovation, which often occur in our diverse and networked modern society, may bring changes to traditional symbols and meanings of colors and their values.

In this study we examine the properties, meanings, and symbols of the colors found in Korean traditional culture, and explore their continued use and transformation in contemporary applications. Investigating the meanings and symbolism of colors reflected in traditional rites and social systems will help us to understand the traditional consciousness of colors based on historical background or thoughts. In addition, examples of color phenomena found throughout current Korean society will help identify significance and interpretation of colors in contemporary Korean society.

KOREAN TRADITIONAL CULTURE AND CONSCIOUSNESS OF COLOR

Historical Background of Korean Culture

Korean traditional culture, handed down through shifting dynasties for 5,000 years, can be classified into three periods: before *Samguksidae* (before the fourth century), from *Samguksidae* to *Goryeo* Dynasty (the fourth century–1392), and *Joseon* Dynasty (1392–1910) (Park 2004: 313–15). By and large, systems of religion and thought such as Yin-Yang and the Five Elements, Buddhism, and Confucianism, pervasive in the Asian cultural area, have had a strong influence on Korean traditional culture across these three periods.

However, as Western religions and cultures were introduced after the opening of a port in the late *Joseon* period (1873), innovations and changes in the way of thinking came to the traditional society and culture, and this brought about changes in living modes, such as in costume and residential space. The Korean War that occurred in 1950 devastated Korean society and the ideological antagonism dividing Korea into the South and the North became a factor in determining the specific political environment of Korean society. As economic development policies in the 1960s and booming exports of construction projects in the 1970s created economic growth, traditional culture, long ignored, began to attract interest. The successful holding of international events such as the Asian Games and the Olympic Games in the 1980s accelerated the globalization of Korean society, and also enhanced the recognition of Korean traditional culture both within and outside of Korea.

As Korean society achieved rapid economic growth and active international exchanges with the conversion to the information society, an attitude of acceptance of foreign cultures shifted to one of researching and developing a rich cultural heritage. Korean people began to gain a new understanding of their traditional culture, and came to have pride as citizens of culture. Furthermore, in the late twentieth century, the so-called *Hallyu* (Korean wave) phenomenon emerged in international society, including Asia, and Korea grew to become a cultural leader.

Color Consciousness in Korean Traditional Culture

According to Jeong (2001: 170–72), color consciousness involves thoughts and theories of color and the psychological response to color formed historically and socially. Park (2004: 313) regarded color consciousness as one of the important factors mediating various types of social communications between class and class, and stratum and stratum, rather than between individual and individual.

Previous studies regarding Korean color consciousness (Eum and Chae 2006; Lee 2009; Seo 2009) regard Korean traditional color consciousness as having formed primarily under the influence of Yin-Yang and the Five Elements, Naturalism, Buddhism, and Confucianism. In particular, according to Park (2004: 313–33) who studied color consciousness in Korean traditional culture, the color culture before *Samguksidae* based on myths and being a process of giving charmed meanings to natural colors, is characterized by the stress on the symbolism of the color white as it related to the harvest ceremony, with the sun being the god. The color culture from *Samguksidae* to *Goryeo* Dynasty, found in ancient tomb murals or religious buildings, reflected Yin-Yang and the Five Elements and the religious belief and doctrines of Buddhism. In the *Joseon* period Confucianism was the state religion, and the use of color was greatly regulated to establish social systems such as political class or social status. Therefore, this period is characterized by the use of symbolic colors with compound meanings.

The use of colors in the long history of Korea can be summarized as having two main characteristics: One is a preference for white and natural colors that were not bleached or dyed, and the other is the harmonious use of primary colors. Examples of the former are a preference for white as a dominant color in casual clothing regardless of status, and the use of neutral colors for plaster and earthen walls of private houses, while examples of the latter include strong contrasts of primary colors and *saekdong*, which are multicolored stripes used in clothing, and *dancheong*, which is multicolored paintwork of the buildings in palaces and temples (Plate 18).

From ancient times, white appeared in myths regarding the foundation of the nation, and Koreans preferred to wear white clothing, to the extent that they were called "white clad folk." In general, white represents truth and light, away from dirtiness. White symbolizes the starting point, the origin, and the root of things. As the anthropologist Turner (1975: 168–69) wrote, white is the most basic symbol to human beings; indeed, white was favored in many cultural spheres who worshipped the sun. However, it is understood that the preference of Koreans for white clothing for thousands of years is regarded as a distinct characteristic of Korea. The preference for white is considered as an implication of aesthetic consciousness toward cleanness, purity, humility, and deep religious belief that inspired devotion to the pure, natural, and nondecorative (Geum 1994: 58–62).

Concepts of Yin-Yang and the Five Elements, a living philosophy for Koreans since ancient times, have affected natural phenomena and human life, and created the concept of *obang* colors (colors of five directions) composed of five primary colors and five secondary colors. Even in the *Joseon* period, which limited the use of colors according

to sumptuary law, the harmonious combination of these primary and secondary colors was used for children's clothing, *dancheong*, and handicrafts. The use of these colors is an expression of pleasure and brilliance, and contains symbolism related to auspicious signs and warding off the evil eye (Geum 1994: 66–68).

Korean traditional color consciousness and color symbolism are reflected in costume colors for traditional rites and for representing social status or political ranks. Colors in clothing represent the national sensibility of beauty and the philosophy of life in the culture, and may be recognized as one of the cultural codes (Lee and Kim 2007: 72). In addition, the unique characteristics of colors found in costumes of each time period represent the respective aesthetic value (Geum 1994: 57), and it is possible to discuss the color consciousness and color symbolism found in Korean traditional culture based on the characteristics of color used in costume.

USAGE AND MEANING OF COLOR IN KOREAN TRADITIONAL CULTURE

Birth and Death

Rites of passage that all people celebrate between birth and death in traditional Korean culture include the 100th day after birth, the first birthday, coming-of-age celebration, wedding, the 60th birthday, and the 60th wedding anniversary. Going beyond life itself, there were funeral rites and rituals to honor ancestors. Among these, the rites of passage that Koreans still celebrate today include the first birthday, wedding, and funeral. The colors used in such rites of passage represent and are meant to express the wishes for each ceremony. For example, Koreans had a tradition of hanging a straw rope on the front door when a baby was born. If the newborn was a boy, they would attach red peppers and coals, and if a girl, they would attach green pine leaves and coals. Seeing this, would-be visitors would know not to enter the house, so as to keep the newborn and the mother safe from the risk of infectious diseases. But this tradition can also be seen as a way of chasing evil spirits away by using red and green representing Yin-Yang and the Five Elements, which signify the unity of the abundance of all living things, life, and spirit.

On one hand, there was a tradition of dressing newborns in white. In fact, newborns would be dressed in white or pale-colored clothing until they reached their 100th day. Even in the royal court of the *Joseon* Dynasty, which shunned the color white, they would still dress princes in white pants on their 100th-day celebration. At this time, white signified the light from the sun, and represented purity and genuineness. Therefore, dressing newborns in white shows the wish to keep evil spirits away from the baby, and the preference of Koreans for light over dark. Even in present day, the tradition remains of dressing newborns in white or pale colors.

On the other hand, white was also used to represent sadness over death. According to the theory of the Five Elements that has influenced oriental thought, the direction that represented death was north. North represented black and winter, where everything

was asleep, which signified death. Therefore, black should have been used for the attire for funerals. However, white or *sosaek* (raw fabric color) was used for funerals in Korean traditional culture. According to the historical record, the use of white funeral clothing derived from the ancient country *Bu-yeo* (the second century B.C.–494) (Cho 1989: 3). Even during the times of *Silla*, *Goryeo*, and *Joseon*, where Buddhism or Confucianism was introduced, white was still used as funeral clothing. Thus, white was accepted as the representative color for funerals in Korean traditional culture. Funeral clothing was considered humble apparel, which did not reflect the personality of the wearer. There-fore, white was used, as a color free from embellishments or extraordinary techniques (Geum 1994: 60–61).

This Korean tradition was in contrast to Western culture, where black has been used as funeral clothing from the time of the Roman Empire, and this reached its peak during the reign of Queen Victoria in the nineteenth century (Fehrman and Fehrman 2004: 240). Western culture began to have an influence on Korea due to internationalization after the Korean War, and this also affected the funeral culture. According to the government enactment of the Simplified Family Rite Standards in 1969 and 1973, funeral clothing began to change. The standards decreed that white *Hanbok* (Korean traditional gar-ments) or black suits be worn to funerals. This was the beginning of people wearing black for funerals in Korea (Yoon 2004: 33–34). In modern funerals, male mourners wear black business suits, and females tend to wear white *Hanbok*. However, in winter times, female mourners also tend to wear black; thus black has become the typical color for funeral clothing in modern Korean funerals.

Birthdays and Holidays

Although white or *sosaek* was preferred in daily life, it was the norm to wear colorful clothing on birthdays or holidays in traditional culture. A person celebrating his or her birthday wore colorful clothing and everyone wore colorful clothing on holidays like New Year's Day or *Chuseok* (Korean Thanksgiving Day). There was a tendency for younger people to wear more colorful clothing than the elderly.

The first birthday carried a special meaning of having overcome an important obsta-cle and babies celebrating their first birthday were dressed in colorful clothing with many auspicious designs, to wish them health and a long life. Although the clothing for boys and girls consisted of different garment pieces, the outer coats worn by children, called *Obangjang Durumagi* or *Kachi Durumagi*, emphasized the significance of color. *Obang-jang Durumagi* used the colors red, yellow, white, blue, and green based on the Five El-ements. *Kachi Durumagi* used *saekdong*, multicolored stripes, for the sleeves, as well as colors from the Five Elements for the bodice. However, black, which carried negative connotations, was not used in the outer coats. Although colorful clothing was worn pri-marily by little children, an adult would wear clothing with stripes similar to those worn by children to celebrate the sixtieth birthday if his or her parents were still alive.

Because adults were prohibited from wearing colorful clothing during the *Joseon* period due to the influence of Confucianism and sumptuary laws, Geum (1994: 79–80) interpreted this to mean that colorful garments for children reflected the yearning of adults to wear colorful clothing. The colors in those garments were also an expression of their willingness to protect children from evil spirits (see Plate 19).

Weddings and Festivals

Koreans were allowed to dress in colorful clothing of their choice for weddings and festivals. In traditional culture, festivals could include seasonal festivals or shamanistic rites performed to wish prosperity for the community. People wore bright-colored clothing in red, yellow, or blue to enhance the mood of the festival.

Weddings in traditional cultures were festive events, where families, relatives, and neighbors would get together to celebrate and bless the couple. Traditionally, in addition to blessing, weddings were regarded as the origin of humanity and morality. Therefore, the wedding ceremony was considered one of the most important rituals of a lifetime, and people would work hard to meet all respectful requirements. The bride and the groom were permitted to wear the most colorful and gorgeous clothing, usually reserved for officials. The groom wore *Dallyeong* (outer coat with a round neckline) worn by officials, and the bride wore *Wonsam* or *Hwalot* (ceremonial clothes) worn by the wives of the officials.

The *Dallyeong* would be worn by officials when entering the palace. High officials wore red, and lower officials wore blue or green according to the costume regulation. During the *Joseon* period, grooms were normally allowed to wear blue or green *Dallyeong*. The bride wore green *Wonsam* lined with red fabric or red *Hwalot* lined with blue fabric that had auspicious designs embroidered on the surface. It was a distinct feature to have contrasting colors on the inside and outside. Underneath the *Wonsam* or *Hwalot* was worn a yellow top and red skirt. Yellow represented earth, to symbolize the production of living things from earth, while red represented prosperity like fire, to invigorate their children and family (Baek 1992: 383–85) (see Plate 20).

In addition to the wedding clothes, many other goods for the wedding ceremony used certain color combinations that showed the oneness of the bride and groom. The most important color combination in Korean traditional weddings was blue and red. The meaning of this color combination can be explained in two ways: folklorically, blue and red, as they are also seen in the Korean flag, were considered the perfect colors to create the harmony of Yin-Yang (Ji 2001: 225–28). Here, red symbolized Yang, representing male, and blue symbolized Yin, representing female. Usage of these two colors for weddings was an expression of a longing to keep the harmony of Yin-Yang. However, according to the Five Elements, blue and red, which belong to the five primary colors, symbolized life, because they represented the direction of south and east, that receive energy from the sun. Therefore, people believed that this color combination would suppress and chase away the dark spirits of evil (see Plate 21).

This traditional wedding culture began to change with the modernization of society according to the introduction of Western thoughts and culture in the late nineteenth century. Changes in the philosophy and values of tradition affected the daily lives of people, and there was also a change in the groom wearing a black suit and the bride a white dress for their wedding costumes. At times, the bride transitioned to wearing a white *Hanbok* with a white veil (Shin and Kim 2009: 45). Traditionally colorful garments were used for festival days and white apparel was worn for daily life and funerals. Wearing a white dress instead of colorful *Hanbok* for the wedding ceremony can be regarded as a most specific change in wedding culture and also can be considered as a dramatic change of the Korean traditional color consciousness.

Social Structure and Status

The colors used in apparel also expressed social norm and status. Just as in ancient Europe the use of purple represented royalty and was prohibited for wear for others by sumptuary law (Charlene 2008: 175–87), traditional Korean society also kept the social order by designating colors that displayed social status. Colors that expressed social status were evident in the political realm. In particular, different colors were used to show the political hierarchy from the king to the officials. Red was used for kings and different nuances of red were used for high officials. Lower-status officials wore blue

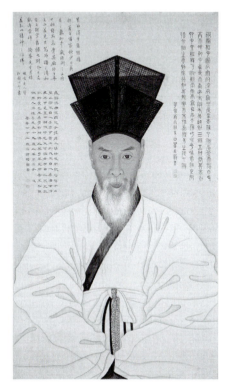

Figure 10.1 Portrait of Confucian scholar Chae Lee, wearing *Simui*, 1807. The *Simui*, which Confucian scholars wore daily, emphasizes the harmony of black and white and is symbolic of Confucianism asceticism and the honorable character of the nobility.
Source: The National Museum of Korea.

or green. Color restrictions were also used to express the level of status for the ladies of court. In terms of *Wonsam*, the empress wore yellow, the queen wore red, and the princess wore purplish red. The wives of officials wore green *Wonsam*. Farmers or commoners were prohibited from wearing colorful apparel in daily life. Exceptions to this rule included shamans, *gisaeng* (female entertainers), and children, who were allowed to dress colorfully despite their social status. However, all people were allowed to wear colorful clothing for special ceremonies, including weddings, birthdays, and holidays.

Specific colors were designated for people in academia or religious orders, which were thought to express their character. For example, scholars who observed Confucianism during the *Joseon* period wore *Simui*, a white outer coat with black border trimming, to visually express the asceticism of Confucianism. White, in this case, represented purity and innocence, and the harmony of black and white created a calm and serene atmosphere, expressing their intelligent and noble spirit. See Figure 10.1. Such colors also reflected the symbolism of cranes, which were not caught up in secular desires but glided in the skies with honor and unyielding spirit (Geum 1994: 63–64).

SIGNIFICANCE AND INTERPRETATION OF COLORS IN CONTEMPORARY KOREAN SOCIETY

According to the Color Experience Pyramid of Mahnke (1996: 11–18), responses to color can be influenced by trends, fashion, styles, and personal relationships. This means that the color consciousness or preference in Korean traditional culture can also be changed by sociocultural changes in modern society. Traditional color and its meaning have been inherited or acculturated in contemporary Korean society and are analyzed through the following representative cases.

Expression of Identity

The use of colors for the traditional purpose of depicting social status or identity still takes place in modern society in various ways, and these include identifying and expressing company, brand, college, occupation, and gender.

Colors to symbolize gender can be found in the color of baby's clothing such as pink and light blue. Even though there are those who criticize the practice of stereotyping babies with colors, usually girls are dressed in pink and boys are dressed in light blue in Korea. Another case where colors symbolize gender can be found in the color of *Hanbok* worn by mothers of the bride and the groom at weddings. Although this practice has been weakening since 2000, with a greater emphasis being placed on personal preference and fashion trends, the groom's mother is expected to wear blue *Hanbok*, and the bride's mother to wear pink *Hanbok*. This phenomenon stems from the wearing of blue and red apparel during traditional weddings in accordance with the harmony of Yin and Yang. However, as this phenomenon began from the latter half of the twentieth century

when Western-style weddings became more established as a social practice, it is still not easy to ignore pink or red to symbolize females and blue to symbolize males.

The use of varying colors to visually differentiate academic majors with different colored hoods of graduation gowns can also be considered as identifying colors. Since the Western education system was introduced to Korea in the early twentieth century, many universities uniformly used black as a main color for the gown, with hoods in various colors according to the academic major. The colors include orange for engineering majors, light blue for education majors, and white for liberal arts, and so on. However, in recent years, certain universities have replaced black with the color that represents the university (e.g., blue for Yonsei University and red for Korea University). This is viewed as an attempt by the universities to emphasize their own identity through the use of color.

The judiciary in Korea have long worn black gowns, following the Western style. As black is appropriate for the expression of dignity and power, it was chosen as the main color for the new judiciary costume in 1998. However, purplish red satin jacquard front panels were added for the new design to emphasize Korean traditional beauty and present a dignified image. Indeed, red was used for high officials in the *Joseon* period, so the color combination of black and purplish red could explain the continuation of Korean traditions as well as authority in administering justice.

Expression of Ideology

The symbolic meaning of color can easily be observed in contemporary Korean political culture. It was difficult to express one's own political ideology in a centralized government under the monarchy of Korean traditional society. However, in modern society, there emerged parties with different thoughts and ideologies. Each political party or candidate chose a certain color to appeal to the voters by imprinting their political idea through color.

Generally, right-wing parties or politicians who support stability and conservatism prefer to use blue, while left-wing parties who support power and liberalism prefer to use red. However, due to Korea's unique political background, it should be noted that the use of red in politics may remind people of communism and result in negative feelings of voters. At the end of the twentieth century, the colors often seen in Korean politics were blue and green, which symbolized stability, honesty, harmony, and growth (Cheon and Kim 2002: 25–31). President Myung-Bak Lee also strategically used blue to present an image of stability or equilibrium, practical conservatism, with an emphasis on economic growth.

However, the most successful use of colors for modern politicians in Korea was the use of vivid yellow by the former presidents Dae-Jung Kim and Moo-Hyun Roh. Yellow had already been used by former president Dae-Jung Kim when he ran for president in 1987, to minimize his strong image as a democratic activist, as well as the negative image of his progressive tendencies. He also wanted to emphasize the hope and peace of democracy through the color yellow. The color yellow had been used by former president

Corazon Conjuanco Aquino of the Philippines and was an effective reminder of the Filipino democracy (Cheon and Kim 2002: 28).

Since the year 2000, yellow has become a trendy color symbolizing the hope of a new millennium. Some companies with low-price strategies, such as E-mart and S-Oil, used yellow color for their corporate identity. Although yellow, according to the theory of the Five Elements, represents centrality or the honor of an emperor, the former president Moo-Hyun Roh chose this color in the 2002 election as a strategy to represent a government that was open to the public. Those who supported Roh used yellow scarves, balloons, and flags during rallies. In the 2005 Asia-Pacific Economic Cooperation (APEC) Summit, President Roh also tried to emphasize his political idea visually in choosing yellow for his traditional outer coat, *Durumagi*; see Figure 10.2.

Some politicians have experienced negative results because of a poor choice of colors. In 2006, a female candidate (Keum-Sil Kang) for mayor of Seoul chose violet as her campaign color to symbolize a new and changing political environment, breaking the contrasting ideological borderline of red and blue. However, unlike red or blue, violet lacks visual clarity and strength. In addition, based on the preference and symbolism of the color violet in Korea, it was not suitable for politics. Violet, a tepid color that is neither red nor blue, is not popular even for children's or women's apparel in Korea,

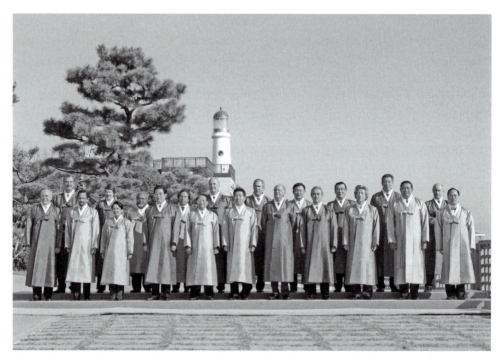

Figure 10.2 Leaders in *Durumagi* for the official photograph of the Asia-Pacific Economic Cooperation (APEC) Summit, Korea, November 19, 2005. President Moo-Hyun Roh (first row, center) was wearing yellow *Durumagi* to express his political ideology of being open to the public.
Source: Ministry of Culture, Sports and Tourism of the Republic of Korea.

unlike the United States or Europe. Furthermore, former first lady Hee-Ho Lee wore a violet*Hanbok* to represent the color of the national flower, Rose of Sharon, as a symbol of silent political resistance and patriotism when Dae-Jung Kim was under house arrest because of his pro-democracy movement. For the families who fought for democracy in Korea, violet is a color that reminds them of pain and suffering. Therefore, the violet campaign of Kang, which overlooked those various meanings of violet in Korean culture, was regarded as an inappropriate strategy.

The Vitality of Festivals

Colors represent the emotions of those who use them and therefore often represent a special event. As the essence of a festival is to boost one's consciousness to the highest level of joy, the sophisticated and elegant colors of the upper class were rejected, and instead bright colors such as red were used to represent freedom, passion, and excitement (Kwon 2005: 13–14). The primary colors used in Korean traditional culture heightened the atmosphere of festivals and added vitality to the event. The uniforms of participants of sports events that feature bright colors with strong contrasts or complementary color combinations also visually enhance the active movement of the participants and imbue the event with vitality.

A new perception of the color red resulted from the 2002 Korea-Japan World Cup. At the time, Koreans cheered for their team with red T-shirts with the inscription, "Be the Reds." This shocked the world with their passionate street cheering that figuratively and literally painted the streets red. A record number of 7 million supporters came out to the plaza and streets to cheer during Korea's quarterfinals with Germany. With sales of 25 million shirts, which is one shirt for every two Koreans, it is not an overstatement to say that at the time this served as the national shirt for Koreans. The Koreans at the stadium, plaza, and streets cheered "Be the Reds" to emphasize their oneness, and they prayed that their cheers and the red energy would reach the players on the field. This event served as an opportunity for the negative concept of red to change to positive and represent optimism.

In Korean traditional culture, red represented honor and respect, and was highly preferred with its symbolism for life, creation, and wishing for health and peace. However, at the end of the nineteenth century, with the modernization of Korea as the turning point, red began to carry a different symbolism in connection with social factors. The political environment of the twentieth century made red symbolic of rapid revolution and social upheaval, and came to represent the political ideology of communism. For Koreans who lived through the Korean War, red came to mean communism, socialism, and radical progressivism. In other words, in the twentieth century, Korean society ignored the beauty of the color itself, perceiving red as part of communist ideology. There were instances where red was prohibited or avoided, leading to the phrase *red complex* (Kwon and Kim 2005: 22–29).

The survey done by Nam and Choi (2007: 30–34) on free association and preference for the color red is a good reflection of this. Survey respondents in their sixties, who had

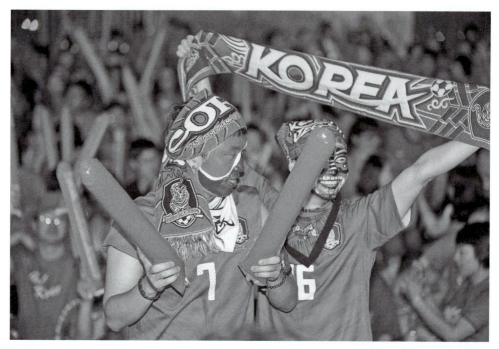

Figure 10.3 Supporters gather in Seoul Square to cheer for Korea in its game against Argentina during the South Africa World Cup, June 17, 2010. Since the 2002 Korea-Japan World Cup, the color red for Korean society has come to represent a wish for victory, the joy and passion of festivals, and freedom and public ownership. Photograph by Jae-Gone Kim.

experienced the Korean War, tended to associate red with communism and communist ideologies; respondents in their forties who had lived through the social movement toward democracy associated the color red with strikes and labor-management disputes. Only 12 percent of respondents said they liked the color red. However, 88 percent of respondents in their twenties responded that they liked the color red, as their primary association was with the FIFA World Cup.

The 2002 Korea-Japan FIFA World Cup gave Koreans a new perception of the color red as symbolizing vitality and festival. In particular, unlike the negative perceptions of the past, now red is thought to draw out passion and excitement in Koreans, and to be a color symbolizing freedom and public ownership, joy, passion, and wishing for victory that connects Koreans in oneness. See Figure 10.3.

Interrelationship with International Trends

In modern global society, world fashion trends can be quickly and easily grasped thanks to technological advancements, and there is a parallel trend for colors. A characteristic of the Korean fashion market is quick acceptance of international trends and changes. Grayish or dull colors like beige, taupe, brown, or khaki, traditionally thought to be unclean, were widely accepted after trench coats became popular through Western movies

and magazines following the Korean War. In addition, black, which represents modernism, is actively used and preferred in Korean society as a result of the influence of Western culture.

Saito (1996: 1–10), who studied color preferences of modern Korea and Japan, discovered that Koreans showed a higher preference for white and black compared to the Japanese. She explained that Koreans' preference for white stems from traditional culture, but did not give a detailed explanation for the high preference for black. However, Lee and Kim (2007: 71–79), who studied women's apparel color from the *Joseon* Dynasty to the end of twentieth century, explained that the reason for the popularity of black in Korean fashion is the influence of the international fashion trend. In the early twentieth century, black was used for school uniforms and was centrally used for trendy apparel worn by women who studied abroad or had no bias toward accepting Western culture. Therefore, black was accepted as the color that represented Westernization and modernism.

Black was also popular in Western society since industrialization, and is still preferred as a basic and trendy color. Although black is not perceived as an optimistic color by itself, it displays a noble, elegant, and avant-garde image when it is used for fashion or products. However, the preference of Koreans for black nowadays is rather unique. Besides wearing black as their daily apparel, Koreans tend to dress in black suits to attend weddings as well as funerals. And also many entertainers choose black dress over any other colors for awards ceremonies. It seems that Koreans, who were once called the "white-clad folk" because of their preference for white, have been taken over by black due to the influence of Western culture. High preference for black in contemporary Korean culture is not only because it is a basic color considered compatible with any other color, but also because it is related to the international symbolism of black as expressing high quality and sophistication.

Promotion and Marketing Strategy

Traditional usages and symbolism of colors are still found in contemporary Korean society in diverse and purposeful ways. Furthermore, colors are used for the purpose of promotion and marketing strategies. Using colors to express one's identity or political ideology also falls into this category. In particular, many businesses use a color-based marketing strategy to boost sales and profits by using colors that touch the consumers' psychology and emotions. For example, during the 2002 Korea-Japan World Cup, the explosive popularity of red was reflected in fashion items and marketing. Inspired by the red passion of Korea, Chanel's make-up creator Dominique Moncoutois created a red lipstick from the red of the Korean flag naming it "Rouge de Seoul," and releasing it to the Korean market. This was the first time a city was used as the name of a Chanel product. Later it was included formally as one of the regular items of Chanel (Jeong 2003: 306–7).

In addition, a credit card company of Korea, Hyundai Card, in 2006, introduced three types of premium-level credit cards in order to display a luxurious image and to

strategically differentiate the service level using the three colors of red, purple, and black. These three are representative colors for Koreans for luxury and high quality. However, the fact that the company placed black at a much higher level than red and purple with the marketing strategy of using black for the top 0.05 percent VVIPs is a good example of the popularity of black and its meaning among Koreans for promotion and marketing strategy.

Thus characteristics of Korean traditional color symbolism, which may contain different meanings according to an event's purpose and aspiration, became more complex with the multiple symbolisms introduced by Western cultures. When using color for promotion and marketing strategy, it is important to understand both traditional and current symbolism of the chosen color and to use it to effectively elicit consumers' latent desires.

CONCLUSION

Understanding how colors have been used in Korean society from the past to the present explains characteristics of Korean culture, and provides opportunities to understand a Korean aesthetic consciousness, way of thinking, and mode of living. The use of colors in Korean culture can be summarized as having two main characteristics.

First, an important characteristic of color in Korean society is the coexistence of change over time, together with the continuance of tradition to the present. That Koreans, who preferred white to the extent that they were called "white-clad folk," began to adopt black clothing in the twentieth century is the result of the pursuit of Westernization and the acceptance of international fashion trends. Yellow, once regarded as the center of all things and the color of the empire, has shifted to a populist image because Koreans have followed the flow of political and social change. The restrictive functions of color in the past due to reactionary conservatism and fulfilling the functions of symbolizing status and rank have shifted to various functions such as individual preferences, flow of fashion trends, and marketing strategies. It can be said that changes in preferences, symbolism, functions, and roles are derived from the diversification and fractionation of the available color range through the development of technology for creating colors, and are the inevitable consequence of information exchange resulting from globalization.

The fact that white is still preferred by people, clear and bright colors are favored, and the function of color used to designate status, class, or rank in the past finds its equivalent today in designating affiliation and occupational identity shows that the traditional characteristics of color are still sustained today. From this, it can be interpreted that traditional viewpoints of color or color consciousness influence contemporary Koreans, consciously or unconsciously. This implies the existence of a Korean prototype of color that has germinated through 5,000 years of history.

Second, color in Korean culture is characterized by the strong action of meaning-centered color consciousness. Traditionally, Koreans tended to give symbolic meanings to

colors, and consider the color combination harmonious to the extent that the symbolic meanings were harmonious with each other. As each color had different meanings, Koreans wanted to express what they desired in colors by highlighting one meaning that was suitable to a specific event or situation. Those Korean ancestors who preferred the color white in daily life as well as in relation to birth and death may be considered as positively accepting each of the different meanings given by white. That they gave different symbolic meanings to clothes by the use of *obang* colors according to the Five Elements also shows the meaning-centered color consciousness. Despite the discord with tradition, the fact that Koreans diversified color meanings according to objectives and functions, gave meanings and symbols to each color to express political identity and ideology, and used colors in promotion and marketing strategies may also be regarded as the strong expression of a meaning-centered color consciousness traditionally handed down.

What is unfortunate in the use of colors today is that traditional meanings or symbols of color, sometimes diluted or distorted due to thoughtless acceptance of foreign cultures, or by giving or interpreting meanings of foreign cultures just for convenience, result in weakening traditional spirits. This study suggests that it is not only necessary to accept the global trend in modern society, but also to respect traditional characteristics to hand down, develop, and modernize the traditional culture in an appropriate direction. In other words, understanding how the traditional prototype of color germinated from long-standing history and culture, as well as accepting a global color prototype and international color trend, will bring a higher likelihood of developing creative and marketable design, and lead to the necessary attitude not only for those who belong to the culture, but also for others who want to communicate with that culture.

REFERENCES

Baek, Y. J. (1992), *Korean Costume*, Seoul: Gyeungchunsa.

Charlene, E. (2008), "Purple Pasts: Color Codification in the Ancient World," *Law and Social Inquiry*, 33/1: 173–94.

Cheon, J. I., and Kim, I. C. (2002), "A Study on the Color Strategy of Presidential Elections in Korea," *Journal of Korean Society of Color Studies*, 16/2-3: 25–34.

Cho, W. H. (1989), "A Study on Mourning Dresses in *Joseon* Dynasty," PhD diss., Sookmyung Women's University, Seoul.

Eum, J. S., and Chae, K. S. (2006), "Comparison Study on Perceived Meaning of Color and Clothing Color of Korea and Japan," *Journal of the Korean Society of Costume*, 56/6: 16–32.

Fehrman, K. R., and Fehrman, C. (2004), *Color: The Secret Influence*, 2nd ed., Upper Saddle River, NJ: Pearson/Prentice Hall.

Geum, K. S. (1994), *The Beauty of Korean Traditional Costume*, Seoul: Youlhwadang.

Jeong, S. H. (2001), "Color Consciousness of Koreans," in Korean Society of Color Studies (eds.), *The World of Various Colors*, Seoul: Kukje Books, 170–76.

Jeong, Y. H. (2003), "Chanel, Rouge de Seoul, Presentation Ceremony, Enthusiastic Shout Contained on the Lipstick," *Happy House*, 185: 306–7, Seoul: Design House.

Ji, S.H. (2001), "Korean Architecture Seen in Color," in Korean Society of Color Studies (eds.), *Now, Colors Tell*, Seoul: Kukje Books, 221–28.

Kim, Y.S. (1987), *Royal Costume in the End of JoseonDynasty*, Seoul: National Culture Library Publishing Association.

Kwon, Y.G. (2005), "Colors for Festivals and Festivals of Color," *Proceedings of the Korean Society of Color Studies 2005 Summer Symposium*, 7–14.

Kwon, Y.G., and Kim, N.R. (2005), "A Study on the Signification and Symbol of Red in Korea, China and Japan," *Journal of Korean Society of Color Studies*, 19/2: 21–36.

Lee, J.H., and Kim, Y.I. (2007), "Analysis of Color Symbology from the Perspective of Cultural Semiotics Focused on Korean Costume Colors According to the Cultural Changes," *Color Research and Application*, 32/1: 71–79.

Lee, S.H. (2009), "A Study on the Color Consciousness and Symbol in *Sillain* in *SamGookYousa*," *Journal of Korean Society of Color Studies*, 23/1: 157–72.

Mahnke, F.H. (1996), *Color, Environment, and Human Response: An Interdisciplinary Understanding of Color and Its Use as a Beneficial Element in the Design of the Architectural Environment*, New York: Van Nostrand Reinhold.

McCool, M. (2008), "Can Color Transcend Culture?," *Proceedings of Professional Communication Conference*, 206–13.

Nam, J., and Choi, B.J. (2007), "The Change of Red Color Symbolism by Generation in Korean Culture," *Journal of Design and Art*, 8: 17–34.

Park, H.I. (2004), "The Color Consciousness Which Appears in Korean Culture (3): From Antiquity Age to Modern Time," *Journal of the Korean Society for Philosophy East-West*, 33: 313–33.

Saito, M. (1996), "A Cross-Cultural Survey on Color Preference in Asia Countries (1): Comparison between Japanese and Korean Emphasis on Preference for White," *Journal of the Color Science Association of Japan*, 16/1: 1–10.

Seo, B.H. (2009), "The Effect of Three Religions on the Unexpressed Color of Traditional Korean Costumes," *Journal of Korean Society of Color Studies*, 23/1: 131–44.

Shin, H.S., and Kim, J.Y. (2009), "A Study on Wedding Costume Worn during the Reigns of King Gojong and Sunjong," *Journal of Seoul Studies*, 35: 10–58.

Turner, V.W. (1975), *Dramas, Fields, and Metaphors: Symbolic Action in Human Society*, New York: Cornell University Press.

Yoon, E.Y. (2004), "A Study on Mourning Garments in Recent Funeral Rites: Centering around Gwangju," master's thesis, Choongnam National University, Daejeon.

Zollinger, H. (1999), *Color: A Multidisciplinary Approach*, Zurich: VHCS; Weinheim: Wiley-VCH.

−11−

Exploring the Colors of Turkish Culture

Gozde Goncu-Berk

Chapter Summary. Color embodies many meanings in a culture that are transferred from generation to generation through traditions, art, and folklore. Turquoise, red, and white are the colors of significance in the Turkish culture that relate to national history and national arts, rituals, rites of passage, religion, and superstitions. Examples are provided about how these colors are used in the contemporary context and in the national branding of the country. The color red is associated with patriotism and plays a significant role in rituals like wedding and baby mooning. White signifies values of wisdom, honesty, cleanliness, and is a very commonly used metaphor in Turkish proverbs. Turquoise plays an important role in the pre-Islamic Turkic belief systems and traditional arts. Turquoise is also commonly used today to communicate the country image in different international mediums.

Color communicates symbolic meanings at micro and macro levels such as personal, sociocultural, and national levels. Three colors—red, white, and turquoise—are significant in Turkish culture and in national branding of the country globally. Red and white are the primary colors of the Republic of Turkey. A secondary color that has been lately used in national branding of the country is turquoise. The significance of these colors in Turkish culture relates back to complex and layered sociocultural history of Anatolia and the geographical location of the country.

The Republic of Turkey is a Eurasian country located across the Anatolian peninsula in western Asia and in the Balkan region of southeastern Europe. The flourish of the earliest civilizations in Anatolia dates back to Prehistoric Age. Since then, the region witnessed the rise and fall of hundreds-of-years-old empires such as the Hellenic Empire, Roman Empire, Byzantine Empire, Seljuk Empire, and Ottoman Empire. Due to its location and history, Turkey's culture has always been a blend of very diverse elements of the Turkic, Anatolian, Ottoman, Mediterranean, Western, and Middle Eastern cultures and traditions. In this chapter I analyze red, white, and turquoise colors in Turkish culture and the contemporary examples of the use of these colors in national branding of the country focusing on three relationships:

1. History: The historical context discusses how and why red and turquoise were significant in the Turkish culture prior to the establishment of Republic of Turkey.

2. Culture: The cultural context discusses the meanings of red, white, and turquoise color in the Turkish culture, the values, beliefs, and norms associated with these colors.

3. Geography: The geographical context looks into how these colors relate to geographical location of the country.

HISTORICAL CONTEXT

The color red—*kirmizi* or *al*—is the most significant color observed in Turkish culture. Red and white are the national colors of the country that are present in the national flag. The national flag of Turkey is a white crescent moon and a five-point star on red background. See Figure 11.1. According to the historic legend of the flag that dates back to the Seljuk Empire, red signifies the blood of Turkish soldiers who fought in the Manzikert War with the Byzantium Empire in 1071.

Red and white have been associated with patriotism in Turkish culture. People dress in red and white when celebrating national Turkish holidays or supporting national sports teams in international games. The main national holidays in Turkey are the Republic Day, Children's Day, Youth and Sports Day, and Victory Day where streets and houses are decorated in red and white and with Turkish flags.

The association of the color turquoise with Turkey relates to two different historical contexts. First turquoise has been a color used by many Turkic countries and the old Turkic civilization known as *Gokturks*—"Blue Turks," "Sky Turks," or "Celestial Turks"—as a national color. Gokturks are the earliest people from the mid-sixth century that used the ethnonym *Turk*. Tengriism was the early Turkic belief system followed by Gokturks.

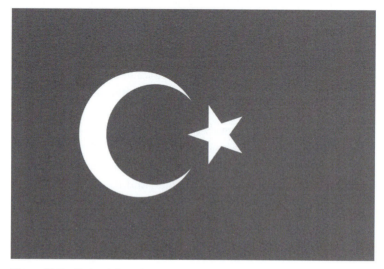

Figure 11.1 National flag of the Republic of Turkey.

Tengri, the "Sky-Father" or the god of the blue sky, was the supreme god in this belief system. For the ancient Turks the words *Tengri* and *Sky* were synonymous, and the Tengri was considered to be timeless and infinite like a blue sky (West 2008; Abazov 2007). Gokturks used the turquoise color in their flags and still this color has been used by many Turkic nations today. See Figure 11.2.

Second, another historical relationship between turquoise color and Turkey dates back to the Ottoman Empire. The color turquoise has been a signature color in the Ottoman art of tile making. Turquoise as a gemstone was originally mined in Persia and traded along the Silk Road, throughout Turkey to the European world. The stone was named after Turkish traders by French Europeans, although the gem did not originate in Turkey. Thus, both the gemstone and the color became known as *turquoise*, derived from the French word for the "Turkish Stone" (Lowry and Lowry 2010). In addition, the color turquoise together with cobalt blue was very widely used in making Ottoman tile and pottery, especially in Iznik and Kutahya tiles (see Plate 22). These tiles are used for decorative purposes in homes, mosques, palaces, villas, and Turkish baths. Sultan Ahmet Mosque in Istanbul, also known as the "Blue Mosque," is the best-known example of turquoise and cobalt blue tiles used in Ottoman architecture. The tiles are famous for their decoration known as underglaze painting applied to the white fritware developed in Iznik in the late fifteenth century. The earliest color used to decorate tiles was "cobalt blue." It is believed that cobalt blue with white decoration was either used to mimic Chinese porcelain or was the influence of those made in Iran and Syria (Denny 2004). The translucent turquoise was the second color added to the repertoire followed by pale purple, true red, and translucent emerald green. Today, this traditional Turkish

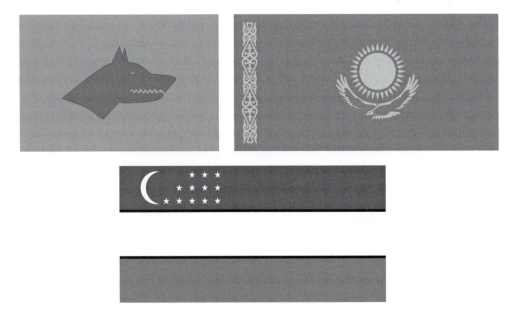

Figure 11.2 Gokturk's flag, Kazakhstan's flag, and Uzbekistan's flag.

art has been inspiring contemporary Turkish designers and architects. Internationally recognized Turkish product designer Defne Koz got inspiration from traditional Iznik tiles in designing her Iznik Collection for VitrA, a leading Turkish ceramic company.

SOCIOCULTURAL CONTEXT

Culture is a dynamic system of shared beliefs, values, norms, traditions, and knowledge among a social group of people that is developed over time. Color can play different roles in cultural contexts, such as it can be used to signify a value, it can be used to mark a rite of passage, or it can be used for spiritual healing purposes. The color red is very commonly observed in cultural rituals in Turkey and carries different meanings and marks a rite of passage.

The color red plays a significant role in different stages of the traditional wedding ritual. The first step when a man and woman decide to get married is the groom's family's visit to the bride's family to ask for her hand in marriage. The groom's family usually brings a box of fine chocolate, a specially arranged bouquet, and several dowry items for the bride wrapped in an embroidered satin fabric and tied with red ribbons. The next phase is the engagement ceremony where red ribbon is used to connect the bride's and the groom's wedding rings to each other. The rings are placed on fingers by an elder in the family and the engagement is announced by cutting the red ribbon, which has celebratory meaning. The third phase is the henna night, which is celebrated among women a few nights before the wedding. This ritual marks the change of status from being a daughter to becoming a wife, leaving the mother's home to go to the husband's home. The legend behind henna night is centuries old, and it is described in Ustuner, Ger, and Holt (2000) as the following: "In the era of prophet Mohammed during religious wars henna—organic reddish dye—was put into the palms of the soldiers to signify the color of blood and that they are ready to give their blood in the name of the god." This war ritual has evolved into a marriage ritual over time. During this ritual the bride usually wears a red dress and her head is covered with a red veil (see Plate 23). She sits on a chair in the center of the room, and her friends make circles around her with lit candles in their hands and singing songs. The mother-in-law prepares the henna and puts some of it into each palm of the bride. The bride refuses to open her palms for henna coloring until the mother-in-law places a gold coin in her palm. Afterward both hands are covered and tied with a red cloth glove, and the celebrations, which include dancing, singing, and eating, begin. The final stage is the wedding ceremony. The night of the wedding ceremony the bride is taken from her parents' home by the groom, and before leaving the bride's father may put a red ribbon belt around the bride's wedding dress, which symbolizes virginity. During the wedding, guests will give gold coins or golden bracelets to the bride as a wedding gift with a little red ribbon bow attached.

The color red also has spiritual meanings in Turkish customs of baby mooning, which is the forty-day period after the labor. During this period the new mother, or *lohusa*, rests,

receives help from family members, and wears a red ribbon band on her hair or a red hair scarf. Birth sherbet or *lohusa* sherbet is served to the new mother and guests visiting to greet the newborn baby. The birth sherbet is a drink made from a special red sugar and a mixture of spices, and its distinctive feature is its bright red color. It is believed that these rituals protect the mother from fevered illnesses and the bad spirit—Al Basti—which is associated with hallucinations that may occur during that period. Al Basti, the "Red Mother" or the "Red Lady" in Turkish folklore, is a bad spirit that visits women who recently have given birth and causes intense fever and wakes them up at night (Ozturk 2005).

White symbolizes honesty, honor, and wisdom in addition to cleanliness in Turkish culture. There are many idioms in the Turkish language in which the word *white* means honest. For example, *yuzu ak olmak*, "having a white face," means being honorable and honest and one who has nothing to refrain from. In Turkish folktales *ak sakalli dede*, "old man with a white beard," is described to be the wise person who would provide guidance and knowledge.

The Evil Eye—*Nazar Boncuğu*—is a dark blue, turquoise amulet that is a very popular charm in Turkish culture. It is believed to protect the owner from an envious look and bad luck. The evil eye bead could be worn as jewelry to protect the wearer or could be hung in houses and cars, with decoration and protection purposes. See Figure 11.3.

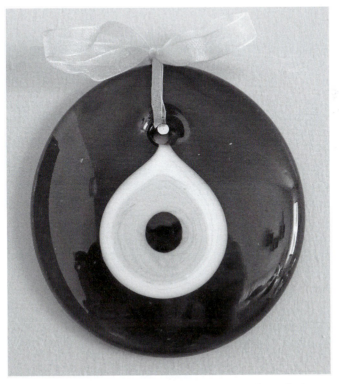

Figure 11.3 The evil eye bead. Photograph by Gozde Goncu-Berk.

Lykiardopoulos (1981) describes the possible reason for the use of dark blue and turquoise colors as the evil eye color; being physically different and having blue eyes among commonly dark eyes in the Mediterranean region, one could be considered as a potential possessor of an envious glance. Thus, people with blue eyes are believed to possess the evil eye (Lykiardopoulos 1981).

GEOGRAPHICAL CONTEXT

In Turkic cultures colors are used to symbolize the four geographical directions: black—north, red—south, white—west, and the color of the sky (turquoise)—east. In the Turkish language, geographic structures such as lakes, mountains, and rivers are named after colors. The seas bordering the Anatolian peninsula are named after directions; in the north *Karadeniz* translates as the "Black Sea," in the west *Akdeniz* (Mediterranean Sea) as the "White Sea," and in the south *Kizildeniz* translates as the "Red Sea" (Genç 1997).

Another association between the color turquoise and Turkey is related to the geographical location of the country and bodies of water that surround the Anatolian Peninsula. The Anatolian Peninsula is surrounded by the Black Sea, the Sea of Marmara,

Figure 11.4 Kaputas Beach located on the southwest coast of Turkey, the "Turquoise Coast." Photograph by Gozde Goncu-Berk.

Bosphorus, Dardanelles, the Aegean Sea, and the Mediterranean Sea or the White Sea. The southwest coast of Turkey, called the "Turquoise Coast," attests to its bright blue water. See Figure 11.4.

NATIONAL BRANDING

Red, white, and turquoise or their combination have been used to represent Turkey in international settings. Especially in the last decade there has been an increased use of the color turquoise in national branding of Turkey in addition to red and white.

Red and white colors have been used in jerseys when different teams represent Turkey in international games. Soccer is one of the most popular sports in Turkish culture. The national soccer team represented Turkey wearing red-and-white jerseys from the establishment of country in 1923 until 2005. Between 2005–2008 the team used almost all-white jerseys and from 2008–2010 jerseys were turquoise and white (see Plate 24). There have been many discussions about the use of turquoise instead of red and white. Some argued that turquoise is a more unique color than red and white and Turkish teams would be recognized more easily with this color, while others argued that the national colors of Turkey are red and white. As a result of these discussions the team started using the very first red-and-white jerseys in 2010 in home games and the turquoise-and-white jerseys in the away games (Turkish Football Federation 2010).

Turkish Airlines has been using the color turquoise along with red and white in its branding internationally. Turquoise symbolizes the sky as well as the nationality in this context. The color has been used in the interior design of the aircraft as well as in flight attendants' uniforms. Turkish Airlines' latest international TV commercial starring Kevin Costner, "Feel like a star," displayed the color turquoise in the interior of the aircraft (see Plate 25) and in details such as the evil eye bead hanging from the page marker (see Plate 26) placed in Kevin Costner's book by the flight attendant. Another commercial that emphasized the turquoise interior design of the aircraft features Turkish Airlines' sponsorship of the Spanish FC Barcelona soccer team, in which the flight attendants place turquoise-colored pillows on players' seats. Turkish Airline flight attendants' latest uniform, designed by a Turkish fashion designer, also displays details in turquoise. The silk scarf worn by the flight attendants features turquoise and cobalt blue patterns inspired from Iznik tiles.

Turquoise has been used to emphasize "made in Turkey" by creating a national logo and accreditation system for Turkish goods exported globally. Turquality is an accreditation system that provides financial support for companies striving to create their own brands. The main objective of this initiative is to support and encourage companies and designers who are in the brand creation process by supplying strategic, operational, organizational, and technological consultancy (Turquality 2003). The brands recognized by the Turquality program carry the turquoise Turquality logo along with their brand name to communicate the common made in Turkey effect and the high quality standards. The

logo brings together the concepts of "Turk" and "Quality," forming the name *Turquality*. In this context the color turquoise is used to communicate Turkishness globally.

The Turkish Ministry of Culture and Tourism's official tourism portal uses the logo with turquoise and red colors in the form of an abstract tulip. Turquoise used in the logo could be a symbol of the Mediterranean culture of Turkey, the turquoise coast of the country along with its historical relations with Old Turkic cultures. Tulips had significant importance in the history of Turkey. The Ottoman Empire has been known to be one of the earliest cultivators of tulips; tulips were an emblem of the era between 1718–1730, called the "Tulip Period" or *Lale Devri*. During this era, high-class society in the Ottoman Empire had a fondness for the tulip, which they associated with nobility and privilege (Salzmann 2000). In addition to tulip bulbs cultivated in gardens and homes, tulip motifs were heavily used in clothing and textiles as well as in architecture and tile making. Tulips continue to be an important symbol in contemporary Turkish culture. Since 2006, Istanbul has celebrated the "Tulip Festival" with 3 million tulips blooming in parks and avenues. See Figure 11.5. Turkish Airlines decorates its aircraft with a tulip figure on the fuselage.

The logo for Istanbul 2010 European Capital of Culture was also centered on the turquoise color. The European Capital of Culture is a city designated by the European Union

Figure 11.5 A park in Istanbul during the Tulip Festival. Photograph by Gozde Goncu-Berk.

for a period of one calendar year, during which it is given a chance to showcase its cultural life and cultural development. The turquoise logo was showcased in all the international events and Turkish Airlines aircraft flew with this logo on them throughout 2010.

CONCLUSION

Color is a strong element that helps to establish shared meanings in a culture, therefore, it's an element that symbolizes the culture. Exploring a color in a specific culture reveals interesting connections in terms of how the meaning of the color changes from one context to another and how it evolves throughout history. For example, in Turkish culture, in contexts such as national holidays red color communicates patriotism; on the other hand, in contexts such as cultural rituals it can mark rites of passage or symbolize supernatural powers.

Color is also a very important element in branding, and it affects how we view and think of things, and how we remember them. Since it is such a strong retrieval tool, many countries have been using color to establish and communicate their country image. Usually the colors in the national flag of the country are used as a retrieval tool for the logos or the brands that signify that country. For example, colors of the IKEA logo are easily associated with the Swedish flag. In this context, Turkey follows a different path and emphasizes turquoise in establishing the country image.

REFERENCES

Abazov, R. (2007), *Culture and Customs of the Central Asian Republics*, Westport, CT: Greenwood Press.

Denny, W. B. (2004), *Iznik: The Artistry of Ottoman Ceramics*, London: Thames and Hudson.

Genç, R. (1997), *Türk İnanışları ile Millî Geleneklerinde Renkler ve Sarı-Kırmızı-Yeşil* [Yellow, red and green: Colors in Turkic beliefs and national traditions], Ankara: TDK Yay.

Lowry, J. D., and Lowry, J. P. (2010), *Turquoise: The World Story of a Fascinating Gemstone*, Layton, UT: Gibbs Smith.

Lykiardopoulos, A. (1981), "The Evil Eye: Towards an Exhaustive Study," *Folklore*, 92/2: 221–30.

Ozturk, O. (2005), *Karadeniz Ansiklopedik Sozluk*, 2 vols., Istanbul: Heyamola.

Salzmann, Ariel (2000), "The Age of Tulips: Confluence and Conflict in Early Modern Consumer Culture (1550–1730)," in Donald Quataert (ed.), *Consumption Studies and the History of the Ottoman Empire, 1550–1922: An Introduction*, Albany: State University of New York Press, 83–106.

Turkish Football Federation (2010), "National Team Introduced New Jerseys," http://www.tff.org/default.aspx?pageID=628&ftxtID=379.

Turquality (2003), "Turquality," http://www.turquality.com/15.aspx.

Ustuner, T., Ger, G., and Holt, D. B. (2000), "Consuming Ritual: Reframing the Turkish Henna-Night Ceremony," in Stephen J. Hoch and Robert J. Meyer (eds.), *Advances in Consumer Research*, Provo, UT: Association for Consumer Research, 209–14.

West, B. A. (2008), *The Encyclopedia of the Peoples of Asia and Oceania*, New York: Facts on File.

The Punk Palette: Subversion through Color

Monica Sklar and Lauren Michel

Chapter Summary. Punks have maintained a thoughtful approach to color in their emphasis on dress, from inception of punk subculture in the 1970s through today. Research was performed through surveys and interviews with self-identified punks from three large cities in the midwestern United States to evaluate their punk dress. Findings indicated punks employ color as tools for self-expression, to ally with subculture, to identify with like-minded others, to distance themselves from social ideas they dislike, and to be individually creative. Interviewees emphasized dark attire with accents of silver and neons as fundamental to their visual interpretation of the punk ethos. However, in interviewees' experiences, aging brought on a willingness to tone down one's obvious punk style, reducing the use of color cues. While punk style has become increasingly acceptable in the mainstream, it generally remains inappropriate in conservative contexts. Thus, there is still potential for color in punk dress, such as green hair, to be viewed as incendiary.

THE FOUNDATION OF AESTHETICS OF PUNK DRESS

Part of establishing a punk identity means feeling in some way disenfranchised from mainstream society and being critical of the art, politics, popular culture, consumerism, and sexual and social mores of conventional culture. Scholars have theorized that dress is of great importance in communicating an identity (Goffman 1959; Roach-Higgins and Eicher 1992). The specific aesthetic components of dress, such as color, factor heavily into the identity expression of individuals who display a punk ideology. There is great variation within what is considered punk style, however many of its components, including the color palette, have become ubiquitous. In the 1970s the bold tartan and metal zippers of designers Vivienne Westwood and Malcolm McLaren, dark-colored denim and black leather jackets of music pioneers The Ramones, and a flourish of bold unnatural hair dye sold by early punk-style retailers, Tish and Snooky, helped establish the color scheme: black and a limited range of dark colors juxtaposed with shocking brights, and accessorized with silver metal. This foundational look has been reinvented repeatedly to suit the times as seen in vibrantly colored

skate/surf-wear of the 1980s, the plaid flannel of 1990s grunge, and the black-clad "emo" style of the 2000s.

RESEARCH STUDY

Men and women who self-identified as punk evaluated the relationship between their punk dress and their other modes of dress. Data were gathered via 208 participants in a mixed-method online survey, from which twenty representative participants were selected for interviews to discuss their dress behaviors and to display selections from their wardrobes. Interviewees were from three large cities in the midwestern United States and between the ages of twenty-six and forty-five. Eighteen of twenty reported that they had participated in the punk subculture for eleven years or more. On a Likert scale, nineteen of twenty reported they "use dress for self expression of punk" and ten of twenty responded "regularly/quite a bit" regarding how often. These committed punks stressed the importance of colors within punk aesthetics, highlighting dressing in dark hues with accents of shock and steel.

FINDINGS: THE PUNK PALETTE

Dressing Dark

All twenty interviewees emphasized the color black as fundamental to their visual interpretation of the punk ethos. Repeatedly, black was characterized as the base color of their wardrobes and dressing dark was considered at the core of punk style in the following quotes from interviewees.

"A lot of black all the time." (Stacey, age range 26–35)
"Dark colors, black, dark blue and stuff like that." (Ben, age range 26–35)
"Dressing a little bit darker." (Chrissy, age range 36–45)

Similarly, dark, low-value shades of gray, red, green, and blue were employed deliberately in interviewees' clothing choices. Dressing dark serves cultural and functional purposes.

Cultural Associations

Interviewees described how they choose dark colors for their cultural associations, such as the presentation of a seditious or intimidating appearance. Also mentioned was the association of black with dirt and filth in contrast to white and its association with pristine purity. In keeping with the proverb "cleanliness is next to godliness," mainstream society equates dressing dark with nonconformity, antisociality, low class, and little worth in society, a stereotype punks embrace and try to turn on its head.

Functional Purposes

Secondly, black and dark colors were stressed as important for functional purposes. Although punks often desire to stand out, interviewees reported the sometime benefits of dressing dark providing anonymity by allowing one to fade into the night or into a busy urban environment, thus avoiding unwanted attention. Also mentioned was black's practicality, both for repeated wear for hiding stains, and for coordinating harmoniously with other colors.

> In general, I always preferred black. Because it's harder to see in the light for one thing, it's easier to hide. It goes with everything. When in doubt, wear black. (Zhac, age range 36–45)

Punks may wear black and dark colors for their symbolic meanings or for their sensible aesthetic qualities. As Fehrman and Fehrman remind us (2004: 65), "Most of our associations with black are negative: blacklist . . . black looks, black sheep. Black is often the garb of the revolutionary, from beatniks to punks." Given the historical antisocial and anticonformist attitude of punk, and Western culture's associations with the color black, extensive wearing of the color seems a natural part of the punk aesthetic.

The Workingman's Metals

The words *silver* and *metal* were used interchangeably to describe the popular color theme for the numerous mentions of studs, spikes, chains, safety pins, buckles, piercings, and padlocks. It was clear that these accessories were readily accessible white metals and not precious metals, yellow gold, or other metallic colors, because they were part of the interviewees' displayed garments, as well as through the researcher's knowledge of common punk appearances.

> Silver, not gold ever. More [silver] is merrier. . . . I'll wear gold to work but typically would not wear gold out anywhere [else] really. It's not really my preference and I don't feel like it's expressive but I have some of it, so I utilize it for work purposes. (Audra, age range 26–35)

The choice of silver over gold may be related to gold's higher price and long association with luxury and wealth, whereas, in contrast, the less costly white metals (aluminum, steel, and tin, for example) are typically associated with industrial cities, and the tools of manual labor. "Silver" is evocative of machinery, transportation, and weapons, images that support punk's self-visualization as utilitarian and strong.

Identity and "Identity Not" through Color

At the same time interviewees maintained a clear distinction between colors that were punk and those that were unequivocally not punk. In addition to dark shades and

silver/metal, further inclusions in the punk palette depended on the specific hue, brightness, and saturation. Study findings indicated that punk equated with the more extreme in darkness or in brightness. Thus blood-red and neon pink are punk examples on opposing ends of the spectrum. The colors most commonly designated by the interviewees as nonpunk included pale shades, neutrals, and mid-toned hues that are soft on the viewer's eye, such as French blue, teal, and lilac. These colors were used by the punks sparingly and only in nonpunk contexts, if at all.

Punks classified many more colors available in contemporary apparel as "nonpunk" than they did colors that were "punk." This concept of "identity *not*," or disidentifications in appearance construction and identity management helps establish the parameters of what is punk (Freitas et al. 1997). Strikingly, of all the colors identified as nonpunk, khaki was the one mentioned the most. Interviewees related their disdain for the color, characterizing it as representative of the antithesis of punk's boundary-bashing ideals, often aligning khaki to the regimentation of a workplace, and related ideas of compliance and uniformity.

> It would feel untrue to myself to be wearing khaki stuff all the time outside of work because . . . of the cultural association. . . . Keep that in the workplace . . . khaki is a workplace thing. (Nate, age range 26–35)

As Nate expressed that khaki resides in the nonpunk sector, there were few overlaps indicated between punk and decidedly nonpunk colors. Although interviewees reported trying to inject their punk preferences into their wardrobes for mainstream contexts, such as for the workplace, they named gray and red as examples that had some fluidity. Brown was characterized as a tolerable color for punk shoes, but was rarely seen in other punk clothing with the exception of military or uniform styles, which are functional and referential in their selection. White was classified generally as a nonpunk color; however, it should be noted that the punk subgenres referred to as "hardcore," "skatepunks," and "skapunks" have been known to include white within their palettes.

COLOR CHOICE MOTIVATIONS

Express Yourself

Expression of punk identity through color necessitates thoughtful choices. The goal is to select colors that have expressive characteristics that instantly generate desired reactions within the wearer and for the viewer arise without thought (DeLong 1998: 14–15). Dressing dark, sometimes in clothing that appears dirty and distressed, can evoke opinions of discomfort, lack of caring, and disdain for convention. A color such as black may be associated with intimidation, depression, or seriousness, whereas

neon pink may indicate excitement, liveliness, or forcing viewer attention. Therefore in contemporary Western culture, punk's gritty clothes or bright hair can promote feelings of fear, shock, or curiosity in the mainstream viewer. The authors' of this chapter each have personal experience with this through the use of vibrant, non-natural hair colors as a form of identity expression (see Plate 27). This gritty and/or bright approach to color is in contrast to the mainstream ideal of a well-groomed appearance using earth-toned and mid-toned colors. In expressive characteristics, such colors give the impression of health, calm, passivity, and agreeability—concepts that are in opposition to punk.

Know It When I See It

In addition to being expressive, another reason the punk palette remains constant is that much of punk dress contains referential characteristics based in knowledge about the forms' meaning within the subculture (DeLong 1998: 15). Punks' dress is often a coded mash-up of looks adopted from counterculture history, incorporated with touches of individualized preferences and a nod to mainstream trends and functional attire. Color is a way to employ referential characteristics by paying homage to the important hues of past subcultures, even if the color's origin story is lost or diluted through generations. Examples would be the use of military greens by protesters wearing army fatigues in irony to fight political and social battles, and the black-and-white checkerboard pattern used by the 1970s British ska scene with its focus on racial integration. Color contextually places references within or outside mainstream stereotypes, as reflected in punks sneering at the perceived conformity of khaki and the passivity of pastels.

Turning down the Visual Volume

The aesthetic details of punk style typically maintain the established foundation, yet are also ever-changing. This is due not only to generational and societal shifts, but is also reflective of individuals' personal development. In the interviewees' experiences, aging brought on a willingness to blend in through toning down one's obvious punk style. Reducing the blatancy of punk colors was one adaptation. Maturity brought comfort in knowing ideology may be represented throughout one's life, not just in dress. Interviewees explained that their position within the subculture is now solidified, personal ideals have been tested, and there is less to "prove."

Further, interviewees explained that in adulthood their finances and free time were limited in ways that they were not during their youth. The result was less discretionary income and time put toward punk dress that would be incompatible in a variety of contexts. Therefore they turn down the visual volume of their punk styles and opt for garments that can multitask for home, work, punk, and other contexts. The punk palette

is employed in less flagrant ways than in youth, while maintaining self-expression and effectively signifying their punk identity to knowing viewers. In doing this, the foundation look is maintained, but with less bright colors and selective use of all-black attire and chunky silver metals. One interviewee expresses this point:

> You couldn't pay me to dye my hair magenta. Because I know how I would be taken and how I would be perceived. And that is no longer a benefit to me. Whereas in the past it was. (Marla, age range 26–35)

However, other interviewees did report that unnatural hair color remains an effective way to express punk rebellion without always being entirely clothed "punk." One interviewee shared her story of her concerns about reactions in her conventional workplace when she dyed her hair an extremely bright shade of red.

> I felt like a cartoon character. And I decided that since my hair was like that, I was going to dress as professionally as I could. . . . I did it on Good Friday, so I had a whole weekend to look at myself and go, "I wonder if I pushed it. I wonder if this is that one step too far." (Kathy, age range 26–35)

Hair color is a cue to differentiation from the norm, as well as a reference to the subculture's past. It is a method to be individually innovative in a temporary manner, promoting constant change, fun, and provocative flouting of convention.

Unnaturally colored dyed hair continues to have impact forty years after punk's inception, as explained through Kathy's internal conflict with expression of her punk self in a nonpunk context, and Marla's thoughts about how the benefits of it change with time.

CONCLUSIONS

A current discourse in popular culture is the debate regarding whether punk dress can continue to be called extreme, countercultural, and shocking, as the style has become increasingly acceptable in some mainstream contexts. However, while this is generally true in casual affairs, punk-style dress is commonly not appropriate within a conservative or formal context. Thus, there is still potential for punk dress, such as green hair, to be viewed as incendiary. In this study we found that punk style was about that goal to stand out and from a punk's perspective the mainstream was often about blending in. Use of color for punk dress expresses that desire to stand out. Punk has gone through many incarnations throughout its four-decade history, and individuals within the subculture have changed as well. Yet through this growth, both cultural and personal, the punk color palette has distinctive characteristics that are maintained and employed to continue to subvert the mainstream.

REFERENCES

DeLong, M. (1998), *The Way We Look: Dress and Aesthetics*, 2nd ed., New York: Fairchild.

Fehrman, K.R., and Fehrman, C. (2004), *Color: The Secret Influence*, 2nd ed., Upper Saddle River, NJ: Prentice Hall.

Freitas, A., Kaiser, S., Chandler, J., Hall, C., Kim, J., and Hammidi, T. (1997), "Appearance Management as Border Construction: Least Favorite Clothing, Group Distancing, and Identity . . . Not!," *Sociological Inquiry*, 67/3: 323–35.

Goffman, E. (1959), *The Presentation of Self in Everyday Life*, New York: Anchor Books.

Roach-Higgins, M.E., and Eicher, J.B. (1992), "Dress and Identity," *Clothing and Textiles Research Journal*, 10/4: 1–7.

PART III

MARKETS AND TRENDS

Part III focuses on how color influences decisions in product development, marketing, and consumer selection. How does cognition influence our perception of color and its function in designed objects? How do color meanings evolve in terms of place identity? How do color trends originate and then filter through the various design applications of products and communications?

ORIGINS AND INFLUENCES OF COLOR TRENDS

Trends and forecasts play an influential role in the way we see and identify color. Consider the colors that become a signature of a specific time period. Fashion decades are often identified through color combinations popular at the time, for example, the use of gold and green in the 1960s and bright psychedelic colors of the 1970s. Colors can be used to trace the influences of new technologies and processes. For example, when aniline dyes were invented in the mid-nineteenth century, the use of colors in clothing became dramatically different. In the 1980s neon-colored play clothes made children highly visible when biking. Not only functional, neon colors became a dominant trend. Cassidy and Cassidy describe the color forecasting process and identify the need for study of consumer preferences in diverse markets in their chapter "Color Forecasting: Seasonal Colors." Following a thorough discussion of current methods, they propose a tool that will allow for data collection that can inform the forecasting process and be adaptable for global commerce. Nagai and Georgiev's chapter proposes a new methodology for determining a person's associations with specific colors. Using a color plan derived from a seasonal palette they demonstrate this method in the examination of colors for medical uniforms. Colors that create a sense of ambience in interior spaces are explored by Olguntürk and Demirkan. Using an experimental design and an environment flooded with different-colored lights they asked participants to identify the degree of calmness or excitement of the space. They conclude that the role of the background and foreground color treatments affect color harmony, ambiance, and a sense of place in the environment.

COLOR, BRANDING, AND IDENTITY

Research studies have shown that people immediately recognize product and corporations via color alone without the shapes or words often contained in a brand image. Coca-Cola's red, IBM's blue, BP's yellow and green combination, and McDonalds' red and yellow have all attained an extensive recognition value. Conversely, independently owned ethnic restaurants tend to use colors typical of the geographic locale they represent and these colors become a form of cultural branding. Bitterman's chapter, "Color the World: Identifying Color Trends in Contemporary City Brands," explores the notion of place branding in a study of over 200 city logos in Europe and the Americas. He finds that the colors are not necessarily signifiers of specific locales but are colors selected because they work well with the production technology. His chapter proposes that the use of color in graphic identities will be more successful if based on a participatory design approach involving people within the communities.

While we often focus on color in a theoretical sense, it is in our daily encounters with objects, places, and people that we experience color. Such is the case with Julia Vallera's Color Wheelz project. Her white van that travels around New York provides an interactive color experience for people in city neighborhoods. Members of different communities adapt the van using colors that represent their own community. The element of color is linked to identity, be it personal, local, or national. Vallera's chapter details how she encourages people to think about how color affects their perception and how it plays an active role in their daily lives. Perhaps most important she provides a space for people to play with color and representation. This project is the link between the often erudite theory of color and daily life.

COLOR IN PRODUCT DESIGN

Digital technology has changed the way in which color is specified, is organized, and is understood. Designers consider color as an integral part of the process and use a variety of different processes to determine effective colors for each project. Madsen and Thomsen's chapter, "Colors and Prototypes: The Significance of the Model's Colors and Textures in Expectations for the Artifact," discusses the importance of examining issues such as the impact of color in terms of a product's form and value, materiality, and cognitive ergonomic variables. Van Meeuwen and Westbrook address color as a variable of expression in architecture through the lens of computer-aided design. They assert that contemporary digital tools are changing the surfaces of buildings and the ways in which colors are being used to create new narrative structures.

Finally, "Color as a New Skin," by Luca Simeone presents an anthropological look at the color applications across cultures. He examines how typically gray technological objects have been embellished with brightly colored stickers and elaborate surface design. Multicolored vehicles in the Philippines and India are seen as a source for new approaches to color that contradict current norms in industrial design.

–13–

Color Forecasting: Seasonal Colors

Tracy Diane Cassidy and Tom Cassidy

Chapter Summary. Color forecasting is essentially part of the fashion trend forecasting process that offers designers direction in the selection of seasonal color palettes and other design decisions for product creation. Trend information is sold in the form of trend packages primarily to fashion and textile companies and to other consumer product industries whose sales also rely on meeting the demands of consumer taste. However, this diversification of the clientele has resulted in the promotion of more generalized color directions; the opposite of industrial practice where knowledge of consumer desires and preferences is intrinsic in design and marketing processes. This chapter explains the role of the forecasting sector and the process they employ to create seasonal color palettes and how these are promoted to the fashion and textile industry. The weakness of the process and the importance of consumer color acceptance are discussed concluding with the benefits of using consumer color data.

Color forecasting is a fundamental part of a collective process known as fashion forecasting or trend prediction, where attempts are made to accurately forecast color and other design elements for fashion-related products that consumers will purchase approximately two years ahead. This specialist sector evolved in the early part of the twentieth century from small independent companies by individuals with a vision for creating seasonal color palettes to influence textile and fashion design. Ironically, as the textile industry sector decreased in the United Kingdom, the United States, and Europe, the forecasting sector expanded as the visionary entrepreneurial types with textile backgrounds migrated from the former industry to the latter. With the growth of the forecasting sector came increasing competition between the forecasting companies to sell their products, the product being the forecasting information most often sold in the form of trend packages. With this came the need to diversify beyond the fashion and textiles sector into other mass consumer product sectors where color is also an important design element. These "fashion-related" markets can also be allured to essentially benefit from color as a marketing tool to create aesthetically saleable products. However, in widening the customer base the trend information has become more general to make it relevant to less fashion-specific industries. This move is the opposite to the common business practices of today where companies are becoming more target market focused

and require more specific information in relation to their consumers' tastes, preferences, and behavior.

The process of color forecasting is an integral part of the roles of many personnel within the industry and currently includes the anticipation of consumer acceptance of color. Seasonal colors are recognized as a powerful driving force of fashion-related or consumer products and consumer research of desires and preferences has become an important and integral part of the design and marketing processes. As trend forecasts are marketed globally they do not take into account the tastes and preferences of target markets that fashion-related industries focus their design and marketing efforts on. The forecasting sector claims to aim for 80 percent accuracy in its predictions but also professes the intentions of the data to be inspirational, not gospel. However, in a previous study by the authors only around 50 percent of consumers when questioned were satisfied with color ranges on offer at that time. Through a rigorous research process the anticipation of consumer acceptance was identified as a weakness of the current color forecasting process and almost 70 percent of industry personnel surveyed that were involved in using the current forecasting process felt that it should be improved. As a result, an improved system model was conceptually developed and tested revealing that almost 70 percent of retail, 50 percent of manufacturing personnel, and more than 80 percent of personnel in the forecasting sector agreed that their company would benefit from the inclusion of consumer color preference data to eliminate the anticipation stage of the process. The idea of a system to assist with the development of seasonal product color ranges in relation to target market specific consumer preferences/acceptance was significantly embraced.

This chapter begins by explaining the role of the color forecasting sector, outlining the processes used to develop seasonal color stories, and the dissemination of these to create a strong color consensus as a marketing tool. The concept and importance of consumer color acceptance is discussed and, in conclusion, the benefits for consumer product industries to work with this type of data specific to their own target markets is explained.

THE DEVELOPMENT AND ROLE OF THE
COLOR FORECASTING SECTOR

The color forecasting sector operates predominantly from major global fashion cities providing a service primarily to the fashion and textiles industry, and more recently to other fashion-related consumer product industries. Individuals working for specialist forecasting companies provide seasonal color stories using a limited number of colors. These are sold as trend prediction packages that promote the selected colors as a trend for a predetermined period of time in the near future. The forecasts indicate anticipated colors assumed acceptable to the consumer compiled through a complex intuitive and analytical process. The information is used by those responsible for color decisions for

their company's products. This source of information is used to assist in their own color decisions for their products, which they hope will result in the creation of products that will have a relatively high chance of meeting their consumers' preferences, desires, and needs.

The current role of the color forecasting sector has evolved through developments in the textile industry that occurred during the early half of the industrial revolution. These progressions enabled the garment manufacturing sector to develop, and in turn, aided the establishment of the fashion industry as we know it today. Earliest indications of the need for inspiration for fashion direction is possibly evidenced by a number of British manufacturers visiting the United States in around 1825 where they were much inspired by lightweight wool blend fabrics produced for outerwear (Diane and Cassidy 2005). The ready-to-wear sector was established much earlier in America than in Britain and with it came new challenges. Previously garments were made bespoke by skilled individuals who later became known as or recognized as being fashion designers. These handmade garments that are now accepted as being the fashion garments of that time were only made for those with the means to pay for them. The lesser-privileged mass market wore homemade and handed down garments. Later, by the end of the industrial revolution, fashion was more readily available and affordable to all classes. By now designers worked predominately within factories and no longer designed for individuals but for mass markets. Thus the direct communication link between the designer and client no longer existed and designers had to rely on anticipating the needs and desires of the new fashion consumer. At this time fashion retail outlets were predominately department stores. In the first instance ready-made garments were part-made and completed to fit by seamstresses working in the fashion departments. This system enabled the garment manufacturing industry to better cope with the problems encountered by nonstandardized garment sizing experienced at this time. However, there was nothing in place to assist the problems encountered by the textile industry to produce yarns and fabrics in desirable colors.

In 1915, the Color Association of the United States (CAUS) was the first known set of individuals to become involved in color forecasting followed by the establishment of Tobe Associates consultancy in 1927 by Tobe Collier Davis (Diane and Cassidy, 2005). While it is uncertain if this was the first of its kind, it was undoubtedly the most important consultancy at that time in America. Finally a company existed that could concentrate on the fundamentals of fashion direction to be delivered to the manufacturers, albeit in exchange for a fee. This freed the manufacturers of this process enabling them to concentrate their efforts on production. Obviously as many manufacturers were then supplied the same information a theme was duly set, and when followed by the subscribers, this theme would become evident. In 1931 the British Color Council was formed and played a key role in the forecasting of seasonal color palettes in the United Kingdom. Its information was presented to fiber, yarn, and fabric manufacturers in advance of the appropriate season (Worth 2000). At this time, the responsibility for color direction was very much with the manufacturers. As the direct communication

link between designers and consumers grew, through the development of the industry's supply chains, it became more difficult for manufacturers to understand and relate to consumer needs in what had now become an increasingly competitive climate. To alleviate some of the difficulties faced by the UK industry, a group of manufacturers formed the London Model House Group in 1947 (Burns and Bryant 1997). They made efforts to begin to co-ordinate a structure to the industry through the introduction of seasonal stock in the growing retailing sector. This assisted manufacturers to work to deadlines on heavier-weight clothing associated with Autumn/Winter seasons and lighter-weight garments for Spring/Summer seasons.

During the 1950s further technical developments in spinning, yarn development, weaving, knitting, and garment production rapidly increased. By now colors and fabrics were establishing a more seasonal direction on the high street, a follow-through from the limited number of forecasting agencies and exhibition directors at this time. The fashion disasters of the late 1960s and early 1970s, such as when the midi skirt was introduced, were a result of misinterpreting consumer demand by the manufacturing industry. These errors in judgment led to serious financial losses and business closures. Earlier in the 1920s costly fashion flops were experienced by the industry when similarly some designers tried unsuccessfully to introduce ankle-length skirts. However, possibly due to increased competition, the mistakes made in the 1960s and 1970s in anticipating fashion change and consumer acceptance were particularly devastating to the industry. This coupled with the onset of an economic recession, which incidentally also occurred at the end of the 1920s with the Wall Street crash in America that also affected the United Kingdom, compelled the need for more accurate fashion direction to be known in advance for survival. Possibly for this reason more color and fashion consultancy businesses were established, including Informa Inc., Promostyl, and International Color Association (ICA). These new companies predicted trends eighteen months in advance. Also by the early 1970s fashion on the high street lacked direction resulting in no single influential driving force being identifiable and consumer demand became more varied. This influenced a need for market segmentation in the retailing sector. By the end of the 1970s the retailer NEXT established George Davies's novel concept of retailing on British high streets. The company used a limited color palette per season and exploited display methods for optimum sales as a key marketing strategy. This emphasized the effective use of color in fashion retailing, which may have been the concept of the initial color forecasting companies and exhibition directors forty years previously (Gray 1998). The need for retailers to segment the market became ever more apparent. This was largely due to a high population with widely varying lifestyles and interests. For this reason market research became an important tool for collating information about the consumer to assist retailers to target their market more effectively.

The existence and prominence of the forecasting sector may be indicative of continuing uncertainty felt by manufacturers and retailers. Also, as will become clear in the following sections, the engineering of the color forecasting industry can be seen to ensure, to a degree, that the color trends predicted will indeed prevail due to the

marketing influences and techniques employed; though as highlighted in the final sections of the chapter, it is the decisions and choices made by the consumer to purchase that ultimately create sales. While manufacturers and retailers cannot control all of the variables that influence these decisions, offering products with high color consumer acceptance levels is one very important aspect that can be controlled. Edelkoort (1999) emphasized the important role that color plays in the fashion business, stating that in general the industry has been led to believe that when the color aspect of design is right, then all else will fall into place. For this reason, companies are willing to invest large amounts of money in trend information.

DEVELOPING SEASONAL COLOR STORIES

Color forecasting can essentially be viewed as both a service and a process, the service being the marketing concept partly fulfilled through the sale of prediction packages to the industry and partly through the dissemination of color stories outlined in the next section. Color forecasting as a process is the selection of colors for a predetermined season in the near future. Personnel within the industry use trend information as a source of inspiration to assist in color decisions to create products that are "on trend" and that will achieve optimum sales. Sproles (1979) viewed forecasting as an anticipation of the timing and direction of change in relation to consumer acceptance based upon knowledge, informed judgment, and intuition in order to analyze, evaluate, and interpret this qualitative data systematically. This was reiterated by Tate (1984) and Sproles and Burns (1994), acknowledging that the forecasters of the specialist sector essentially attempt to take control of the resulting seasonal color trends.

The process involves a seemingly accurate evaluation of the moods and buying behavior of consumers (Brannon 2000). This is coupled with a collection of color data to be analyzed and interpreted *delineating the possibilities* (Perna 1987) to anticipate change on a seasonal basis. In particular, changes in the direction and the rate or speed of these changes in relation to the timing of acceptance by the consumer (Sproles 1979) is essential. The seasonal color stories indicate hue, value, and intensity and are heavily promoted throughout the industry. The promotion of these seasonal color stories is thought important to instigate high street sales through a consensus of color. However, they can also be seen to set limitations and may serve to dissuade companies from developing palettes that would better suit the preferences of their own target markets.

Patricia Verlodt (Linton 1994) recognized color forecasting methodology as having specific tools, one of which being past experience. This can include historical trends, research, experience, and intuition. She also suggested that design can more often than not influence color, that is, by shape, size, and texture. Alison L. Webb spoke of the importance of timing and that colors evolved that can be experienced in a systematic manner (Linton 1994). Color consultant Julie Buddy (1992) identified three main areas within the color forecasting process: exploration, evaluation and analysis, and finally

collation where all of the information is compiled into a fashion marketing concept. She viewed market research as a fundamental tool for the forecaster and the process of observation to be constant. She also pinpointed consumer segmentation as an essential tool. Edelkoort (1999) reported the methodology as a continual collection of color representatives, of any form or substance, to be stored away until the time comes to put together a new color palette. The color representations most appealing to the eye (of the forecaster) are intuitively selected from this collection. Then from the many colors that are laid out on a surface, natural color stories are identified. Ideas for fashion begin to formulate around the colors and are then developed into color story boards. This process occurs biannually. Dale Russell of the Color Group demonstrated that lifestyles are very important influences when compiling color stories or themes, which are then presented in the form of mood boards for discussion. Also relevant updates in technology may also be added to the discussion. Russell stated that the ultimate decisions for the final colors were the product of brainstorming workshops (BBC Video 1991). Edelkoort emphasized the importance of awareness in the forecasting process stating the importance of observing aesthetics and patterns in society. Such data are collected visually, remembered, and later analyzed in order to filter into trends (Fearon 1996). Jabanis (1983) noted that interpretation requires a preliminary process of eliminating the information not considered to be applicable. This process of elimination may be based on intuitive reasoning or a more objective and fundamental approach. The remaining data form the color story.

Further fashion-specific forecasting methods include the measurement of the diffusion of fashion using diffusion curves developed employing the number of adopters over points of time. This is a more theoretical approach to forecasting. The rate of acceptance is analyzed and the current level of acceptance is evaluated. The extent of the trend should then be possible to estimate. Mostly, levels of acceptance are observed and experienced by the forecaster as opposed to actually calculating it. The forecasters prefer to view this technique as part of their intuition. Sproles (1979) included consumer surveys, consumer panels, test marketing, and the monitoring of designer collections, fashion cities, and the high street as sources of data collection that are considered to be fashion-specific, though evidence of the three former sources is minimal in practice. Trends in consumer spending were also included in Sproles's list.

Two types of forecasting can be identified, short range and long range. The differences between the two are predominantly the time scale involved and accuracy. Short range is likely to be more accurate due to its shorter time span, which may only be a few months ahead or up to two years ahead. Longer time spans of long-range forecasts, three to five years, have a higher risk of inaccuracies due to unforeseen factors materializing at a later date. Long-range forecasts lend themselves better to marketing strategies and short-range forecasts to fashion forecasting. In both instances trends are identified and levels of demand assessed as well as the timing of acceptability by the consumer. Due to the traditional time scales required by the industry to produce garments and for retailers to sell them, the forecasters originally worked around two

years ahead. However, as lead times are generally shortening within supply chains, some forecasters are now working to shorter time spans. Due to the changing climate in the industry and producing orders on demand within short time scales, a more trend-responsive system would serve to further reduce inaccuracies for manufacturers and retailers. Such a system is discussed later in the chapter.

After an initial sourcing of inspiration, the forecaster works through a sequence of stages in order to develop a color story as shown in Figure 13.1.

There are two fundamental sets of forecasters that operate within the forecasting sector. The first set initiate, develop, and disseminate color stories in the first instance. These include the color groups, such as the Color Marketing Group (CMG), and the larger color forecasting companies, such as the Color Association of United States (CAUS). These groups are often made up of individuals from the industry, including fiber manufacturers, fabric manufacturers, designers, and forecasters from the smaller fore-casting companies. The role of the color groups is to essentially develop and market seasonal colors to the industry. The smaller forecasting consultancies or agencies can be viewed as the second set of forecasters. These companies may have a small or large clientele but are not major players in the development of the initial seasonal color pal-ettes that are eventually heavily marketed and disseminated throughout the industry, as described below. Rather, this second set of forecasters uses the seasonal color pal-ettes in much the same way as designers to distill into their own trend prediction pack-ages. Depending upon their clientele, these prediction packages may be more fashion product specific, such as knitwear, lingerie, or bridal wear, and most often include style direction, thus building moods and ranges around the initial color themes.

After briefly setting out the process used by individuals to develop a color story Edel-koort (1999) described how the resulting story boards are shown at national and in-ternational color meetings. This process was also described by Joanna Bowering, the founding member of the British Textile Color Group (Hulse 1997). The process begins with a panel of around twenty-five individuals who each bring along his or her own pre-viously compiled color stories in the form of mood boards, or color story boards. Each color story would have been developed in much the same manner using the aforemen-tioned process. Each person presents his or her board visually and verbally, conveying his or her personal interpretation of moods, emerging color directions, and his or her rationale as he or she anticipates forthcoming changes for the predetermined season ahead. Plate 28 shows a representation of industry personnel in attendance at a na-tional color meeting with their individually produced color story boards to present.

After each person has presented, the similarities are honed in on, these include the inspirations used to support the color stories and word associations as well as the ac-tual colors. Discussions are then entered into until eventually a color palette is mutu-ally decided upon based upon the commonalities identified. A consensus is formulated around these similarities using images, words, moods, and colors. By the end of the meeting a color card has been agreed upon. This process occurs in the first instance at national level. Each country involved in the global fashion industry will hold similar initial

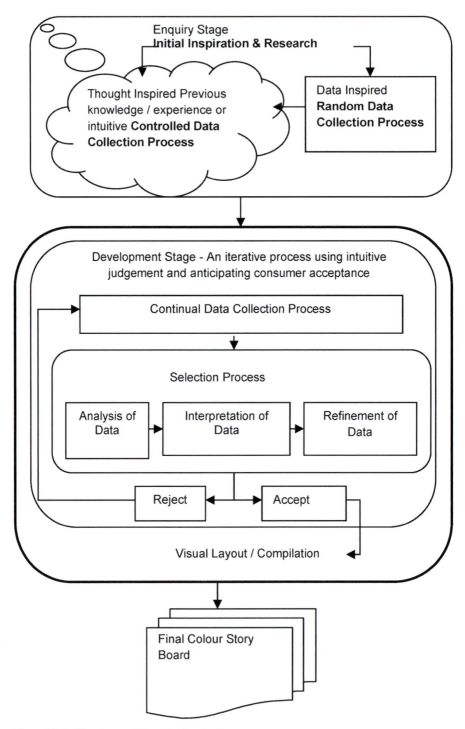

Figure 13.1 The stages of the color forecasting process.

color meetings. The color card produced is therefore a representation of that particular nation's interpretation of color evolution in the form of a color card. Plate 29 shows the national color meetings happening simultaneously around the globe.

The process is repeated at an international color meeting held at Intercolor in Paris, which is represented in Plate 30. Up to thirty representatives from the national color meetings are in attendance and present their country's national color card in the form of a color story board. Similarly an international color card is developed based on the commonalities presented. The resulting color card is then disseminated to the fiber, yarn, and fabric manufacturers for their interpretation and later disseminated through the trade exhibitions to the industry as described in the following section. Mood boards are an important tool for both the compilation of the color data into a convincing color story and in the presentation, dissemination, and marketing of this story.

COLOR CONSENSUS AS A MARKETING TOOL

Fiore and Kimle (1997) stated that the influence the forecasters have on the industry is highlighted very much through the power of promotion and advertising. As previously stated, the initial color groups such as CAUS and CMG are made up of individuals who are in turn connected to the industry and to some of the smaller color forecasting services. Obviously they are all going to promote the same color stories after the initial color palettes have been jointly decided upon and approved. David Wolfe, of the forecasting service D3, was reported to have declared during an interview that the garment ranges confirm the predicted trends (Fiore and Kimle 1997). However, it would be rather foolish of the company, if the collections they produced contradicted their previous predictions. Though it must be recognized that the forecasters promote a color story creating a consensus, and that in itself is important, this is accentuated by the role of the trade exhibitions.

Premier Vision (PV) has been found to be the most popular exhibition as a source of inspiration for the fashion and textiles industry. It is said to act as a "color filter" for the industry and plays a key role in disseminating the color card from the international color group meeting previously mentioned. Premier Vision begins life with the meeting of the panel members at the PV office. The panel is reputed to consist of no less than eighty members from all areas of the fashion industry. The panel works on the color ranges eighteen months ahead of the specified season. Meetings are held for members to discuss the season, the market, and to select a color range. The colors are then grouped into themes and market sectors. Further discussions are undertaken to refine the colors into an acceptable shade card. Subsequent meetings are arranged in France, Spain, Italy, Belgium, and Great Britain, presenting the color ranges to the fiber, yarn, and fabric companies. One month before the exhibition the Paris office receives weavers' fabrics for display. Each fabric sample is checked against the PV color shade card. If colors are contained within the samples that are not represented on the color card, those fabric

samples are rejected. This ensures that the whole exhibition relates to the color stories set by the panel for that season, thus instilling and promoting a consensual theme. Successful fabrics are used for display, the fabric resource library and samples of each are sent to Li Edelkoort for the assembly of her audiovisual presentation. Her team collates samples of the same color to present as a strong color story. The rest of the colors are promoted as the fashion or accent colors. Around 450 trend boards are made for the exhibition supported by a wealth of accessory props to help communicate the mood and to accentuate the color stories (International Textiles 1992). The color card given allows PV to regulate the colors shown in the exhibition and thus ensures that the colors support the exhibition's own prediction package. Buyers will pick up this continuity of color and read it as the trend colors. Buyers will then include some or all the colors seen at the trade fair into their selections and so accentuate the trend. This is then collectively delivered to the high street where consumers will recognize the color story as a trend. This will also be supported by the fashion media who would have attended the trade fairs. The predicted colors therefore become the reality, courtesy of clever promotional activities.

The competitiveness of the fashion and textile industry is the main reason for many manufacturers and retailers investing in trend prediction information, basically to survive. However, rather than staying one step ahead of their competitors, as they work with the same information, they are producing very similar products with little point of difference. The forecasters consider it to be the role of the information users, predominately the designers, to be creative in the application of the trend predictions to offer the consumer something different. In addition, consumer acceptance is still being anticipated rather than being measured and understood.

THE CONCEPT AND IMPORTANCE OF CONSUMER COLOR ACCEPTANCE

While fashion forecasting incorporates all aspects of the design of garments and accessories, color is reputed to be of high consideration to the consumer when making a purchasing decision. Buddy (1992) stated color, feel, then price to be the recipe for the consumer's purchase decision-making process, though it may be more appropriate to use the more general terms, aesthetics, tactility, and value. She invited the cooperation of a store to assist in an experiment to prove the above conceptual statement. Although no explanation of the colors or methodology used, nor the theory behind the concept, was given, the results showed *30 percent better sales by color*. Eric Danger (1987, 1968) has long supported the role color has to play in the sale of consumer products as did Faber Birren (1945, 1978) many years previous.

In a small-scale consumer color survey undertaken by the authors, twenty-seven of the thirty-five respondents taking part felt that color was a very important consideration when purchasing clothing, with an additional seven claiming color to be fairly important.

Also when asked, twenty-nine of the thirty-five respondents claimed to only sometimes follow trends when purchasing clothing, with only six claiming to always consciously follow trends. In addition, only ten of the respondents claimed that they would wear a particular color purely on the grounds of it being currently in fashion, while thirty of the thirty-five confirmed that they would wear a color that was not currently fashionable. These findings give some strength to the importance of color meeting consumer demand, as colors considered to be fashionable were not always well received or preferred and colors not considered to be fashionable at that time would still be worn. In other words, individuals will wear colors that appeal to them regardless of their considered fashion-ability. In a second consumer shopping survey 83 percent of the 100 randomly selected respondents surveyed claimed color to be an influential factor in the product they had just purchased and a further 66 percent claimed that of other products already purchased that day, the color had influenced their choice. Other important factors for clothing purchases were found to be other aesthetic factors and the tactility of the fabrics. Color was a lesser factor where the fabric was either denim or suede. However, these types of fabric are generally limited in color variations, which are likely to be variations of blues, grays, and black for denim and neutral colors of browns and beige for suede fabrics. Only 51 percent of consumers, however, were satisfied with the color choices at the time of questioning and many would have liked to have seen more of the particular colors that they prefer to wear in the product ranges. While the surveys were not large enough to make sweeping generalizations, they do serve as a good indication that color helps to sell products and that consumers are more likely to buy the colors that they personally prefer over colors that are "trendy."

Seasonal colors have therefore become a powerful driving force of fashion today. As previously stated, the color forecasting service was established through a perceived lack of communication between the manufacturing sector and the consumer. Whatever colors are finally decided on for a season and however these colors are promoted throughout the industry to the consumer, it is ultimately the decision to purchase made by the consumer that determines whether or not the color selections were an accurate reflection of consumer desire. While retailers may influence consumers to feel a need to make a purchase through marketing efforts, the color choice is still the decision of the consumer, and is based upon his or her personal color preferences. It is therefore proposed that for manufacturers and retailers to make optimum color choices for their products, consumer color acceptance data is a potentially important source of information that is as yet currently underused.

CONSUMER COLOR DATA SPECIFIC TO TARGET MARKETS

Retailers have become more aware of consumer needs and desires through market segmentation and target market profiles. Target marketing aims to assist retailers to stock product in accordance with the requirements of their "average" or typical type of customer. While customer profiles are fictitious they are based on market research

including demographical information and lifestyle analysis, the latter often referred to as psychographics. The analysis of consumer behavior also became widely accepted as an important aspect of the forecasting process because the concept of lifestyles has progressively become a more integral part of design and marketing applications. However, to date little development in the area of consumer color acceptance in relation to consumer product has taken place. In reality, color preference testing has not progressed much beyond the works of Birren and Danger where one representative of a select number of colors was tested and in isolation from any specific product or market. Some industry personnel claim to have consumers test colors, however, from their descriptions of the process it would appear that trials were conducted in-store to test acceptability on the basis of sales as opposed to asking consumer opinion. While this method can have its advantages, still only data in relation to what is on offer at that given time can be obtained. In-store testing was discussed by Goworek (2001) who stated that only large retailers are financially in a position to do this due to the quantity of stock required for testing and that the acceptability of the colors may be low due to underexposure of the color to the consumer. It must be stressed that in-store testing in this context is not testing color preferences as we propose.

Hann and Jackson (1985) referred to the necessity for ascertaining the methodology of the actual movement of color change from season to season to assist the fiber, yarn, and fabric manufacturers in order to establish a worthwhile approach to color forecasting to be used by themselves. Frings (1991) stated that color cycles are analyzed and that color preferences naturally evolve. Evidence of personnel within the prediction services analyzing the actual movement and repetitiveness of color over time is severely lacking. While some investigations of this nature have been conducted in the educational sector, still no clear methodology for the movement of fashion colors for the purpose of understanding the color forecasting process has been recorded.

A systematic and analytical approach to the changes of color in forecasts and the acceptability by the consumer was proposed to industrial personnel as an improved system model. The proposed model includes market research information to eliminate the need for the anticipation of acceptance. While positively received, concerns were expressed about the time investments required to develop such a system and therefore information of this type would need to be made readily available. Hence the research is ongoing to develop a color tool that will enable certain sets of data to be entered such as a designer's observations, past color sales data, trend data, and intuitive notions of color to be used in conjunction with accurate in-built color acceptance data specific to product and target markets. The advantages of such a system would enable fashion-related industries to take better control of waste product that impacts heavily on the environment and may contribute to lowering overall costs without affecting quality as consumer needs would be better met. Thus its users would naturally be more competitive in the global marketplace and would have a positive impact on economies.

CONCLUSION

This chapter has put color forecasting into context for fashion-related product industries, first through a brief discussion of the historical background of the fashion and textiles industries that led to the necessity for a better informed manufacturing sector of consumer needs and desires. It then introduced the current color forecasting process and a rationale for the need for an improved color forecasting system that would be of benefit to all fashion-related consumer product industries. The importance of seasonal colors to generate sales and the creation of these color stories was given along with the process used and other typical forecasting methods. The dissemination of the color stories throughout the industry via trade exhibitions, in particular Premier Vision, through a consensus of color and the power of such marketing strategies was also well documented. The importance of consumer color acceptance as a vehicle for sales was also discussed and finally a rationale for improving the current color forecasting system was introduced.

REFERENCES

BBC Video (1991), "The Colour Eye."

Birren, F. (1945), *Selling with Colour*, New York: McGraw-Hill.

Birren, F. (1978), *Colour and Human Response*, New York: Van Nostrand.

Brannon, E. L. (2000), *Fashion Forecasting*, New York: Fairchild.

Buddy, J. (1992), "A Slave to Fashion? Fashion and Colour Trends in the 1990s—Forecasting the Future," *Journal of the Society of Dyers and Colourists*, 108/2: 64–69.

Burns, L. D., and Bryant, N. (1997), *The Business of Fashion*, New York: Fairchild.

Danger, E. P. (1968), *Using Colour to Sell*, Farnham, UK: Gower.

Danger, E. P. (1987), *The Colour Handbook: How to Use Colour in Commerce and Industry*, Aldershot, UK: Gower Technical.

Diane, T., and Cassidy, T. (2005), *Colour Forecasting*, Oxford: Blackwell.

Edelkoort, L. (1999), "The Theories behind Colour Forecasting," Seminar at the Briggait Centre, Glasgow.

Fearon, F. (1996), "Trend Forecasting," *Knitting International*, 103/1223: 58–59.

Fiore, A. M., & Kimle, P. A. (1997), *Understanding Aesthetics for the Merchandising and Design Profession*, New York: Fairchild.

Frings, G. S., (1991), *Fashion from Concept to Consumer*, Englewood Cliffs, NJ: Prentice-Hall.

Goworek, H. (2001), *Fashion Buying*, Oxford: Blackwell.

Gray, S. (1998), *CAD/CAM in Clothing and Textiles*, Farnham, UK: Design Council/Gower.

Hann, M. A., and Jackson, K. C. (1985), "Fashion: An Interdisciplinary Review," *The Textile Institute*, 16/4: 1–45.

Hulse, T. (1997), *The Colour Conspiracy*, Birmingham, UK: *Hotline* Magazine.

International Textiles (1992). "Behind the Scenes at Premier Vision: The Story Unfolds," *International Textiles*, 731: 38–39.

Jabanis, E. (1983), *The Fashion Directors: What They Do and How to Be One*, Ontario: John Wiley & Sons.

Linton, H. (1994), *Colour Consulting—A Survey of International Colour Design*, New York: Van Nostrand Reinhold.

Perna, R. (1987), *Fashion Forecasting*, New York: Fairchild.

Sproles, G. B. (1979), *Fashion: Consumer Behaviour toward Dress*, New York: Burgess.

Sproles, G. B., & Burns, L. D. (1994), *Changing Appearances: Understanding Dress in Contemporary Society*, New York: Fairchild.

Tate, S. L. (1984), *Inside Fashion Design*, 2nd ed., New York: Harper & Row.

Worth, G. (2000), "The Lineage of Colour Forecasting in the UK," *Point Art and Design Research Journal*, 9: 22–28.

Methodology to Analyze and Predict In-Depth Impressions of Color and Design on the Basis of Concept Networks

Yukari Nagai and Georgi V. Georgiev

Chapter Summary. Accounting for the difficulty in capturing an inherent part of the user's impressions from designed artifacts, this study introduces a new methodology for product design based on analysis of human underlying associations to develop association-based products. We focused on color with respect to in-depth impressions of design that underlie the superficial impressions. The case of a hospital was considered to investigate and propose colors for the uniforms worn by nurses in hospitals. We applied a methodology to identify the in-depth impressions using concept network analysis. The results have confirmed that the in-depth impressions reveal correlation between colors and associations. On the basis of these results, we propose a color scheme for the uniform sets that represents desired impressions according to different seasons, paying attention to the underlying association of colors to nature and family. The proposed color scheme adopts a pattern that resonates with expected human associative needs.

CONTEXT AND OBJECTIVE

In order to understand market and product trends, one needs to gain a deep understanding of the user's mind, that is, understand human perception. Understanding the user's mind helps create an image of the product on the basis of the impressions held in the user's perception, that is, the user's cognitive interpretation of the designed product (Norman 2004).

A user's impression of a designed product, which is dependent on numerous dynamically changing factors, creates new market and product trends. One of these factors—color—creates very fundamental impressions on the user's perception. It has a strong impact on memory resulting in impressions that are not easily altered. Thus, color changes have to be investigated with respect to deep impressions of design that underlie the superficial impressions.

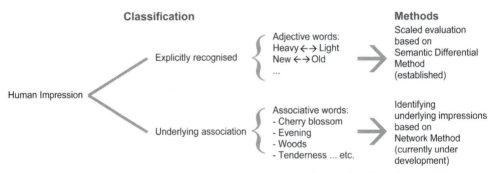

Figure 14.1 Authors' classification of human impressions from designed artifacts into explicitly recognized (affective) and underlying association (essential) based on the human associations.

Only a few studies have focused on deep impressions caused by the products. Fasiha et al. (2010) focused on deep impressions in terms of the deep feelings users or consumers have toward a product that underlie explicitly recognized human impressions (Figure 14.1). Their study captured the user's deep feelings that reveal virtual networks of concepts. Aiming to understand why users prefer a certain product over another, they developed a method for constructing and analyzing "virtual impression networks." They showed that such techniques are successful in capturing the user's impressions, which are complex and uncertain. The results of their study suggest that the understanding of deep impressions and underlying associations may be the key to understanding human preferences. It should be noted, however, that their study used existing products as stimuli instead of creating a new product to evoke specific impressions from users (Fasiha et al. 2010), obtaining a nondynamic perception.

In this study, the impressions of designed artifacts are referred to as *design impressions.* The superficial impressions of the designed artifacts are explicitly recognized by users. We use the term *in-depth impressions* to define a user's underlying cognitive impressions of the designed artifact, which are difficult to express. For the in-depth impressions, we have accounted for the difficulty in capturing an inherent part of the user's associations and emotions from designed artifacts (Norman 2004). To understand the psychological effects of color, we aim to apply a methodology that analyzes and predicts in-depth impressions.

METHODOLOGY

This study focuses on capturing the underlying associations in a user's perception and considers the design of ideal products by testing color associations. Further, a set of original products is developed according to these associations. To achieve these objectives, we are faced with two challenges: the *first challenge* was determining how to capture a user's underlying associations. To capture these associations, we applied a methodology to identify the in-depth impressions that underlie the surface impressions

of a design by using concept network analysis (Zhou et al. 2009). The methodology involves (1) association analysis of a user's descriptions, (2) construction of a concept network, and (3) extraction of in-depth impressions from the network. The association analysis detects the stimulus words used to evoke the explicit and superficial impressions. In practical terms, underlying in-depth impressions can be considered as those associations that initiate a high number of connections. The number of connections can be assigned as weights for these associations. Thus, highly weighted associations are the cores of an underlying association.

An advantage of the proposed methodology is that the data obtained from free descriptions are in a natural language, and therefore it is completely different from the scale-based descriptors (e.g., Semantic Differential Method, Osgood et al. 1957) (Figure 14.1).

The *second challenge* was to better understand a user's perception of products, which is the focus of this chapter. We study the user's perception using product prototypes that have been designed in accordance with the user's preferences (a set of seasonal colors was chosen on the basis of a prestudy); these preferences are used in this study. This study fits into the category of action research as it is an interactive inquiry that analyzed colors in a prestudy to understand preferences based on underlying associations (in this case, "colors" with season-related impressions), thus enabling predictions about color trends. The main study was conducted for the case of the impressions invoked due to the color of health care products (uniforms).

Health care products must be designed as per a user's associations and impressions. Jun et al. (2010) investigated health care systems design. Their research provides insights into how the user's requirements for health care products are dynamic. To address this issue, we propose customized products that dynamically correspond with the user's associations with respect to season and color. We studied the uniforms of the staff of a hospital. In this case, a conflict exists: patients eager and highly evaluate one color; however, if such one is decided, it creates a static environment. Such a static environment is stressful because humans require both stability and change. Thus, the assignment of color to a patient's environment should be done in a systematic manner. The changes made to color should be such that the patients are not adversely affected.

A different color evaluation system is required for different types of markets. For example, fashion and professional health care apparel have different needs with respect to color. A planned color system is effective in the case of health care systems, but is impossible in the case of fashion.

STUDY ON COLOR COORDINATION OF HOSPITAL UNIFORMS

We studied the effects of the color of uniforms of hospital staff on patients. Nine types of hospital uniforms (three groups) were selected for examination. The three groups included three types of colors: (1) conventional (white [CU4]), (2) random selection of

strong, that is, vivid (red [CU5] and ultramarine [CU1]), and (3) the prestudy-based six seasonal colors (cherry pink [CU6], young green [CU7], light blue [CU9], apricot yellow [CU8], grass green [CU3], and pale pink [CU2]) (Zhou et al. 2009). Thirteen participants (visitors at the hospital) were administered a set of questions to determine their impressions of each uniform. Subjective descriptions of these impressions were collected for each stimulus (uniform).

We applied our methodology to identify the deep associations that underlie the superficial design impressions, using concept network analysis (for details of this methodology see Zhou et al. 2009). We explored the underlying in-depth impressions on the basis of the associations behind each of the impressions evoked by a person interacting with the designed artifact.

We examined the differences in the impressions evoked by all three groups of hospital uniforms. By using centering resonance analysis (CRA, Corman et al. 2002) on the association network, the free description data were automatically computed into visualization files using an approach based on an associative concept dictionary. Eighty-two in-depth impressions were extracted. Structures of the concept networks for each uniform were visualized as graphs (Plate 31). From the analyses results, we have identified the characteristics of the impressions formed for the uniforms colored as per the seasons as compared to those formed for the vivid-colored and conventional-colored uniforms.

CRA is a new text analysis method based on the linguistic theory that deals with how people create coherence in their communication (Corman et al. 2002). Networks based on CRA accurately represent the concept map that emerges when a person reads a text.

On the basis of significant underlying associative words and CRA, we constructed semantic maps for the different colors of hospital uniforms (Plate 32). These maps indicate the relative placement of the uniforms (CU1 to CU9) on the scales "relaxed–exited" and "warm–cool." The words indicating the underlying perceptions representing users' impressions are placed on these semantic maps. In order to investigate the relationship between the nine uniforms and the underlying associative words, we categorized the in-depth impressions into seven categories (Plate 32). The categorization is based on the obtained underlying associative words belonging to a high (general) abstract conceptual category. The concept hierarchy of the WordNet 2.1 database was employed for this purpose (WordNet 2009). For example, in-depth impressions such as "lily," "cherry," and "chrysanthemum" belong to the high abstract category of "natural object." In our case, seven major categories of the obtained in-depth impressions were identified: natural object/plant, color, person, artifact (connected with living space), phenomenon, abstraction, and other (general category). This categorization is relevant to the discussed case only. These categories are shown on the map of the CRA results (Plate 32).

The results integrate separate colors of uniforms into semantic maps to investigate the relationships within the total impression space. *Preferred impressions* lie toward either warm or relaxed directions according to the underlying associations and impressions connected to family members. *Nonpreferred impressions* lie toward either

cool or relaxed according to the underlying associations connected to a hospital and house.

RESULTS AND DISCUSSION

We have confirmed that the in-depth impressions (the weightiest core concepts) (Plate 32) reveal not only the correlation between selected colors and associations of users but also the differences with regard to seasons. On the basis of these results, we propose a *color system* (Table 14.1). The system depends on the season and proposes a dynamic and multilayered system of colors to respond to users' associations and impression needs. Moreover, the diversity of the color of the uniforms depends on the season. The colors proposed are based on the key concepts identified from the constructed semantic maps.

In this study, on the basis of the CRA results and the classification of the underlying associative words (in-depth impressions) we selected colors of uniforms that would evoke images of a user's "family" and suggest "gentle dynamics of nature" while avoiding images associated with a "hospital" and "forces of nature." The new color system of uniforms consists of the following characteristics: (1) sequential and planned changes in the colors of uniforms according to the season, and (2) synchronicity of the colors at every stage, considering warm and relaxed dimensions (Table 14.1). Three trend colors are proposed. These characteristics create metalevel dynamics of the human impressions of these uniforms; thus, ensuring that the product is customized to the specific impressions of the users according to their underlying associations and season-based user requirements. These findings offer a systematic view of color schemes, and the proposed color system provides a methodology to predict in-depth impression and obtain preferred color imagination.

Table 14.1 Color coordination for sets of colors of uniforms on the basis of the impression of seasons.

	Color Coordination								
	Existing Colors						Trend Colors		
							T1	T2	T3
Season	CU2	CU3	CU6	CU7	CU8	CU9	(high scores on relaxed and warm axes)	(high score on relaxed and low score on warm axes)	(high score on warm and low score on relaxed axes)
	Pale Pink	Grass Green	Cherry Pink	Young Green	Apricot Yellow	Light Blue			
Spring	–	–	O	O	O	–	O	–	O
Summer	O	O	O	–	O	O	O	O	–
Autumn	–	O	–	–	–	O	–	O	O
Winter	O	–	–	O	O	–	–	–	O

This study points to future interactions between designers and users that will be dynamically structured. Understanding of users' impressions and the underlying associations will guide the thought process involved in design toward a metalevel structured response to the dynamics of users' requirements.

CONCLUSIONS

This study has introduced a new methodology for product design based on human impressions and underlying associations to develop association-based products. We considered the case of a hospital to investigate and propose colors for the uniforms worn by nurses in a hospital. The colors proposed were such that they represented desired impressions according different seasons. The results suggest a color scheme for the uniform sets, paying attention to the underlying association of colors to nature and family. In particular, the proposed color scheme adopts a pattern that resonates with expected human associative needs.

REFERENCES

Corman, S.R., Kuhn, T., McPhee, R.D., and Dooley, K.J. (2002), "Studying Complex Discursive Systems: Centering Resonance Analysis of Communication," *Human Communication Research*, 28/2: 157–206.

Fasiha, M.Y.N., Sakayama, Y., Yamamoto, E., Taura, T., and Nagai, Y. (2010), "Understanding the Nature of Deep Impressions by Analyzing the Structure of Virtual Impression Networks," paper presented at the DESIGN 2010 Conference, Dubrovnik, Croatia, May 17–20.

Jun, T.G., Hinrichs, S., Jafri, T., and Clarkson, P.J. (2010), "Thinking with Simple Diagrams in Healthcare Systems Design," paper presented at the DESIGN 2010 Conference, Dubrovnik, Croatia, May 17–20.

Norman, D. (2004), *Emotional Design: Why We Love (Or Hate) Everyday Things*, New York: Basic Books.

Osgood, C.E., Suci, G., and Tannenbaum, P. (1957), *The Measurement of Meaning*, Urbana: University of Illinois Press.

WordNet 2.1. (2009), http://wordnet.princeton.edu/.

Zhou, F., Nagai, Y., and Taura, T. (2009), "A Concept Network Method Based on Analysis of Impressions Formation: Color Schemes of Uniforms from Impressions of Seasons," paper presented at the International Association of Societies of Design Research IASDR09, Seoul, Korea, October 18–22.

Color Ambiance in Interiors

Nilgün Olguntürk and Halime Demirkan

Chapter Summary. Ambiance is the character and atmosphere of a place that is of great importance to interior designers both to express themselves and to create emotionally fulfilling spaces. Color and lighting are powerful design tools for creating different ambiances. This chapter purports to find out how colored light is used in an interior to provide a specific ambiance. One hundred and fourteen undergraduate interior architecture students were asked to make twelve groups to create either a "calming" or "exciting" ambiance in a specially designed set-up. All groups were free to use red, yellow, green, blue, and white colored lights. Findings of the study indicated that for an exciting ambiance, general and foreground brightness were kept bright and color contrasts were used. A calming ambiance was created with dimmed general and foreground brightness and with subtle color differences. Furthermore, factor analysis was used to group the related items in creating an ambiance according to their importance.

The character and atmosphere of a place is the most important aspect of an interior design both for designers to express themselves and for users to feel content in a space. If one word needs to be designated to both grasp the character and atmosphere of a space, that word should be *ambiance*. Ambiance can also be thought of as feelings or mood associated with a particular space. Algase et al. (2007: 266) described ambiance as the "person-environment interaction from an emotional or affective rather than cognitive perspective."

For a designer, creating an ambiance in a space (e.g., a room) is about thinking of this room's surfaces together with lighting of that room. Color is one of the main ingredients of creating a specific ambiance, although it might be subtle, especially as it is often integrated with the existence of a specific material (e.g., wood floorings, steel balustrades, etc.). Color is an inherent property of all materials and surfaces and is an inseparable element of design (Dalke et al. 2006: 343). How color affects emotions or mood has recently been studied, mostly by asking the test participants a set of questions on a predesigned space or image (Hårleman et al. 2007; Manav 2007; Smith and Demirbilek 2009). However, there is no research on how a specific ambiance could be created. This chapter purports to find out how color is used in interior design to provide

a specific ambiance. Also, the aim of the study is to determine the factors that can be evaluated as the color components of ambiance in interior spaces.

METHOD

Setting

In order to explore the effect of color on ambiance, a specially designed set-up was built. The set-up consisted of two perpendicular achromatic vertical surfaces (walls), a set of six lighting units on the ceiling, and a white armchair placed in front of one of the surfaces (Figures 15.1 and 15.2). Lamps 1, 2, and 3 were lighting the background wall. Lamps 4 and 5 were for general ambiance lighting. Lamp 6 was for lighting the armchair.

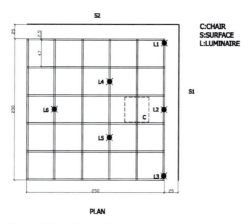

PLAN

Figure 15.1 Plan of the setting.

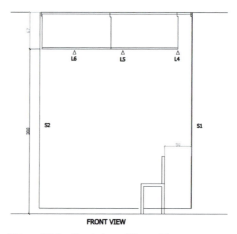

FRONT VIEW

Figure 15.2 Front view of the setting.

The locations of the lamps are shown in Figure 15.1 and the height of the lamps is shown in Figure 15.2.

Participants and Procedure

One hundred and fourteen undergraduate interior architecture students were asked to make twelve groups consisting of nine or ten students in each group. Six of these groups were asked to create a "calming" ambiance, while the remaining six groups were asked to create an "exciting" ambiance. The set-up was designed to provide a background color at the back of the armchair, a foreground color on the armchair, and a general color within the space. All groups were free to use red, yellow, green, blue, and white colored lights. Light was used instead of surface colors, since color of lights could easily be altered in interiors to obtain subtle to dramatic effects on the environment. In other words, potentials of colored lighting were explored in this study as an "invisible" yet strong tool to create differing ambiances. The groups were asked to create their chosen ambiance (calming or exciting) by using the six lighting units with the combination of colors they choose. After the groups worked on their designs, they presented their chosen ambiances in the provided set-up (Plates 33 and 34) and also, a set of drawings.

Analysis

The authors analyzed each ambiance through the specific cases designed by each student group. One of the two ambiances (calming or exciting) was voluntarily chosen by each student group, who then created the intended setting accordingly. Specific designs were analyzed both through information on color, light (dim or bright), and their usage of warm/cool colors, color contrasts, and color harmonies. The results were statistically analyzed in order to understand how overall color schemes of the space could be formulated into creating an intended ambiance (calming or exciting).

Data for each design were tabulated under the following headings: Lamp details for each lamp (color, dim/bright), ambiance information on the visual environment (general ambiance color and dimness/brightness, background color and dimness/brightness, foreground color and dimness/brightness), brightness contrast (high contrast vs. homogeneous treatment), color harmony (monochromatic, analogous [neighboring], nearly neighboring, tricolor [three colors with equal distances], split-complementary, contrasting), and color usage (warm, mixed, or cool colors). Factor Analysis was conducted on this data to find the relevant headings and significant inclinations on ambiance. Thus, it would be possible to determine how well the specified headings above correspond with the intended ambiance.

Principal Component Analysis (PCA) was used as a method for data reduction in order to understand ambiance. The PCA method was used to determine the number of components with eigenvalues greater than 1.00 with Statistical Package for the Social Sciences (SPSS).

RESULTS AND DISCUSSION

The correlation matrix was examined in order to find out the specific design elements of light and color that would imply the intended ambiance. The correlation values showed that brightness of lamp 6 is highly correlated with ambiance (−0.73). This lamp was dimmed if the intended ambiance was a calming ambiance, and it was kept bright if the intended ambiance was exciting. General brightness level was also highly correlated with ambiance (−0.73). General brightness was dimmed if the intended ambiance was calming and kept bright if it was exciting.

Color contrast was highly correlated with ambiance (0.71). Color contrasts were used if there was an exciting ambiance and contrasts were not used if there was a calming ambiance.

Brightness of lamp 5 was also correlated with ambiance (−0.70). This lamp was dimmed if the ambiance was calming and kept bright if the ambiance was exciting. Lastly, foreground brightness was correlated with ambiance (−0.63). Again dimness was used for a calming effect and brightness was used for an exciting effect.

Furthermore, factor analysis was used to group the related items under a factor and to order these items according to their importance. A list of prioritized factors and their items was obtained for the exploration of the effect of color on ambiance. An orthogonal factor rotation was performed using the Varimax with Kaiser Normalization. Among the 5 factors, 3 of them had at least 3 items and the rest had less, thus these 3 factors were considered in this study. These 3 factors accounted for the 59.95 percent of the variance. The loadings of the items on these 3 factors are shown in Table 15.1. The factors

Table 15.1 Prioritized three factors of ambiance with the corresponding items.

Factor	Scale	Items with Loadings ≥ 0.50
1	Background color treatment	Color harmony (0.93)
		Brightness of lamps lighting the background (0.85)
		General brightness (0.80)
		Background brightness (0.79)
		Brightness of lamp 5 (0.76)
		Brightness of lamp 4 (0.65)
2	General color	Background color (−0.86)
		Colored light of lamp 6 (0.84)
		Color of overall environment (−0.77)
		Foreground color (0.61)
3	Foreground color treatment	Brightness of lamp 6 (0.85)
		Brightness of foreground (0.73)
		Color (warm/cool) usage (−0.64)
		Brightness contrast (−0.61)

included only the items with 0.50 or more loading weights. The prioritized factors and their related items are listed from the most important to the relatively less important.

"Background color treatment" was found to be the first principal component for designing an intended ambiance. Background color treatment was loaded on 6 positive items: namely color harmony, brightness of the lamps lighting up the background (lamps 1, 2, and 3), general brightness, background brightness, brightness of lamp 5, and brightness of lamp 4. Thus, color harmony was found to be closely related with general and background brightnesses obtained in the room. Less amounts of and closely distanced colors were preferred to be used dimmed, whereas with the increased amount of colors and more increased distances in between colors (e.g., contrasting colors) bright lights were preferred.

The second principal component in designing an intended ambiance was found to be "general color." General color was loaded on two negative items as the background color and dominant color of the overall environment. Also, it was loaded on two positive items as colored light produced by lamp 6 and foreground color. When choosing a general color for an ambiance, warm background colors and warm colored environments were used together with cool or white foreground lighting. Similarly, cool or white background colors and cool colored environments were used together with warm foreground lighting.

The third and the last principal component was found to be "foreground color treatment." It was loaded on two positive items as brightness of lamp 6 and brightness of foreground. Also it was loaded on two negative items as color usage and brightness contrast. In creating an ambiance, when color treatment was preferred to be with warm colors, it was also with bright foreground lighting with high contrast brightness treatment (e.g., dimmed background lighting). If cool colors were used, homogeneous brightness treatment and dimmed foreground lighting were preferred.

CONCLUSION

Finally, it is concluded that "background color treatment," "general color," and "foreground color treatment" are the three factors that determine an ambiance in interior spaces. The study has shown that "background color treatment" affects the design of ambiance more than other issues when designing with colored lights. There seems to be a close relationship between selecting a color harmony and determining brightness of individual lamps and areas within the visual field.

This study confirms with Fotios and Levermore's (1999) statement that color properties of lamps affect the perception of an interior space, which is illuminated with a specific light. In the literature, there are studies concentrating on the effects of single and isolated colors. For example, Nakshian (1964) noted that red and the other warm colors such as orange and yellow have arousing or exciting effects on behavior of individuals whereas blue and green have restful effects. However, to the best of the authors' knowledge there is no study using combinations of colored lighting. This study did not limit

itself to single and isolated colors and more than one color could be used in a setting. Thus, the study analyzed color contrasts. Color contrasts were highly correlated with ambiance, and they were used if there was an exciting ambiance and absent if there was a calming ambiance.

This study also helped the students to increase understanding of variables that contribute to the ambiance of an interior. They learned the importance of background treatment as well as how colors and brightnesses could contribute to their design. Lighting seems to be a more distant tool than paints or soft furnishings for students of interior design. Most of them were hesitant to choose and try different types of lamps. Finally, when they created their chosen/intended ambiance, they were more confident to use lighting as a design tool.

This study focused on colored lighting, thus, the findings scientifically only apply to lighting. Further studies can be done with settings where colors are present in paint or other coatings/finishing materials. Background–foreground color relationship is one of the most important aspects of design, as this would either make perception possible so one could distinguish an object from its background or would camouflage things by merging them visually in their background. Thus, designing ambiances in interiors requires careful planning of background–foreground color relationship whether it is with light, paint, or materials used.

REFERENCES

Algase, D. L., Yao, L., Son, G., Beattie, E.R.A., Beck, C., and Whall, A. F. (2007), "Initial Psychometrics of the Ambiance Scale: A Tool to Study Person-Environment Interaction in Dementia," *Aging and Mental Health*, 11/3: 266–72.

Dalke, H., Little, J., Niemann, E., Camgöz, N., Steadman, G., Hill, S., and Stott, L. (2006), "Colour and Lighting in Hospital Design," *Optics and Laser Technology*, 38: 343–65.

Fotios, S. A., and Levermore, G. J. (1999), "The Effect of Lamp Colour Properties upon Perception: A Summary of Research and the Implications for Lighting Design," paper presented at CIE Symposium '99: 75 Years of CIE Photometry, Budapest, Hungary, September 30–October 2.

Hårleman, M., Werner, I.-B., and Billger, M. (2007), 'Significance of Colour on Room Character: Study on Dominantly Reddish and Greenish Colours in North- and South-Facing Rooms," *Colour: Design and Creativity*, 1/9: 1–15.

Manav, B. (2007), "Color-Emotion Associations and Color Preferences: A Case Study for Residences," *Color Research and Application*, 32/2: 144–51.

Nakshian, J. S. (1964), "The Effects of Red and Green Surroundings on Behavior," *Journal of General Psychology*, 70: 143–61.

Smith, D., and Demirbilek, N. (2009), "What Is That Place? Observations of the Impact of Environmental Colour through Photographic Analysis," in *Proceedings of the 11th Congress of the International Colour Association*, Sydney, Australia, September 27–October 2, 2009, http://eprints.qut.edu.au/28107/.

Color the World: Identifying Color Trends in Contemporary City Brands

Alex Bitterman

Chapter Summary. The efficacy of place brands is questionable. Most attempts to review the success or failure of place brands do not discern place brands from corporate-style brands. This flawed approach has substantially overlooked the use of color in the visual articulation of place brands. Through a study of the visual characteristics of 560 place brands, a taxonomy has been developed by the author that includes a means for assessing the use and effectiveness in the use of color. This chapter explores the development of this method of analysis and examines the inherent limitations of it and concludes with a discussion of the use of color in place brands.

THE VISUAL STRUCTURE OF A PLACE BRAND

Brands are largely composed of three main elements: typography, graphic form, and color scheme. While sound and verbal elements sometimes play a role in creating a brand, these elements are used less frequently than the "big three." Branding is not a new phenomenon and brands influence the endless consumer choices, products purchased, and services chosen. From the perspective of marketers brands embody choice and desire and delineate products from generic counterparts, which underscores the principal goal of a brand, to help customers identify and identify with a specific product, company, or organization. From a psychosociological perspective brands provide a mode to express individuality while at the same time allowing the user to remain safely within accepted societal limits. Contemporary life is increasingly dominated by brands that adorn nearly everything from food and cars to medical and banking services to clothing and household goods, the prevalence of brand names, indeed, pervades every facet of daily life. In the urban environment, streets are "awash in consumers playing the role of walking billboards, clad from baseball cap to sneakers in product endorsements" (Morris 2004: 3). In most contemporary Western societies, marketers contend that brands have become a shorthand used to convey who "we" are and what we believe in, both individually and collectively. The examples are many,

and can be found especially among those brands (e.g., Apple, Nike, Levi) that have carved out a prominent position in popular culture. Across both the design and marketing literature, comments glorifying brands are common. Brand scholars Cowley and Gobé note:

> The concept of a brand is probably the most powerful idea in the commercial world. Indeed, the way in which it provides a means of explaining the phenomena of business life, is in some ways analogous to the impact of Newton's theories on the physical sciences. (Cowley 1996: 11)

> The fact is that great brands have personalities; they have attitude and they give greater depth and meaning to the product. (Gobé 2002: ix)

Fueled by this popularity, the use of brands continues to increase and the practices through which brands are developed and deployed are rapidly branching out to include previously unbranded realms: governments, constituent departments, and political candidates; systems, such as public transit; and places, at the scale of continents, nations, and cities. The latter—place branding of cities—is the focus of this chapter. An example of place branding is shown in Plate 35.

The term *place branding* first came to use in 2002, championed by British academic Simon Anholt. Anholt's early definition of place branding encompassed the application of corporate identity-like constructs to a place: a nation, state, city, or part of a city, such as a business district or neighborhood. This early version of place branding promulgated by Anholt was broad and inclusive, but focused more on the branding of nations than of cities. An exact definition of place branding is difficult to distill, because even after nearly ten years of use, the term remains vague and unwieldy. Perhaps this elasticity partly explains the meteoric rise in use of the term across a broad cross-section of disciplines that previously were unrelated. For the purposes of this chapter, place branding will be defined as a logo, which is a part of a broader graphic identity effort that may include other elements such as a slogan, soundmark, jingle, carefully orchestrated advertising campaign, mascot, or stylized objects in situ that endeavor to define and reinforce the "essence" of a specific geographic place.

METHOD

The constructs of branding and color are both complicated areas of research inquiry. Both are relative to the viewer and dependent on interpretation and memory in order to be effective. Toward this end, how does color influence the success or failure of a place brand?

To examine this question, 327 city brand logos were recorded using materials available on websites for 230 cities in Europe, North, Central, and South America. (Note: some cities presented more than a single place brand.) Cities were selected based on

population, in each country (state in the United States, and province in Canada) the three largest urban population centers were examined. The logos were cataloged in a database and coded by colors used in the presentation of the logo. The color was assigned to the color category presenting the highest value in the construction of the logogram or logotype, including the background color (e.g., a deep purple-pink Pantone Rhodamine Red C would be categorized simply as "red" as the RGB values for this color are 224, 17, 157, respectively, and the CMYK values are 9 percent, 87 percent, 0 percent, 0 percent, respectively, therefore demonstrating an overwhelming tilt toward "red" in both modes of analysis). The color with the greatest number of pixels for each logo sample was delimited as the primary color in the logo composition, with secondary and tertiary colors identified by the next subsequent highest pixel values. Using a percentage-based system, primary, secondary, and tertiary colors were identified and classified according to the most basic palate of nine colors: white, black, red, blue, green, brown, yellow, purple, orange. Shades of each color and complicated shades (e.g., peach, periwinkle, teal) were assigned according to one of the above colors, using a digital color-picker using RGB and CYMK color modes.

The result was a database entry arranged as shown in Plate 36. This database information was then used to derive the five most commonly used colors currently used to brand cities.

THE USE OF COLOR IN CITY BRANDS

This study identified the five most common colors used in place branding among a sample of 327 place brands. The most common colors are (in rank order of frequency) blue, green, white, black, red, followed by yellow, orange, brown, and purple as shown in Table 16.1. The first five will be briefly analyzed and discussed.

Table 16.1 Most common colors used for place brands.

Rank	Color	Frequency
1	Blue	72%
2	White	64%
3	Green	51%
4	Black	47%
5	Red	23%
6	Yellow	17%
7	Orange	8%
8	Brown	7%
9	Purple	6%

Blue

Blue is the most frequently appearing color in city-based place brands and appears in 72 percent of the place brands examined. The fact that blue is the most commonly occurring color is not at all surprising: a 2004 international study by two marketing organizations and a visual study organization (Cheskin, MSI-ITM, and CMCD Visual Symbols Library 2004) indicates that blue is the favorite color of about 40 percent of the world population.

Pragmatically, blue reproduces reliably both in RGB (electronic) colorspace and CMYK (ink printing) colorspace. In the logos examined, blue is used most frequently to represent water and next most commonly to represent sky. Blue is the color of the globe and sky—it is the color that surrounds us.

White

White appears second most frequently and presented in 64 percent of the place brands examined. The fact that blue is the most commonly occurring color is rather unexpected: the 2004 study indicates that blue is the favorite color of about only 40 percent of the world population. Why the disparity between blue and white?

The prevalence of white in city logos is likely due to pragmatic reasons: white is the color of most paper, and limits the cost of printing collateral materials. White also offers a distinct contrast to blue. White helps to balance negative and positive space, making logos readable from a distance and ensuring print and digital reproductive reliability. White, in the natural environment, is the color of snow and clouds, it is the color that naturally complements blue.

Green

Green appears third most frequently and presented in 51 percent of the place brands examined. The 2004 study indicates that green is the favorite color of about 12 percent of the world population.

Green has very positive connotations among the general public, as it represents the environment and environmental stewardship. It is one of the few color names that is used not only as an adjective, but also as a noun and verb.

Like blue and white, green appears through the natural environment. In logos, it is used to represent mountains, trees, grass, and other vegetation; in tropical and northern environments, green is the color that, along with white and blue, surrounds us.

Black

Until this point, the most frequently used colors in place branding are derived from the natural environment. The next two colors deviate from that observation. Black is the

fourth most commonly occurring color used in city brands. Black appears nearly as frequently as green, present in 47 percent of the logos examined. Arguably, black is so common not because it is a strong international favorite (only 8 percent of 2004 survey respondents identified black as a favorite color), but instead because it is in both CMYK and RGB colorspaces, a default color.

Black is the color of most basic ink, and provides the sharpest contrast on white, the most common paper color. It reproduces consistently and can be used to create shade and shadow in conjunction with other colors.

Red

Red appears in a comparatively small number of city brands, in just about one-quarter of those examined, 23 percent. Red provides, with blue and white, a quintessential American, British, French, and Russian color palate, which is likely the reason for its prevalence. In Northern Europe, black and red appear frequently together.

Red provides a sharp complement to any of the four top colors. It is the favorite of 11 percent of the global population and is said to connote power and consistency.

Initial Analysis

The color used in city brands follows a different schema than either of the two more obvious points of comparison and does not correlate closely with the 2004 study of color usage; indeed several low-ranking colors in the 2004 study of favorite colors appear quite frequently in the composition of city brand logos. Colors that ranked very high in the 2004 study typically rank very low in this study (e.g., purple). The prevalence of colors in nature seems to correlate to the use of colors in the composition of city brand logos; however, some colors very prevalent in nature (i.e., brown) appear in relatively few city logos, so neither schema closely correlates to the frequency of color used in city brands.

Moreover, the use of color in city brands does not seem to communicate any critical information to the user. Color appears to be used in most city brands examined as little more than decoration.

DISCUSSION

The increasing proliferation of city brands makes necessary the critical examination of place brands, including the efficacy of the place-branding exercise. One important question that has not been examined is the efficacy of color used in city brands. Such an examination of the contemporary place-branding practice and product can foster a clearer understanding of the practice and provide evaluators with necessary guidance to assess the efficacy of a place brand, as well as aid stakeholders to better manage the place-branding exercise, and also more accurately predict the long-term impact of place branding.

However, despite the best effort of designers and marketers, and in contrast to the fervent popularity of brands, the general public typically encounters a degree of difficulty delineating one brand from another, especially when presented out of context. Some brands have become icons, but the vast majority of brands are ephemeral and difficult to discern or remember. The color data examined in this study highlight a confused design public with regard to the use of color in city brands. If designers are confused about the use of color, or are using color haphazardly, they risk further cluttering the landscape with meaningless visual noise. Because of these prevalent difficulties, the overall efficacy of place brands can be called into question. Unique when first introduced, brands quickly become part of the visual background in which it becomes increasingly more difficult to delineate one graphic construct from another. Though nearly every company, service, university, organization, and city works to cultivate a brand identity, the actual reason for doing so remains arguably unclear and objectively unproven. These questions demand careful further studies by researchers and practitioners across a broad range of disciplines.

Color is open to a broad range of interpretation for various reasons covered elsewhere in this book. Biologically, color is perceived slightly differently by each person. This variance in color perception ability is hardly considered a disability in most areas of the world, though indeed, it presents interesting questions when examining the recallability and efficacy of place brands. Researchers and practitioners would be wise to examine the role of color and its position in the place-branding exercise.

City branding is an activity engaged by a broad range of stakeholders. Civic governments, chambers of commerce, booster groups, travel and tourism agencies, industrial development groups, and public/private partnerships, citizen action groups, and NGOs—among others—actively engage the practice of branding cities, each with a distinct set of processes and goals. In about one-third (just over 30 percent) of the cases examined in this study, the "city" has more than one brand, which is often developed in parallel by separate organizations within the same city, each arguing from a different perspective and hoping for a different outcome. This duplication creates unnecessary expenditure and from a marketing point of view undoubtedly dilutes (or at the very least, confuses) the overall brand message for that locale. These dueling place brands very rarely complement as much as cancel the efforts of the other.

CONCLUSIONS

The use of color in the development and deployment of city brands does not seem to correlate to the natural environment nor internationally established color preferences, though arguably the two most prevalent colors in the natural environment are the two most commonly occurring colors in this study, save for white. Used to represent water and sky, blue occurs most commonly, whereas green, used to represent mountains and land, occurs next most commonly, with white completing the interstitial ranking.

The use of color in the development of city brands seems haphazard and largely driven by the technology designers use to create these brands, CMYK and RGB color-space. These basic defaults omit a large portion of the color gamut, and arguably employ color in an uncreative manner.

While seemingly a "good idea" to most the branding of place seems to create more problems than it could likely solve. The definition of contemporary place branding is vague and adds a confusing element to the examination of the efficacy of city brands. When harnessed, and if deployed conscientiously and responsibly, place brands can help to reinvigorate ailing cities and urban areas; when mismanaged, place brands can damage the reputation and economic outlook for a city or region. Color plays a significant role in the visual recollection of a place brand, and by extension, the success or failure of that brand.

City brands demand multidisciplinary professional collaboration that presents pragmatic and philosophical challenges for everyone involved with the place-branding exercise. This dynamic tension can help to generate more effective place brands and could act as a self-monitoring system of checks and balances. However, these same barriers presented by the various stakeholders in the place-branding exercise could potentially spawn misunderstanding that leads to significant conflict. When poorly managed, the rich diversity that underpins place branding can become a breeding ground for an emotionally charged and discordant debate with divisive results, which in effect could potentially divide the populations that place-based branding aims to bring together and undermine the goals of the exercise.

NOTE

The author wishes to thank Daniel Baldwin Hess, Bruce Jackson, Jean LaMarche, Carine Mardorosian, and Daniel Skrok.

REFERENCES

Cheskin, MSI-ITM, and CMCD Visual Symbols Library (2004), *Global Market Bias: Part 1 A Series of Studies on Visual and Brand Language around the World COLOR*. San Francisco: Visual Symbols Library.

Cowley, Don (1996), *Understanding Brands: By 10 People Who Do*, paperback ed., London: Kogan Page.

Gobé, Marc (2002), *Citizen Brand: 10 Commandments for Transforming Brands in a Consumer Democracy*, New York: Watson-Guptill.

Color and Community Involvement

Julia R. Vallera

Chapter Summary. Color Wheelz is a 1997 Ford van that travels through the five boroughs of New York City (NYC) filled with playful activities that facilitate exploration into the world of color. Visitors cover the inside and outside of the van with art made from a variety of colorful materials. Each artwork has a corresponding voice recording describing what colors are used and why. This creates a fun and engaging way for visitors to consider how color represents their world. This consideration is an opportunity for people to think about their surroundings in a visual way, which results in a colorful commentary on the neighborhoods in New York City.

Color Wheelz (Plates 37 and 38) attempts to address how color defines who we are. It is a public installation that aims to inspire curiosity and learning through arts-related socialization. Through hands-on activity and conversation, it asks questions such as, What color are the objects that surround you? What color are your memories? What color are your friends? What colors are in nature? The various ways that visitors respond initiates thoughtful consideration about how color affects our perception. Acknowledging these perceptions enables visitors to ask questions and think critically about how color exists in their everyday lives. Documenting outcomes in each location is an ongoing effort and has resulted in a valuable collection of color-related stories and art, which contribute to the topic of color theory in a variety of ways. Results are documented through photographs, video, and voice recordings and published on the official website http://color wheelz.org/. A map is updated on the website and on a twitter account so that people can find the location of Color Wheelz at any point.

Drawing from characteristics defined as public art, Color Wheelz intends to strengthen every community it visits. This goal is most accurately articulated in the words of Lily Yeh, a dedicated artist who spent her career as a public art entrepreneur. In documentation about her career she wrote "We need to focus on building compassionate communities where people have a strong relationship with each other and are genuinely concerned for the welfare of all. Art and culture can function as powerful tools to connect people, strengthen family ties, preserve cultural heritage and build community" (Moskin and Jackson 2004).

Through my experience as a visual artist and a color theory teacher I find that color is a term that everyone understands and one that is easy to identify both visually and

verbally. Color Wheelz empowers participants to create meaningful artwork that many of them didn't think they could or never thought they would. It is a blank canvas for the application of color, which is a vehicle for people to learn about each other and about themselves. I am interested in how color association changes from person to person and from place to place. I wonder why and in what ways people associate color to culture, location, and memory. Gathering feedback from individuals that participate in Color Wheelz is a way for me to find answers to my questions. I am inspired by what participants add to the project in each community I visit.

When I arrive at a location I take out my signs, folding table, material bins, and put on my apron. Many people come up to me and ask me what I am doing. I briefly explain the project and ask if they would like to contribute a color story. Participation lasts for as little as ten minutes to as long as two hours. I walk visitors through the process. I show them the materials and how to apply their artwork on the van. If it is not too busy I offer to work with them. Soon after that, people start to gather or call their friends and family to come see "this girl with a van."

The methodology used in this project continues to evolve, but the overall attempt to create a mobile color installation that generates visitor participation has continued to be the main priority. Originally, instructional sheets guided visitors through the Color Wheelz experience. One sheet directed them around the inside of the van, another sheet around the outside. Both sheets listed three questions. What things do you see around you? What color are those things? What shape are they? As they considered those questions, each participant got an identical material kit to work with. The materials in the kit could be applied to any wall, window, floor, or ceiling of the van.

After some tests, I adjusted the process so that instead of following activity sheets, visitors could follow a design grid built into the van itself. This led me to segment the van into sections by neighborhood. Each neighborhood was given the categories of architecture, people, and nature. The back and inside of the van were designated for free expression.

This grid method allowed participants from the same neighborhood to place color on the same part of the van. In doing this, I thought each section of the van could be identified by similarity in color and would serve as a color map of each location. The results demonstrated that there was no similarity in the way people chose color. Every participant had a different choice that resulted in very different interpretations of the surrounding color.

The next and most recent evolution in methodology eliminated the grid and categories. I decided to let the visitors place their artwork anywhere they chose. At this time I began doing audio recordings of the visitors explaining the colors they used and why, which provide an archive of the stories that visitors tell me and each other. The recordings are paired with the corresponding artwork and posted on the website.

Each piece of art on the van represents a unique idea. Sometimes the art is a literal depiction of something from the neighborhood and other times it is completely abstract. Through conversation with participants, I learn what their color choices mean. As the

facilitator it is important for me to share these results with as many people as possible, particularly those interested in public art, color perception, and participatory learning. For this reason, documentation is the most important part of this project.

Every visitor takes a different approach to Color Wheelz. Some begin making art immediately and others take a lot of time to consider exactly what it is they want to make. Some reflect on culture, family, or language. Others reflect on nature, architecture, or composition.

Everyone benefits differently from participating in Color Wheelz. In Crown Heights, Brooklyn, it left a lasting impression for the kids on St. Johns Street. So much so, that one of them recognized me another time and ran over to say hello. In Red Hook, Brooklyn, a lifelong resident and war veteran came twice in one day to make sure I didn't change his design. On the Upper West Side, a young man thanked me for the opportunity because he loved making art and had never experienced anything like Color Wheelz. In Williamsburg, Brooklyn, a timid young boy got to show me what colors the inside and outside of his orthodox Jewish family's home had, while a newly married couple combined their favorite colors into one symbolic design.

This project has been fulfilling for me in many ways, but it is most fulfilling in that it brings people together to trade stories, learn new things, and share in the same experience. I plan to continue this project and hope to archive the work in a museum or NYC gallery. I would like to do this in other cities with other vans so that perhaps more cities could have their own van to showcase as a representation of the people that live there. Many people have contributed to the project's success.

REFERENCE

Moskin, B., and Jackson, J. (2004), "Warrior Angel: The Work of Lily Yeh," http://www.barefoot artists.org/barefootartists_resources.html.

Colors and Prototypes: The Significance of the Model's Colors and Textures in Expectations for the Artifact

Klaus Madsen and Bente Dahl Thomsen

Chapter Summary. The color scheme of a product is especially used as a means of enhancing the product's visual appeal. Both surface textures and the materiality are equally important in the experience of the product's colors. Our work therefore revolves in developing features in the design process that ensures that shape and surface are created in a combined process that includes the gradual clarification of material, technical, marketing, production, and manufacturing aspects. The features enhance efforts in both research and concept development as the processing and the experience of the surface is highlighted as a separate subject in the Key Performance Indicator[1] (KPI). The features are focusing on the generation of model surfaces as a presentation of the product designers' intentions of the surfaces so they appear as true as possible. The survey's version of the KPI is seen in Figure 18.1, which visualizes the mutual expectations of what the design process includes.

To exemplify how the color composition of a product is significant to our experience of the product, the color scheme of the thermos shown in Plate 39 is initially analyzed. The thermos consists of three parts, when we leave out the inner parts: a black foot, a white body with handles, and a black lid with a white top surface. In addition a rectangular red area is placed asymmetrical in the top surface just above the opening in the lid's inner closing function. In our culture we often associate the color red with stop, for example, most emergency stop buttons are red, so we would immediately assume that the red spot indicates a stop of some kind. The thermos's open and closing function consists of the lid being a screw with an opening in the thread. When the lid is screwed tightly the thermos is closed, and as seen in Plate 39, the red rectangle refers to nothing in this position. Turning the lid from the closed position till the red rectangle reaches the middle of the spout, as seen in Plate 39 in the top righthand corner, the thermos opens just enough that you can pour a cup of coffee without the lid falling off. Rotate the lid further and it can be separated from the thermos. If the red spot is perceived as a kind of stop signal, it is logical that a position next to the spout means that the outlet is

Figure 18.1 The Key Performance Indicator shows what is emphasized in the design process. The colored area expresses the overall resource and the area's points show the level of resources devoted to such elements as development of the product's visual appeal.

closed and the diametrically opposite that the outlet is opened, but this is not how the thermos's open and closing function works and therefore this solution cannot be said to be cognitive ergonomic. Simply replacing the red colored spot with a color that does not in the same way signal either stop or start would create less confusion. A vertical milling on the edge of the lid would also facilitate the reading, since the milling would signal that there is a screw lid and not a kind of plug. The edge of the lid is also milled to enhance the slip security. The color scheme of the thermos is neutral with respect to the context we often encounter with the thermos; it is both robust, suitable for applying your corporate logos and functional when you are familiar with it. The thermos's black/white color contrast makes it easy on the senses, to identify the foot's meeting with bright tablecloths and the lid's meeting with the thermos's body.

Supposedly the thermos is made of plastic, which is why the color scheme of the thermos has been subject to the requirements of the manufacturing process where the injection molded parts should be made as simple as possible. The red rectangular area though is not embedded in the top surface due to the manufacturing processes, but solely

because of the functionality as it is the only signal we have to indicate where the underlying opening is located. Both for reasons of wearing and the experience of a "real surface," it might be necessary to bind the color scheme to the material and plan a delineation of the colored areas, with consideration to the selected manufacturing method as in the example of the thermos. Or if acceptable the colors can be applied by paint, adhesion of films or similar process, and the designer will have a wider range of choice, but will then be facing a problem of authenticity. Namely a clarification of whether the surface appears as a copy of something else, such as wood's year rings, or as a design pattern with its own identity that tells a story of origin. Plate 40 shows a good example of how a color mix can emphasize the product's reference to a bird without the pattern actually looking like feathers.

The foregoing considerations have opened our eyes to the fact that surface characteristics must have a central role in the design process from the beginning. With this as a starting point, the studies initiating problems were limited to:

How to create awareness of surface issues in the research phase?
How to handle surface issues in the concept development phase?
What criteria are relevant in assessing the result?

The first question led us to develop a research instruction focusing on surface conditions, which could be combined with participants' inquiries about their own product ideas. Product fairs are good both to draw inspiration from and to check whether the design you are researching doesn't already exist. Therefore we chose to develop a research instruction and test its functional ability during a visit to the interior and design fair Formland. The purpose of the research instruction was to ensure that surface issues were identified, and the participants collected examples of good design solutions. The research instruction is elaborated in the section "Identifying Process Problems Concerning Surfaces."

The handling of surface issues should be seen in relation to our study, which is based on a design process with a concept development similar to the Bauhaus Dessau school, which entails: Products are created with a basis in theoretical knowledge of aesthetics, in an experimental process with materials and their textures as a starting point for the concept selection. The form and its surface are clarified by experiencing both. The experimental approach involves testing the product's functionality and aesthetics through digital as well as physical models. Addressing the model technical problems this approach entails are discussed in the section "Methods in an Experimental Approach" (Rasmussen 1966).

CLARIFICATION OF CONCEPTS

Some of the concepts that are fundamental to an understanding of this chapter have more obscure meanings. Consequently, we must first give a clarification of the meaning of these concepts concerning this study:

The color value—depends on how it emphasizes the character of the product (appearance attributes), accentuates the shape and substance, and clarifies the content (the product's objective, weight, use, etc.).

Cognitive ergonomics—is about the physical reception of information and how it gives us a sense of the surroundings. A color scheme, based on cognitive ergonomic considerations, is therefore based on experiences in the way we have learned to decode and understand the world.

The materiality—characterizes the material's physical distinctiveness, material composition such as whether it is homogeneous or grainy, whether the material feels smooth—furry, hard—soft, cold—warm, moist—dry, transparent—translucent—saturated.

Structure—the way in which something is created, formed, constructed of elements, joined by its components. This means the mutual order of the components in which something consists.

Texture—surface characteristics or mechanical processing, that refers to the tactile sensation. Textures include all sorts of micro patterns that stand out from or enter the object surface.

Visual appeal—refers to the aesthetic characteristics that appeal to our sense of vision. That means properties that capture the consumers' attention and make an impression. It means one or more properties that excite attention such as a feature of a tool that ties it to an underlying story or a humorous touch as do many of the Alessi products.

The aesthetic concerns everything that appeals to our senses—what we see, hear, smell, taste, feel, and recognize from our experience of time and place. Colors that are the focus of this study can only be experienced through sight, so we have limited the inquiry to address the visual appeal, while making no distinction between intellectual and emotional appeal (Favrholdt 2000).

IDENTIFYING PROCESS PROBLEMS CONCERNING SURFACES

In Scandinavia we have again seen a change in interior design from preferred colors that blend into the context and natural occurring materials to strong colorful wall areas possible with a white edging and matching products, emphasizing the room's atmosphere. The more expensive interior though is still kept in the more neutral color schemes, while the cheaper interior accessories and tools are to be subjected to trends or seasonal color schemes to boost consumer spending. The increasing individualism has simultaneously triggered a demand for new color variations with the ability to select individual products in contrast or bright colors. In our investigation, we have made a delimitation from looking at the color scheme of products compared to the mentioned interior design trends. We will instead investigate the color scheme, which has the aim of emphasizing the product's appearance and increase the product's user value from a cognitive ergonomic perspective,

that is, in the case concerning the color value. This distinction gave us the freedom to explore the products detached from the context they are designed for and in which we cannot experience them at design fairs. The criteria's usability is tested by the participants both in their mid-term seminar and in the final examination of the product proposal.

Initiating a study of surface problems is in itself a way to enhance the participants' awareness of these issues, therefore we involved our students in the study. The many participants made it possible to cover the entire fair, as the participants each had an area they should cover. This division of the study area also contributed to the analysis of a diverse range of products. Participants who chose to do the investigations at a store often chose the same products as were elected at the fair, which can be seen as an indication that these products represent particularly good design solutions.

The research instruction was as follows:

Find in the assigned area (or at a chosen store) a product whose visual appeal is entirely dependent on the color, texture, and materiality.

Draw or take a picture of the product and explain why you think the product's visual appeal is depending on color, texture, and materiality. If you cannot find a product in which the color, texture, and materiality are part of the visual appeal, you may find several products that together exemplify the color, texture, and materiality of the product's visual appeal.

Find also at least one example of a product whose colors, texture, or materiality contributes to cognitive ergonomics. Explain how you think the colors, texture, or the materiality are essential for the product based on a cognitive ergonomic consideration.

The participants brought crayons in case it was not possible to get permission to photograph the product, get a brochure or material samples. The method of recording using crayons comes from architect Anne Kappel (Kappel 1998).

A total of fifty-eight students participated in the survey, of which forty-two were at the Formland Fair. Participants had to pay for both transportation and admission to the fair, therefore, the remaining sixteen students preferred to do the survey in local stores, which contributed to the study's range.

At Formland the many exhibitors had their focus on the six selected colors: warm red, yellow, orange, oriental blue, spring green, and dark purple. Even the company Stelton had designer Paul Smith remake Arne Jacobsen's classic jug series in bright colors on the occasion of Stelton's fiftieth anniversary (see Plate 41). The new eye-catching colors have a lot of visual appeal next to the uncolored original, but hardly among the other colorful products, where the colors have to fight for our attention. From a cognitive ergonomic consideration the colored functional surfaces can facilitate our physiological reception in relation to information of, for example, where we must grab. Viewed from this perspective Stelton's approach is an improvement of the product's usability.

Stelton's new color scheme for Arne Jacobsen's design breaks with the original monochrome principle, which emphasizes the whole product because the gray-colored steel and the black-colored handle match each other in contrast to the colored handles.

Among the products selected for visual appeal was the "Crushed Cup," designed by Rob Brandt for AMTT (Figure 18.2), because the porcelain mug's form in itself is sculptural, but the noncolored surface also strengthens the product's appeal because the color contributes significantly to the reference of the classic Dutch cups in plastic. The cups are dented and crumpled as we know it from the plastic cups that are easily deformed.

The Michael Graves kettle with bird that Alessi produces in two monochrome versions with color and material contrast between white or black plastic and the original colored version with a soft light blue in contrast to the polished steel. The juxtaposition of a colored and an uncolored version of the kettle illustrates how colors can emphasize the nature of the product and link the individual components together. The grip on the boiler's handle and heating element are connected by the light blue color, and the whistling bird's dark red color links it to the boiler because of the small balls of the same color on each side of the grip. A monochrome version is shown in Figure 18.3.

Eva Solo's decanter and appertaining cloak has a visual appeal that is dependent on both color and texture in interaction between the individual elements' materiality. It is precisely the interplay between these elements that makes the product interesting and different. The decanter is made of a glass bottle with a drip-free spout in polished steel and a rubber ring.

The insulating cloak is a textile made of Neoprene. The design of the cloak with the big zipper in the fabric means that we associate it with a suit or coat, which consequently gives the product visual appeal. The contrast between the cold and warm, the smooth/shiny and furry/rough materials combined with the large zipper makes the

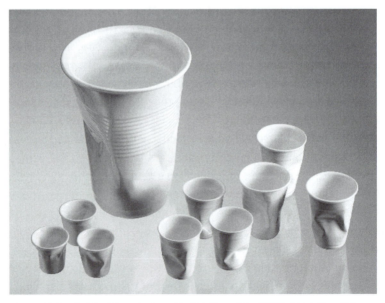

Figure 18.2 Crushed Cup, designed by Rob Brandt for AMTT. © Rob Brandt (www.robbrandt.com).

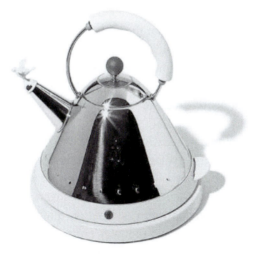

Figure 18.3 Electric kettle, designed by Michael Graves. Courtesy of/© Alessi (www.alessi.com).

product seem almost toy-like (see Plate 42). It arouses one's curiosity and make one want to look at the jug and touch it, try it. Furthermore the color contributes to the decanter's visual appeal but whether the appeal is positive or negative will depend on the combination of the textile color and the color of the drink the consumer will pour from the decanter. The combination of the color of the drink and the colors of the tableware have an impact on our well-being (Kringelbach and Thomsen 2009).

The color scheme of both the electric kettle and the decanter also takes the cognitive ergonomics into account, as the functional surfaces are highlighted by both color and material contrast on the two products. The plastic's materiality on the boiler's grip is highlighted by a vague uniform texture, which makes us perceive it as a heat-insulating handle. The decanter's cloak is made of a knitted fabric, which has a texture that makes us perceive it as something that is pleasant to touch, and gives us a good grip on the cool bottle that otherwise can be steamy and slippery.

One of the many mugs and drinking glasses that have been fitted with a colored ribbon, it should be noted for the way the materiality, color, and texture are exploited in terms of cognitive ergonomics, and not just to highlight the product's uniqueness. For example, the double-sided mug from Bodum Design Group Canteen (www.bodum.com) provides a gripping surface with a soft rubber band positioned in a recess in the mug's surface between 14 millimeters (9/16 inches) from the bottom and 28 millimeters (1 7/64 inches) from the top. The ribbon comes in multiple colors, that all stands in clear contrast to the white porcelain of the mug. The ribbon has a distinct texture in the form of a horizontal milling. The gripping surface is thus clearly marked with a signal of a non-slippery, soft grip. The ribbon also differentiates the drinking and supporting surfaces.

The Index cutting board designed by Damian Evans for Joseph Joseph is an example of colors used as a tool for functional differentiation. The product contains four cutting

boards in a single storage box. The four cutting boards are provided with an icon and a corresponding color to tell the user what the cutting board's use should be limited to in compliance with the hygienic rule of differentiation between the different types of food during cooking. The cutting board with the fish icon is blue and should be used for raw fish, similarly, the red for raw meat, the green for vegetables, and the white for cooked/ prepared food. This way it becomes easier to keep the different types of food separated in the kitchen.

The cutting boards can be purchased alone—only with the storage box, but it is also possible to acquire them with matching knives. Each knife is equipped with a colored dot that tells what cutting board it belongs to and hence for what type of food the knife is intended. The idea of linking each of the cutting board's color with a certain type of food is good. However, the solution with raw meat on a red plastic cutting board may be less effective as most users would probably prefer a wooden cutting board, as it gives a better color perception of the meat and also improved hygiene as beech is both bacteria-destructive and suitable for dishwashing (Institute of Technology 2002).

In connection with the research at the Formland Fair it was observed that the color, texture, and partly the materiality often didn't emphasize the character of the product or the product's use from a cognitive ergonomic consideration. In the specific exhibition areas at Formland reserved for students and recently qualified, it was also observed that the exhibited prototypes far from often gave a true presentation of the surface design desired on the finished product.

METHODS IN AN EXPERIMENTAL APPROACH

The aforementioned research provides the basis for our examination of how problems concerning the creation of the surface can, if not be equated with problems surrounding the creation of the form, then at least get more attention in the concept development. According to the Belgian Groupe μ the form is the sensory perception's central unit, while colors and textures are secondary (Groupe μ 1992). The materiality is not accentuated as a separate parameter in the Groupe μ's sensory model. The form's existence is dependent on a material's existence in the same way as the surface's existence is dependent on a form's existence. In aesthetics the colors and textures are characterized as secondary figurations (Bundgård 2004), precisely because neither the color or texture can be present without a form with surfaces. In the experimental work we often develop color, texture, and material using small samples and models in materials whose properties are very different compared to those of the product. An example is seen in Figure 18.4, which shows a model in wood where the growth rings give a completely different experience of form next to the mirroring prototype in brass.

The design process involved in the investigation had its focus on clarifying the leading features, that is, indicating the idea and structure of the product's overall form, as well as the content of specific form elements. The overall shape is the whole that constitutes

Figure 18.4 Model in wood and prototype in brass of the same door handle made by Lise Kaasing Munk.

the product. This clarification of the leading features is similar to Alexander Baumgarten's "illuminating methodology" (Brandt and Kjørup 1968). We assumed in the study that a surface area that constitutes a functional surface may be regarded as a form element, taking into account the cognitive ergonomics that determines the presence of well-defined areas with the same color or color mix that differs from the whole. The previously mentioned thermos's foot constitutes an external functional surface that the designer has chosen to give the color black, like the edge of the lid constituting a second functional surface. An external functional surface is a surface that has an active function to the surrounding world according to engineer Eskild Tjalve (Tjalve 1976). The participating students were initially introduced to Tjalve's method of systematic product development.

It was the introduction to Tjalve's model that led us to the fact that surface problems can be solved using the same design approach as we developed by combining the "illuminating methodology" with artist Erik Thommesen's "form element method" (Morell 2006; Thomsen and Craudin 2008). The method consists of subdividing the overall form into a number of form elements whose general location is defined by the form's structure; for example Forsters + Partners's door handle, Fusital—Two Ranges Door Furniture Italy, 1995–1995, used at Bundestag Berlin, is divided into an outside and an inside element in colored plastic with a connecting element between the two and a joining element in metal closest to the door plate. Form elements' mutual size are adjusted while their relative positions are tweaked until the form is in balance and harmony is achieved between the form elements. As indicated earlier we associate surface properties like color and texture to these form elements like material properties. An overall form will consist of multiple form elements that are processed separately in terms of shape, color, texture, and materiality. Simultaneously the whole of the form is being assessed after each adjustment of the overall form's form elements. This division has proved well suited to handle the surface issues in the concept development phase, although it provides some model technical challenges in obtaining an accurate expression of texture and materiality in a model material that is significantly different from the product. The treatment of surface issues using models in scale, for example, 1:5, is

especially a problem, since the model's materiality should be finer-grained and the texture should be in the same scale as the model.

Designer Hella Jongerius, with "Polder sofa XXL," Figure 18.5, has shown how such a division in the form elements can give the product a distinctive visual appeal by an individual color scheme. The green colors in the sofa reflect the variation found in different tree crowns and with this choice Jongerius achieves both an unusual interior color scheme and, from nature, a very recognizable color scheme that draws nature into the living room.

THE MODEL'S PRESENTATION OF THE DESIGNER'S INTENTIONS

Through the senses, the experience of form, color, material, and texture penetrate into the mind and gather into an "image" of the future product. It provides the manufacturers who are considering acquiring the rights to manufacture the product with some expectations for the finished result. The same applies to the buyers at a fair that place an order on the basis of a catalog and a model or prototype. Very often both architects and designers prepare monochrome work and sales models to give a tangible impression of the future product.

The uncolored abstract model that changes from cold white in the light to warm and broken in the half shadows and gray in the shadows is a fascinating spatial form with its own artistic expression that presents itself beautifully at an exhibition. The improved options to produce models with milling and three-dimensional printing has significantly contributed to at least the model's form being consistent with the future product. It's harder, though, with the material and surface properties, both of which will reflect the manufacturing process and the model's materiality. As a presentation of the future product's values the monochrome model is therefore often so inadequate that even professionals can be surprised when they see the finished product.

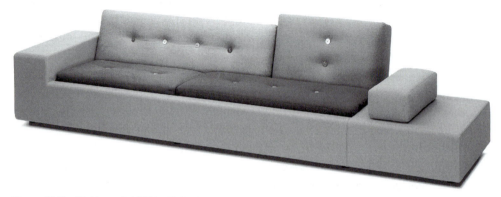

Figure 18.5 "Polder sofa XXL" by Hella Jongerius. © Vitra (www.vitra.com).

Models that are being colored and perhaps have textures applied seem more real and in that way help the viewer to imagine the future product. The model's materiality may deviate from the product because of different scales, since it can distort the overall picture if, for example, shadow effects from the surface's structure do not fit the scale. The model material's (or the primer's) color can also shine through the paint and give us a different experience of the color of the model than the same color paint would give the product. Even models painted in the colors the product will consist of can present the viewer with problems imagining the quality of the product. In addition colors are perceived very differently in combination with a coarse uniform texture, a pattern, or a completely smooth surface. Text, drawings, and material samples, though, may support the presentation of the designer's intent, but it is left in the hands of the viewer to gain an overall understanding of the future product.

The first step toward a solution to this model interpretation problem is to increase awareness of the problem among all parties and allow them to train the ability to combine the many inputs about the product's surface texture into a perception of the whole. The combinations of model, prototype, and product that can be seen on many design exhibits is a very good way to achieve this.

The next step we must take is that we as designers make it clear to ourselves what the model should convey in the specific context. For instance, if the model is being used in a competition context or at a museum or gallery exhibit, its artistic expression can be at the highest priority. If, however, the model is being used for sales fairs or meetings with collaborators, an expression as true as possible to the product's surface must be at the highest priority.

Through experiments with old and new painting techniques and model materials, it is possible to get very far in efforts to convey the product's surfaces via models, but it is required that surface problems that occur are treated early in the process. It requires both a number of experiments and a good process to achieve credible surfaces.

Our best product examples have been exhibited at fairs, such as CODE at the Bella Center, where most visitors expect to see finished products, and therefore evaluate models as such. These models or prototypes must first help to capture the visitors' attention as they are passing by, and in that situation it may well be accepted that only the visual impression is credible. This means that:

1. We must choose model materials, with a materiality that visually is as close to the final product as possible. Finishing the product with staining, filling, roughening, and so on can be considered.
2. The color scheme of the model must be consistent with the product.
3. The texture must appear to resemble the product so much that a credible expression can be achieved, for example, by adding paint filler, so the finished result is similar to the product's surface after polishing, painting, and so on.

If the model has enticed the guest to enter the stand, we have the opportunity to explain how the overall sensory impression of the product is expected to be, therefore it can better be accepted that the materiality is not completely credible and that the tactile experience is a little unclear.

RESULTS OF THE STUDIES

Regarding the issues raised in the introductory paragraph, the studies have provided some practical useable answers:

> It is possible to raise awareness of surface issues in the research phase, by letting the design of the surface be a separate topic both in the Key Performance Indicator and in the research instruction.
>
> Surface problems can be handled in the concept development phase by dividing the overall form into form elements so that each functional surface represents an area on a form element. For the individual form elements' surface characteristics such as color, the color's micro patterns, materiality, texture, and perhaps textures for additional elements, along with the form's geometry and material, are being specified.
>
> Clarification of criteria that are relevant to the assessment of surface characteristics in comparison with the product's achievement of high visual appeal and clear cognitive ergonomics:
>
>> The surface's ability to emphasize the product's character respectively
>> The surface's ability to emphasize the product's use.
>
> Furthermore, there may be cases where ethical criteria regarding "the surface's authenticity" can be presented, that is,
>
>> The surface's ability to convey the materiality, or
>> The surface pattern's ability to emphasize the surface's character and origin.
>
> Criteria for assessing the qualities of the model surface in relation to conveying the expectations for the product:
>
>> The surface's ability to visually convey the quality of the product's surfaces in both light and shadow
>> The surface's ability to convey the product's materiality, primarily visually and secondarily textile
>> The surface's ability to convey the product's textures, primarily visually and secondarily textile.

Of course there are also a number of issues concerning the surface's ability to patinate aesthetically, worn so that it highlights the character of the product and the color's interaction with the contamination. These issues were investigated by Engelhardt (Frederiksen 1965) and they would be very relevant to include among the evaluation criteria, but in regard to this study's context, the exhibitions at Formland and CODE, this was not possible. They should nevertheless be included in future studies that deal with the products in used conditions.

NOTE

1. An explanation of the Key Performance Indicator can be found at http://www.kpilibrary.com.

REFERENCES

Brandt, Per Aage, and Kjørup, Søren (1968), *Baumgarten og æstetikkens grundlæggelse*, Copenhagen: Forlaget Eccers, 73–74.

Bundgård, Peer F. (2004), *Kunst Semiotiske beskrivelser af æstetisk betydning og oplevelse*, Copenhagen: P. Hasse & Søns Forlag, 85.

Favrholdt, David (2000), *Æstetik og filosofi*, Copenhagen: Høst Humaniora, 116–51.

Frederiksen, Erik Ellegaard (1965), *Knud V. Engelhardt Arkitekt and Bogtrykker 1882-1931*, Copenhagen: Arkitektens Forlag.

Institute of Technology (2002), "God hygiejne starter på et skærebræt af TRÆ—Overrasket?," http://vot.teknologisk.dk/_root/media/Tr%E6_og_levnedsmidler_konsument.pdf.

Kappel, Anne (1998), *Farvens Format*, Copenhagen: Kunstakademiets Arkitektskoles Forlag.

Kringelbach, Morten L., and Thomsen, Kristine Rømer (2009), *Den farverige hjerne*, Louisiana Museum of Modern Art, Magas in #31, 40–49.

Morell, Lars (2006), *Skulpturen. Samtaler med Erik Thommesen*, Rønde: Boggalleriet.

Groupe μ (1992), *Trait du signe visuel. Pour une rhtorique de l'image* [Treatise on the visual sign: Towards a visual rhetoric], Paris: Seuil.

Rasmussen, Steen Eiler (1966), *Om at opleve arkitektur*, Copenhagen: Gads Forlag, 161–87.

Thomsen, Bente Dahl, and Chraudin, Marianna (2008), "The Dilemma—The Creation of Forms via Digital or Manual Models," 10th International Conference on Engineering and Product Design Education, Barcelona, Spain.

Tjalve, Erik (1976), *Systematisk Udformning af industriprodukter*, Copenhagen: Akademisk Forlag.

Color and Computer-Aided Design

Rene Van Meeuwen and Nigel Westbrook

Chapter Summary. The use of color in buildings has become a relatively new form of expression that has burgeoned with the impact of computer software. Color-matching techniques, combining codified computer color specification, allow designers a high level of control over color in their work. Current computer-aided design tools allow buildings to be tested and trialed using a palette of thousands of colors. In computational software terms, the pixel is the primary ordering device of color. Buildings' components are utilized like pixels in order to build images. The implications and relations within these images exposed by the mediation of various colors within pixels create signs that infer meaning. The use of color explored in this chapter is not merely painterly, but also mediated by material typologies and predetermined swatch colors figured by selections of color, somewhere between conditions governed by historical nostalgia and contemporary fashion. Architecture has a long tradition of the use of color in designs to augment the legibility of buildings within urban contexts. More recently Lynch has described the city as a generator of mental images, while Venturi describes architecture as a series of semiotic signs that construct our environment. Poststructuralists, however, argue for a language of color that has an expressional force beyond and independent of linguistic structures or meaning. Initiated by computer-aided design software, and executed by computer-aided manufacturing, color becomes vital in the contemporary expressivity of architecture. While the digitally enhanced use of images in advertising and billboards is well-covered territory in cultural theory, this chapter will cover the implications of the color of buildings within the same context. There is no direct message, instead the outcome results in a new language of image as urban fabric, indelibly a result of historic precedent fused with computational software as an expressive medium.

Visualization software and Photoshop in particular have had a transformative effect on the use of color in architecture. This transformation can be categorized into two separate forms: a latent transformation via the agency of the software, and its everyday use within architects' offices for image production. The other transformation is more direct—some architects use Photoshop and its inherent aesthetic and technical functions to create architecture the meaning of which has been constructed by its software

realization. This study focuses specifically upon the latter condition and its contribution to a shift in architectural methodology away from both modernist psychological perceptions of space and postmodernist figural semiotics.

HISTORICAL CONTEXT OF USE OF COLOR IN MODERN ARCHITECTURE

The modern use of color in architecture may be traced back to the color experiments by Owen Jones at the Oriental Court of the Great Exhibition in London. Drawing upon his study of Islamic and ancient Egyptian art, and his knowledge of scientific studies on the effects of color on perception, Jones developed a color theory based around the primary colors of blue, red, and yellow, supplemented by the use of white and black. In his classic book *The Grammar of Ornament*, Jones put forward a series of rationalistic propositions for the use of color in architecture. Notable was his emphasis on advancing and recessive color, and the effects of complementaries upon each other.[1] This positivist use of color was later paralleled in the color theories of Johannes Itten at the Bauhaus, and the creation by the De Stijl artists Mondrian and Van Doesburg of a painterly space, which could be counterposed against dimensional space, as seen in Mondrian's studio experiments with colored and tonal panels in Paris, and Van Doesburg's Café Aubette in Strasbourg, where the diagonal color fields, employing recessive and advancing color panels, created what Van Doesburg called a "counter-composition" in relation to the spatial structure of the building. These coloristic experiments found their most developed architectural expression in the Schröder House, designed by the De Stijl architect and furniture maker Gerrit Rietveld in Utrecht in 1924.[2] The rationalistic and "scientific" use of color has continued to form the dominant paradigm through the long history of modernism in the twentieth century. Color was called upon to supplement and support the architectural expression of spatial play and structural ordering. The ethical normativity of modernist discourse suppressed its inherently decorative aspects.

Within East Coast American architectural culture of the 1970s, such constraints were progressively undermined by postmodernist experimentation, ranging from Michael Graves's early formalist rereadings of the Corbusian canon, such as the Snyderman House (Fort Wayne, Indiana, 1967–1968), where the highly colored architectural expression became a three-dimensional working out of two-dimensional cubist painting, and Peter Eisenman's subversive revisiting of the Schröder House in his Frank House ("House VI") in Washington, Connecticut, of 1975, where he merged the two categories of modern architecture and Abstract Expressionist art. Through the sustained critique of Robert Venturi, the modernist ethics of truth to materials and functional and structural expression was exposed as arbitrary (fictional) and productive of poorly communicative design. Venturi's new category of the Decorated Shed became paradigmatic for a new emphasis upon the building as semantic mediation.[3] The connection with the modernist canon was fully severed in later postmodernist works like Graves's Portlandia

Building (Portland, Oregon, 1976–1980), where the two-dimensional painterly image emerged onto the exterior as figurative ornament, reprising the flattened ornament of the Viennese Secessionist architecture of Olbrich, Hoffmann, and Wagner.[4] Form was now to be discussed as much in terms of the optics of figural perception than of the plasticity of sculptural configuration. Space as the site for architecture was contested by surface. In this new conceptual environment, the architectural world became receptive to the possibilities that were to open up with the new pixelated surfaces of the digital.

Visualization software such as 3D Studio Max has allowed for the materiality of building being manifest as a discrete set of surfaces through the design process. Before construction method or materiality has been nominated, the visualization technique systemically treats the building form as a canvas that one might paint rather than construct through the choice of a material such as stone, brick, or concrete. Visualization software uses bitmap images to create materials—the latter are then assigned to a surface to then represent a material within a building. The material editor positions Photoshop as a primary curator of the color in buildings from the point of view of a design procedure. Architects have recognized the connection between virtual visualization and the procedure that uses Photoshop to create materials and therefore patterns, and have exploited this in their design methodology.

We will discuss two buildings as case studies that manifest the use of Photoshop in the final appearance of the building: Lilydale TAFE College, an educational facility, in Melbourne, Australia, by Lyons Architects,[5] and a significant public building, the National Museum of Australia (NMA) in the nation's capital, Canberra, by Ashton Raggatt McDougall.[6] In each example the architects have deliberately used the aesthetic results of the software to acknowledge a shift in design from manual haptic methods to computational methods. Although both examples are an attempt at a visual logic that uses color to recognize cultural shifts through design practice, they are undertaken in different ways, reflecting the function of the buildings.

The Lilydale TAFE building manifests itself as a pure example of a *decorated shed* (Plate 43).[7] All of the façades are either pixelated, or use graphically manipulated ambiguous images. Two materials are used to create the decorated effect: bricks and Colorbond steel sheet. The multicolored bricks are utilized to create a pixelated surface, and the Colorbond is used to create large graphic effects. The actual patterns and graphics remain abstract enough so that no meaning can be derived from the color effect. The primary design device, a deliberate ambiguity between two- and three-dimensionality, clearly reveals the use of Photoshop as design generator. This architectural "graffiti" is understandable to the predominately teenage users of the educational building. The building is identifiable to an audience who could be described as *digital natives* (a term used to describe a generation that has grown up with computers as a day-to-day device). It brings pop culture forward into the digital age, creating surfaces for which the closest analogy is the computer or television screen.

The TAFE building relies on color to achieve its design intention. This has been achieved in two different ways: the brick colors selected from the product catalogue are

close in proportion to the dimensions of Photoshop pixels (see Plate 44). The transition from an image in Photoshop to an entire façade reconstructing the chosen image by utilizing the color of bricks is straightforward. Colorbond, a precoated colored metal sheet, is used to construct chromatic planes that create ambiguous graphic effect. Thus, for example, color shifts create the appearance of an archway near the building's entry. A three-dimensional form is rendered as two-dimensional surface. This is a significant design shift mediated purely by color through the technique of Photoshop.

The National Museum of Australia, on the other hand, uses color in many different ways. Firstly, in the rear façade of one of its buildings, the AIATSIS center (see Figure 19.1),[8] the architects have used color in the most profound and rhetorical manner. Here the architects have taken Villa Savoye, an archetypical modernist building by Le Corbusier, constructed it almost precisely as a simulacrum of the original, and then literally, with the stroke of the mouse, painted it black. Strictly speaking, black is the absence of color; however, the point of the matter is the use of color to signify a specific meaning. In this first instance the building was copied in its entirety, literally downloaded from an architectural model website and inserted into the project. The AIATSIS building houses an institution fostering research of and by Australia's indigenous people. Its "Not Villa Savoye" façade has a direct axial relationship with the Australian Parliament house. The architects have alluded to many different readings to explain this color change; however,

Figure 19.1 AIATSIS center, showing the copied Villa Savoye painted black, designed by Ashton Raggatt McDougall. Photograph by Rene Van Meeuwen, 2009.

the obvious and clearly defined meaning allows for a heroic modernist building from Europe to be reflecting a black face rather than a white face, in an inversion of cultural colonization.[9]

Photoshop collage is used on the façade of the building like a form of graffiti, a significant example being the "Eternity" sign, alluding to a famous graffiti message that used to appear on the streets of Sydney.[10] See Figure 19.2. In the NMA the architects have cleverly disguised this graffiti image over the entirety of the exterior surface of the main exhibition space. The façade was flattened using 3d Rhinoceros, a computer-aided manufacture software, then using Photoshop the eternity graffiti was literally stenciled across the flattened façade. Once made three dimensional the eternity graffiti, colorized into the panels of the façade, is only ever partially apparent at different moments from exterior views of the building. Here Photoshop has been used as a tool to allow the sampling of graphics and through various digital techniques their use as symbolic gesture at various scales on the building.

The other use of color is in the red surface that continually reappears through the main museum building. The use of the color red is again symbolic—implying the blood spilt during the white occupation of Australia (see Plate 45)—and is an intentional affront to the denial on behalf of historians, politicians, and media of this history. The building itself represents the institution of the museum, while the red color memorializes the political moment in time. The commissioning and construction of such a building, celebrating and elaborating on Australian history and culture while the government of the time was unable to issue a national public apology to its indigenous people, is indeed ironic. The red insists the building is not about a singular truth, but rather about

Figure 19.2 Photograph of the unwrapped façade of the Main Hall of the National Museum of Australia combined with the Eternity graffiti. Tangled Destinies, National Museum of Australia, pp. 44–45. Image courtesy of Luxford, 2002.

revealing stories of difference. The "bloody" insertions and subtractions act as a kind of abstract counternarrative or negative rhetoric, resisting the brushing aside of these issues in the creation of the national "story." Like a kind of architectural Wikileaks, they demand that we see the damage.

These short examples are musings of further research into the transformative effect that color, mediated through the computational software Photoshop, can have on a more general theory of aesthetics and meaning within the discipline of architecture. Interestingly, the net effect is a new interest in the use of digitized color to propagate this general theory, and also a borrowing from cultural practices that give signification, narrative, or meaning to particular colors or patterns. Photoshop and architecture are still in the early years of design strategies that specifically utilize such methods; however, there is no doubt that when historians and theorists of architecture write about color and contemporary architecture they will be enquiring on the use of pixels and color data.

NOTES

1. Owen Jones, "Propositions," in *The Grammar of Ornament* (London: Day & Sons, 1856).
2. On the development of color theory within the Bauhas, see F. Birren, ed., *Itten: The Elements of Color: A Treatise on the Color System of Johannes Itten* (Stuttgart: Urania Verlag, 2003); H. Engels and U. Meyer, *Bauhaus-Architektur, 1919–1933* (Munich: Prestel, 2001); E. S. Hochman, *Bauhaus: Crucible of Modernism* (New York: Fromm, 1997). On the development of color theory within the De Stijl group, see A. Doig and A. Doin, *Theo Van Doesburg: Painting into Architecture, Theory into Practice* (Cambridge: Cambridge University Press, 2004); H.L.C. Jaffe, *De Stijl, 1917–1931: The Dutch Contribution to Modern Art* (Cambridge, MA: Harvard University Press, 1986); S. Fauchereau, *Mondrian and the Neo-Plasticist Utopia* (Barcelona: Ed. Polygrafa, 1994).
3. R. Venturi, *Complexity and Contradiction in Architecture* (New York: Museum of Modern Art Press, 1966); R. Venturi, with D. Scott Brown and S. Izenour, *Learning from Las Vegas: The Forgotten Symbol of Architectural Form* (Cambridge, MA: MIT Press, 1977).
4. E. Kudalis, *Michael Graves* (Minneapolis: Capstone Press, 1996), 31–32; K. Vogel Nichols, P. Arnell, and T. Bickford, *Michael Graves: Buildings and Projects 1966–1981* (Tokyo: A.D.A. Edita, 1982).
5. Lyons Architects is a large group practice focusing primarily on health and education projects. One partner, Corbett Lyon, spent a period working for Venturi & Scott Brown, while its chief design architect, Carey Lyon, has built upon a study of Venturi to propose a theory of "thin surface" and pixilated image.
6. Ashton Raggatt McDougall (ARM) is an innovative practice that grew out of a rich architectural debate in Melbourne in the late 1970s, stimulated by the writing and work of Peter Corrigan, and the influence of Robert Venturi.
7. The term derives from Venturi, Scott Brown, and Izenour, *Learning from Las Vegas.*
8. The Australian Institute of Aboriginal and Torres Islander Studies.
9. There are also references to a mask that was used by an infamous Australian bush ranger, Ned Kelly. His mask was formed out of dark sheet metal and had a distinctive slot for his

eyes. Here there is a remarkable formal similarity with the strip windows of (not the) Villa Savoye, set into their black surrounds.

10. The graffiti was spruiked around the streets of Sydney by Arthur Stace, a destitute alcoholic who found redemption in Christianity. Stace wandered the streets for thirty-seven years scrawling over a half a million times the word *eternity* in chalk and crayon predominantly on foot paths. This motif was made famous when Australia proudly used it in the 2000 Sydney Olympics Opening Ceremony over the Sydney Harbour Bridge.

Color as a New Skin: Technology and Personalization

Luca Simeone

Chapter Summary. What color is associated with technology and technological objects? Observing the consistent quantity of metalized, pearly white, and satin black products (laptops, mobile phones, domestic appliances), one wonders whether there should be a universally shared grammar for the design of technological objects. It is as if the limitation of color, smooth packaging, and satiny surfaces could highlight how precious and high-performing the technological equipment hidden inside is. This chapter highlights some stories where individuals use layers of color (paint, stickers, decorations) to cover their technological objects, thus inscribing new meaning onto them. This resemantization of objects through colored layers becomes a strategy and an individual and social practice for questioning and contesting orders of reality.

In particular this chapter analyzes the use of color stickers and objects in taxis, mostly their dashboards, as a means of encoding more personalized symbolic worlds, at the crossroads of multiple, dislocated, and radically different social and cultural articulations.

Leaving there and proceeding for three days towards the east, you reach Diomira, a city with sixty silver domes, bronze statues of all the gods, streets paved with lead, a crystal theatre, a golden cock that crows each morning on a tower.

All these beauties will already be familiar to the visitor, who has seen them also in other cities. But the special quality of this city for the man who arrives there on a September evening, when the days are growing shorter and the multicoloured lamps are lighted all at once at the doors of the food stalls and from a terrace a woman's voice cries ooh!, is that he feels envy towards those who now believe they have once before lived an evening identical to this and who think they were happy, that time. (Calvino 1978: 7)

LAYERING STATES OF REALITY

Poststructuralist deconstructive sensibilities consider the world as a perspectival construct that flows continuously across all its indeterminate and polycentric multiplicity; "a world that is diversified, heterogeneous, fragmentary, connectable, disassemblable and

overturnable, made of layers" (Gregory 2003: 26). Individuals weave their lives, narratives, memories into this complex, multilayered system, fluctuating between global and local dimensions and moving across intervals of time, space, and culture. Inside and across specific contexts patterns and practices of color usage might represent forms of aesthetic, historical, and political expressions, visual narration, and sensibility. Recent works on color have taken into account approaches from psychophysics, neuropsychology, cultural anthropology, and linguistics in order to identify color usage categories and patterns across different cultures (Hardin and Maffi 1997; Nassau 1998). Meanwhile, other researchers have adopted a more poststructuralist approach highlighting the transmuting dynamics of color semiosis practices. Meaning associated with color and color application is decomposed into a chain of ramifying connotations based on cultural specificity and individual situatedness (Gage 1999; MacLaury, Paramei, and Dedrick 2007). Within this theoretical framework, the interpretation and use of color are seen as variables dependent on the historically situated imaginations of people living within and across specific social, cultural, economic contexts.

This chapter tries to highlight some specific stories in the field of the anthropology of consumption where individuals use layers of color (paint, stickers, decorations) to cover technological objects, thus inscribing new meaning onto them. This resemantization of objects through colored layers becomes a strategy for questioning and contesting orders of reality, an individual and social practice acting at both a conscious and subconscious level. In particular this chapter analyzes the use of color stickers and objects in taxis, mostly their dashboards, as a means of encoding more personalized symbolic worlds, at the crossroads of multiple, dislocated, and radically different social and cultural articulations. As such, it will examine problems and issues that arise in the use of color layering in evolving syncretic and hybridized cultural and social spaces. Three images exemplifying the personalized touch of these syncretic aesthetics can be seen in Plates 46, 47, 48.

TECHNOLOGICAL OBJECTS AND COLOR LAYERING IN CONTACT ZONES

Stephen Eskilson focuses on the relation between product design and the industrial use of color on the 1920s and 1930s environment in the United States (Eskilson 2002). He remarks that from the earliest industrial design periods onward "color played a key role in this shift in the United States' economy toward the dominance of consumption" (Eskilson 2002: 28). Color is an important element in the shaping of identity and positioning of both products and brands as semiotic engines. As Jean Baudrillard points out: "In order to become an object of consumption, the object must become sign; that is, in some way it must become external to a relation that it now only signifies, a-signed arbitrarily and non-coherently to this concrete relation, yet obtaining its coherence, and consequently its meaning, from an abstract and systematic relation to

all other object-signs. It is in this way that it becomes 'personalized', and enters in the series, etc.: it is never consumed in its materiality, but in its difference" (Baudrillard 2001: 25). The use of color is a key factor in defining differentiation, value, and marketing strategies of a specific product within the reactive, complex, and animated landscape of consumption.

Although much information is unpublished because of competitive concerns, several studies from various fields have investigated the relationships between the use of color and marketing strategies, positioning, and practices, and in particular how color influences the perception and interpretation of products and subsequently increases their appeal (e.g., Trent 1993; Grossman and Wisenblit 1999; Crowley 1993; Bellizzi, Crowley, and Hasty 1983). Marketing experts on color draw on scientific literature where several dimensions of color are explored ranging from color as a primary physical phenomenon to theories that see it "as a more subjective phenomenon making it the product of our sensory apparatus and/or of the processing and interpretation that takes place in the brain" (Garber and Hyatt 2003: 315). Within this set of theories color is considered a (partially) cultural artifact that holds personal meanings for an individual. Learned contexts and culturally and historically based visions of the world mediate and at times dominate neurophysiological color response (Scott 1994; Garber, Hyatt, and Starr 2000). Other studies specifically deal with cultural contextual influences on product choices and the degree of consistency for color preferences among different cultural universes (Funk and Ndubisi 2004; Ndubisi and Funk 2004; Funk and Ndubisi 2006; Crozier 1999).

Some of the studies mentioned above additionally focus on marketing strategies, positioning, and practice for technological products. What color is associated with technology and technological objects? Observing the consistent quantity of metalized, pearly white, and satin black products (laptops, mobile phones, domestic appliances), one wonders whether there should be a universally shared grammar for the design of technological objects. It is as if the limitation of color, smooth packaging, and satiny surfaces could highlight how precious and high-performing the technological equipment hidden inside is in a more representative way. Shades of silver, pearl, metalized gray have been among the most popular automotive color trends in the last twenty years in Western markets (North America and Europe). In a 1996 interview about future color trends in the auto industry, Bob Daily, DuPont Automotive Finishes color styling and marketing manager, stated: "We see the high-tech trend influencing silver and gold with metallic and pearlescent effects, as well as pigment technology that creates hue shifts based on different viewing angles" (Triplett 1996: 21). The 2011 *DuPont Global Automotive Color Popularity Report* still states that silver, black, white, and gray are the top colors in the first-ever ranking of worldwide vehicle color popularity.[1]

Technological objects are often seen as machines of wonder that promise such a variety of experiences that maybe they cannot be represented if not with neutral colors, on which each of us is free to project his or her desires, enthusiasm, and hopes.

This fleet of technological products is often designed in the workshops of companies in the United States, Europe, Japan, China, South Korea—in a limited number of

countries—and then distributed pervasively throughout the world. Yet, the aesthetic of this uniform milky grayness (and how much it conceals behind it) is not appreciated everywhere. The result is that sometimes new aesthetics, syncretic and triumphant with colors, cover these neutrally designed objects equipping them with new multicolored skins. A cross-cultural example of these transformations can be traced observing the visual styling of taxis (and other vehicles) across several countries from the United States to India, Thailand, Mexico, Bolivia, the Philippines: decorative frames and layers, with their sweeps of color, reappropriate representational forms, resemantizing automobiles, vehicles, trucks and linking them to local, private histories, to more familiar aesthetic and narrative dimensions. As the interaction designer Ranjit Makkuni points out in a recent interview: "Taxi drivers in Mumbai ornament their taxis (a technology) so that the migrant driver (who is far way from home) can remember his village and values while on the move. Hence part of the solution today may be the recapture of ornament and the creation of personalized meaning in an environment of depersonalization" (Simeone 2009: 60).

Color usage and layering through stickers, spray painting, and applying sticky objects is a common practice to inscribe personal meaning onto these objects, thus transforming their physical bodies and spaces into sites of cultural identity. These practices of cultural reappropriation happen particularly frequently in those areas labeled as "contact zones." *Contact zones* is a term derived from Mary Louise Pratt's work: "I use this term to refer to social spaces where cultures meet, clash, and grapple with each other, often in contexts of highly asymmetrical relations of power, such as colonialism, slavery, or their aftermaths as they are lived out in many parts of the world today" (Pratt 1991: 34). The streets of Manila, bus stations in Bangkok, the decorated dashboard of a taxi driven by a Sikh and crossing the avenues of New York are all contemporary contact zones where technology encounters a specific subset of users. As James Clifford argues, contact zone theories are perspectival constructs that: "do not see 'culture contact' as one form progressively, sometimes violently, replacing another. They focus on relational ensembles sustained through processes of cultural borrowing, appropriation, and translation—multidirectional processes. And if the productions of modernity are exchanges, in this perspective, they are never free exchanges: the work of transculturation is aligned by structural relations of dominance and resistance, by colonial, national, class, and racial hierarchies" (Clifford 2003: 34).

New grammars and languages emerge inside contact zones; color layering functions as a discursive strategy to inscribe individual identity and meaning within contexts of evolving, transmigrant interpretation. Ranjit Makkuni is the Indian interaction designer who currently runs the Sacred World Foundation, a laboratory in New Delhi that develops experimental digital media based on natural interactions, augmented reality, and wearable computers. Makkuni started his professional career in the Xerox laboratories of Palo Alto, developing programming languages and the first GUIs (Graphic User Interface). The Xerox studies on GUI were then taken on by large computer companies such as Microsoft and Apple, to develop the near totality of the operative systems and

software that is spread in millions of copies around the planet. However, at a certain point in his professional pathway, Makkuni effected a radical development: he considered the limitations of the applications that were produced by American companies principally for an American market and then sold in many countries to many people with extremely different cultures, habits, and needs. This is how Makkuni describes the crux of his observation: "In rural communities, villagers may be illiterate with respect to Silicon Valley's notions of GUI, i.e., button pushing, point and click, but highly sophisticated with respect to hand skills and tactile interfaces. What is the equivalent of GUI in village contexts? What narratives are found in the village in the traditional performing arts of puppetry, theatre, mask dance? How do these narrative forms reflect a traditional society's perception of time and space? How might these inform the design of non-Windows based GUI?" (Forero and Simeone 2010).

Following this line of thought, Ranjit Makkuni has developed a syncretic aesthetics where interaction design devices get wrapped and decorated with Indian multicolored traditional artwork and patterns, as in the installations exhibited in the recent Crossing Project and Planet Health Museum in Delhi. Ranjit Makkuni pioneers the personalization of what he considers "impersonal" technological devices through the inclusion of world motifs, patterns, and crafts in the products, thus restoring colors.

TAXI DASHBOARDS FROM CALCUTTA TO DURBAN

Colors for exterior and interior surfaces of taxis are often decided in collaboration with international and local authorities, and they are usually consistent within specific geographic areas. Uniform fleets of yellow, green, black cabs cross the streets of Rome, Mexico City, London so that customers can immediately recognize official taxi services. Dashboard colors are even more highly standardized. While the exterior design is the realm of automotive stylists and car designers, dashboard design is often a collaborative and co-design process where ergonomic and functional dimensions are crucial. Multidisciplinary teams with people coming from different backgrounds (ergonomics, human factors, cognitive psychology, interaction design, marketing, operation) work together to define the best driving experience. Within this domain, every element of the dashboard is highly significant and carefully defined so as to create a driving interface that is easy to use, efficient, and effective (Norman 2004; Brown 2009). The design of a dashboard therefore requires significant investments across the entire production line. This is the main reason why car dashboards, once designed, tend to be consistent across times, markets, and cultures. Typical taxi dashboard colors are black, gray, beige, silver: a neutral, highly functional grayness that immediately highlights commands and driving information.

It is not surprising then that this neutral grayness becomes a writing board ready to be personalized by taxi drivers who spend most of their daily life inside their cab. Taxi dashboards function as sites of inscription, where multicolored stickers and window

decals, bottles of perfumes and oils, incense sticks, holiday cards, religiously inscribed bookmarks, wall plaques ornament this neutral technological environment.

As Joann D'Alisera notices during her ethnographic observation of Muslim Sierra Leoneans' taxi cabs in Washington, DC: "From the outside, his weathered black and white sedan appears to be a typical Washington, DC taxi. The inside is another story. Like many taxis driven by Muslim Sierra Leoneans, Mustafa's is inscribed with his personal vision of Islam. The dashboard is covered with stickers, Qur'anic verses in Arabic. An embroidered box that contains a copy of the Holy Qur'an sits on top. Multiple copies of various pamphlets that Mustafa gets free from the Islamic Center, and cassette tapes, all of which are Qur'anic recitation (D'Alisera 2001: 91–92) are strewn on the front seat. And again, "As a site that is both private (his) and public (passengers'), his taxi becomes a vehicle in which multiple social codes interact, at times in conflict" (D'Alisera 2001: 93). Mustafa's cab is a public site on which he encodes his vision of the world, a site in which Islam is negotiated according to their owners' own subject positions.

Swati Chattopadhyay studies the ways in which the interior and the exterior surfaces of vehicles get covered by color layers representing slogans, icons, religious symbols, thus creating an informal, molecular art, in perennial movement. This vehicular art "constitutes one way by which the marginalized populations of the city have created their own space in the city—physically, economically, culturally. The spatial logic of marginality in Calcutta in the second half of the 20th century was a product of a series of compromises between city authorities, the poor, and the middle classes, between the elite and the subaltern, between the formal and informal economy" (Chattopadhyay 2009: 136). Chattopadhyay specifically focuses on the unbalanced power relationships within postcolonial contexts and sees these new colorful skins as a grammar for a subaltern insurgency in India, in the terms clearly represented by Ranajit Guha: "a massive and systematic violation of the words, gestures and symbols which has the relations of power in colonial society as their significata" (Chattopadhyay 2009: 132). And Chattopadhyay follows by asking: "Could we translate this relation between the subaltern and the popular to everyday life by seeing the crisis not as sudden spectacular rupture but as woven into daily transactions as small disjointed events?" (Chattopadhyay 2009: 133). For taxi drivers in Calcutta, fuchsia, bright yellow, fluorescent green stickers are some structural elements of this subaltern grammar.

Stephen R. Inglis studies the effect of printing technologies in the act of personalizing several objects such as taxi dashboards: "Most Indian paintings originally were an integral part of the building for which they were designed. [. . .] Printing technology and rapid reproduction have tended to reverse this situation, in that the painting travels to the viewer rather than the viewer to the painting" (Phillips and Steiner 1999: 132). Advancements in printing and molding technologies allow the production and distribution of inexpensive objects that can be used as color layers: stickers, decals, cards, a fleet of affordable, easy-to-use objects, ready to create temporary sites of inscription across vast geographic areas (from the *colectivos* in Peru, Bolivia, and Mexico to the tuk-tuk in Thailand).

In a recent ethnographic account, Thomas Blom Hansen studies taxi decorations in Chatsworth, a formerly Indian township south of Durban, South Africa (Hansen 2006). Indian taxi drivers experience the new condition of the post-apartheid in Durban that emerges "as a new, immensely creative African metropolis . . . a properly urban space, marked by unpredictability, difference, and the incessant movement of anonymous bodies and signs" (Hansen 2006: 186). Hansen analyzes the way taxi drivers ornament their cabs trying to redefine and express their identity within this new complex array of intersecting circumstances: "The swanking taxis and their decorations are distinctly Indian interpretations of the world of taxis. For taxis in the African townships, style is marked by the style of drivers and conductors and the style of music rather than by visual decoration. The style of decoration and equipment in the Indian townships reflect the wider obsession with cars—the single most important staple of everyday male conversation—and the technical competence that abounds in Chatsworth" (Hansen 2006: 198). And again: "In a bid to attract the burgeoning market of style-conscious teenagers in Chatsworth—keen consumers of white, Afro-American, and the globally circulating South Asian forms of fashion and music—taxis began to compete on style and sound. By the late 1990s the so-called swanking taxis, or swankers, appeared—painted in bright colors and sporting striking and dramatic motifs, seats in matching colors, and huge sound systems. The motifs range from dragons and huge weapons to half-naked blondes in leather outfits. The names range from Bad Boyz, Bone Crusher, or Spiderman, to distinctly unsubtle ones such as Ladykiller and Big Willie. Other taxis take their names from the local soccer heroes, the Manning Rangers (also known as the Mighty Maulers), and some taxis flaunt the Muslim identity of their owners with green colors and inscriptions such as 'Allah-hu-Akbar [Allah is great]' " (Hansen 2006: 197). The paint and colors help Indian taxi drivers renegotiate their identity in the evolving, transmigrant, fragmented context of post-apartheid. "The style of decoration on taxis also reflects an ironic play on stereotypes about Indians—the loud and colorful style, the over-the-top quality of the Bollywood style and aesthetic. When discussing this apparent Indian predilection for colors, the taxi drivers, owners, and ordinary customers always provided ironic and mocking explanations: 'We Indians love colors, don't you know?'; 'Ah, it is like Bollywood!'; 'When you *witous* (whites) think it is too much, that is when the *charous* love it!' Others would ironically repeat the slogan of Radio Lotus, the biggest Indian radio station in the country: 'Not Everything Is Black or White!' " (Hansen 2006: 199).

In Durban's post-apartheid multiple dislocations and differences, color stickers are a way for Indian taxi drivers to elaborate and narrate their positioning in society. In another study, Olatunde Bayo Lawuyi analyzes the world of Yoruba taxi drivers, focusing on vehicle slogans as expressions of social stratification among the Yoruba of southwestern Nigeria (Lawuyi 1988). He notes that: "An intricated set of colored stickers act as a wrapper of new meaning for the taxis, both the interior and exterior, a layer where slogans such as 'Tie da?' ('Where is yours?') signify that the vehicle owners have special powers which, however unroad-worthy their vehicles are, make them better off

than those without or 'Aiye e ma binu wa' ('World, don't be angry with us') that is a pray for a good destiny (*ori*). A really complex grammar of colorful stickers accompany drivers in their daily life struggle and sets on stage the Yoruba vision of the world and Yoruba divine symbols, the *juju*, to evoke beliefs, sentiments and emotions for security and success" (Lawuyi 1988: 5–9).

Through the use of these temporary layering tools taxi drivers transform a physical space into a site of cultural negotiation. Colored dashboards work as an active semiotic engine where relevant cultural traditions can be preserved and utilized and as an emerging aesthetics that merges "multiple interacting codes drawn from national and regional identity, tourism, political ideology, language, cultural background, and immigrant status" (Cadaval 1991: 206–7).

CONCLUSION

Diomira, the metalized city narrated by Italo Calvino, all encrusted with layers of gold, silver, bronze, lead beams particularly splendidly when multicolored lamps are lighted up. Multicolored reflections are a symbol of a previous (forgotten?) happiness. In a recent book Thomas Friedman argues: "Because it is flattening and shrinking the world, Globalization 3.0 is going to be more and more driven not only by individuals but also by a much more diverse—non-Western, non-white—group of individuals. Individuals from every corner of the flat world are being empowered. Globalization 3.0 makes it possible for so many more people to plug and play, and you are going to see every colour of the human rainbow take part" (Friedman 2005: 10). Friedman's optimistic vision of globalization only partially takes into account the existing unbalanced relations of economic, political, and military power and dominance. As Kathleen Connellan remarks: "Post-apartheid society and the fêted rainbow nation have been generally romanticized as a colorful ideal of multi-lingual ethnicities making efforts to share cultures and bury hatchets. But that is an exterior, trendy street view and constitutes a quintessential postmodernism, one that is vibrant and edgy" (Connellan 2010: 60). At times and in specific contexts, groups of individuals must actively fight to express their share of the human rainbow.

Multicolored stickers, window decals, cards serve as some sort of creative weapon for semiotic drifts and cultural reappropriations. Color layering practices in taxi dashboards and over other technological objects constitute a structural element of hybrid grammars and discourses, an element deeply immersed into the historical and political processes of sustaining, making, and remaking cultural bodies in contemporary contact zones. Bright colors layered on top of the metalized, pearly white, and satin black surfaces of technological objects work as crystallized secretions of the historical, linguistic, and political situatedness of individuals living (and fighting) in contact zones. We hope that all sorts of multicolored skins will keep lighting up as signs of more polyphonic visions, as a testimony to new actors establishing their own discursive identity.

NOTE

1. 2011 DuPont Global Automotive Color Popularity Report Insights, http://www2.dupont.com/automotive/en-us/au/article/color-popularity.html (accessed June 22, 2012).

REFERENCES

Baudrillard, J. (2001), *Selected Writings*, ed. M. Poster, Stanford, CA: Stanford University Press.

Bellizzi, J. A., Crowley, A. E., and Hasty, R. W. (1983), "The Effects of Color in Store Design," *Journal of Retailing*, 59/1: 21–44.

Brown, T. (2009), *Change by Design*, New York: HarperCollins.

Cadaval, O. (1991), "Making a Place Home: The Latino Festival," in S. Stern and J. A. Cicala (eds.), *Creative Ethnicity: Symbols and Strategies of Contemporary Ethnic Life*, Logan: Utah State University Press.

Calvino, I. (1978), *Invisible Cities*, New York: Harvest Books/HBJ.

Chattopadhyay, S. (2009), "The Art of Auto-Mobility: Vehicular Art and the Space of Resistance in Calcutta," *Journal of Material Culture*, 14/1: 107–39.

Clifford, J. (2003), *On the Edges of Anthropology*, Chicago: Prickly Paradigm Press.

Connellan, K. (2010), "White and Fitted: Perpetuating Modernisms," *Design Issues*, 26/3 (July 1): 51–61.

Crowley, A. E. (1993), "The Two-Dimensional Impact of Color on Shopping," *Marketing Letters*, 4/1: 59–70.

Crozier, W. R. (1999), "The Meanings of Colour: Preferences among Hues," *Pigment and Resin Technology*, 28/1: 6–14.

D'Alisera, J. (2001), "I? Islam," *Journal of Material Culture*, 6/1 (March 1): 91–110.

Eskilson, S. (2002), "Color and Consumption," *Design Issues*, 18/2: 17–29.

Forero, A. A. M., and Simeone, L. (eds.) (2010), *Beyond Ethnographic Writing*, Rome: Armando Editore.

Friedman, T. L. (2005), *The World Is Flat: A Brief History of the Twenty-First Century*, Waterville, ME: Thorndike Press.

Funk, D., and Ndubisi, N. O. (2004), "Does Consumers' Favourite Colour Affect Their Choice of Unpackaged Product (Car)?," in ICOQM Conference Proceedings, 303–10, Korea, October 25.

Funk, D., and Ndubisi, N. O. (2006), "Colour and Product Choice: A Study of Gender Roles," *Management Research News*, 29/1: 41–52.

Gage, J. (1999), *Color and Meaning: Art, Science, and Symbolism*, Berkeley: University of California Press.

Garber, L. L. Jr., Hyatt, E. M., and Starr, R. G. Jr. (2000), "The Effects of Food Color on Perceived Flavor," *Journal of Marketing Theory and Practice*, 8/4: 59–72.

Garber, L. L. Jr., and Hyatt, E. M. (2003), "Color as a Tool for Visual Persuasion," in L. M. Scott and R. Batra (eds.), *Persuasive Imagery*, Mahwah, NJ: Lawrence Erlbaum Associates.

Gregory, P. (2003), *New Scapes: Territories of Complexity*, Basel: Birkhäuser.

Grossman, R. P., and Wisenblit, J. Z. (1999), "What We Know about Consumers' Color Choices," *Journal of Marketing Practice: Applied Marketing Science*, 5/3: 78–88.

Hansen, T. B. (2006), "Sounds of Freedom: Music, Taxis, and Racial Imagination in Urban South Africa," *Public Culture*, 18/1: 185–209.

Hardin, C. L., and Maffi, L. (eds.) (1997), *Color Categories in Thought and Language*, Cambridge: Cambridge University Press.

Lawuyi, O. B. (1988), "The World of the Yoruba Taxi Driver: An Interpretive Approach to Vehicle Slogans," *Africa: Journal of the International African Institute*, 58/1: 1–13.

MacLaury, R., Paramei, G. V., and Dedrick, D. (eds.) (2007), *Anthropology of Color: Interdisciplinary Multilevel Modeling*, Amsterdam: J. Benjamin.

Nassau, K. (ed.) (1998), *Color for Science, Art and Technology*, New York: Elsevier.

Ndubisi, N. O., and Funk, D. (2004), "The Moderation Effect of Gender in the Relationship between Colour Dimensions and Car Choice," in AIMS Conference Proceedings, 466–73, India, December 28.

Norman, D. A. (2004), *Emotional Design: Why We Love (Or Hate) Everyday Things*, New York: Basic Books.

Phillips, R. B., and Steiner, C. B. (eds.) (1999), *Unpacking Culture: Art and Commodity in Colonial and Postcolonial Worlds*, Berkeley: University of California Press.

Pratt, M. L. (1991), "Arts of the Contact Zone," *Profession*, 91: 33–40.

Scott, L. M. (1994), "Images in Advertising: The Need for a Theory of Visual Rhetoric," *Journal of Consumer Research*, 21/2 (September): 252–73.

Simeone, L. (2009), "Beyond Natural Interaction," *Disegno Industriale/Industrial Design*, 39: 56–61.

Trent, L. (1993), "Color Can Affect Success of Products," *Marketing News*, 27/14: 4.

Triplett, T. (1996), "Automotive Color Trends for New Millennium," *Marketing News*, 30/20: 20–22.

Index